RUSKIN AND TUSCANY

**Under the patronage of
the Prime Minister of Great Britain
and il Ministero Italiano
per i Beni Culturali e Ambientali**

Jeanne Clegg and Paul Tucker

Ruskin and Tuscany

Ruskin Gallery, Collection of The Guild of St George, Sheffield
in association with Lund Humphries, London

The Guild of St George

The title 'Guild of St George' may well evoke Victorian images of 'Merrie England' but Ruskin's St George was equally shared by Italy – the Venetian saint depicted by Carpaccio. As Jeanne Clegg and Paul Tucker eloquently explain in their Preface, it was Ruskin's reading of Tuscan art and laws that formed the basis of the economic, social and moral teachings embodied in his 'St George's Company'. Following his own studies and recordings of Tuscan art and architecture, Ruskin commissioned younger artists to work for his 'National Store' of cultural treasures at Sheffield.

In 1985 the Collection of the Guild of St George was re-established in Sheffield with the support of the City Council. Since that time the displays in the Ruskin Gallery have been supplemented by temporary exhibitions organised by the Keeper, Janet Barnes. The Guild is glad to sponsor this major project. The treasures at Sheffield are enhanced by loans from many institutions as well as the complementary Ruskin collections at Bembridge and Brantwood. Grateful thanks are due to all the lenders. The scholarly work of Jeanne Clegg and Paul Tucker and the immense organisational task of Janet Barnes demanded a wider audience. The Guild was delighted that both the Accademia Italiana in London and the Fondazione Ragghianti in Lucca agreed to hold the exhibition in their splendid premises. The generous help and encouragement given by dott. Letts and her staff are gratefully acknowledged; likewise the support and co-operation of Pier Luigi Del Frate, prof. Santini and dott. Lanzillo in Lucca.

The financial donation by The Henry Moore Foundation is singularly appreciated. Moore's study of Pisan sculpture can be rehearsed in many of the exhibits.

The Guild has been honoured by many distinguished persons joining the Committee of Honour. The patronage of the Prime Minister and the reciprocal representation of Italian ministers is a significant hallmark to this first cultural event in European Year 1993.

ANTHONY HARRIS
September 1992

The Accademia Italiana

Over two years ago when I was approached by the Master of the Guild of St George to hold an exhibition of *Ruskin and Tuscany*, at the Accademia Italiana in London, I felt both excited and flattered.

Flattered, for the Accademia had been honoured to be able to place within its walls the works of one of the greatest Englishmen of all who had touched the Italian soil; and through the works themselves to be able to act, as it were, as host to the spirit of this great man. Yet he was just one of many, for almost all the most sophisticated and sensitive British intellects have made and enjoyed at least one Italian tour.

It should be remembered that what is now an easy and simple excursion, taken by many and mostly to satisfy the physical needs and pleasures, was in previous years an enterprise of physical endurance offering little physical pleasure. All was endured to satisfy the spirit, the intellect, the mind. Unquestionably the intellectual traveller is the most flattering to those Italians passionate about their own country and culture.

Yet ironically Ruskin was the one who by inclination was the least adaptable to Italian ways and forms. Most of the utterances in his writings about his experience of his Italian tours spoke of rejection and contempt; and yet, often within the same pieces, at times twenty years after the event, he succumbs to the magic, the intense poetry, the bitter flair of the Italian towns' artistic message.

It seems to me that this happened almost unconsciously responding to the pressure of his own 'genius'. In a letter to his father he wrote of genius as follows:

there is such a thing, and it consists mainly in a man's doing things because he cannot help it, intellectual things, I mean.

One of the most beautiful examples of Ruskin's approach is in a letter he wrote to a friend back in England upon his first encounter with Rome, my own town and therefore one I know well and sense deeply:

St Peter's, I expected to be disappointed in. I was disgusted ... In the city, if you take a carriage and drive to express points of lionization, I believe that most people of good taste would expect little and find less. The Capitol is a melancholy rubbishy square of average Palladian – modern; the Forum, a good group of smashed columns, just what, if it were got up, as it very easily might be, at Virginia Water, we should call a piece of humbug ... and the rest of the ruins are mere mountains of shattered, shapeless brick, covering miles of ground with a Babylon-like weight of red tiles.

But if, instead of driving, with excited expectation, to particular points, you saunter leisurely up one street and down another, yielding to every impulse, peeping into every corner, and keeping your observation active, the impression is exceedingly changed. There is not a fragment, a stone, or a chimney, ancient or modern that is not in itself a study, not an inch of ground that can be passed over without its claim of admiration and offer of instruction, and you return

**Accademia Italiana delle Arti
e delle Arti Applicate**
24 Rutland Gate, London SW7 1BB

CHAIRMAN
Rosa Maria Letts

EXHIBITION OFFICER
Roberta Cremoncini

EDUCATION OFFICER
Sarah Burles

MARKETING
Gigi Letts
Sara Pearce

PRESS OFFICE
UK:
Sue Bond Public Relations
Italian:
Paola Parretta Roscini

ITALIAN REPRESENTATIVE
Luciana Di Leo

The Accademia Italiana wishes to
thank the Ministry for the Arts and
The Museum and Galleries
Commission for arranging
Government Indemnity

*home in hopeless conviction that were you to substitute years for the days of
your appointed stay, they would not be enough for the estimation or
examination of Rome.*
(From a letter to the Revd T. Dale, 31 December 1840)

Ruskin, although not a Roman, nor even an Italian, knew and
understood that Rome like Naples is, once one penetrates beyond the
surface, a deeply melancholy city. Melancholia, is none other than 'il
dolore del passato' (the sufferance of the past), and Romans and
Neapolitans suffer this more deeply than others because of their acute
consciousness of all that is past and dead.

Tuscany, perhaps the most beautiful region in Italy, softer, more
suave and gentle at least in its landscapes, is more akin to the British
spirit. This exhibition is the story of Ruskin's reaction to this region,
its art, its nature. I cannot wait for the story to unfold for Tuscany, as
we read in this poetic description of flowers in Lucca, touched quite
another chord of the writers' sensitivity:

It will be quite worth while, if those policemen will let you, to come to Lucca
next year to see those cyclamens. They are the common mountain flower which
grows in autumn everywhere in nooks of limestone, but at Lucca it has fine
marble for the nooks, and these terraces of turf as I said for recreation: and
truly it is a new vision in flower-life to see it clustering and scattering along
them in that purity of lilac light.
(From a letter to Mrs La Touche, 2 November 1882)

ROSA MARIA LETTS
Accademia Italiana
delle Arti e delle
Arti Applicate
August 1992

Foreword

The idea of bringing the exhibition *Ruskin and Tuscany* to Lucca was greeted by the Fondazione Ragghianti with great interest.

This exhibition presents an opportunity for Tuscany – its towns, monuments and works of art – to be seen afresh through the sharp eyes of a visitor as exceptional as John Ruskin. It re-discovers the nineteenth-century vision of Tuscany, now often lost or changed.

The exhibition also shows how, and to what extent, Ruskin's knowledge and understanding of Tuscany influenced his historical, socio-political and artistic thinking. Charmed by the region, this cultivated Englishman developed a personal and suggestive vision of Tuscany, seeing it as the meeting-place for diverse cultures, the crucible from which 'European' man was formed in the late Middle Ages.

Our warm thanks go to the Ruskin Gallery and the Guild of St George, who organised the exhibition, and to Jeanne Clegg, who first conceived of it and who, together with Paul Tucker, has studied Ruskin's works in detail. They give us the opportunity to offer Tuscany a new representation of itself, and they contribute to our knowledge of a man who so strongly influenced the culture of Victorian England, itself a crucible for so many events in modern Europe.

PIER LUIGI DEL FRATE
President, Fondazione Ragghianti

First published in Great Britain in 1993 by
Ruskin Gallery
Collection of The Guild of St George, Sheffield
101 Norfolk Street
Sheffield S1 2JE
in association with
Lund Humphries Publishers
Park House
1 Russell Gardens
London NW11 9NN

on the occasion of the exhibition
RUSKIN AND TUSCANY
Accademia Italiana, London, 8 January to 7 February 1993
Ruskin Gallery, Sheffield, 20 February to 10 April 1993
Fondazione Ragghianti, Lucca, 1 May to 12 June 1993

British Library Cataloguing-in-Publication Data
A catalogue record for this book is available from
the British Library

ISBN 0 85331 626 0

Designed by Alan Bartram
Made and printed in Great Britain by BAS Printers Ltd
Over Wallop, Hampshire

Contents

Foreword

Why should a nineteenth-century British writer on art and culture have placed so many works relating to Tuscan art and architecture in a collection deliberately intended to reach the artisans of Sheffield, an industrial city in the North of England? The reasons for this apparently curious connection of Tuscany and Sheffield lie in Ruskin's acute awareness that the European cultural heritage was not, in origin or substance, really a matter of nation states and their 'official' identities, but, more especially, a matter of specific regional cultures historically interrelating within a framework of commonly inherited secular and religious values. Few people have taken the meaning and truth of art as seriously as John Ruskin, and fewer still have been as actively intent upon asserting the humanity of the arts as being a common European heritage.

The Ruskin Gallery in Sheffield has a unique origin and structure. It houses the Collection of the Guild of St George, a collection founded by Ruskin in Sheffield in 1875. The Guild of St George was formed by Ruskin in 1871 to be an active source of cultural influence. The collection is unique in that it reflects the wide-ranging enquiries of a man whose long working life was an active engagement with nature, art and history. The collection comprises medieval illuminated manuscripts, plastercasts of architectural details, minerals, photographs, prints, drawings, watercolours and a library. Moreover, it was very much intended by Ruskin to be a resource collection giving direct public access to its artefacts and not, in sharp contrast to prevailing prestige-orientated collections of private patronage and civic pride, a didactic paternalistic display. Ruskin was an educator and populariser whose habitual method was to encourage, by close study of valuable examples, the direct development of personal sensibilities and understanding.

Since its reopening, in 1985, the Ruskin Gallery has sought to develop a vigorous programme of exhibitions that not only reflect the historical importance of Ruskin's work but, also, keep faith with his strongly activist intentions. Whilst Ruskin has been traditionally associated with Venice, the Alps and the French cathedral towns, the importance of Tuscany in the development of his appreciation and understanding of the achievements of European art and culture has been relatively overlooked. However, not only the substantial number of works in the Collection of the Guild of St George but, also, the frequent and increasing references in Ruskin's writings, attest to the significance of Tuscany in Ruskin's thought. The fundamental importance of Tuscan art and culture, particularly with reference to Ruskin's teachings – both as subject-matter and example – was first suggested as being worthy of an exhibition by Dr Jeanne Clegg whom I first met when she was researching the 1983 Arts Council of Great Britain major exhibition on Ruskin's life and work. Early consideration of *Ruskin and Tuscany* soon showed that a thorough examination of the subject would necessitate a large-scale

exhibition and an extensive accompanying publication. We were there-
fore very pleased that Paul Tucker expressed enthusiasm for the project
and undertook to carry out research covering both the details of Ruskin's
journeys in Tuscany and the tracing of the often complicated develop-
ment of Ruskin's arguments and insights.

Moreover, in the present climate of an ever-increasing awareness of
the cross influences of European culture, a direct contemporary connec-
tion between Ruskin, Sheffield and Tuscany became desirable. We were
particularly pleased to find that the idea of this exhibition was welcomed
by the Fondazione Ragghianti in Lucca, for it was in Lucca that Ruskin
received his first great insight into the significance of medieval
architecture:

> Here in Lucca I found myself suddenly in the presence of twelfth century
> buildings, originally set in such balance of masonry that they could all stand
> without mortar; and in material so incorruptible that after six hundred years
> of sunshine and rain, a lancet could not now be put between their joints.
> Absolutely for the first time I now saw what medieval builders were and what
> they meant ... and thereon literally *began* the study of architecture.
> (Works xxxv, 350)

We would like to think that by 'returning' Ruskin's appreciations and
insights to a Tuscan context, not only will both be refreshed and illumin-
ated but, also, in a small way, an example provided of how, in the future,
the regions of Europe might move closer together in discussion of their
mutual heritage and enter into direct cooperation on issues of importance
to us all. Such an international profile has been further realised by placing
the London showing of this exhibition in the Accademia Italiana, an
organisation for the promotion of Italian history and culture.

This project would not have been possible without the active support
of the Directors of the Guild of St George, especially the encouragement
and creative collaboration of the Master of the Guild, Anthony Harris.
We would like to thank the sponsors of the exhibition, The Guild of St
George and The Henry Moore Foundation who looked kindly upon the
project in consideration of Henry Moore's close connection with Tuscany
from early in his career. We would also like to thank Sheffield City
Council whose vigorous and imaginative arts policy provides a foundation
for this and all the Ruskin Gallery's exhibitions.

Key to the success of the project has been the generosity of institutions
and private individuals who have lent works crucial to the realisation
of the exhibition. A full list of lenders is given below. However, I would
especially like to thank the following for their direct help in organising
the project:

Fiona J. M. Brown, Sarah Bunney, Corinne Cherrad, John Dawson,
James Dearden, Dennis Farr, Albert Gallichan, Janet Gnosspelius,

Richard Gray, Anthony Griffiths, Bruce Hanson, Simon Jervis, Mary Lago, Susan Lambert, Vera Magyar, Sandra Martin, Hazel Poole, Peter Rose, David Scrase, Victoria Slowe, Elizabeth Smallwood, Catherine Whistler, Stephen Wildman and Ed Yardley.

JANET BARNES
Keeper, Ruskin Gallery
September 1992

List of Lenders

Abbot Hall Art Gallery and Museum, Kendal, Cumbria
Ashmolean Museum, Oxford
Birmingham City Museum and Art Gallery
The British Museum, London
Courtauld Institute Galleries, London
The Education Trust Ltd, Ruskin Galleries, Bembridge School, Isle of Wight
and Brantwood Trust, Coniston
Fitzwilliam Museum, Cambridge
Manchester City Art Galleries
Manchester City Libraries
Private Collections
Ruskin Museum, Coniston
E. H. Yardley

Map of Tuscany showing the main places
referred to in the text

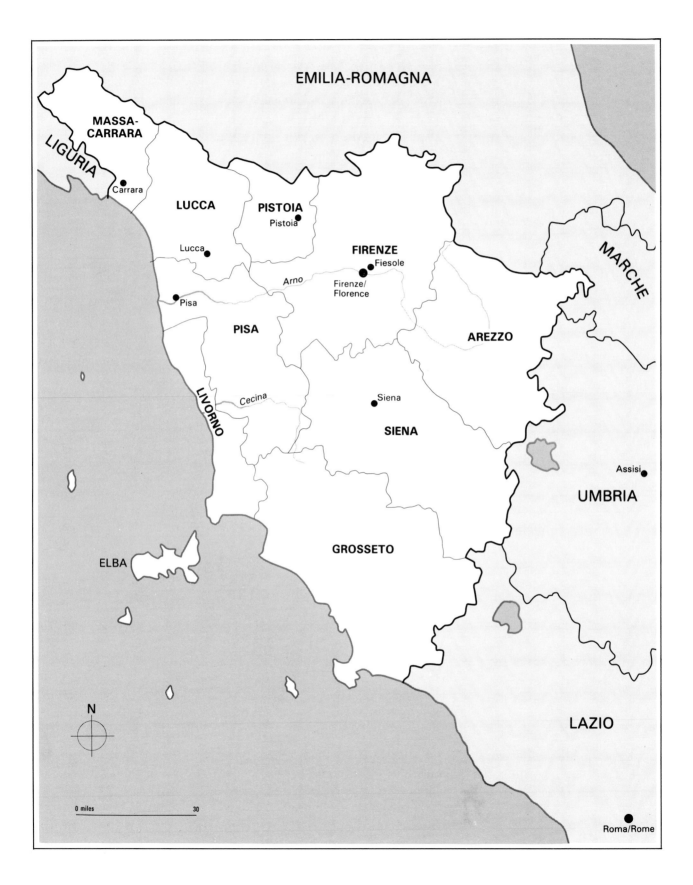

Preface

*Jeanne Clegg
and Paul Tucker*

The object of this exhibition is to make visible a part of Ruskin's work which has so far been almost invisible. There have been exhibitions on many of the centres of his thought, but never one on Ruskin's Tuscany. Much of his best writing on Tuscany is hidden in volumes and collections of materials ostensibly concerned with quite other subjects: *Modern Painters*, *The Seven Lamps of Architecture*, *Fors Clavigera*, *Aratra Pentelici*, the collections of drawings, copies, and photographs which Ruskin built up for his students at Oxford and for the workers of Sheffield. Other key titles – *Ariadne Florentina* and *The Aesthetic and Mathematic Schools of Art in Florence* – sound obscure and have in any case long been out of print. If everyone can connect Ruskin with Venice or with Amiens, it is also because he dedicated books explicitly to those cities. And if two of his Tuscan volumes, *Mornings in Florence* and *Val d'Arno*, have had good fortune – at least in Italy – it is perhaps because they announce their topographicality clearly. Yet neither of these contain Ruskin's best writing on Tuscany, and *Val d'Arno* is one of his most difficult texts: certainly not the regional guide book which its title seems to suggest. Where it does come into its own is as one of the four series of Oxford lectures which, in attempting a new synthesis of the principles of art, draw their examples almost wholly from Tuscany.

Which brings us to our own, in some ways misleading, title. Commenting on one of the most widely-read and influential books on art of the second half of the nineteenth century, Crowe and Cavalcaselle's *History of Painting in Italy*, Ruskin wrote:

Such a title is an absurdity … you can no more write the history of painting in Italy than you can write the history of the south wind in Italy. The sirocco does indeed produce certain effects at Genoa, and others at Rome; but what would be the value of a treatise upon the winds, which, for the honour of any country, assumed that every city had its native sirocco? (XXIII, 337-8)

Like the south wind, painting does have its local 'effect', but Ruskin is not interested in merely 'patriotic' celebrations. His Tuscany, like his Italy, is something much larger than an administrative region. It is a place where issues of basic principle come to a head: light versus colour; line versus mass; nature versus design; emotion versus practicality; chivalry versus justice. Even Ruskin's historical Tuscany is less important for any autonomous tradition than for its receptivity to other cultures. As 'Etruria' it is a place where north and south, east and west, Greek and Gothic, infidel and Christian meet, clash and interconnect. It is because it is a meeting-place of opposites that it gives Europe its art, and 'the first European man'.

But 'Etruria' is the Tuscany of Ruskin's later years, an imaginary and rhetorical place which had built up layers of meaning over visits made under different circumstances, and through repeatedly re-experiencing places and people, town atmospheres and landscapes. It is for this reason

that the exhibition – and the catalogue – is structured roughly according to chronology of production. The first journey to 'Italy proper' (as opposed to Lombardy) follows Romantic routes in search of subjects for poems and picturesque views; and scientific ones in search of unusual geological specimens. The journeys of the 1840s bring excited and exhausting study of early religious painting, of Romanesque architecture, of medieval history; and out of them come a wealth of drawings and daguerreotypes – made more as personal records and means of study than as pictures in their own right – and two important volumes: *Modern Painters* II and *The Seven Lamps of Architecture*. In the 1850s and 1860s Ruskin, losing his own faith, turns away from an art seen as wholly religious, only to come back to Tuscany in the 1870s as his appointment to the Slade Professorship at Oxford brings him to rethink fundamental principles of art. Through the sculptures of Nicola Pisano he explores the chiaroscurist and naturalist 'School of Clay'; through Angelico, Lippi and inlaid Romanesque façades the use of flat, pure, blocks of colour 'fitted edge to edge' by artists and builders of the 'School of Crystal'. Out of the study of Botticelli's frescoes in the Sistine Chapel and of fifteenth-century Florentine engravings come a demanding series of lectures on the 'labyrinthine line' and the 'art of scratch'; from curiosity about the culture that had produced them come two more difficult series, one on the political and economic history of the Val d'Arno, the other illustrating its essentially Etruscan-Christian nature. Also during the 1870s, this time as sole author of *Fors Clavigera* and founder of the Company – later Guild – of St George, Ruskin reads Tuscan art and laws as sources of economic, social and moral teaching, images of perfect social, governmental and sentimental relations. Parallel to the attempt to recover the lessons of the past is the attempt to make records for the future, for Ruskin felt the art and architecture of Tuscany – like that of Venice and Amiens and the landscape of England – to be in danger of destruction. The final journey, that of 1882, sees him handing on the work of recording and studying the art and life of Tuscany to younger men and women, students and artists instructed to work for the construction of a 'National Store' of cultural treasures at Sheffield.

A great deal of what Ruskin 'intended' was never realised, or half-realised, and many images in this exhibition are no more than clues to an idea. In addition, national stores, like Etrurian treasures, become dispersed, and identities are lost. Exhibitions are also means of reversing diaspora. In image at least, this one tries to bring some parts of Ruskin's complicated Tuscany together, and by itself travelling, bring them back to modern Tuscany. It has been the occasion for tracking down sculptures, drawings, engravings and copies whose Ruskin connections are not obvious in their present homes. Visitors to the Metropolitan in New York, to the Washington Museum, or to the British Museum, would not know,

and would not in any case perhaps wish to know the nineteenth-century ownership of pieces of a dismembered Pisan pulpit, of a Luca della Robbia relief, of a fifteenth-century *Florentine Picture Chronicle*. The exhibition has also been the occasion for tracking down the subjects of drawings unknown or mistaken. Mistakes will inevitably remain, and gaps. Some images have gone too far afield to be brought back, or have gone to important exhibitions elsewhere. We have been unable to trace early drawings of the Ponte Vecchio. The importance of Fra Angelico and Giotto is poorly reflected – partly because, though Ruskin wrote a great deal about both, he made and commissioned fewer copies than he did of say, Lippi, on whom he wrote less. Giotto, too, needs following to Padua and into Umbria – something beyond our scope for the moment. In this oddly unexplored region of Ruskin's mind, a lot has still to be done.

For the great deal that has been done by others we owe many thank-yous. Firstly to the Guild of St George and its Master for making the research possible and enjoyable, and to Janet Barnes for organising it and us, an enormous job. At the Italian end the Fondazione Ragghianti made the 'bringing home' possible, and our job in particular could not have been done without the generous help of dott. Lanzillo. To go further back in time, the Scuola Normale Superiore of Pisa, and in particular prof. Enrico Castelnuovo and prof. Paola Barocchi have given vital encouragement by organising a series of seminars and forming the nucleus of a Ruskin library. A grant from the Italian National Research Council (CNR) has helped towards the costs of research, which has naturally involved a great deal of travelling between Italy and England. James S. Dearden's knowledge of the Bembridge Collection and of Ruskin's drawings and works as a whole has been essential to the entire project. The following have gone to great trouble in answering specific enquiries: Sandra Beresford of Massa; signora Bianchi of the Istituto Lombardo of Milan; Sarah Bunney of London; Dr Lucilla Burn of the British Museum; Hans Buys of the Fondation Custodia, Paris; prof. A. Caleca of the University of Pisa; Malcolm Cole of Whitelands College, London; Marco Collareta of the Scuola Normale Superiore of Pisa; Philip Dalziel of Abbot Hall Art Gallery and Museum, Kendal; Daniela Dinozzi of Livorno; Peter Fuhring of Paris; Miss Janet Gnosspelius of Liverpool; Paul Goldman of the British Museum; dott. F. Guidobaldo of the CNR, Rome; Tim Hilton of London; Claire LeCorbellier of the Metropolitan Museum; R. N. Linsley, Secretary of the Carlton Club; Royal Willis Leith of Cambridge, Mass; Donata Levi of the University of Pisa; Richard Lockett of the Birmingham Museum and Art Gallery; Liliana Murray of Florence; Donald Myers of the National Gallery of Art, Washington; Lucia Nuti, University of Pisa; Robert Parks of the Pierpont Morgan Library, New York; prof. Salvatore Settis of the Scuola Normale Superiore of Pisa; maggiore Valerio Toccafondi of the Istituto Geografico

Militare, Florence; prof. L. Tongiorgi Tommasi of the University of Pisa; Rayner Unwin of London; Carlos van Hasselt, director of the Fondation Custodia, Paris; J. Wallace of the British Museum; David Wooton of the Chris Beetles Gallery, London. Thanks are also due to Renzo D'Angiolo and Peter Tucker for the care taken in photographing material in Florence and London. We are also grateful to prof. Teresa Zanobini and prof. Renato Chierici, both of the University of Pisa, for helpful advice, and to dott. Umberto Parini of the Scuola Normale Superiore of Pisa, ing. Luciano Fortunati of the CNR in Pisa and dott. Giuliano Meini for help with constructing the database which has been so essential in preparing the catalogue entries.

Alfonso Berardinelli's poem originally appeared in Italian in *Reporter* (27-28 July 1979); translation by Jeanne Clegg and Barbara Gunnell. The difficult job of translating the catalogue itself for the Italian edition was undertaken by Caterina Ranchetti and workshop.

Chronology

1819 born 8 February London, 54 Hunter Street

1823 move to 28 Herne Hill, near Camberwell

1825 family visit to Paris and field of Waterloo

1830 first poem printed, 'On Skiddaw and Derwent Water', in *Spiritual Times*

1832 birthday gift of Samuel Rogers' *Italy* with vignettes after Turner

1833 tour of Germany, Switzerland, Italy

1834 first geological publication in Loudon's *Magazine of Natural History*

1835 tour of France, Switzerland, Italy

1836 writes letter defending Turner, but artist discourages publication

1837 enters Christ Church, Oxford

1838 first book, *The Poetry of Architecture*, published in parts in *Architectural Magazine*

1839 begins collecting Turners

1840-1 Italian tour: Ruskin travels with his parents, cousin and old nurse in a hired carriage through France, following the coast down as far as Massa, then turning inland to Lucca, Pisa and Florence. They proceed via Siena to Rome and then go on to Naples, Salerno and Paestum, returning to Florence and reaching Venice via Bologna, Ferrara and Padua. The return journey includes Verona, Cremona, Milan and Turin.

1841 *The King of the Golden River* written for Effie Gray

1842 move to 163 Denmark Hill, London

1843 takes degree; *Modern Painters* I

1845 first journey abroad without parents: Ruskin accompanied by John Hobbs, his young servant. They travel in a light carriage and visit Geneva on their way to Italy to meet up with Joseph Couttet, Ruskin's mountain-guide. The party goes on to Genoa, Lucca and Sestri. At Pisa Ruskin studies the frescoes of the Camposanto and then travels on to Florence where he stays six weeks. By mid-July Ruskin leaves the city and heads towards the Alps.

1846 takes parents over route of 1845: Ruskin wants to share the journey of 1845 with his parents, and by mid-May they reach Venice via Turin and Verona. They travel via Padua, Ferrara and Bologna to Florence; and then on to Pisa and Lucca stopping at Prato and Pistoia en route. By the beginning of July they are in Massa, from which Ruskin goes to Carrara, then they continue up the coast to Genoa and Turin, leaving Italy by mid-July; *Modern Painters* II

1848 marries Effie Gray; tour of Normandy; *The Seven Lamps of Architecture*

1849 mountain drawing in the Alps; winter in Venice

1851 *The Stones of Venice* I; *Examples of Venetian Architecture*; *Pre-Raphaelitism*; death of Turner; winter in Venice

1853 *Stones* II and III; holiday at Glenfinlas with Effie and Millais

1854 Effie leaves Ruskin and marriage annulled; *Lectures on Architecture and Painting*; journey to France and Switzerland; undertakes teaching at Working Men's College, London

1855 *Notes on the Royal Academy* annually to 1859 also 1875

1856 *Modern Painters* III and IV; *The Harbours of England*; summer in France and Switzerland

1857 *The Political Economy of Art* lectures at Manchester; *The Elements of Drawing*; spends winter arranging Turner Bequest drawings

1858 meets La Touche family; summer in Switzerland and Turin

1859 *The Two Paths*; *The Elements of Perspective*; visits German galleries and Switzerland

1860 *Modern Painters* V; goes to Savoy and writes 'Unto This Last' essays for *Cornhill Magazine* – publication suspended

1861 holiday in Boulogne; plans home in Savoy; presents Turner drawings to Oxford and Cambridge

1862 takes Burne-Jones family to Milan and sends them to Venice; 'Essays in Political Economy' (later *Munera Pulveris*) begin to appear in *Fraser's Magazine*

1863 J. A. Froude, editor of *Fraser's* forced to stop publication of 'Essays'; buys land at Chamouni

1864 death of John James Ruskin; Joan Agnew (later Mrs Severn) comes to live at Denmark Hill; *Sesame and Lilies*; 1864-5 'Cestus of Aglaia'

1866 proposes to Rose La Touche; tour of France and Switzerland; *The Ethics of the Dust*; 1866, 1873 *The Crown of Wild Olive*

1867 *Time and Tide by Weare and Tyne*

1868 summer in Northern France

1869 'The Flamboyant Architecture of the Somme'; *The Queen of the Air*; summer in Verona; elected first Slade Professor of Fine Art at Oxford

1870 'Verona and its Rivers'; *Lectures on Art*, Oxford Inaugural course; founds Drawing School at Oxford; spring in Switzerland and Italy: Ruskin leaves England on 26 April with Mrs John Hilliard,

wife of the Rector of Cowley, Oxford, her daughter Connie and Joan Agnew, Ruskin's cousin, and Downs, Ruskin's gardener. Travelling by train they were away for three months, spending the first two weeks in France and Switzerland, they reach Italy on 17 May and visit Milan. From Milan the party goes to Venice via Verona where they stay nearly three weeks, Ruskin studying Carpaccio and Tintoretto. On to Padua to study Giotto's frescoes where Ruskin suddenly decides to go to Florence where he becomes very interested in Filippo Lippi. On 24 June the party leave for Siena, Ruskin sketching Nicola Pisano's pulpit. Returning to Florence they are in Pisa by 30 June via Lucca and then on to Pistoia on their way home, Ruskin promising to return the following summer.

1871 begins *Fors Clavigera: Letters to the Workmen and Labourers of Great Britain* and gives £17,000 for St George's Fund; *Aratra Pentelici* and *Lectures on Landscape* courses delivered at Oxford; mother dies; buys Brantwood by Lake Coniston

1872 *The Eagle's Nest, The Relation between Michaelangelo and Tintoret* and *Ariadne Florentina* lectures delivered at Oxford; begins publishing all writings through George Allen; tour of Tuscany and Venice: Ruskin leaves mid-April with Mrs Hilliard, Connie, Joan and her new husband, the artist Arthur Severn. Albert Goodwin, a landscape painter, is also included. The journey covers the same ground as in 1870: Turin, Genoa, Ligurian coast stopping at La Spezia before going to Pisa and Lucca. The main intention of the journey is to go to Rome and visit Joan's father-in-law, Joseph Severn. Once there, Ruskin studies the frescoes of Perugino and Botticelli in the Sistine Chapel. From Rome they go on to Assisi and Perugia and then to Siena and Orvieto before returning to Florence, where they stay for two weeks before going on to Venice. The journey is cut short when Ruskin hears that Rose La Touche wants to see him in England.

1873 *Val d'Arno* and *Love's Meinie* lecture courses

1874 'The Aesthetic and Mathematic Schools of Art in Florence' lectures at Oxford; begins Hinksey diggings; opens Paddington tea-shop; employs street sweepers in Seven Dials; spring and summer in Italy: Ruskin leaves England at the end of March, travelling with Crawley his servant and a German courier named Klein who later acts as valet; to Assisi via Genoa and the coast, visiting Pisa for one day. Stay in Rome to study the Botticelli frescoes interrupted by a ten-day visit to Sicily. After Rome Ruskin returns to Assisi and then in mid-July moves to Perugia and then Florence. From there he visits Lucca several times, studying the Ilaria del Carretto tomb in the Duomo. By 19 August Ruskin was back in Florence working on *Mornings in Florence*. He finally left Florence for Lucca on 20 September stopping at Pistoia on the way. Setting off for home at the end of the month; he had been away for six months.

1875 death of Rose La Touche; 1875-7 *Mornings in Florence*; founds St George's Museum at Sheffield; 1875-83 *Deucalion*; 1875-86 *Proserpina*

1876 *Bibliotheca Pastorum* series begins; spends winter in Venice; first delirious visions

1877 *Guide to the Academy at Venice*; 1977-8 *The Laws of Fésole*; 1877-84 *St Mark's Rest*

1878 first madness; Fine Art Society Exhibition of Ruskin's Turners; Whistler *vs* Ruskin libel case

1879 resigns Slade Professorship; *Notes on Prout and Hunt*

1880 *Elements of English Prosody*; visits Northern France; 1880-5 *Bible of Amiens*; 1880-1 *Fiction, Fair and Foul*

1881 second attack of madness

1882 continental tour: Ruskin leaves London on 10 August in company with W. G. Collingwood, a former Oxford pupil. They visit many places in France, travelling by the new coast tunnel from Sestri to La Spezia to Pisa, where they spend a few days before going to Lucca. On 5 October they go to Florence, returning to Lucca to continue their work. Pisa and Lucca dominate Ruskin's time during this journey. They returned home travelling from Pisa to Turin mid-November.

1883 resumes Oxford chair; *Art of England* lectures; third madness

1884 *Storm-Cloud of the Nineteenth Century*; *Pleasures of England* Oxford lectures

1885 resigns professorship; fourth madness; 1885-9 *Praeterita*

1887 fifth madness

1888 last continental tour

1900 dies; buried at Coniston

Catalogue

Abbreviated references

References to published works by Ruskin are to the Library Edition, eds E. T. Cook and A. Wedderburn, London, 1903-12, citing volume and page number only, *eg* XXXVIII, 268

AA = photocopies of John Ruskin's correspondence with Angelo Alessandri. Collection of Jeanne Clegg

AC = Arts Council

ALS = autograph signed letter

Bartolomei = Lia Bartolomei, 'John Ruskin a Lucca e a Pisa', unpublished thesis, Università di Pisa

Beckett = 'John Constable's Discourses, Compiled & Annotated by R. B. Beckett'. *Suffolk Records Society* XIV (1970)

Bem. = The Education Trust Ltd, Ruskin Galleries, Bembridge School, Bembridge, Isle of Wight

Bod. = Bodleian Library, Oxford

Birch = Dinah Birch, *Ruskin's Myths*. Oxford: Clarendon Press, 1988

Brant. = The Education Trust Ltd, Brantwood, Coniston

Burresi = Mariagiulia Burresi, *Santa Maria della Spina in Pisa*. Milano, 1990

Clegg = 'Circe and Proserpina: John Ruskin to Joan Severn, Ten Days in Sicily, 1874', in *Quaderni del Dipartimento di Linguistica*, Università della Calabria (1986)

Costantini/Zannier = *I dagherrotipi della collezione Ruskin*, a cura di Paolo Costantini e Italo Zannier. Florence/Venice: Alinari/Arsenale editrice, 1986

CRN = The Correspondence of John Ruskin and Charles Eliot Norton, J. L. Bradley and I. Ousby (eds). Cambridge University Press, 1987

Dearden = J. S. Dearden (ed.), *The Professor: Arthur Severn's Memoir of John Ruskin*. London: Allen & Unwin, 1967

Diaries = The Diaries of John Ruskin, J. Evans and J. H. Whitehouse (eds). 3 vols. Oxford, 1956-9

FAS = Fine Art Society

Finberg = A. J. Finberg, *The History of Turner's Liber Studiorum*. London, 1924

Forman = H. Buxton Forman, 'An American Studio in Florence', in *The Manhattan*, III, No.6 (June 1884), 525-39

Harris = Anthony Harris, *Ruskin and Siena*. The Ruskin Lecture 1991. St Albans: Brentham Press, 1991

Hind = A. M. Hind, *Early Italian Engravings. A Critical Catalogue with Complete Reproduction of All the Prints Described*. London: Quaritch, 1938

Horne = Herbert Horne, *Alessandro Filipepi, Commonly Called Botticelli, Painter of Florence*. London: George Bell & Sons, 1908

Houghton = Houghton Library, Harvard University, Cambridge, Mass

HRHRC = Harry Ransom Humanities Research Center, University of Texas at Austin

Hunt = John Dixon Hunt, *The Widening Sea: A Life of John Ruskin*. New York: Viking Press, 1982

Italy 1986 = *I Dagherrotipi della Collezione Ruskin*, Florence and Venice

Kendal 1968 = *Cumbrian Characters*, Abbot Hall Museum and Art Gallery

Kendal 1971 = *Works by W. G. Collingwood and Mrs E. M. D. Collingwood*, Abbot Hall Museum and Art Gallery

Lancaster = Peter Scott Gallery, Lancaster University

Maas = Maas Gallery, London

Memorials = G. Burne-Jones, *Memorials of Edward Burne-Jones*. London: Macmillan, 1904

Morgan = Pierpont Morgan Library, New York

Morley = Catherine Morley, *Ruskin's Late Work*. New York: Garland Press, 1983

Nuti = Lucia Nuti, *Pisa, progetto e città, 1814-1865*. Pisa: Pacini, 1986

Penny = Nicholas Penny, *Ruskin's Drawings*. Oxford: Phaidon/Christie's Ltd in association with the Ashmolean Museum, 1989

Princeton = Princeton University Library, Princeton, New Jersey

RA = Royal Academy, London

RI = H. Shapiro (ed.), *Ruskin in Italy. Letters to his Parents 1845*. Oxford: Clarendon Press, 1972

RWS = Royal Watercolour Society

Rylands = John Rylands University Library, Manchester

Scott = Edith Hope Scott, *Ruskin's Guild of St George*. London: Methuen, 1931

Sheffield = The Ruskin Gallery, Collection of the Guild of St George

Swett = Lucia Gray Swett, *John Ruskin's Letters to Francesca and Memoir of the Alexanders*. Boston, Mass: Lothrop, Lee & Shephard, 1931

Switzerland 1988-90 = *John Ruskin and the Alps*, Basel, Schaffhausen, Lucerne, Sion, Turin, London

TS = typescript

V&A = The Victoria and Albert Museum, London

Walton = Paul Walton, *The Drawings of John Ruskin*. London: Oxford University Press, 1972

Whitehouse = J. Howard Whitehouse, *Ruskin the Painter and his Works at Bembridge*. London: Oxford University Press, 1938

Whitworth = Whitworth Art Gallery, University of Manchester

1840 : Italy Proper

This was not the first time the family had travelled abroad. In 1825 the six-year old Ruskin had been taken to visit the site of the battle of Waterloo. Eight years later his enthusiasm for Samuel Prout's *Sketches in Flanders and Germany*, recently published, prompted the family to set out to see the places depicted by the artist themselves. A further continental tour was made in 1835, after which Ruskin's matriculation at Oxford (1837) ensured that the summer took them no further afield than the Lake District. This pattern was broken by the interruption of Ruskin's undergraduate career from ill health. In the spring of 1840 he suddenly developed what had all the appearance of being a consumptive cough, the result of over-work (he had been encouraged to try for an Honours degree in the summer) coupled with the emotional distress caused by the news that the girl he loved, Adèle, daughter of his father's Spanish partner Pedro Domecq, was to be married. His eyesight was also affected. He was instantly removed from Oxford and obliged by the doctors (including the Queen's own surgeon) to refrain from all forms of exertion. They also advised wintering abroad, particularly after the return of the cough later in the summer. Preparations were made and on 15 September the family, bearing the signatures of Lord Palmerston and the French, Austrian and Sardinian Ambassadors, left London for the Continent. They would stay away for ten months.

The party consisted of Ruskin, his parents, his cousin and adopted sister Mary Richardson and his old nurse Anne Strachan. They travelled, as on previous tours, in a hired carriage and with a courier. Avoiding Paris, home of Adèle, they drove slowly south (not more than thirty miles a day) through Normandy, the Loire and the Auvergne to Nice and the Riviera. Though they had visited Italy before, they had never ventured south of Genoa. Now their itinerary, recorded in John James's diary *(cat.10)*, was that of the classic Grand Tour, and took them into 'Italy proper', as distinct from Lombardy, 'Italy of the stone pine and orange and palm, white villa and blue sea' (xxxv, 267). Following the coast down as far as Massa they turned inland for Lucca, Pisa and Florence. From here they proceeded via Siena to Rome, where they stopped a month. They next travelled down the coast to Naples, where they again stopped a month before going on to Salerno and Paestum. Here they turned round, reaching Florence once more towards the end of April. Heading now for Venice they passed through Bologna, Ferrara and Padua. Finally they travelled back towards the Alps via Verona, Cremona, Milan and Turin, leaving Italy towards the end of May.

Ruskin was intermittently troubled by his cough and bad eyesight for much of the trip. But despite repeated complaints to correspondents that this prevented serious writing or drawing, the tour produced a copious diary and a large number of drawings. Ruskin's diary and letters document the religious and artistic prejudices armed with which this confident twenty-one year old and voluble invalid approached the Catholic and Classical South. Above all they reveal an overriding concern with natural beauty, fostered by his reading of poets such as Byron and Shelley and by the art of Turner, his touch-stone of poetic power and truth since he had encountered it in the landscape vignettes to Samuel Rogers' poem *Italy (cat.4)* eight years earlier. Thus the highpoint of the early part of the tour was undoubtedly the drive along the coast from Nice to La Spezia, 'the most glorious combination of scenery I ever passed through', as Ruskin wrote to Thomas Dale – and thoroughly romantic by association with the drowning of Shelley (I, 379). It culminated in the mountains of Carrara, whose stark, quarried peaks were to figure as a metaphor for unfathomable human nature in a poem written the following year and published like much of Ruskin's early poetry in the annual *Friendship's Offering (cat.13)*. Meanwhile the mountains' scientific appeal was also strong. Geology had been a passion with Ruskin since his boyhood, and he had already published articles on the subject. Many entries in the diary for this tour consist of notes on local rock character and formation or catalogue the contents of the various 'chip boxes' filled *en route (cat.11)*.

Little wonder that when they reached Lucca John James was able to comment with satisfaction, 'His capabilities of enjoyment seem to be as great as at any period of his life – and perhaps no invalid was ever medicined more to his mind' (TS, Bod. MS Eng.Lett.c.32, 52). But neither Lucca nor any of the other Tuscan cities they now visited could match up to the excitement of that coast-drive. Their religious art and architecture, later so important, had as yet little significance for Ruskin. The diary shows him examining the make of the buildings closely enough, but rarely in sympathy with what he saw. His admiration is reserved for the richness of their materials and decoration. These qualities doubtless satisfied the taste for varied surface incident and texture nourished by the architectural drawings of Samuel Prout. It was with an eye to precisely this kind of effect that Ruskin searched the towns for suitable subjects of his own to draw, but he found little to interest him. At Florence he complained 'there is really not a single piece of this whole city thoroughly picturesque. The windows are all shallow and unornamental – there are no arcades – no Moresco or Turkish ornaments – all is stale and unprofitable' (TS, Bod. MS Eng.Misc.c.210, 63). His dis-

appointment was perhaps all the stronger here because of specific associations with Rogers' *Italy*, two of whose poems had Florentine subjects, both with vignettes by Turner *(cat.4)*. Only from the top of the Campanile, from Fiesole or San Miniato would the town sometimes 'compose', seen against the background of its hills or the snow-covered Apennines.

All works are by Ruskin unless otherwise stated. All measurements are in millimetres.

1

CONSTANTIN ROESLER FRANZ
Cameo portrait of John Ruskin
1841
leather case inscribed, 'John Ruskin, January 1841'
50 × 45
Brant.721
EXH: RA 1919, 15; AC 1964, 27.
LIT: J.S. Dearden, *Apollo* (December 1960)

The cameo was cut in Rome during the present tour. John James's account book (Bem. MS 28) shows that he paid 63 shillings for it. In *Praeterita* Ruskin recalls how it afforded him an unaccustomed glimpse of the less favourable aspects of his face and character: 'The cameo finished, I saw at a glance to be well cut; but the image it gave of me was not to my mind. I did not analyse its elements at this time, but should now describe it as a George the Third's penny, with a halfpenny worth of George the Fourth, the pride of Amurah the Fifth, and the temper of eight little Lucifers in a swept lodging' (XXXV, 280).

2

JAMES NORTHCOTE
Portrait of John James Ruskin as a young man
1825
oil on canvas
National Portrait Gallery, London on extended loan to Brantwood
(illustrated only)

3

EDITH MARY COLLINGWOOD
Margaret Ruskin, from a portrait by James Northcote
watercolour on ivory
115 × 90
The Trustees of the Ruskin Museum, Coniston, Cumbria (CONRM 1990.382)

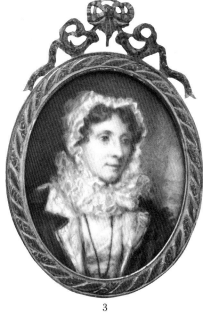

1

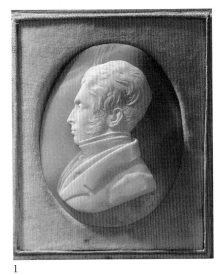

2

PROV: W.G. and E.M. Collingwood.
EXH: Coniston 1900, 289; AC 1964, 7; AC 1983, 7

Northcote's portrait of Ruskin's mother (Brant. 758), was painted in 1825, when the sitter was forty-four. This miniature copy *(cat.3)* was made by the wife of William Gershom Collingwood, Ruskin's assistant and biographer. Daughter of Thomas Isaac, a corn merchant of Notting

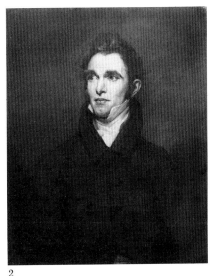

3

Hill, she was also a talented pianist.

James Northcote also painted Ruskin's father *(cat.2)* and Ruskin himself as a small child. The three portraits may be seen hanging side by side in the photograph of the dining-room at Brantwood shown here *(cat.96)*.

4

SAMUEL ROGERS
Italy, A Poem
(2nd edn) London: T. Cadell, Jennings and Chaplin, E. Moxon, 1830
open to show vignette by Edward Goodall after Turner, 'Galileo's Villa, Arcetri'
Sheffield

Son of a London banker, Samuel Rogers (1763-1855) began to move in literary circles in the early decades of the century, after his father's death in 1793 left him with independent means. A personal friend of Byron, Moore and Wordsworth, Rogers was famous for his literary breakfasts, to which Ruskin too would be invited after meeting the poet in 1843. *Italy* was first published in 1822, an imaginary tour of the landscape, history

4

'the little bend of the wall within which they are placed is not really a part of the Franciscans' garden, but one of the turns of the road in the ascent to Fiesole' (XIII, 424).

6

E. FINDEN, after Samuel Prout
The Baptistery, Duomo and Leaning Tower, Pisa
frontispiece to W. Brockendon, *Illustrated Road-Book from London to Naples*, 1835 edn
engraving
(not in exhibition)

Prout sold two drawings of Pisa in 1831, one of them to Finden, and so probably the original for this engraving. He also exhibited a watercolour of Pisa at the Old Watercolour Society in 1832. He had been to Tuscany in the course of his Italian tour of 1824-5, but Tuscan subjects are rare among his work.

7

J. M. W. TURNER
Santa Maria della Spina, Pisa
?1832
watercolour on buff paper
190 × 173
The Visitors of the Ashmolean Museum, Oxford
PROV: Ruskin; Oxford University Galleries, 1861.
LIT: Luke Hermann, *Ruskin and Turner*. London: Faber, 1968, cat.52, p.80

Turner's drawing was engraved by Finden as the frontispiece to the first volume of *The Works of Lord Byron*, published by Murray in 1832-4 (Byron had lived in Pisa from November 1821 to September 1822). The engraving is dated 1 May 1832 and bears the inscription 'Drawn by J. M. W. Turner R.A. from a sketch by W. Page'. However, as Luke Hermann points out, 'Turner himself visited Pisa, and the pencil drawing on folio 55 of the Genoa and Florence Sketch Book (Inventory, No.CCXXXIII), which was used in 1828, shows the same view of the chapel and its surroundings, though it does not include the boats'. The Spina drawing was one of forty-eight Turners given by Ruskin to Oxford in 1861. A copy by Alexander Macdonald, first Master of the Ruskin Drawing School was once in

and art of the country in verse and prose. In *Praeterita* Ruskin recalls how, on his thirteenth birthday, his father's partner, Henry Telford, gave him this second, illustrated edition of the poem and 'determined the main tenor of my life' (XXXV, 79). The book gave him his first opportunity to make a close study of Turner's work, and he immediately set himself to imitate the steel engravings in pen.

In these vignettes alone, Ruskin later thought, Turner caught the true spirit of Italy. 'Galileo's Villa' he instanced as the 'first approach and gathering' of a peculiar kind of Turnerian sky, 'one of the most perfect pieces of feeling ... extant in art, owing to the extreme grandeur and stern simplicity of the strange and ominous forms of level cloud behind the building' (III, 390).

The villa is the Villa il Gioello at Arcetri, south of Florence, where Galileo passed the last nine years of his life in semi-captivity.

5

A Picturesque Tour of Italy, from Drawings made in 1816-1817 by James Hakewill Archt.
London: John Murray, 1820

open to show plate 'Florence from Fiesole', after Turner
Sheffield

In 1878, when Ruskin exhibited his collection of Turner drawings at the Fine Art Society, he placed Turner's study for the present engraving in a section entitled 'Dreamland, Italy'. Turner's Florence, he elsewhere wrote, 'compels me to think, as a scholar, or (for so much of one as may be in me) a poet'. For Turner 'saw things as Shelley or Keats did; and with perfectly comprehensive power, gave all that such eyes can summon, to gild, or veil, the fatalities of material truth'; not only 'the thing itself' but 'himself too, and ever so much of fairyland besides' (XIV, 396-7).

In his catalogue to the exhibition, Ruskin drew special attention to 'the tenderness' of the 'distant undulating hills' in Turner's drawing; 'carried out with subtlety of tint and perfectness of form, quite undreamt of before Turner saw it'. He also remarked on the sympathy and reverence shown by Turner for monks at this time, prompted perhaps by his own memories of making hay with the Franciscans of Fiesole in the summer of 1845. His familiarity with Fiesole and the convent also enabled him to point out a small instance of Turnerian topography:

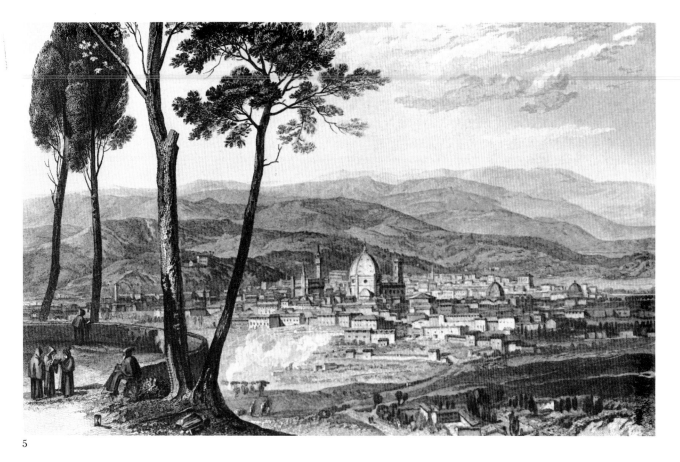

the Ruskin Cabinet at Whitelands College (xxx, 355n).

Santa Maria della Spina dates from the first half of the 13th century, and originally served as an oratory for the newly constructed Ponte Novo. It was enlarged and embellished in the 1320s, and from 1333 housed the sacred relic, a fragment of Christ's crown of thorns, from which it gets its name.

8

The Poetical Works of Coleridge, Shelley, and Keats. Complete in One Volume
Paris: Galignani, 1829
full vellum gilt; some marks and annotations
open to show Shelley's 'Evening: Ponte Al Mare, Pisa', p.223
Bem.8.7

In Praeterita, Ruskin rather inaccurately recalls that his first sight of Pisa, especially the 'solemnity and purity of its architecture', impressed him deeply; though he is surely right when he adds, 'yet chiefly in connection with Byron and Shelley' (xxxv, 267). Shelley lived in Pisa intermittently between 1818 and his death in 1822. His poem 'Evening: Ponte Al Mare, Pisa', was first published by Mary Shelley in *Posthumous Poems*, 1824. The

1840 Sept 15 Dover Dept for Carriage (Calais
500 fr 25 Nap £30 1/3 off 1500 —
Montreuil Abbeville Rouen
Evreux, Chartres Orleans (Ht. Loiret)
Blois, (H. d'Europe) Tours (Htel de Londres)
Oct 2 Chateroux Gueret, Aubusson
StGeraud, Clermont, Brioude Lepuy
13 St Etienne – Valence Montelimart
17 Avignon (Hotel Europe) Aix (du 3eme)
22 Brignoles (delaposte) Frejus, Nice
(Htel des Etrangers) Mentoni, Oneglia
Albenga, Savona Genoa (H. Four Nations)
Nov 3 Chiavari Sestri (Htel d'Europe)
Sperzia (Lunevars) Borghetto to Sarzana
Carrara Massa (Four Nations)
12 Lucca (Europe) Pisa (Hussar)
13 Empoli Florence (Schneiderffs)
25 Sienna Radicofani Viterbo
28 Rome 1501 miles from London
Hotel Europa
1841
Jany 7 Cisterna, Mola Gaeta & Naples
9 Ht Crocelle 1654 miles from London
Vesuvius Solfatara Camaldoli

1841
Feby 25 Sorrento (Ht. Syrens)
Mch 2 Castelamare Salerno Pæstum
5 Pompeii Castelamare
9 Amalfi Naples
16 Mola Stri Cisterna Albano (Villa deparsy)
22 Rome, (Europa) Frascati
April 14 Tivoli
16 Setterni Civeta Castellani Terni
20 23 Foligno, Perugia Arezzo Florence
27 Vallombrosa –
29 Coneglago Bologna
May 4 Rovigo Ferrara Padua Fusina
6 Venice (Rl. Hotel)
17 Fusina Padua Verona (Gran Parigi)
21 Mantua Cremona Milan (R. Hotel)
27 Novara Vercelli Turin (Europe)
31 Susa Marlebourg St Jean
June 3 Chambery 26 post 125 miles from Susa
June 4 Geneva Lausanne Neuchatel
11 Tavanne 12 Basle (3 Kings)
15 St Morreie, Plombieres (Tete d'Or)
16 Nancy Barle Duc Chalons sur Marne
Rheims, Laon (Ht. Hure)

10

Ponte a mare was the western-most bridge over the Arno at Pisa, incorporated into the fortifications defending the city from the sea. Built between the end of the 13th and the beginning of the 14th centuries, it collapsed in the floods of 1869. The bridge can be seen in the background of Ruskin's drawing of Santa Maria della Spina (cat.12).

9

JOSEPH FORSYTH
On Antiquities, Arts and Letters in Italy
4th edn, London: Murray, 1835
original cloth binding; bookplate ('Ex Libris/John Ruskin/Brantwood') inside front cover; inscription in pencil verso of title-page, 'A. Severn/Brantwood'
open to show title-page with vignette by S. Williams of Ponte a Santa Trinita, Florence
Bem.6.1

10

Diary for 1872-3
containing John James Ruskin's diary for 1840-1 and route of tour
Bem. MS 18
(illustrated only)

11

Diary for the tour of 1840-1
237 × 205; maroon calf; 265 pp, of which the first 34 are missing
open to show list of minerals collected during journey, p.65v
Bem. MS 2

12

Santa Maria della Spina, Pisa
1840
inscribed by Ruskin lower left in grey wash, 'Sta Maria della Spina. PISA.'
pencil, mauve-grey wash, pale yellow bodycolour on light blue paper
353 × 507
Courtauld Institute Galleries (Witt No.3830)
PROV: R. A. Hadfield; Captain C. E. Loseby; Sir Robert Witt (bought Sotheby's, 31 July 1946); Courtauld Institute Galleries (Witt Bequest, 1952).
EXH: FAS 1878, 13; Coniston 1900, 177; RWS 1901, 187; FAS 1907, 13; AC 1964, 140
LIT: XXXVIII, 274 (1319)
(shown at Sheffield only)
 Despite assertions to the contrary in

the debris beside the path ... Carrara. 20 of same place ... I think from high path.

B.3. 22. Vein in granite. 8 miles east of Pont Gibaud. 24. two pieces within

B.16. 23. Hill coming out of Savona. / 18 inches of each other if the rock

24. 25. Lead of Pont Gibaud. ... same place.

B.25. ... finest Carrara marble in principal quarry.

B.27. Average finest marble. chief quarry

B.29. Surface of the weathered fine marble on high path. returning

B.30. From debris of lower road.

B.31. High path. I think.

B.32. Three specimens from rocks in place - right side of road between village & quarry. A fourth should go with them, too small to mark

B.33. Three specimens from road descending on Lucca - the other subsequent specimens from same place.

B.34. Should have gone with 21. & 22. It is from same rocks. a little further on.

B.35. From my morning seat. Mont Cenis - Lanslebourg June 2nd. 41.

mountain running 5000 ft above the valley, and piercing the clouds with wedges and pyramids of crag - more like Chamouni than anything I have seen in Italy - very impressive. The road strewed with snowy fragments of marble, the quarries showing white in different hollows on the hills - but like these chips out of Lucca - Nov 7) the enormous mass of calcareous rock. Travelled up to the lowest quarry over a debris of snowwhite marble - chipped off the blocks to square them. this lowest bed about 50 feet thick - is the finest marble thoroughly well crystallized & almost translucent with little webs of noncrystalline in the upper & imperfect beds - the quarry not half so large as the one at the bottom of Vesuvius - with a little green stagnant water resting in the white basin hollow - they blast it, which is a great sin - but they seem to have enough to supply the world for a few thousand years. The upper quarry was up on the face of precipice - about 1000 or 1500 ft - the men hung by ropes to work - it looked yellow from below. and is not of equal quality. They have black & grey marble in great quantity, and crystals of quartz & sulphur in the white. the crystals fine and beautiful, but small. Returned by a narrow path on the marble hillside a noble view of the pyramidal quarry cliff above - it is strange that this splendid marble should be quarried in one of the very finest mountain scenes of Italy. A vast number of people chipping and working away at the marble - some dead - one most deadly state of ...

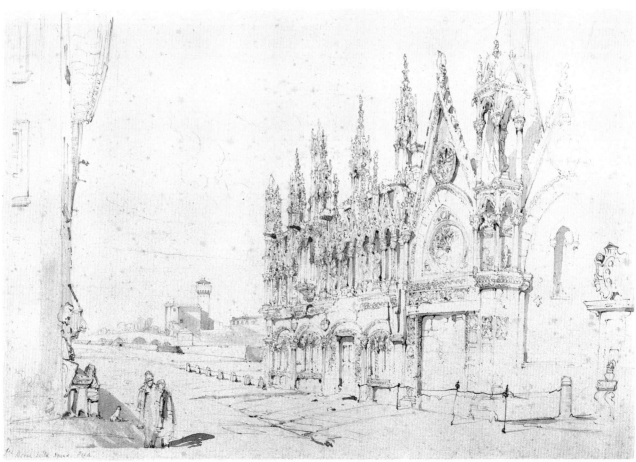

Praeterita, his diary shows that Ruskin was far from impressed by Pisa on this his first visit. He found it flat and shabby. Apart from the Cathedral group (which in many points, however, met with his disapproval) it was 'totally wanting in interest'. The other churches were merely 'ugly and cold'. On the other hand, the view from the top of the tower – sea plain to one side and Apennines to the other, 'their white villas flashing through fragments of cloud' – was 'noble' and the townspeople grouped themselves prettily about their doors (*Diaries*, 108-9). But his chief consolation was doubtless in sketching. He must have fixed on Santa Maria della Spina on his first day in Pisa (strangely the chapel is never mentioned in the diary), and spent the next two mornings drawing it.

The drawing shows the intricate Gothic decoration of the chapel's south side, with its loggia framing statues of Christ and the twelve apostles. Here was a richly worked and rather decrepit architectural surface of the kind which Ruskin had learned to appreciate through the drawings of Prout. But his model in this drawing, as throughout the tour, was the more precise and spacious manner of David Roberts. An exhibition that spring of the artist's sketches in Egypt and the Holy Land had much impressed him. 'They were faithful and laborious beyond any outlines from nature I had seen, and I felt also that their severely restricted method was within reach of my own skill, and applicable to all my own purposes.' From Roberts he learned 'the use of the fine point instead of the blunt one; attention and indefatigable correctness in detail; and the simplest means of expressing ordinary light and shade on grey ground, flat wash for the full shadows, and heightening of the gradated lights by warm white' (xxxv, 262).

13

Friendship's Offering and Winter's Wreath; a Christmas and New Year's Present, for 1842
London: Smith, Elder & Co, 1842
original embossed cloth
open to show poem by Ruskin, 'The Hills of Carrara'
Bem.3.1

Ruskin's celebration of the mountains of Carrara as a symbol of the impenetrability of human feeling was suggested by their unexpected starkness: 'marble in fact but not in appearance', he noted in his diary (*Diaries*, 105). And yet, as he wrote in a letter to his Oxford friend Edward Clayton, out of this 'dead mass life is leaping day by day into every palace of Europe' (I, 431).

1845: Glorious New World of Art

The first volume of *Modern Painters* was published in May 1843, having far outgrown its originally intended size and scope. Ruskin had begun it as a reply to the critics of Turner, but when it was finished admitted in his preface to himself not knowing whether it was more an essay on landscape painting in general or a critique of a particular painter. What was clear was that though 'complete in itself', the book was only a portion of a larger work, and soon after its publication Ruskin was already at work on its sequel. This however would not attain its final form for another three years. The delay was due to the largeness of the subject: the second volume was to develop the theory of beauty underlying the critical principles laid out in the first. It was soon apparent to Ruskin that his knowledge of painting, especially of the older schools, was inadequate. A letter of 17 June shows him engaged in improving it: 'I don't like to pass a day without adding to my knowledge of *historical* painting, especially of the early school of Italy: this commonly involves a little bit of work from Raffaelle, and some historical reading, which brings me into the wilderness of the early Italian Republics, and involves me also in ecclesiastical questions' (I, 493). The letter was written from Oxford, where Ruskin was keeping term. The 'work from Raffaelle' involved visits to Blenheim to see the so-called Ansidei Madonna, painted in 1506 and now in the National Gallery, London: 'a most pure and instructive Raffaelle of his early time' (I, 495). Meanwhile, in his own college of Christ Church Ruskin drew and took notes on some of the 13th- and 14th-century Tuscan paintings donated by Hon. W. T. Fox-Strangways in two recent benefactions of 1828 and 1834 – one of few such collections in England. And he was also learning Italian, 'as in the pursuit of the ancient school of religious painting, I must necessarily go to Italy' (I, 494). The language would also have served to read Vasari, who had not yet been translated into English, and probably Dante too, of whose works Ruskin certainly possessed an Italian edition by 1845 (*RI*, 122). Back in London that autumn Ruskin further prepared himself by experimenting in oil-painting, and reading Alexis Francis Rio's *De la poésie chrétienne* (1836), a fervent, Catholic apology for 'Pre-Raphaelite' piety.

By the end of the year the new book was 'well on', but Ruskin's ideas were becoming confused. The composition of a preface for the second edition of the volume already published occupied him from January through to mid-March, leaving little more than a month before he was due to begin preparing for a summer tour to Switzerland. In mid-April he decided to lay the book aside till the winter 'and collect materials' (TS, Bod. MS Eng.Misc.c.211, 105).

The need to go to Italy was probably still more strongly felt after a visit to the Louvre on the return from Switzerland. Here it was Bellini, Titian, Tintoretto, Veronese and Perugino that occupied him, prompted in part by his friend the painter George Richmond, of whom he had asked advice on what to study: 'I have only a week, and how can I find out things in such time?' (XXXVI, 38). The winter was spent in preparation. He was studying the figure, 'at home from Fra Angelico [*cat.18*], and at the British Museum from the Elgins', as he wrote to another mentor in questions of art, Henry George Liddell (III, 669). Richmond and Henry Acland, Ruskin's medical friend from Oxford, lent him bones to study and draw. Meanwhile, he had been introduced into the circle of Samuel Rogers, and would have been able to examine the pictures in his collection, unusual in that it included specimens of the early Tuscan school, among them works attributed to Giotto and Fra Angelico.

Ruskin finally left for the Continent on 3 April 1845, accompanied only by his young servant John Hobbs, renamed George by the family to avoid confusion with his master. This was his first tour abroad without his parents. He travelled as usual in a rented carriage, a light *calèche* drawn by two horses. His initial destination was Geneva, where the veteran mountain-guide, Joseph Couttet, was waiting for him. Couttet had had charge of him among the Alps the previous summer, and had been asked to look over him on the present journey. They reached Italy by 23 April and were in Genoa three days later. Ruskin here examined pictures and churches, but did not allow himself to be unduly detained, being eager to get to Lucca, which he eventually reached on 3 May, after a brief stop at Sestri to draw stone-pines.

He had written to his father that he did not know how long he would need at Lucca, 'there is so much of Fra Bartolomeo' (*RI*, 45). In the event, though he did carefully study the painter, copying the figure of St Mary Magdalene from a picture then in the church of San Romano *(cat.20)*, it was more the architecture that kept him – the Romanesque 'church fronts charged with heavenly sculpture and inlaid with whole histories in marble', but in such a state of neglect and decay, that the need to preserve them in drawings and descriptions was imperative. This also meant taking measurements, which he learned to do by trial and error: 'I'm never satisfied now with my architectural sketches unless I have measures & details', he later wrote to his father, 'and I don't know how architects get these, but I find it not so easy a thing to measure columns especially, and the rate of bulge bothers me to death' (*RI*, 85).

In Pisa ten days later he found the frescoes of the Campo-

santo in a state still more perilous than the churches of Lucca, and spent a fortnight drawing and note-taking among them. Meantime there was the Duomo and the other churches to inspect, and the picture collections to visit. Everything demanded his attention: 'I am perpetually torn to bits by conflicting demands on me, for everything architectural is tumbling to pieces, and everything artistical is fading away', he wrote to his father (*RI*, 71).

He finally got away on 28 May, setting out for Florence via Pistoia, which he had not visited before, but knew to be 'important'. He found it to be 'a wonderful place ... the most untouched middle age town in Tuscany', its churches 'quite perfect – or at least free from any intentional injury on the outside' (*RI*, 85).

The six weeks he spent in Florence were mostly devoted to looking at paintings. He was finding his way, with a little difficulty, in the 'glorious new world of religious art' he had entered and of which this was the metropolis. There was so much to be seen and thought through for himself, that there was little time left for drawing, though he felt incapable of forming 'anything like, or approximating to, a fair opinion' of a picture until he had drawn some part of it (XXXVI, 51). His work was mainly done in churches and convents he had not so much as entered in 1840, where he now studied the works of Giotto, Taddeo Gaddi, Fra Angelico, Benozzo Gozzoli, Ghirlandaio, Perugino, Masaccio and others. He also reviewed the paintings in the galleries of the Uffizi, the Palazzo Pitti and the Accademia. He slowly began to be of the opinion that though 'great fellows' Raphael and Michelangelo had been 'the ruin of art' (*RI*, 97).

Ruskin intended that the second volume of *Modern Painters* should be illustrated, and in the last two weeks of his stay he did several drawings with this aim in view: Rubens, Salvator Rosa, the background to Masaccio's *Tribute Money (cat.78)* and the giant pea-pods carved on the marble arches supporting the lantern above Brunelleschi's dome. He was indeed not neglecting his botany (he had Couttet gathering flowers on the hills around Florence, to help him in the identification of those in the paintings) or any of his interests. 'It requires a good deal of courage', he wrote to his mother, 'to work as I am working at present – obliged to take a shallow glance at everything & to master nothing. I am not studying a branch of science in which I feel steady progress, but gathering together a mass of evidence from a number of subjects, & I have to think before everything I see of its bearings in a hundred ways. Architecture – sculpture – anatomy – botany – music – all must be thought of & in some degree touched upon' (*RI*, 130). The note of self-justification is not infrequently sounded in Ruskin's letters to his parents on this tour. His father was concerned that Ruskin's studies were simply delaying progress on the second volume of *Modern Painters*, and needed continual assurance on this point. It was perhaps with relief that in mid-July he received news of his son's having left Florence, knowing him on his way north to the Alps and to those mountain studies whose pertinence to the work in hand he could more easily appreciate.

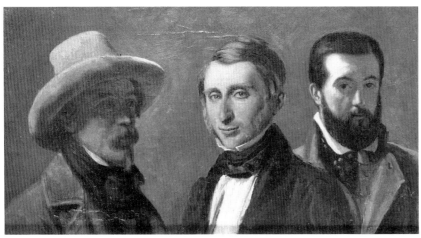

14

14

RUDOLF DURHEIM
Portrait of John Ruskin, Ernest-Augustin Gendron and ?Eugène-Paul Dieudonné
1846
oil on wood
135 × 240
Kunstmuseum Bern, Gottfried Keller-Stiftung
PROV: Paul Lindt; Gottfried Keller-Stiftung, 1898
(illustrated only)

Ruskin met Durheim (1811-95) in Florence, probably in the Tribune of the Uffizi, where he was copying Ghirlandaio's *Adoration of the Magi*. 'Today I drive out

to the Certosa in Val d'Ema', Ruskin wrote to his father, '– with a poor Swiss artist of very sweet character and great power – we are quite friends – like all the same things – and he has given me a sketch of a little blue-eyed Swiss cousin of his – so very Swiss it is quite a treasure – little thing of ten or 12' (*RI*, 136). In addition to the gift and drive, in *Praeterita* Durheim's memory is associated with a lesson in artistic self-discipline, gratefully acknowledged in a letter written by Ruskin a year after their meeting: 'C'est vous qui m'a donné la leçon qui m'a ete de plus grande utilité que toutes les autres que j'ai jamais reçues de dessiner *toujours quelque chose*' (ALS, Morgan, MA 1626/3). He valued Durheim's artistic gifts sufficiently to commission watercolour copies of the portrait of Dante and the kneeling St Mary Magdalene from the recently discovered frescoes, traditionally ascribed to Giotto, in the chapel of the Palazzo del Podestà (or Bargello). Durheim also drew him something by Mino da Fiesole. *Praeterita* paints a gloomy picture of Durheim's after-life as portrait-painter to the Bernese *bourgeoisie*. Ruskin recalls meeting the 'arid remnant' of him in Bern many years later. This was in 1856, during his last foreign tour with his parents. They seem not to have corresponded after this date.

An old label written in French on the back of the portrait is inscribed 'Florence 1846'. As Durheim was in Alexandria when Ruskin returned to Florence in that year, the portrait was probably painted from a study made the previous summer. The label also identifies one of the other two sitters as the French painter Ernest-Augustin Gendron (*b*.1817), but indicates that the name of the third had been forgotten. This is probably Eugène-Paul Dieudonné (*b*.1825), mentioned in *Praeterita* in connection with Florence and remembered especially for his beautiful pencil drawings after Fra Angelico. Gendron and Dieudonné were presumably the two French artists Ruskin 'picked up ... in the Campo Santo' in Pisa before coming to Florence, and who had given him 'some useful renseignements' on 'old paintings of the right sort' (*RI*, 71). In writing his autobiography, Ruskin apparently forgot that, far from not knowing the value of Dieudonné's drawings in 1845, as he states, he had commissioned copies from him too. These were never executed, however, as Dieudonné passed the commission on to his friend the Lyonese painter François Fleury Richard (keeping half the advanced fee for himself). Ruskin received an unspecified number of drawings (at least ten) after Fra Angelico from Richard when he returned to Florence in 1846. 'Il ne dessine pas mal', he wrote to Durheim, '– j'achetai ses dessins au prix convenu'. Meanwhile a lawyer in Paris was charged with the job of tracking down Dieudonné. Ruskin showed Richard's drawings at three meetings of the Graphic Society the following spring.

15

J. C. L. SIMONDE DE SISMONDI
Histoire des républiques italiennes du moyen age, Vol.II.
Bruxelles, 1838
extensively annotated by Ruskin
Bem.6.3

Sismondi's history of the Italian republics (originally published in 16 volumes, 1809-18) was one of the books Ruskin took with him to Italy in 1845, where a passage over breakfast was the regular start to his day's work. He had read it in on the previous tour, but had found the history of 'these rubbishy little republics ... as confused as Thucydides', savouring only the occasional 'little story' (TS, Bod. MS Eng.Misc.c.210, 88). Now the same events were an object of real interest to him, and he was 'always at Sismondi'. The change seemed to him symptomatic: if he had lost some of his old passion and imagination (which he regretted), he had acquired a 'quiet, truth-loving, fishing, reasoning, moralizing temperament' (*RI*, 168).

Reading the history of the medieval republics surrounded by the art they produced, and amid continual reminders of the inability of their modern descendants to achieve anything comparable, provoked some political self-questioning. From Florence Ruskin wrote to his mother that he was 'much more republican than I was, because the race of Giotto & Orcagna & Dante were a very different people from those of the present day – & I do honestly believe the Grand Duke to be one of the best of monarchs, but the Italians are certainly not made to live under either emperors or Kings' (*RI*, 128-9). This prompted Ruskin's father, an arch Tory, to quote Thomas Arnold on the incomprehensibleness of the English gentleman, 'Christian, manly and enlightened', to republicans such as Guizot or Sismondi (ALS dated 'London 7/8 August 1845', Bem. L 3). In reply, Ruskin wrote a long defence of Sismondi's theory of 'the necessity of giving men at some period of their life a high & ungoverned position, in order that the preparation for it & expectation of it may give the utmost dignity & energy to the individual character'. No school, he concluded, could be finer than the Florentine system (*RI*, 183-5).

Ruskin made continual use of Sismondi after this. His diary for 1854, when he was planning a work on the 13th century, contains extensive notes from the book. Later, in the series of lectures on Tuscan art given at Oxford in 1873, published as *Val d'Arno*, he refers constantly to Sismondi. Ruskin's copy of the *Histoire* is open to show the page marked with a cross fleury and the date 1254, which Ruskin informed his Oxford audience he found in his 'long-since-read volume of Sismondi ... meaning that I was to remember that year as the beginning of Christian warfare' (XXIII, 73). 1254 was the so-called 'year of victories', in which Florence took Pistoia and Volterra and forced Siena and Pisa to sign a treaty favourable to the Guelph party, not, as Sismondi explained, 'to subjugate them, or to impose hard conditions, but to force them to rally round the party which they considered that of the church and of liberty' (Eng. edn, London, 1832, 84).

The cross and date may have been inscribed in the book in 1868, as many of the neighbouring annotations were made between 9 and 12 September at Abbeville, and Ruskin was at Abbeville on these dates in that year. His diary for the period twice records 'Did good history' (*Diaries*, 645, 655); and in a letter to his cousin Joan Agnew he wrote, 'Yes – the stars are strange things I am reading Italian history again with this new idea about destiny;

and it is wonderful what a different, and
clear, though terrible, light it seems to
give' (ALS dated 'Abbeville. 12th Sept.
1868', Bem. L 39).

16

*The Works of George Herbert. Second
edition. Vol.II. The Temple: Sacred
Poems and Private Ejaculations*
London: Pickering, 1838
half brown morocco and marbled boards;
with Ruskin's Brantwood bookplate
Bem.8.5

Another important part of Ruskin's
reading on this tour, during which the
lasting debt to Herbert acknowledged in
later writings was first contracted. Ruskin
learned the poems off by heart, and quoted
them frequently in his letters. In
Praeterita he analyses their importance
for the development of his religious
thinking. They exemplified a rational and
undogmatic approach to questions of
faith, and a 'central' phase of
Protestantism. This was all the more
obvious at the time by comparison with
John Bunyan's *Grace Abounding*, which
his mother had packed in his bag. In
letters to her he contrasts Bunyan's self-
engrossed, fear-ridden spirituality and
near-insane imagination with Herbert's
love for and trust in God and his lucid
poetic vision. It was this same quality of
'sincerity and brightness of imagination'
which Ruskin now found reflected in the
early religious painting of Pisa and
Florence. The comparison is often explicit,
such as when he wrote to his mother, 'I
really am getting more pious than I was,
owing primarily to George Herbert, who is
the only religious person I ever could
understand or agree with, and secondarily
to Fra Angelico & Benozzo Gozzoli, who
make one believe everything they paint, be
it ever so out of the way' (*RI*, 108).

17

*The Vision: or Hell, Purgatory, and
Paradise, of Dante Alighieri, translated
by The Rev. Henry Francis Cary AM*
London: William Smith, 1844
bound in full black morocco; contains
Ruskin's Brantwood bookplate;
extensively annotated, with sketches in
pencil on fly-leaves; many annotations
clipped during re-binding

19

Bem.8.3

It is impossible to consider here the
huge subject of Ruskin's debt to Dante,
one of the authors he most frequently
referred to in his writings. Ruskin seems
first to have read him sometime between
the tours of 1840 and 1845. On the later
journey Dante, along with Sismondi and
Horace, formed part of his daily reading.
From the quotations contained in several
letters to his father (*RI*, 56, 84, 117, 153),
it appears that Ruskin was reading him in
Italian. One passage he read with 'infinite
gusto' was the celebrated curse of Pisa,
beginning 'Ahi Pisa, vituperio de le genti'
(*Inferno*, XXXIII, 79), which he mentally
applied to contemporary 'Pisan
barbarity', currently manifested in the
restoration of the Baptistery (*RI*, 83-4).

18

GIOVAN BATTISTA NOCCHI
*La Vita di Gesù Cristo: dipinta da Fra
Giovanni da Fiesole, detto il Beato,
lucidata dagli originali che si conservano
nell'I.R. Galleria Fiorentina Delle Belle
Arti*
Firenze, 1843
(not in exhibition)

One of the books in which Ruskin had
studied Fra Angelico the previous winter.
'I have scraped an acquaintance with an
old engraver', Ruskin wrote to his father

from Florence, 'the man who did the Vita
di Cristo in my study, the large book from
Fra Angelico. I drove him up to Fiesole
yesterday, and he took me to private
houses and inaccessible chapels and all
sorts of places and showed me wonderful
things and a fresco of Perugino's that
nobody has ever heard of ...' (*RI*, 120).

Nocchi's engravings are from the thirty-
five panels depicting the life of Christ once
forming the doors of the silver cupboard in
the church of the Santissima Annunziata.
In 1845 the panels were in the Accademia,
but are now in the Museo di San Marco.
Only nine are now thought directly
attributable to Angelico. This may in part
explain Ruskin's disappointment with
them. Most of Angelico's work had been
washed off, he suspected, or else 'so
daubed and defaced as to alter the
expression of the faces and make them
monstrous or ludicrous' (IV, 100n). He was
mortified too by the surprising crudeness
of colour and unfeeling depiction of open-
air backgrounds. This last fault seemed to
confirm the weakness of conception he had
detected in other works by Angelico and
which he attributed to a cramped
monastic imagination.

PISA
Palace on
L. L'Arno

21

19

G. CLINT, after J. M. W. Turner
Procris and Cephalus
published in Part VIII of *Liber Studiorum*,
February 1812
mezzotint (1st state)
215 × 291 (plate mark)
Sheffield
EXH: Sheffield 1988.
LIT: Finberg, cat.41

Ruskin returned to Italy in 1845
equipped with a new drawing style.
J. D. Harding, with whom he had renewed
his lessons the previous year, had
encouraged him to imitate the broad light
and shade of the plates in Turner's *Liber
Studiorum* using pen and sepia wash. In
Praeterita Ruskin recalls how this practice
enabled him by the spring of 1845 'to
study from nature accurately in full
chiaroscuro, with good frank power over
the sepia tinting' (xxxv, 340).

Ruskin considered this plate one of the
finest in the *Liber*, and strongly influenced
by Titian and the 'great Venetian school
of landscape', to which Turner owed

'almost the only healthy teaching' he had
from earlier art (v, 399).

20 (Colour plate II)
Notebook used in Italy in 1845
red leather with brass clasp; grey paper,
ruled recto, plain verso; extensive notes on
paintings at Genoa and Lucca in Ruskin's
and John Hobbs' hands; many drawings
and sketches by Ruskin in various
techniques
Bem. MS 5A

21
Notebook used in Italy in 1845
brown marbled cardboard covers; white
lined paper, with extensive notes on
architecture and paintings, Lucca, Pisa
and Florence, mostly in John Hobbs's
hand, some marginal notes and headings
by Ruskin; some sketches in pen and
pencil
Bem. MS 5B

Ruskin wrote no diary on this tour, its
place being taken by the often daily letters
to his parents. But he also compiled a sort

of review or 'résumé', as he called it, of the
paintings and architecture of Genoa,
Lucca, Pisa and Florence. This was
written up from notes taken on the spot,
and then copied out by Hobbs into the
notebooks shown here. They were clearly
much referred to in the writing of the
second volume of *Modern Painters* (1846),
as well as in preparing the third edition of
the first volume (1846). Portions of the
text were also incorporated *verbatim* into
the second edition (1846) of Murray's
*Handbook for Travellers in Northern
Italy*, which Ruskin used on this tour, and
of whose inadequacy he complained to its
publisher.

The first notebook *(cat.20)* is open to
show (p.2v) a study in watercolour and
bodycolour of the figure of St Mary
Magdalene from Fra Bartolomeo's *God
the Father with Sts Mary Magdalene and
Catherine*, originally in San Romano, but
now in the Villa Guinigi, Lucca. Of this
painting Ruskin wrote in the epilogue to
the re-arranged edition of *Modern
Painters* II (1883):

'Fra Bartolomeo's Magdalen was the first example of accomplished sacred art I had seen, since my initiation, by the later Turner drawings, into the truths of deep colour and tone. It is a picture of no original power (none of Fra Bartolomeo's are), but it sums the principles of great Italian religious art in its finest period, – serenely luminous sky, – full light on the faces; local colour the dominant power over a chiaroscuro more perfect because subordinate; absolute serenity of emotion and gesture; and rigid symmetry in composition. These technical principles, never to be forgotten, (and leaving very few to be added), that single picture taught me in the course of a day's work upon it; and remains accordingly, without being the subject of special admiration, extremely dear to me' (IV, 347).

The second notebook *(cat.21)* shows a sketch of one of the windows of the Palazzo Agostini in Pisa *(see cat.35)*.

22

22

Interior of San Frediano, Lucca
1845
pencil, brown ink and wash
333 × 480
Manchester City Art Galleries
PROV: F. R. Hall; Hugh Allen.
EXH: AC 1954, 15; AC 1960, 7; AC 1964, 184; AC 1983, 201.
LIT: XXXVIII, 264 (1044)

'What in the world I am to do in – or out of – this blessed Italy I cannot tell', Ruskin wrote to his father the day after his arrival in Lucca. 'I have discovered enough in an hour's ramble after mass, to keep me at work for a twelvemonth'. Among the discoveries was the church of San Frediano: 'Such a church – so old – 680 probably – Lombard – all glorious dark arches & columns – covered with holy frescoes – and gemmed gold pictures on blue grounds' (*RI*, 51). It was little frequented, even at mass-time, and Ruskin was able to spend the mornings drawing in it undisturbed. Its columns, he remarked in his notebook, 'are the perfection of proportion, and their multitude … renders it about the most impressive interior of this character which I recollect out of Rome' (TS, Bod. MS Eng.Misc.c.213, 26). In the 1883 epilogue to *Modern Painters* II, Ruskin wrote of

the impression made on him by this church as an architectural revelation: 'the pure and severe arcades of finely proportioned columns at San Frediano, doing stern duty under vertical walls, as opposed to Gothic shafts with no end, and buttresses with no bearing, struck me dumb with admiration and amazement; and then and there on the instant, I began, in the nave of San Frediano, the course of architectural study which reduced under accurate law the vague enthusiasm of my childish taste, and has been ever since a method with me, guardian of all my other work in natural and moral philosophy' (IV, 346-7).

The church was built between 1112 and 1147, on the site of a basilica of the 6th century.

23

San Michele, Lucca: part of the façade, with details of columns and arches
1845
inscribed by Ruskin lower right, in pen, 'San Michele, Lucca 1845 JR' and below three columns, in pencil (partly rubbed out, possibly clipped) '[illegible] two arches below [illegible] small one at each [illegible] 4 middle [illegible] in pairs. & one in middle all as [illegible]'
watercolour, wash and bodycolour over

pencil, on grey paper
330 × 233
The Visitors of the Ashmolean Museum, Oxford (Ed. 83)
EXH: AC 1954, 14; AC 1960, 5.
LIT: XXXVIII, 264 (1040); Walton, 66; Penny, 64

Another architectural discovery was the inlaid decoration of the Romanesque church fronts, again as opposed to the familiar fretwork of northern Gothic. His afternoons would be spent in the open air drawing the richly ornamented façade of San Michele. 'It is white marble', he wrote to his father, 'inlaid with figures cut an inch deep in green porphyry, and framed with carved, rich, hollow marble tracery. I have been up all over it and on the roof to examine it in detail. Such marvellous variety & invention in the ornaments, and strange character. Hunting is the principal subject – little Nimrods with short legs and long lances – blowing tremendous trumpets – and with dogs which appear running up and down the round arches like flies, heads uppermost – and game of all descriptions – boars chiefly, but stags, tapirs, griffins & dragons – and indescribably innumerable, all cut out in hard green porphyry, & inlaid in the marble. The frost where the details are fine, has got underneath the inlaid pieces,

24

and has in many places rent them off, tearing up the intermediate marble together with them, so as to uncoat the building an inch deep. Fragments of the carved porphyry are lying about everywhere. I have brought away three or four, and restored all I could to their places' (*RI*, 54).

The new focus of attention produced the first examples of a new style of drawing, more documentary in aim. Ruskin's 'careful study' of the church façade is explicitly cited in his notebook as a record of its 'general architecture'. 'It has four stories of such arches', he elaborates, 'two of 14 and two of 6 and owing to this altitude of proportion, it produces the most sublime impression of any church I know in this style' (TS, Bod. MS Eng. Misc.c. 213, 29).

This drawing, together with *cats 72* and *73*, was later placed by Ruskin in the art collection attached to his Drawing School at Oxford, where it was given the title *Part of the Façade of the Destroyed Church of San Michele at Lucca, as it appeared in 1845*. Ruskin's catalogue note of 1870 or

1872 reads, 'It was destroyed by having its façade, one of the most precious twelfth-century works in Italy, thrown down, and rebuilt with modern imitative carving and the heads of the King of Sardinia and Count Cavour instead of its Lombardic ones' (XXI, 123). The restoration was carried out by Giuseppe Pardini between 1858 and 1866, around the time of the unification of Italy. Pardini replaced some of the original heads with those of Cavour, Napoleon III, Garibaldi, Vittorio Emanuele II, Pius IX and Dante, arguing that by so doing he was rendering the building of greater interest to his contemporaries and as it were signing and dating what by his own admission was less a work of restoration than of reconstruction (Bartolomei, 84).

A portion of the drawing (indicated by the four points marked ('P') was later engraved by J. C. Armytage for the first volume of *Stones of Venice* (Pl.XXI). The central of the three details of column ornamentation was incorporated into Pl.XII of *The Seven Lamps of Architecture* (*cat.65*).

24
Lucca, from the ramparts
1845
inscribed lower right, pen, 'Ramparts – Lucca/Thursday evening May 8th'
pencil, ink, white on grey-brown paper
160 × 220
Bem.940

After an afternoon spent drawing San Michele, Ruskin would walk on the city walls for exercise. Built between the mid-16th and mid-17th centuries, these had been variously 'beautified' in recent decades under Maria Luigia of the Bourbon house of Parma. 'There', he reminded his father, 'I have the Pisan mountains, the noble peaks of Carrara, and the Apennines towards Parma, all burning in the sunset, or purple and dark against it, and the olive woods towards Massa, and the wide, rich, viny plain towards Florence – the Apennines still loaded with snow, and purple in green sky, and the clearness of the Sky here is something miraculous. No romance can be too high flown for it – it passes fable' (*RI*, 54).

25

View of Pisa with campanile of San Niccola
1845
inscribed bottom right, 'Pisa 13th May'
and verso, 'JRs sketchbook'
watercolour, pencil, ink, white on grey paper
154 × 186
Bem.1445
EXH: AC 1954, 19; AC 1960, 9; London 1969, 23; Kendal 1969, 68; Portsmouth 1973, 18

On arriving in Pisa on 12 May, Ruskin wrote to his father, 'I am perfectly well, and have had a regular draught of all that is divine out of the cathedral already. I have read myself thirsty, & my mind is marvellously altered since I was here – everything comes on me like music' (*RI*, 60). The change is partly apparent in what he has to say the next day (when he also made this drawing) of the town he had found so uninteresting five years earlier: 'I am quite well ... and the views and walks are most precious' (*RI*, 62). A few days later, however, with his work in the Camposanto underway and a preliminary inspection of the churches having revealed a quantity of pictures to be examined, he professed himself lucky the town itself offered no distractions in the way of out-of-door subjects.

The drawing seems to have been done some way out of the centre of the city, to the west, probably just within the walls. To the left can be seen the top of the campanile of San Niccola, attributed to Nicola Pisano and drawn by Angelo Alessandri for Ruskin nearly forty years later on his last visit to Pisa (*cats 276, 277, 278*).

26, 27, 28, 29, 30

Five plates from CARLO LASINIO's Pitture a fresco del Campo Santo di Pisa *(1812)*
i. after 'Orcagna' (?Buffalmacco)
Il trionfo della morte (The Triumph of Death)
500 × 834
ii. after 'Simon Memmi' (Antonio Veneziano)
Morte di S: Ranieri (Death of St Ranieri)
481 × 830
iii. after 'Giotto' (?Taddeo Gaddi)

25

Gli amici di Giobbe (Friends of Job)
468 × 840
iv. after Benozzo Gozzoli
Innocenza di Giuseppe (Innocence of Joseph)
413 × 819
v. after Benozzo Gozzoli
Le Nozze di Giacobbe e di Rachele (Wedding of Jacob and Rachel)
362 × 804
engravings
Sheffield

31

GIOVAN PAOLO LASINIO
Le pitture a fresco del Camposanto di Pisa, disegnate da Giuseppe Rossi e incise dal Prof. Cav. G.P. Lasinio Figlio – Firenze Tipografia All'insegna di Dante, MDCCCXXXII
open to show engraving after Benozzo Gozzoli, *Partenza di Abramo da Agar* (Departure of Abraham from Hagar)
Sheffield

In a letter to his father written on his arrival in Pisa and furiously denouncing the state of neglect in which he had found the frescoes in the Camposanto, Ruskin also vented his anger against the local engravers, who he felt had only added insult to injury (*RI*, 61). He was undoubtedly referring to the work of Carlo Lasinio (1759-1838) who had largely contributed to making the Camposanto one of the most celebrated monuments of early Italian art. Lasinio was born in Treviso but had settled in Florence by 1780, when he became one of a team of artists engaged in engraving the vast collection of self-portraits in the Uffizi. In 1806, now an engraver of some repute, he visited the Camposanto in Pisa for the first time and was appalled at the condition of the frescoes, and still more that no measures were being taken for their preservation. A chance encounter with Giovanni Rosini, Professor of 'eloquence' at the University of Pisa, author and publisher (and whom Ruskin was himself to meet in 1845) led to a plan for a complete series of engravings. Rosini had long contemplated such a project, convinced that it would not be long before the entire cycle of frescoes had perished. The huge undertaking (the Camposanto contained some 2000 square metres of painted wall-surface) took six years to complete, most of the preparatory

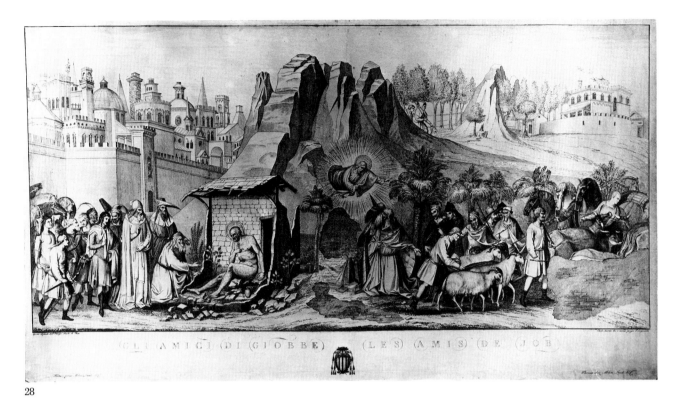

GLI AMICI DI GIOBBE LES AMIS DE JOB

28

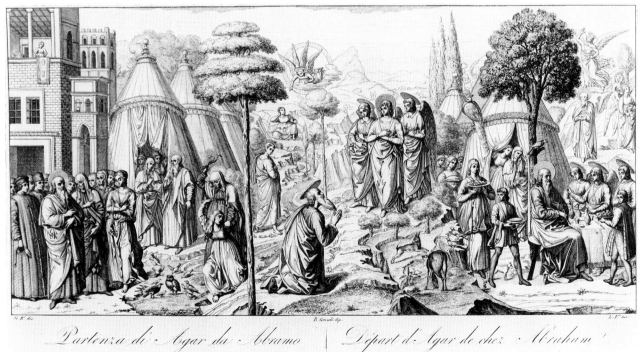

Partenza di Agar da Abramo Départ d'Agar de chez Abraham

31

drawings for the forty plates being made by the engraver himself. Lasinio, appointed *Conservatore* or 'Keeper' of the Camposanto in 1807, was not popular locally, and his engravings were criticised among other things for their inordinate size. This was probably the reason for the reduced scale of a further series of engravings published by his son Giovan Paolo, from new drawings by Giuseppe Rossi, in 1832 *(cat.31)*.

As *Conservatore* of the Camposanto Lasinio was responsible for bringing together a large number of the Roman sarcophagi still exhibited there, and which Ruskin on his first visit found so detracted from the building's solemnity.

32

after Benozzo Gozzoli
Abraham parting from the angels
1845
pen and ink, pencil
*c.*470 × 316 (sheet, uneven)
460 × 363 (image)
The Visitors of the Ashmolean Museum, Oxford (Stand. 25)
LIT: XXXVIII 255 (797); Walton, 66

The study of the Camposanto frescoes was one of the main objects of this tour, a task rendered urgent by their fast deteriorating condition. At a loss to know where to begin, Ruskin eventually decided on this episode from the *Abraham and Hagar* panel *(cat.31)* in the sequence of Old Testament stories by Benozzo Gozzoli *(c.*1420-97), as suitably 'small & well made out', and also endangered by swelling plaster. Abraham takes leave of the three angels come to inform him of God's decision to destroy Sodom and Gomorrah (Gen. xviii). The figure of Abraham, 'his hands folded in entire resignation, but with ... a quivering distress about the lips and appeal for pity in the eye', had, Ruskin told his father, brought tears to his own eyes as he drew *(RI,* 65). Gozzoli's realisation of the story was a small instance of the 'simple, hard reading real Bible truth' which Ruskin felt generally 'protestantized' (TS, Bod. MS Eng.Misc.c. 213, 69) his depictions of the patriarchal histories. For only two of the three angels was shown leaving for Sodom, precisely as in Genesis. This faith in the letter of the Bible and its lucid translation into visible,

32

palpable reality thrilled Ruskin. An example was the scene immediately below the one he had chosen for his drawing: 'Abraham sits *close* to you entertaining the angels – you may touch him & them – and there is a woman bringing the angels some real, *positive* pears, and the angels have knives and forks and glasses and a table cloth as white as snow, and there they sit with their wings folded – you may put your finger on the eye of their plumes and believe' *(RI,* 68).

Gozzoli's art, Ruskin noted in his 'résumé', was the highest in the Camposanto, though he regretted its occasional lack of vigour and severity and questioned its originality. The finest group in the whole series, the three angels in the central portion of the *Abraham and Hagar* panel *(cat.31)*, he found 'full of Fra Angelico' though not so intense, and the character of the attendant figures generally borrowed from Masaccio. But all Gozzoli's own was 'the beautiful country feeling and fresh air breathed through all', only enhanced by the fading of some of the colours, leaving the greens and the reds predominant (TS, Bod. MS Eng.Misc.c. 213, 69).

33

after 'Giotto' (?Taddeo Gaddi)
God instructs Job's friends to sacrifice
1845
pencil
348 × 453
The Visitors of the Ashmolean Museum, Oxford (Stand. 24)
EXH: FAS 1878, 25a, with correct title.
LIT: XXXVIII, 255 (798: 'Jacob and Laban's Flocks'); 274 (1312: 'outline from "Job"')
(illustrated only)

Intent on copying something by each of the masters who had worked in the Camposanto in order to learn their individual styles, Ruskin next tackled a scene from the *Stories of Job*, a cycle then ascribed to Giotto and now attributed to two painters, one an anonymous non-Florentine, the other a follower of Taddeo Gaddi probably working in the 1360s. He chose the bottom right-hand portion of the lower central panel (the cycle consisted of six frescoes ranged in two rows of three), in which God reprimands Job's friends and instructs them to sacrifice (Job. xliii). The Job frescoes were among those that had suffered most from damp and neglect. Vasari had deplored their condition already in 1568, while in 1810 Giovanni Rosini had boasted of having 'saved' the only two still legible by having had them copied four years previously *(cat.28)*, since when they had appreciably deteriorated: he did not expect them to last another ten years. Ruskin's first impression indeed was that 'Giotto's Job is all gone – two of his Friend's faces and some servants are all that can be made out'. He was horrified, moreover, to find that the two western-most panels had largely been obliterated by having tombs built up against them, in one instance as recently as 1808. Convinced of the imminent destruction, or disintegration of what remained, Ruskin took extra pains with his drawing. 'Giotto' proved more difficult, however, than he appeared, necessitating the abandonment of pen for pencil. The hands were especially taxing: 'They are as badly drawn as can be, but there they are all full of life and feeling, running out at the very fingers ends. If I draw the hand as well as I can, it isn't like – if I draw it rudely and badly, the

33

rudeness and badness is all mighty like, but the feeling is all gone' (*RI*, 70). Yet after four days' work Ruskin pronounced the finished copy 'as Giottesque as can be' (*RI*, 71) and a more accurate rendering of the original than Lasinio's (TS, Bod. MS Eng.Misc.c.213, 66).

In the third edition of *Modern Painters* I (1846), Ruskin cited the 'sweet piece of rock incident' just above the group he copied as an instance of the landscape sensibility of the earliest Florentine school, later overwhelmed by the Renaissance (III, 183). John Constable, in his Royal Institution lectures on landscape of 1836, had shown an enlarged copy of G. P. Lasinio's engraving from this same fresco to illustrate the 'first great step' in landscape made by Giotto (Beckett, 42-3).

The drawing is incorrectly described in the catalogue of the Ruskin collection at Oxford as 'Jacob and Laban's Flocks' after Gozzoli.

34
after 'Simon Memmi' (Andrea di Bonaiuto)
The conversion of San Ranieri
1845
inscribed on mount, 'I drew it for the sake of the leaf crown I have just touched with ink – Which I never got to. First sketch of mine in 1845 from (Simone Memmi?) life of St Ranieri in Campo Santo of Pisa. It has got the expression of the principal figures a little, and has something of the grace of the lines. The figures were out of

drawing in the original – of course got worse in mine
(J Ruskin 1868)'
pencil, watercolour, ink
255 × 387
Bem.1440

From a fresco ascribed by Vasari to the artist he called Simon Memmi (*alias* Simone Martini), but now known to be by Andrea di Bonaiuto (*act*.1343-77). It is one of a series depicting the life of Pisa's patron saint. Ruskin explained the subject to his father: 'he is a youth preparing to play on a lute to a circle of Florentine maidens, just giving each other their hands to dance, and there passes by a palmer, and one of the maidens lifting her hand in jest says to St Ranieri – Wilt thou not follow the angel? And St Ranieri

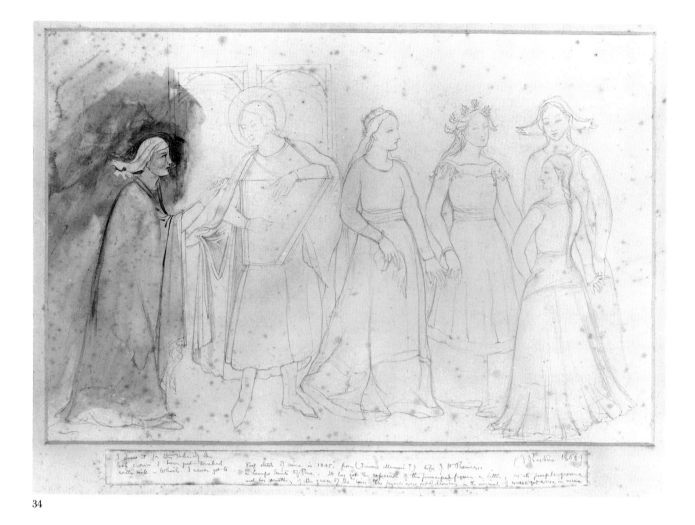

34

accepts the sign and follows him' (*RI*, 68). This is a slightly garbled version of the traditional story of the saint's conversion (the question was asked in earnest, and by a matronly kinswoman of Ranieri's, not by one of the damsels), which Ruskin evidently got from Murray's guide. Unlike the other frescoes he had copied, this was high on the wall and required scaffolding. Once 'up to it' he was able to correct his account: the girls were not preparing to dance but dancing, 'though the motion is so "still & quiet" that from below it is not felt – but such dancing. It does not come upon you at once – the figures seem at first a little stiff – but gradually ... they grow into life as you look, until you can see the very waving of their hair' (*RI*, 72-3).

In *Praeterita* Ruskin also mentions a second, coloured drawing of this scene,

afterwards destroyed 'in shame of its faults' (xxxv, 355).

35

Palazzo Agostini, Pisa
1845
watercolour, ink, white on grey-green card
478 × 338 (irregular)
The Syndics of the Fitzwilliam Museum, Cambridge (1590)
PROV: Severn; Fitzwilliam (bought Sotheby's 20 May 1931, lot 142).
EXH: AC 1983, 198.
LIT: XXXVIII, 274 (1318), where incorrectly described as 'Palazzo Gambacorti'

Due to leave Pisa on Monday 26 May, Ruskin prolonged his stay to draw the Palazzo Agostini on the river front, 'because I expect it to be destroyed when

I return, and there is nothing like it in Italy that I know of' (*RI*, 79). The early 15th-century brick palace (Ruskin, following Murray's guide, mistakenly associated it with the time of the Republic) seemed near to collapsing. 'They have knocked a great hole in the middle', he wrote to his father, 'to put up a shield with a red lion and a yellow cock upon it for the sign of a consul, and they have knocked another at the bottom to put up a sign of a soldier riding a horse on two legs, with inscription All-Ussero-Cafè-&c, and they have knocked down the top story altogether, & put up a whitewashed wall instead, and they have filled up one of the windows with bricks, and as the necessary result of all these operations the whole building has given way and is full of fearful rents and curves and broken

arches' (*RI*, 71). It was not until the Wednesday, however, that the weather permitted him to draw it. Even then he had 'a nice piece of work to get' it, between rain and sun and wind and having to jump up and down to get out of the way of men towing boats from the quay-wall where he was sitting: 'but I have got it in spite of all – a dashing sketch of its shadows, and architectural ones from which I could build, of its details – the *lowest* I have down to the smallest rosettes, and the uppermost I should have had if I could have got a ladder, but I hunted all over the town and couldn't get one!' (*RI*, 85). Of the 'architectural' sketches, also referred to in the course of the extensive account of the palace's façade contained in Ruskin's notebook, only those in the notebook itself (*cat.21*) have survived.

Prominent in the foreground of the drawing is one of the 'strange stones built into the quays of the Arno' mentioned in an earlier letter, and whose function Ruskin had been unable to discover. He had consulted a local guide-book (*Nuova guida di Pisa*, 1845, one of the many books and prints he bought for reference purposes during the trip) but had found only an effusive description of the Lungarni.

The *Nuova guida di Pisa* does however show that the Palazzo Agostini was not used as a Consulate but housed a set of civic meeting-rooms, opened in 1818, on

36

its first floor, over the café. Nor, apparently, had the 'whitewashed wall' mentioned by Ruskin replaced, as he thought, the top floor of the palace. What appeared to be a solid wall was probably temporary plasterwork serving to close off the open loggia, which would not be permanently closed in brick until 1858 (Nuti, 55, 58).

36

Campanile and cloister of San Francesco, Pisa
1845
inscribed lower right, over base of column, 'square'
pen and wash
330 × 444
Bem.1363
EXH: RWS 1901, 55 (as Guinigi Palace); FAS 1907, 44 (as G. Pal.); AC 1960, 8 (as G. Pal.).
LIT: XXXVIII, 264 (1049; as G. Pal.)

Thought until now to be a view of the Guinigi Palace, Lucca, this drawing in fact shows the Pisan cloister of San Francesco, described in *Praeterita* as 'exquisite in its arched perspective and central garden, and noble in its unbuttressed height of belfry tower' (XXXV, 355).

In a letter to his father of 27 May

Ruskin reported that though prevented from drawing the Palazzo Agostini (*see cat.35*) he had got 'a beautiful campanile & cloister of convent where St Thomas Aquinas lived & preached' (*RI*, 82). If this is the drawing, Ruskin had confused San Francesco with the Dominican convent of Santa Caterina.

The cloister's almost triangular appearance in the drawing seems due to a failure, perhaps through haste, to reconcile the different viewpoints which Ruskin evidently adopted in order to include both lateral arcades and the whole of the campanile.

The campanile originally terminated in a spire. This was struck by lightning in 1788 and not restored until around 1900.

37

after Fra Angelico
The Annunciation
1845
pencil
210 × 243
Bem.1114
EXH: Rye 1970, 3; Oxford 1970, 21; Oundle 1977, 3; Whitworth 1982, 85; AC 1983, 217; Switzerland 1988-90, 51 (illustrated only)

His first calls in Florence, Ruskin wrote

35

to his father on getting there, would be the tomb of Giotto and Fra Angelico's convent of San Marco (*RI*, 87). He discovered this *Annunciation* (from a reliquary also showing the *Adoration of the Magi*) in another Dominican convent, Santa Maria Novella, for which it was painted between 1430 and 1434 (it is now in the Museo di San Marco). Ruskin spent several elating, frustrating days' work copying the panel, ensconced in the sacristy. He had never seen it engraved, though no engraving could have prepared him for what, after its holiness of expression, most enthralled him about it, the exquisitely wrought gilt surface and pure colour. Angelico's panels, he observed in his 'résumé', might be 'considered as mere jewellery', and this was 'carried further here than in any of his works, the gold deeper, and the ornaments more detailed and delicate. The glories are formed of rays indented in the gold deeper and deeper as they approach the head, so that there is always a vivid light on some portions of them, playing in the most miraculous way round the head as the spectator moves ...' This, subordinated to faces 'luminous with love', made it 'his most perfect work' and one of 'the most exalted and faultless conceptions which the human mind has ever reached of divine things' (TS, Bod. MS Eng.Misc.c. 213, 155, 157).

The figure of the Virgin was later engraved as the frontispiece to *Modern Painters* V (1860) *(cat.91)*.

The attribution to Fra Angelico has been questioned by John Pope-Hennessy, who considers the panel a production of his workshop.

38
View from San Miniato, Florence
1845
brown ink (pen and wash) over pencil
333 × 485
*Birmingham Museums and Art Gallery
(140'07)*
PROV: Birmingham (presented anonymously) 1907.
EXH: AC 1954, 18; Lyons 1966, 106; V & A 1968, 155; AC 1980-1, 51; Tokyo and tour, Bankside and Birmingham 1991-2, 93.
LIT: XXXVIII, 252 (723); Joan Evans, 'John Ruskin as Artist', *Apollo* (Dec. 1957), 139-45, fig.XX; *RI*, 103, pl.7;

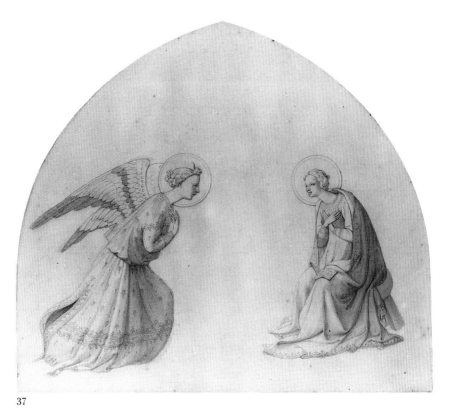

37

Pierluigi Nicolin (ed.). *Le città immaginate – un viaggio in Italia: Nove progetti per nove città*, Milan, 1987, 46 (repr. with title 'Veduta di Firenze da Montaguto' and dated '*c.*1845')

39
The garden of San Miniato, Florence
?1845
pencil, pen, ink, watercolour, heightened with white
333 × 473
PROV: Severn; H. Baldwin; sold at Christie's, 11 July 1989.
EXH: FAS 1907, 128.
LIT: XXXVIII, 252 (708)
(illustrated only)

Inaccurately described as *View of hills from Florence, with S. Felice below* (XXXVIII, 252) and as 'from the foot of the hill of Montaguto' (Birmingham inventory card), *cat.38* in fact shows the view once seen from the steps of the church of San Miniato, hence looking north (away from San Felice and towards Monte Acuto). This may be seen by comparing it with *cat.39* (probably the 'study in the rose-garden of San Miniato' referred to in *Praeterita* [XXXV, 363]), in which the

northern-most pilaster on the façade is just visible. At Bembridge (1261) is a pencil sketch of the relief over the gateway (apparently a *Madonna della Misericordia*), inscribed with the name of the church. The relief has been removed and the wall rebuilt, thus obstructing the view from this particular angle. The small belfry seen to the right in *cat.39* remains.

Harold Shapiro identifies *cat.38* with 'a pretty outline' mentioned by Ruskin in a letter to his father of 6 June, showing 'the hills with Galileo's house on them, & the Val d'Arno, with Caiano – the place where Bianca Cappella [*sic*] perished – and the Carrara mountains behind' (*RI*, 103). But if this is so, Ruskin's geography is at fault. The large villa to the left is not Poggio a Caiano, which lies well out of the picture to the west, but probably Careggi, while Galileo's villa at Arcetri is at the back of the spectator.

After a full day's picture-work Ruskin would often climb to this church ('deserted, but not ruinous' is how he recalls it in *Praeterita*) to revive himself. Towards the end of his stay he had to report to his father that he now saw it for the last time, 'for it is going to be

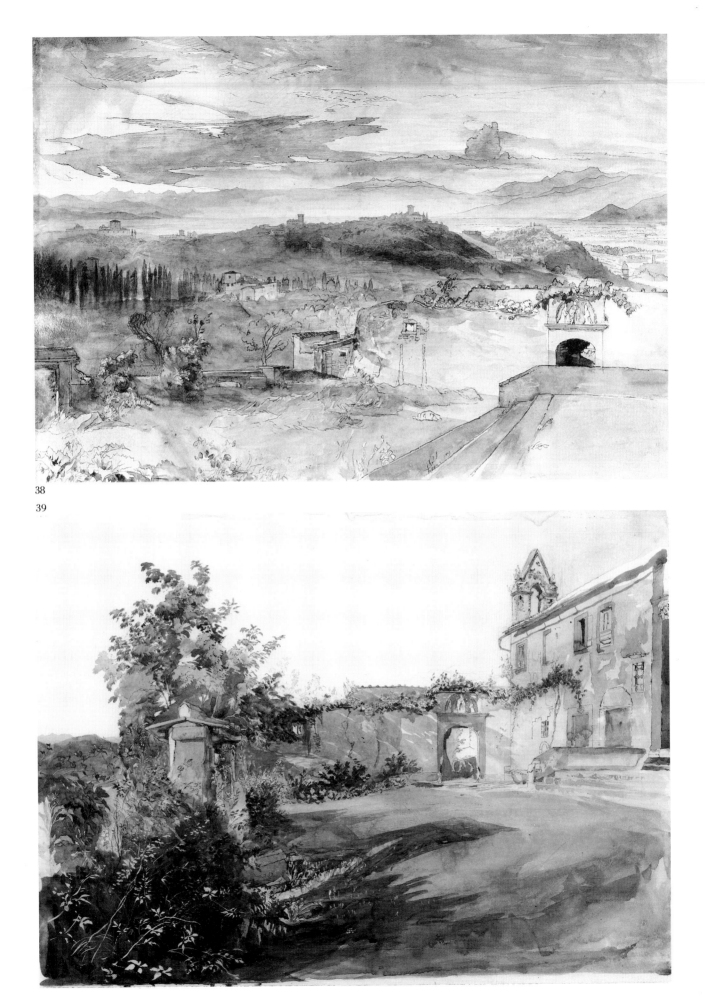

38

39

"restored"' (*RI*, 127). However, though plans for the church's restoration, including the conversion of the hillside on which it stands into a cemetery, had indeed already been presented, the political turmoil of the following years would delay the work until the mid-1850s.

40

The road to Florence
1845
pencil and sepia wash
380 × 539
Bem.1260
EXH: ?FAS 1878, 25a; Coniston 1919, 47 (as 'Road near Florence, 1845'); RA 1919, 106 (as 'Road near Florence, 1845'); Portsmouth 1973, 16; AC 1983, 197.
LIT: XXXVIII, 252 (?722)

There is no record of how this drawing acquired its present title. It is probably to be identified with No.722 in Cook and Wedderburn's catalogue, a *Study outside the South Gate of Florence*, which Ruskin exhibited at the Fine Art Society in 1878 along with *cat.33*, to show how in 1845 he 'carried on at the same time separate outline and chiaroscuro studies, which few persons, I believe, would imagine were by the same hand; and still less, that they were done contemporaneously' (XIII, 508). The south gate of Florence is the Porta Romana, by which Ruskin would have left the city for a number of his favourite walks: Arcetri, Bellosguardo, and the avenue of cypress, oak and larch leading to the villa of Poggio Imperiale. This drawing may indeed be a 'memorial' of happy youth mentioned in *Praeterita*, a study 'in the cypress avenue at the Porta Romana' (XXXV, 363), if this is not rather to be identified with a *Tree study* now at Bembridge (1562), a group of olives seen from a thoroughly Tuscan cypress-lined roadside.

1846: Memorandums

The second volume of *Modern Painters* was written in the winter of 1845-6, and the effort told on Ruskin's health. As soon as it was finished he returned abroad to recover, this time with his parents. He was eager to share with them, especially with his father, his Italian discoveries of the previous summer. Their itinerary this year took them over the Cenis to Turin, Verona and Venice, which they reached around the middle of May. After this they travelled via Padua, Ferrara and Bologna to Florence, where they stayed three weeks, prolonging their visit for the feast of St John on 24 June, 'altho we scarcely need for there is fete making perpetually – anything but working or thinking', Ruskin's father complained (TS, Bod. MS Eng.Lett.c.32, 244). They then headed for Pisa and Lucca, stopping at Prato and Pistoia *en route*. By the beginning of July they were in Massa, from which Ruskin made an excursion to Carrara. They then travelled up the coast to Genoa, and Turin, leaving the country by the Cenis again around the middle of the month.

This Italian part of the tour was not the success Ruskin had hoped, as it soon became apparent to both his father and himself that their interests and particularly their tastes in art, once so similar, were rapidly diverging. 'For the first time', Ruskin wrote in *Praeterita*, 'I verily perceived that my father was older than I, and not immediately nor easily to be put out of his way of thinking in anything. We had been entirely of one mind about the carved porches of Abbeville, and living pictures of Vandyck; but when my father now found himself required to admire also flat walls, striped like the calico of an American flag, and oval-eyed saints like the figures on a Chinese teacup, he grew restive' (xxxv, 418-19).

The root of the problem was John James's keen disappointment at his son's abandonment of poetry: he had written none since the previous tour, when he had reluctantly compiled some verses on Mont Blanc to keep a promise to his father. From Venice John James was obliged to reply to W. H. Harrison's request for a poem for his forthcoming annual, 'I regret to say there is no chance of this; my son has not written a Line of poetry and he says he cannot produce any by setting himself to it as a work – he does not I am sorry to say regret this – he only regrets ever having written any' (TS, Bod. MS Eng.Lett.c.32, 243). Not only had Ruskin given up his poetry, his work on art was developing in ways his father could not comprehend. In the same letter, John James gives an account of his son's investigations: 'He is cultivating Art at present searching for real knowledge but to you and me this knowledge is at present a sealed Book It will neither take the shape of picture nor

The Carlton Club, St James's Street, London *(see cats 61-2)*

poetry. It is gathered in scraps hardly wrought for he is drawing perpetually but no drawing such as in former days you or I might compliment in the usual way by saying it deserved a frame – but fragments of everything from a Cupola to a Cartwheel but in such bits that it is to the common eye a mass of Hieroglyphics – all true – truth itself but Truth in mosaic.'

Ruskin's father was indeed anxious about progress on *Modern Painters*. A month earlier, in reply to Harrison's offer to see the planned revised edition of the first volume through the press, he wrote somewhat nervously, 'when the first volume revised may come I know not and the third volume I fear has yet to be written. If unexpectedly the materials of first are prepared for printing – I shall gladly avail of your kind offer – the Revise was to my son worse than the first composition. However my son feels bound to complete the work first and last vol. as soon as his health

allows and the time he will yet take to either will chiefly be with a view to make it more perfect' (TS, Bod. MS Eng. Lett.c.32, 242).

It was no doubt due in part to John James's presence on this tour that much of it was eventually spent on the revision of the first volume: 'In Italy', Ruskin later wrote to George Richmond, 'I lost the greater part of my time because I had to look over the first volume of *Modern Painters*, which I wanted to bring up to something like the standard of knowledge in the other' (XXXVI, 64). The major addition was a 'general sketch of ancient and modern landscape' beginning with the 'ideal landscape of the early religious painters of Italy'. By the time they reached Genoa in mid-July, John James was able to send Harrison the first parcel of revised sheets, clipped to save postage, the final batch of 'cut letterpress and disjointed manuscript' being sent him a month later from Vevey. The work of revision was probably begun in Florence, where John Hobbs's diary, now in the Pierpont Morgan Library (MA 2539), shows he was doing

a good deal of 'writing' for Ruskin. His being taken up with *Modern Painters* would explain why Ruskin's own diary for the Tuscan part of the tour is so fragmentary, most of the not very numerous entries taking the form of notes on paintings and architecture written up in Geneva and later from a small 'memorandum book' now at Coniston *(cat.42)*.

The contents of this notebook, mainly architectural, reflect the dominant concern of this tour: much of the information gathered in it would in fact find its way into *The Seven Lamps of Architecture* (1849). However, even the more elaborate drawings done on this journey were regarded primarily as 'bits' of information: Ruskin told Samuel Prout he had considered them all 'merely as memorandums' (XXXVIII, 341). His primary concern was knowledge, and it was precisely as an aid to knowledge that he valued the daguerreotype so highly. If the tour did not produce a great many drawings, it considerably enlarged Ruskin's collection of these 'precious records' (TS, Bod. MS Eng.Lett.c.32, 249).

41

ANON
Silhouette of John Ruskin
?1846
black paper
105 × 68
Bem.30
EXH: Switzerland 1988-90, 105

In the catalogue to his exhibition *Ruskin and the Alps*, J. S. Dearden dates this silhouette at around 1846. In view of the fact that Ruskin is shown with glasses, it was probably cut, he thinks, *en route* for Italy in Switzerland, as at this period the only sort of spectacles Ruskin wore were tinted ones against the glare of the snow.

42

Architectural notebook 1846, referred to as 'small memorandum book'
133 × 88; hard cover; 82 leaves
The Trustees of the Ruskin Museum, Coniston, Cumbria (CONRM 1990.381)
EXH: RA 1919, p.13, no.2

43

Pl.IV, 'Intersectional Mouldings', The Seven Lamps of Architecture *(1849)*
soft-ground etching (print of 1880 on india paper)
268 × 185
Sheffield R425

Cat.42 is open to show (p.88) outlines of the church of San Miniato al Monte, Florence and its neighbouring buildings, and (p.89) two architectural details from Prato. The upper detail, showing the dovetailing of the stones (alternate serpentine and marble) in the lintel of the south-east door of the Duomo, was later etched for *The Seven Lamps of Architecture* (1849), where it appears as Pl.IV, Fig.4 *(cat.43)*. The detail is referred to in the text as an example of legitimate delight in the intricate fitting together of stones, a feature that 'may sometimes serve to draw the eye to the masonry, and make it interesting, as well as to give delightful sense of a kind of necromantic power in the architect'. Ruskin notes how the 'maintenance of the visibly separate stones ... cannot be understood until their cross-cutting is seen below' (VIII, 70-1). Fig.5 in the same plate gives the form of each stone.

Seven Lamps was the first of Ruskin's books to carry illustrations: the fourteen plates included in the first edition were etched by the author himself using the soft-ground process taught him by the French engraver Louis Maurey (1815-50). Despite their 'hasty and imperfect execution' (he later recalled how the last had been bitten in his hotel bedroom

washbasin at Dijon), for which due apologies were made in the preface, Ruskin angrily asserted their worth against criticisms in the press. To his publisher, George Smith, he complained that none of the reviewers appeared to have understood the etchings' 'purpose and value', and that, such as they were, they constituted 'the most sternly faithful records of the portions of architecture they represent which have ever been published' (VIII, 276). In an appendix to the first volume of *Stones of Venice* (1851) he again came to their defence: black, over-bitten, coarse and disagreeable they might be, still 'their truth is carried to an extent never before attempted in architectural drawing' (IX, 431). The plates were, however, re-etched for the second edition, by R. P. Cuff; with the exception of Pl.IX, 'Tracery from the Campanile of Giotto, at Florence', for which Ruskin made a new drawing, which was engraved by J. C. Armytage and was used as frontispiece. The original etchings were not used again except in 1880, when some copies at least of the large-paper edition included impressions on india paper of both Ruskin's and Cuff's plates (a feature not mentioned in the bibliographies). It was evidently for this edition that *cats 43* and *74* were made.

42

Ruskin and the Daguerreotype

Invented by Joseph-Nicéphore Nièpce and Louis-Jacques-Mandé Daguerre, the Daguerreotype was announced to the public in 1839, the first photographic process to be so. It consisted in sensitising the polished surface of a silver-coated copper plate with iodine fumes and then exposing it first to sunlight in a camera obscura *and then to mercury vapour. The unique image was formed by the deposit of tiny particles of mercury-silver amalgam on the surface of the plate, and was thus prone to be wiped off through rubbing or careless handling. To be seen as positive it must reflect a dark ground.*

The image is normally reversed, but this was sometimes corrected using a mirror or lens, as in most cases here.

In Praeterita *Ruskin recalled having first heard of the invention during his 'last days at Oxford'. This would have been in 1842, when Ruskin returned to the University to take his degree. This is likely, as the process had been announced in the British press in January of 1839. Less plausible is the claim that the plates he then had sent to Oxford from Paris were the first to be sent to England. However, that Ruskin acquired daguerreotypes before 1845 is shown by a letter to Samuel Rogers, dated 4 May*

1844, in which he attempts to entice the author of Italy *to Herne Hill by promising to show him 'one or two of our Turners' and 'some daguerreotypes of your dear, fair Florence' (XXXVI, 38). It was as much the collector as the poet who was being appealed to, since Rogers' own heterogeneous collection included early photographs.*

The revelation of the daguerreotype's value as a documentary tool came in 1845, in Venice. Just when Ruskin was despairing of finding a way of getting general views of the palaces that would give him not simply an outline but all 'the cracks & the stains' too, without

46

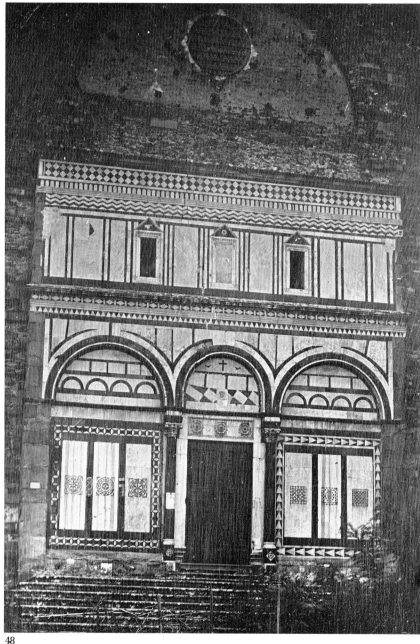

48

occupying him for a month at a time, he came on a 'poor Frenchm[an]' and bought from him 'some most beautiful, though small, Daguerreotypes of the palaces I have been trying to draw – and certainly Daguerreotypes taken by this vivid sunlight are glorious things. It is very nearly the same as carrying off the palace itself – every chip of stone & stain is there – and of course, there is no mistake about proportions' (RI, 218, 220).

 The following year Ruskin obtained additional Venetian specimens, but was also able to add to his collection of daguerreotypes of Florence and the other Tuscan cities, which in 1845 he had already passed through by the time he chanced on that poor Frenchman in Venice. On the way home he announced his purchases to Prout and to W. H. Harrison, declaring his alliance with 'certainly the most marvellous invention of the century – given us, I think, just in time to save some evidence from the great public of wreckers' (TS, Bod. MS Eng.Lett.c.32, 249).

 Ruskin did not at this stage take his own daguerreotypes (it would soon form one of John Hobbs's, as later his successor Frederick Crawley's, special duties). But he certainly commissioned them on the spot, and, to judge from the Preface to Seven Lamps, seems to have supervised their taking as well.

44

ANON
North door of the Duomo, Florence
c.1846
daguerreotype
150 × 111
Bem.Dag.45
EXH: Italy 1986, 53.
LIT: Costantini/Zannier

45

ANON
South door of the Duomo, Florence
c.1846
daguerreotype
147 × 109
Bem.Dag.51
EXH: Italy 1986, 54.
LIT: Costantini/Zannier

46

ANON
Detail of the south door of the Baptistery,
Florence
*c.*1846
daguerreotype
149 × 100
Bem.Dag.47
EXH: Italy 1986, 55.
LIT: Costantini/Zannier

47

ANON
Detail of the north door of the Baptistery,
Florence
*c.*1846
daguerreotype
105 × 137
Bem.Dag.48
EXH: Italy 1986, 56.
LIT: Costantini/Zannier

48

ANON
Façade of the Badia, Fiesole
*c.*1846
daguerreotype
144 × 103
Bem.Dag.53
EXH: Italy 1986, 57.
LIT: Costantini/Zannier

49

Part of the façade of San Miniato al
Monte, Florence
?1846
inscribed, top left, 'Not to be put[?in]
watercolour, pencil
400 × 365
Brant.913
EXH: Boston 1878, 77; Coniston 1900, 57;
RWS 1901, 98; Manchester 1904, 246
(dated 1845)
LIT: XXXVIII, 252 (707; dated 1845)

Cat.49 is more likely to have been done
on the present tour than on the previous
one, as in 1845 Ruskin's Florentine work
was entirely pictorial, and he went to San
Miniato mainly for the quiet of its garden
and the view. Hobbs's diary for 1846, on
the other hand, records whole mornings
and afternoons spent at the church. That
year, Ruskin visited it soon after his
arrival in Florence, and his diary for
7 June expresses his relief at finding it still

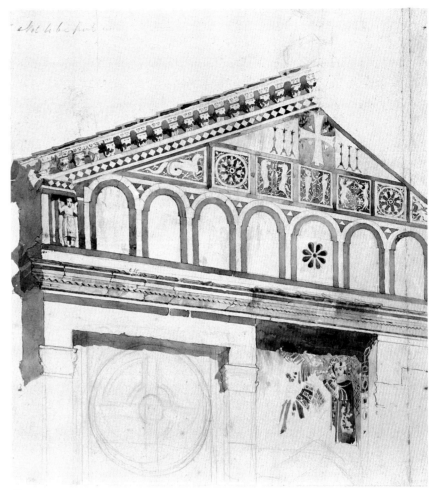

49

untouched: 'not a rosebush cut, nor a
stone replaced'. He goes on to analyse its
strange façade: 'one of the most singular
mixtures of classical ornament, especially
friezes, with barbarous figures & quaint
mosaics; thus in the principal window of
the facade, supported by columns of
beautiful proportion, with delicate
classical capitals and the richest egg and
arrow mouldings above; while the
columns at the bottom are supported on
two entirely barbarous monsters'. Passing
to the mosaic above the central doorway,
Ruskin compares it with other Byzantine
mosaics – from the Baptistery in Florence
and from Pisa, Bologna and Murano –
remarking that though all are archaic,
there is still a marked 'difference of
majesty' noticeable between them. This, of
Christ between St Minias and Mary, he
found 'too much bearded and

moustachioed for expression' (Bem. MS 5c,
33-4).

The present church dates from the
beginning of the 11th century, when a
Benedictine Cluniac monastery was also
founded here by Henry II. The façade was
begun around 1090, and completed in the
early 1200s. The mosaic is of the 13th
century.

50

The Seven Lamps of Architecture
London: Smith, Elder & Co, 1849
to show original embossed cloth binding
Sheffield R.3614

The cover of the first edition of *Seven
Lamps* was designed by W. Harry Rogers,
presumably to Ruskin's specifications,
and is based on the early 13th-century
inlaid floor panels of San Miniato. The
versatile John Hobbs may also have had a

hand in its preparation. His diary shows that on the morning of Tuesday 23 June he was at work 'on the floor' of the church, having been 'occupied' there during the morning and evening of the previous day. The entry suggests that he was drawing, or perhaps tracing the floor for Ruskin. That Hobbs did draw is also shown by his diary: a week earlier he had spent an afternoon (when he was generally free) sketching or 'trying to sketch some things' in San Miniato (Morgan, MA 2539).

A note in *Seven Lamps* (VIII, 185) draws the reader's attention to the cover design, comparing the floor of San Miniato with the inlaid panels of the contemporary façade of San Michele in Lucca, instanced in the text as an example of the type of 'pure architectural decoration' in which organic form is 'abstracted to outline (monochrom design)'.

50

51

ANON
Tracery of window, Orsanmichele, Florence
c.1846
daguerreotype
108 × 148
Bem.Dag.49
EXH: Italy 1986, 50.
LIT: Costantini/Zannier

52

ANON
Duomo and Campanile, Florence
c.1846
daguerreotype
145 × 103
Bem.Dag.46
EXH: Italy 1986, 51.
LIT: Costantini/Zannier

53

Drawing for Pl.IX, The Seven Lamps of Architecture, *'Tracery from the Campanile of Giotto, at Florence'*
1848-9
pencil
220 × 138
Sheffield R O743
LIT: Morley, 217

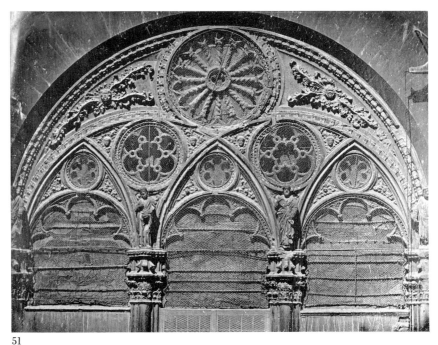

51

54

The Seven Lamps of Architecture
London: Smith, Elder & Co, 1849
full morocco
open to show Pl.IX, 'Tracery from the Campanile of Giotto, at Florence'
Bem.10.3 (copy A)

55

Original steel plate with soft-ground etching for Pl. IX (rejected version), The

Seven Lamps of Architecture (*1849*)
1848-9
285 × 208
Bem.
EXH: Switzerland 1988-90, 23

56

Proof taken from plate cat.55
Bem.
EXH: Switzerland 1988-90, 24

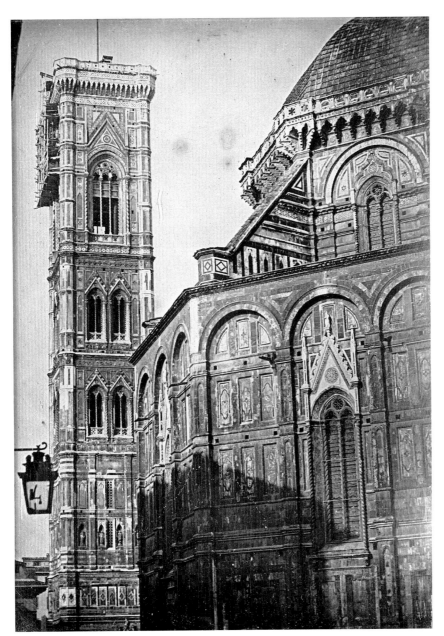

52

once'. In his own etching of the tracery of the Campanile *(cat.54)* he had made a special effort to get not just the design but above all the effect of it: 'black shadows of a graceful form lying on the white surface of the stone, like dark leaves laid upon the snow' (VIII, 126).

Later in *Seven Lamps* the Campanile is cited as 'the model and mirror of perfect architecture', the one building in the world in which all the conditions of what Ruskin calls Power and Beauty are combined, and all to the highest degree possible. The stranger, he surmises, will find the tower unpleasing at first, 'a mingling ... of over-severity with over-minuteness'. But let him give it time, as he, Ruskin, had done: 'I remember well how, when a boy, I used to despise that Campanile, and think it merely smooth and finished. But I have since lived beside it many a day, and looked out upon it from my windows by sunlight and moonlight, and I shall not soon forget how profound and gloomy appeared to me the savageness of the Northern Gothic, when I afterwards stood, for the first time, beneath the front of Salisbury' (VIII, 187-8). In Florence in 1845 Ruskin had taken rooms that gave onto the Cathedral square (immediately overlooking the Loggia del Bigallo).

Ruskin's etching of the Campanile window was enlarged from a daguerreotype *(cat.52)*. 'Unfortunately', he writes in his Preface, 'the great distance from the ground of the window ... renders even the Daguerreotype indistinct; and I cannot answer for the accuracy of any of the mosaic details, more especially of those surrounding the window, which I rather imagine, in the original, to be sculptured in relief. The general proportions are, however, studiously preserved; the spirals of the shafts are counted, and the effect of the whole is as near the thing itself, as is necessary for the purposes of illustration for which the plate is given' (VIII, 4). These difficulties explain how Ruskin came to etch the plate twice. The rejected version, the original plate for which is shown here *(cat.55)*, was first published in the Library Edition of Ruskin's *Works*.

In *Seven Lamps*, the windows of Orsanmichele and of Giotto's Campanile are cited to show how Gothic architects enhanced wall-surfaces by means of more or less intricately cut window-tracery. Ruskin points out how 'In Italian traceries the eye is exclusively fixed upon the dark forms of the penetrations, and the whole proportion and power of the design are caused to depend upon them.' Indeed for this reason he found it pointless to draw Italian tracery in outline, as was customary in works on architecture. No outline drawing of the Orsanmichele windows could show, what the daguerreotype here exhibited *(cat.51)* perhaps does, 'that all this sculpture was extraneous, was a mere added grace, and had nothing to do with the real anatomy of the work, and that by a few bold cuttings through a slab of stone [one] might reach the main effect of it all, at

57

58

57

ANON
Campanile of Duomo, Pistoia
*c.*1846
daguerreotype
151 × 95
Bem.Dag.64
EXH : Italy 1986, 67.
LIT : Costantini/Zannier

58

*Palazzo del Comune and Campanile of
Duomo, Pistoia*
1845 or 1846
inscribed upper left, 'Pistoja' & lower left,
'JR'
pen and wash
Brant.972

In this drawing the campanile is seen
behind the 17th-century raised
passageway connecting the Duomo with
the Palazzo del Comune. The drawing is
not dated but for stylistic reasons seems to
belong to either this or the previous tour.
On both occasions Ruskin spent less than
a day in Pistoia, a city which despite
enthusiastic first impressions, he soon
found he did not greatly like.

59

ANON
Side of San Giovanni Fuorcivitas, Pistoia
*c.*1846
daguerreotype
109 × 148
Bem.Dag.66
EXH : Italy 1986, 69.
LIT : Costantini/Zannier

The side of this church, described by
Ruskin as 'the most graceful and grand
piece of Romanesque work, as a fragment,
in North Italy', is given in *Seven Lamps*,
together with the Duomo of Pisa, as a
supreme example of 'Living Architecture':
architecture that has 'sensation in every
inch of it, and an accommodation to every
architectural necessity, with a determined
variation in arrangement, which is exactly
like the related proportions and provisions
in the structure of organic form' (VIII,
204). It was probably on the present tour
that Ruskin took the measurements cited
in the text to show how subtle variations
in the apparently regular proportions
between the arches of the three arcades
confuse the eye and make of the building
a single mass.

60

ANON
Façade of Sant'Andrea, Pistoia
*c.*1846
daguerreotype
145 × 108
Bem.Dag.70
EXH : Italy 1986, 70.
LIT : Costantini/Zannier

61

*Drawing for Pl.XIII, 'Wall-Veil
Decoration', The Stones of Venice, Vol. I
(1851)*
*c.*1851
ink, wash, white
122 × 203
Brant.1083
EXH : Manchester 1904, 277 or 278

62

The Stones of Venice, Vol. I
London : Smith, Elder & Co, 1851
Sheffield

Pl.XIII of the first volume of *Stones of
Venice* (engraved by T. Lupton from the
drawing by Ruskin) presents two examples
of 'wall-veil decoration' for the reader to
choose between. That on the right, a detail
from the façade of the church of San
Pietro at Pistoia, shows the decorative
system adopted by the Pisan Romanesque
architects : alternate bands of coloured
stone. No other ornaments, Ruskin
affirms, are more deeply suggestive in
their simplicity and no school employing it
more noble and attractive. The example
on the left shows the system preferred by
modern architects, a detail from the
façade of Arthur's Club, St James's St
(now the Carlton : *see* ill. p.45), which had
been rebuilt to a design of Thomas
Hopper's in 1825. With this system of
chiselling to accentuate the lines
separating courses, Ruskin complains,
'half the large buildings in London are
disfigured'. This, he insists, is a 'wilful
throwing away of time and labour in
defacing the building', whereas coloured
stones 'naturally' dispose themselves in
bands of varying width according to their
relative costliness. Moreover, straight lines
in themselves are ugly, and only
admirable as delimitations of coloured
zones (IX, 348).

61

from a drawing in Ruskin's architectural notebook of 1846 *(cat.42)*. (In *Seven Lamps* Ruskin ascribes the pulpit to 'Nicolo Pisano', in the sketchbook to Nino: it is in fact by Giovanni Pisano.) In 'The Lamp of Life' this detail illustrates a notion first hinted at in the sketchbook in connection with the sculpture of Benedetto da Maiano, and developed here with reference to Mino da Fiesole and Michelangelo: the idea of 'sculptural sketching'. What in the mouldings at first appears mere roughness of execution, is in fact 'the correspondent to a painter's light execution of a background: the lines appear and disappear again, are sometimes deep, sometimes shallow, sometimes quite broken off; and the recession of the cusp joins that of the external arch at *n*, in the most fearless defiance of all mathematical laws of curvilinear contact' (VIII, 200).

63

ANON
Duomo and Leaning Tower, Pisa
*c.*1846
daguerreotype
110 × 152
Bem.Dag.57
EXH: Italy 1986, 60.
LIT: Costantini/Zannier

64

ANON
Apse of Duomo, Pisa
*c.*1846
daguerreotype
149 × 105
Bem.Dag.56
EXH: Italy 1986, 61.
LIT: Costantini/Zannier

65

Drawing for Pl.XII, 'Fragments from Abbeville, Lucca, Venice and Pisa', The Seven Lamps of Architecture (1849)
1848-9
pencil
224 × 144
Sheffield RO743
EXH: AC 1983, 205

Of the various architectural details in this, one of several composite plates in *Seven Lamps*, of relevance here are Figs 2, 4, 7. The latter shows one of the square panels decorating the front of the Duomo

of Pisa, a motif commonly found in buildings of this style. It features in a detailed analysis (fruit of Ruskin's examination of the building in 1845 and no doubt again in 1846) of the Duomo's fusion of the two architectural principles of concentration or breadth (interest in the wall as a broad, unbroken surface) and contraction or length (interest in the wall primarily as extendible and divisible). The first favours the use of square and circle, the second employs oblong forms often marked by a continuous series of some single feature, such as a range of arches. In the Duomo the square panels are framed by a range of semi-circular arches on cylindrical shafts, surmounted by three similar ranges. This is only one of the instances offered of an arrangement ('not perhaps the fairest, but the mightiest type of form which the mind of man has ever conceived') combining broad and contracted surfaces, but based 'exclusively on associations of the circle and the square' (VIII, 112).

Fig.2 shows designs from two inlaid marble columns of the façade of San Michele, Lucca *(see cat.23)* which in the chapter 'The Lamp of Beauty' is cited to show that architectural, like natural colour, must be either soft or simple in outline.

Fig.4 shows the mouldings of an arch from the pulpit in Sant'Andrea, Pistoia,

66

ANON
San Paolo a Ripa d'Arno, Pisa
*c.*1846
daguerreotype
145 × 107
Bem.Dag.59
EXH: Italy 1986, 63.
LIT: Costantini/Zannier

The church is mentioned in documents of the middle of the 11th century, but attained its final form in the middle of the 13th. Traditionally known as the Duomo vecchio, it was thought to have served as a model in the construction of the Duomo. There is an autograph note to this effect on a photograph of the church once owned by Ruskin, now at Bembridge.

67

ANON
Santa Maria della Spina, Pisa (south side towards east end)
*c.*1846
daguerreotype
148 × 110
Bem.Dag.62
EXH: Italy 1986, 66.
LIT: Costantini/Zannier

68 (Colour plate I)
Santa Maria della Spina, Pisa (south side towards east end)

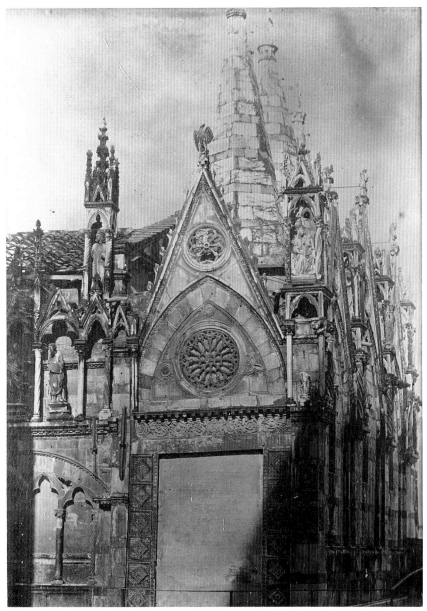

67

state offended the sensibilities of many actively engaged in often radical attempts to 'beautify' the city. However, there was also a growing sense of the chapel's historical value and beauty, and fourteen years before Ruskin's visit its restoration had for the first time involved the removal of what were considered the inappropriate alterations undergone during the preceding centuries (Burresi, 15).

The rumours prompted Ruskin to obtain permission to 'get up on the roof' of the chapel 'to draw the details before they throw them into the river' (*RI*, 65). Ruskin's notebook for 1845 does in fact contain a few slight sketches of some columns from the upper part of the chapel, although he would not necessarily have had to climb onto the roof to get these, the building then being on a lower level than the road; and in any case he clearly did not find the time in the end to make a thorough study of the church as he apparently intended.

On his return in 1846 Ruskin procured two daguerreotypes of the Spina: one of the façade and that shown here (*cat.67*). He subsequently copied the latter (*cat.68*), 'so that people might not be plagued in looking at it, by the lustre', as he explained many years later in *Fors Clavigera* (xxvii, 349). It is possible that the drawing was made for an exhibition of his work held at a meeting of the Graphic Society in February 1847. Although not specifically mentioned in the report published in the *Athenaeum*, this shows that drawings of other Tuscan churches, such as those of San Michele, were exhibited, 'in juxtaposition with' a 'series of daguerreotype views of many of the Italian ecclesiastical buildings' (*Athenaeum*, 20 February 1847, 206).

?1846-7
inscribed upper left, pencil, 'Not to be [?put in]' and lower left 'J[?R]'
watercolour, ink, pencil
495 × 365
Sheffield R51
PROV: Oxford, 1872; Guild of St George (Walkley, 1888).
EXH: Coniston 1900, 177; Sheffield 1901, 232 (dated *c.*1846); Manchester 1904, 245; Rome 1911, 97; AC 1983, 266; Lancaster 1992.

LIT: XXXVIII, 274 (1320); Morley, 213-14
In 1845 Ruskin wrote to his father that he had heard of plans to pull Santa Maria della Spina down 'to *widen the quay*' (*RI*, 62-3). These were indeed years which saw the effective widening of the Lungarni at many points through the straightening of the extremely irregular course of the old quays with their frequent points of access down to the river. It is not impossible, moreover, that the demolition of the Spina was mooted by some: both its style and

69
ANON
Lower portion of façade of San Michele, Lucca (reversed image)
*c.*1846
daguerreotype
95 × 70
Bem.Dag.69
EXH: Italy 1986, 71.
LIT: Costantini/Zannier

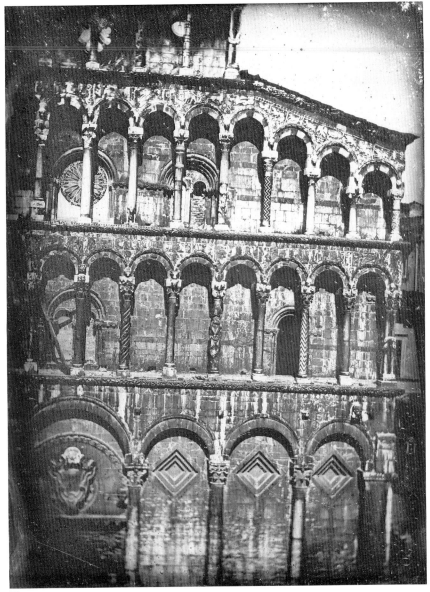

69

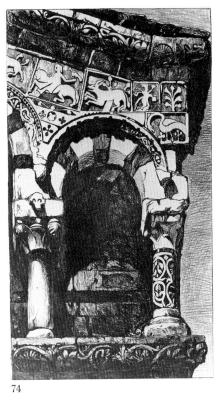

74

watercolour, pencil
457 × 238
*The Visitors of the Ashmolean Museum,
Oxford (Ed.85)*
PROV: Oxford 1870-2.
LIT: XXXVIII, 264 (1042)

74
*Pl. VI, 'Arch from the Façade of San
Michele, Lucca'*, The Seven Lamps of
Architecture *(1849)*
1848-9
soft-ground etching on steel (1880 print on
india paper)
256 × 178
Sheffield R 426

75
HENRY GALLY KNIGHT
*The Ecclesiastical Architecture of Italy.
Vol.II*
London, 1842
open to show Pl.XIV, 'San Michele, Lucca'
Manchester City Libraries
 All three studies of the façade of San
Michele placed by Ruskin in the Oxford
Drawing School collection *(cats 23, 72,
73)* are dated 1845 in the catalogue of that

70
ANON
*Upper portion of façade of San Michele,
Lucca*
c.1846
daguerreotype
150 × 109
Bem.Dag.72
EXH: Italy 1986, 72.
LIT: Costantini/Zannier

71
ANON
*Lateral view of façade of San Michele,
Lucca*
c.1846
daguerreotype
148 × 105
Bem.Dag.71

EXH: Italy 1986, 73.
LIT: Costantini/Zannier

72 (Colour plate IV)
Part of the façade of San Michele, Lucca
?1846
watercolour, pencil
407 × 246
*The Visitors of the Ashmolean Museum,
Oxford (Ed.84)*
PROV: Oxford 1870-2.
EXH: AC 1983, 202.
LIT: XXXVIII, 264 (1041)

73
*Lateral view of the façade of San Michele,
Lucca*
?1846

collection. However, in only one case is the date inscribed on the drawing itself, and for several reasons it seems more likely that *cats 72* and *73* were done in 1846. Compared with the dated study they form a distinct pair, showing less concern for the careful delineation of the forms of panels and columns than attention to the way their sculptured surfaces take the light, the meticulous outlining in pen and heightening in white giving way to a freer use of the brush. It is unlikely, moreover, that Ruskin had time to complete three drawings of the façade in 1845: indeed, his notebook for 1845 refers, as we saw, to 'my study of the façade' in the singular (although it does note a feature of the façade illustrated in *cat.73*, ie 'that the two uppermost stories ... are built for their own sake, they are an ornamental *wall*, raised clear above the roof, *a flat* tower, so to speak' (TS, Bod. MS Eng.Misc.c.213, 29). Hobbs's diary for 1846, on the other hand, shows that Ruskin spent a part of both the days he was in Lucca (30 June and 1 July) drawing this church.

In view of the peculiarly sculptural quality of these two drawings, as opposed to the study of 1845, it is not surprising that Ruskin should have used a portion of *cat.72* (together, apparently, with a daguerreotype, *cat.69*, of the same part of the façade, whose reversed image he curiously reproduces), to illustrate *Seven Lamps (cat.74)*. For the façade is there given as an example of the way in which Romanesque Christian architects set off the broad wall-surface by 'points or masses of energetic shadow' obtained 'by means of ranges of recessed arcade, in the management of which, however, though all the effect depends upon the shadow so obtained, the eye is still, as in classical architecture, caused to dwell upon the projecting columns, capitals and wall' (VIII, 125). Indeed, Ruskin spoke of the illustrations to *Seven Lamps* as 'architectural notes of shadow' (VIII, 15).

A comparison of *cats 72* and *69* will show that in his 'memorandum' Ruskin has shifted the position of the elaborately carved column, fifth from the end in the second storey. This column, now in the Villa Guinigi, Lucca, was one of the pieces replaced during the restoration of the 1860s *(see cat.23)*.

In defending his etchings against criticism *(see cat.43)*, Ruskin more than once used Pl.VI *(cat.74)* as an example of the superiority of his illustrations', 'rough veracity' over the 'delicate fiction' then current in the way of architectural drawings. In doing so he compared his own representation of the façade of San Michele with that found in Gally Knight's *Ecclesiastical Architecture of Italy (cat.75)*. Knight's drawing of the entire front, he warned readers of *Stones of Venice*, 'may serve to give them an idea of its general disposition', though out of proportion and perspective: 'but every bit of the ornament on it *is drawn out of the artist's head*. There is not *one line* of it that exists on the building'. And yet the work was 'referred to as an authority, by our architects' (IX, 431).

76

ANON
Façade of the Duomo, Lucca
c.1846
daguerreotype
145 × 107
Bem.Dag.70
EXH: Italy 1986, 74.
LIT: Costantini/Zannier

Comparing the architecture of the Duomo with that of San Michele in 1845 Ruskin found the former 'superior in refinement' but flawed by 'a few apparently trifling circumstances which it is of importance to study'. The addition of the atrium and the reduction of the number of arches in the first storey from seven to three he considered an improvement (he also recorded these arches' measurements to demonstrate their irregularity). Also, the decorated columns were even richer than that at San Michele and the mosaics 'as interesting and delicate'. However, the extra arch added to the small rows at the wing (five rather than four, as at San Michele) was misjudged, 'making it, had the front been completed, considerably too wide, as the rows would have been of 16 instead of 14 arches'. Moreover, the Duomo lacked a fourth range of arches, 'and with them the star window which gives as [sic] much grace to San Michele, as well as the lifting of the arches at the top, those of the cathedral being all on a level which I

imagine is the greatest defect of all'. In general too the Duomo lacked something of the 'deeply stained' and 'grandly time-worn' appearance of the other church: it wanted 'the weeds which adorn, while they destroy San Michele' (TS, Bod. MS Eng. Misc.c.213, 30-1).

77

ANON
Tomb of Ilaria del Carretto by Jacopo della Quercia in the Duomo, Lucca
c.1846
daguerreotype
60 × 129
Bem.Dag.68
EXH: Italy 1986, 76.
LIT: Costantini/Zannier

Ruskin had not noticed this tomb on his first visit to Lucca in 1840, perhaps because it was then in a chapel and not as now in the north transept, where it was moved in 1842. In 1845 it was one of many important discoveries made by Ruskin in the city. Forty years later her wrote, 'The statue of Ilaria became at once, and has ever since remained, my ideal of Christian sculpture' (IV, 347). Its distinction in this respect had to do with a delicate combination of 'living' likeness and 'chaste' severity. 'It is impossible to tell you', Ruskin wrote to his father in 1845, 'the perfect sweetness of the lips & the closed eyes, nor the solemnity of the seal of death which is set upon the whole figure. The sculpture, as art, is in every way perfect – truth itself, but truth selected with inconceivable refinement of feeling. The cast of the drapery, for severe natural simplicity & perfect grace, I never saw equalled, nor the fall of the hands – you expect every instant, or rather you seem to see every instant, the last sinking into death. There is no decoration nor work about it, not even enough for protection – you may stand beside it leaning upon the pillow, and watching the twilight fade over the sweet, dead lips and arched eyes in their sealed close. With this I end my day, & return home as the lamps begin to burn in the Madonna shrines; to read Dante, and write to you ...' (*RI*, 55).

Ilaria del Carretto was the second wife of Paolo Guinigi, Lord of Lucca from 1400. She died in 1405, and her tomb was probably carved shortly afterwards, at any

rate before 1409, when Paolo Guinigi married again. Some modern critics share Ruskin's belief, expressed in his 1845 notebook, that Jacopo della Quercia was not responsible for the frieze of putti on the plinth ('cherubs and garlands such as one sees over cheesemongers tombs in city churches'). Others make the same claim of the frieze on the other side of the sarcophagus, which Ruskin did not see, as it had long since been detached from the rest of the monument, and was in the course of the century even to make its way to Florence. At this period, the tomb was in fact placed against the wall in the north transept and not free-standing as now *(see cat.237)*.

78

J. H. LE KEUX, from a drawing by Ruskin after Masaccio
Pl.13, 'First Mountain Naturalism',
Modern Painters *III (1856)*
1856
engraving
60 × 209
Sheffield R357

79

Modern Painters IV (1856) 2nd edn.
London: Smith, Elder & Co, 1868
Sheffield R3622

Cat.79 is open to show Pl.47 'The Quarries of Carrara', engraved by J. H. Le Keux after Ruskin. The original drawing must have been done in 1846, as the previous year Ruskin's eagerness to get to Lucca had prevented him from stopping long in Carrara. Hobbs's diary for 1846, on the other hand, records that Ruskin spent an afternoon drawing at the quarries. The plate illustrates a passage on the 'facts' of the aqueous erosion of hillsides, recognised by Turner 'in the boldest opposition to the principles of rock drawing of the time', and before him by Masaccio alone: the reader is referred to the landscape background of the *Tribute Money* in Santa Maria del Carmine, Florence, which Ruskin had had engraved in *Modern Painters* III *(cat.78)* from a drawing of his own (probably made in 1845). The exceptionally soft contours of Masaccio's landscape, Ruskin pointed out, were typical of the limestone hills of Florence, but having no memorandum of those hills to hand, he had made use of a drawing showing the same limestone structure, made 'at a spot which has, I think, the best right to be given as an example of the Italian hills, the head of the valley of Carrara' (VI, 362-3).

1850-70: Pupils and Protégés

Ruskin would not return to Tuscany for twenty-four years. In this period his work was elsewhere, chiefly in England. The 1850s and 1860s saw him attempting to exercise a more direct influence on the practice of contemporary artists and on the taste of their prospective patrons, as also in the field of industrial design. They were the years in which he began his career not only as a public lecturer, to the considerable chagrin of his father, but also as a professional teacher of art, at the Working Men's College in London, founded in 1854 by the Christian Socialist F. D. Maurice. His essentially moral conception of art and sense of its place in the life of the nation led to the direct consideration of political, social and economic questions, discussed in polemical works such as *The Political Economy of Art* (1857) and *Unto this Last* (1860).

There were tours to Italy, but exclusively to the North and chiefly to Venice, where Ruskin spent the winters of 1849 and 1851 in work for *Stones of Venice*, returning in 1862, with Edward Burne-Jones and his wife and baby as his guests, and again in 1869, when work for the Arundel Society took him to Verona. In 1858 he also spent six weeks studying Veronese in Turin. The long absence from Tuscany was not entirely intentional, however, and on one occasion at least a trip to Florence was definitely planned. In March of 1863, Ruskin wrote to Burne-Jones from Geneva, proposing to take him to Italy again the following year, and suggesting they might go on this time to Florence: 'and we would have such games – up at Fesole and in the sweet convent gardens, and wouldn't we draw!' (ALS, Burne-Jones Papers XII 7, Fitzwilliam Museum Library, Cambridge). However, the death of his father on 3 March 1864 prevented Ruskin from travelling that summer.

Though unable, or not caring, to renew it by direct study, in his writings Ruskin continued to draw on the knowledge of Tuscan art acquired in 1845-6. From *The Seven Lamps of Architecture* on – where Pisan Romanesque is listed as one of four possible sources for a modern national style – medieval Tuscan art and architecture is cited as a standard, often (and inevitably) not a purely artistic one. In a lecture on modern manufacture and design, for instance, delivered at Bradford in 1859, a Pre-Raphaelite vision of medieval Pisa is opposed to the squalor of suburban Rochdale to make the point, repeated over and over again in these years, that 'Beautiful art can only be produced by people who have beautiful things about them' (XVI, 338). Again, as we shall see *(cat.187)*, in one of the lectures on *The Political Economy of Art*, Ambrogio Lorenzetti's *Allegory of Good Government* at Siena was described at length to illustrate directly 'the principles of Good Civic Government' (XVI, 54).

And though physically absent from Tuscany, Ruskin enjoyed a sort of vicarious presence there in the work of two artists closely associated with him. Though Ruskin proved unable to take Burne-Jones to Tuscany in 1864, his protégé cannot have been unmindful of him on his first visit there in 1859, when he was already versed in Ruskin's writings and a close friend of three years' standing *(see cat.80)*. Moreover, Ruskin may have been directly responsible for the choice of Tuscany as a home for John Wharlton Bunney from 1863. Bunney had been his pupil at the Working Men's College and had already carried out commissions for Ruskin in Switzerland in 1859 and 1860. In 1863 Ruskin was living at Mornex in Switzerland and it was after a stay with him there that Bunney and his newly wedded wife travelled south to Florence, where they lived until 1870. During this period Bunney continued to draw for Ruskin, both in Florence and Lucca *(cats 84, 85, 86, 121)*, as he would later in Verona and Venice.

It is not possible to give a full account of Ruskin's life and work in the 1850s and 1860s here, but three events, in addition to that of his father's death, already referred to, need to be mentioned. First, his marriage in 1848 to Euphemia Gray, and its annulment six years later on grounds of impotence. Second, what Ruskin later called the 'Queen of Sheba crash' (XXXV, 497) in Turin in 1858, when Veronese's painting of that subject was instrumental in finally loosing 'the bonds of my old Evangelical faith'. Veronese and the great Venetians, together with Turner, Velasquez, Reynolds and Gainsborough, were revealed as 'heads of a great Wordly Army, worshippers of Worldly visible Truth, against (it seemed then to me), and assuredly distinct from, another sacred army, bearing the Rule of the Catholic Church in the strictest obedience, and headed by Cimabue, Giotto, and Angelico; worshippers not of a worldly and visible Truth, but of a visionary one, which they asserted to be higher; yet under the (as they asserted – supernatural) teaching of the Spirit of Truth, doing less perfect work than their unassisted opposites!' (XXIX, 89). Lastly, in the same year Ruskin first met the ten-year old Irish girl, Rose La Touche *(cat.172)*, the tragedy of his love for whom would dominate his life and thought even after her death in 1875.

84

80 (Colour plate III)
EDWARD BURNE-JONES
Sheet (f.10) from an album of drawings made in Italy in 1859 and 1862
inscribed, right, 'Angelo Gaddi/Santa Croce'
watercolour (blotted), pencil
size of sheets 269 × 333; no cover, sheets originally bound together in one section in the middle by a heavy string
The Syndics of the Fitzwilliam Museum, Cambridge (1084)
PROV: Sir Philip Burne-Jones, Bart, and Mrs Mackail (artist's children); Fitzwilliam, given April 1923

The sheet of drawings exhibited – the upper of which shows a detail from a fresco of *Birth of the Virgin* in Santa Croce, Florence, now attributed to Giovanni da Milano – was evidently made during Burne-Jones's first visit to Italy in the autumn of 1859, as he did not go to Tuscany in 1862. The tour was made in the company of Val Prinsep and Charles

Faulkner and lasted almost two months. Their route took them from Paris to Marseilles, and then by boat to Genoa, from where they travelled to Pisa, Livorno, Florence, Venice and Milan. Val Prinsep recalled that the twenty-seven year old Burne-Jones, always a poor traveller, was 'never completely happy except when visiting churches and seeing pictures, but that his energy in that way was wonderful'. Burne-Jones himself wrote to his future wife from Florence, 'I have been quite well all the time through, and worked tremendously at the pictures, and shall go back quite an educated man' (*Memorials* I, 197).

81

JOHN WHARLTON BUNNEY
Self-portrait with hat
*c.*1870
pencil
275 × 210
S.E.Bunney

81

86

82

J. W. BUNNEY

Florentine sketchbook

180 × 245

M. J. H. Bunney

83 (Colour plate V)

J. W. BUNNEY

View of Florence from south-east

1863-4

watercolour

419 × 698

Private collection

The city is seen from a point to the south-east, probably from the hill of San Miniato. The foremost of the bridges is the 13th-century Ponte alle Grazie, destroyed in the last war, and purged, a year after Bunney made his drawing, of the chapel and houses built on its piers.

84

J. W. BUNNEY

Santa Maria della Rosa, Lucca

1866

inscribed lower right: 'Chapel of Santa Maria della Rosa Lucca Dec 66 – White marble'

pencil

460 × 528

The Visitors of the Ashmolean Museum, Oxford (Ref. 81)

PROV: Ruskin; Oxford 1870-2

85

J. W. BUNNEY

Guinigi Palace, Lucca: windows

1867

inscribed (lower left), 'Window on First floor 2nd in Via San Simone / Palace of the Guinigi Lucca'; (lower centre) '1. Junction of ornament on first floor seen on a level / with the window – / 2 ornament on second floor'; (lower right) 'Window on second floor seen from below on opposite side of street / Palace of the Guinigi Lucca Jany. 67.'

pencil

400 × 522

The Visitors of the Ashmolean Museum, Oxford (Ref. 82)

PROV: Ruskin; Oxford 1870-2

86

J. W. BUNNEY
Guinigi Palace, Lucca: full view
1867
inscribed lower right, 'Palazzo di Paolo
Guinigi in Lucca Jany. 7th 67 –'
pencil
402 × 518
*The Visitors of the Ashmolean Museum,
Oxford (Ref. 83)*
PROV: Ruskin; Oxford 1870-2

In the autumn of 1866 Ruskin wrote to
Bunney in Florence expressing his concern
that his former pupil was 'getting so wrong
by being out of England that I felt quite
undecided whether to ask you to come
home and work here, or to try to put you
right in Italy'. Having decided on the
latter, he advised Bunney to limit himself
for the moment to pure outline, with only
a little light shading. With this end in
mind, he asked him to go to Lucca, 'and
look there for a little chapel, if not pulled
down, somewhere near the south ramparts
– very diminutive and make me a drawing
of it' (TS of letter dated '11th November,
1866', private collection). This was the
chapel of Santa Maria della Rosa, built in
1309 to house a miraculous image of the
Virgin: one winter towards the middle of
the previous century a dumb boy had
regained the faculty of speech after
picking a rose found growing near the
neglected shrine which originally held the
image. The chapel was enlarged to its
present size in 1333.

In the same letter Ruskin also asked for
'careful' drawings of 'the windows of the
great brick palace there … in the middle
of the town. And another of the view of it
down the street … The tower used to have
bushes at top, but I suppose its
whitewashed by this time, but please go &
tell me.' The palace was that built by the
Guinigi family in the 14th century and
then used, according to Murray's guide, as
a 'dépôt de mendicité', or hospice for the
poor (Ruskin himself in a letter of 1845
speaks of its being turned into 'shops and
warehouses' [*RI*, 52]). By 13 February
Ruskin had received Bunney's drawings

and wrote to thank him: 'I am entirely
delighted with these drawings. They are
exactly what I wanted and exquisitely
careful, and laboriously faithful and
successfully laborious. You must be in
"splendid health" to be able to do
anything like them.' Ruskin also
encouraged him to go on with similar
drawings 'wherever you can find buildings
of this kind', suggesting he might find such
in the 'old towns between Florence and
Siena', Volterra for example (TS of letter
dated 'Denmark Hill / 13th Febry, 1867',
private collection).

It was typical of Ruskin to turn the
work asked of his copyists to as many uses
as possible. In this case, the drawings
served partly to restore Bunney's
weakened sense of line, but also to record
buildings which Ruskin sensed to be under
threat of destruction, whether through
neglect or restoration. The drawings were
placed in the Reference Series at Oxford,
and their documentary value underlined
in the 1872 catalogue, which announces
the destruction in that year of both Santa
Maria della Rosa ('by plastering up its
arches') and the Guinigi Palace ('by
scraping over all its bricks') (XXI, 33).

In his review of Lord Lindsay's *History
of Christian Art* of 1847, Ruskin referred
to the Guinigi Palace as an example of the
noble 'simplicity and power' of Italian
domestic Gothic. In 1871, in a lecture on
sculpture given at Oxford, the chapel of
Santa Maria della Rosa, Santa Maria della
Spina at Pisa, Santa Maria dei Miracoli at
Venice and the Parthenon were cited for
their exemplary smallness of scale: 'the
best buildings I know are thus modest;
and some of the best are minute jewel
cases for sweet sculpture' (XX, 304).

By the date of the commission, the
chapel would have acquired private
significance for Ruskin by association with
the name of Rose La Touche. In 1866 the
relationship was undergoing a grave crisis.
Ruskin's proposal of marriage had been
refused in February, and all
communication between the two forbidden
by Rose's parents shortly afterwards.

1870: School of Clay

Ruskin learned of his appointment as first Slade Professor of Fine Art at Oxford while in Verona in August 1869. He did not hesitate to accept the offer. To his mother he wrote, 'I hope – quietly and patiently, to be of very wide use in this position. I am but *just ripe* for it. I should have committed myself – in some way – had I got it sooner. But now it will enable me to obtain attention, and attention is all I want to enable me to say what is entirely useful instead of what is merely pretty or entertaining' (XIX, lviii-lix).

Ruskin's first course of lectures, afterwards published as *Lectures on Art*, were delivered in the early part of the following year. The course ended in March, but Ruskin stayed in Oxford to arrange and catalogue a preliminary 'series of examples' for his students. The tour taken shortly afterwards was intended as a rest from a strenuous first term, and was planned partly with a view to giving his friend Mrs John Hilliard, wife of the Rector of Cowley, Oxford, the chance to see Italy. Mrs Hilliard's daughter, Mary Constance ('Connie'), and Joan Agnew, Ruskin's cousin, now resident with Ruskin and his mother at Denmark Hill, were also to come, as was Ruskin's gardener, Downs, so that *he* might be shown the barren Alpine valleys which his master dreamed of reclaiming by proper irrigation. The group was completed by Frederick Crawley, Ruskin's valet, and the 'perennial parlour-maid', Lucy Tovey.

The party left London by train on 26 April, and was abroad for three months. After two weeks in France and Switzerland, they reached Italy on 17 May and were soon in Milan, where for some began the round of sight-seeing, walks and drives duly chronicled in Joan's diary (now in the Pierpont Morgan Library, New York [MA 3451]). The ample space also devoted in this to descriptions of 'beautifully furnished' hotel suites, carriages and liveried coachmen endorses Ruskin's comment in a note to the final chapter of *Praeterita* regarding the 'luxurious hotel life' imposed on him by the company of the Hilliards and Joan on this and the following tour, a life-style which he complains was 'practically answerable' for his having never completed 'the historic study begun in Val d'Arno' (XXXV, 562).

Ruskin himself kept only a minimal diary on this tour. He initially planned to write it in his letters to his mother, just as in 1845 he had in letters to both his parents. But first the job of revising his lectures for publication, then new work prevented this. 'Now that I am a "professor"', he wrote to his mother from Milan, 'I have so much to notice and set down every moment of my day in Italy, that you must bear with short letters' (ALS, Bem.B.VI, 293).

From Milan the party made their way via Verona to Venice, where they stayed almost three weeks. Ruskin dedicated himself to the study of Carpaccio – drawing the lizard carrying his signature in the *Funeral of St Jerome* for his 'Oxford zoological class' – but above all of Tintoretto, at whose power, so he told his mother, he was 'sick with wonder and fear' (ALS, Bem.B.VI, 309). By the middle of June he had decided to give his five autumn lectures on one painting alone, Tintoretto's *Paradiso* in the Ducal Palace, and was dictating to Joan in front of the picture. He could not now think of returning so soon as he had intended, and planned to see his party to Switzerland, where he needed to draw 'some rocks for Oxford', and then remain 'within reach of Venice' to work on his lectures (ALS, Bem.B.VI, 315). But on 20 June he was still unwilling to commit himself to any definite programme, telling his mother, 'I leave Venice on Saturday for Padua, but cannot determine anything of going or staying, except from day to day ... It's of no use planning' (ALS, Bem.B.VI, 320). At Padua were Giotto's frescoes, which, for relief from Tintoretto, Ruskin had gone to see earlier in the month. That visit possibly started him thinking that the large claims he wished to make for the Venetian in his coming lectures required endorsing by specific comparison with the earlier Italian schools. Ruskin's unwillingness to commit himself to any definite plan after Padua may have been due to the sense that what was really needed was not simply the examination of Giotto's works there, but a thorough review of the whole Florentine school, such as could only be made in Florence itself.

This was the decision he came to quite suddenly on the very day he wrote to his mother, 'It's of no use planning'. 'At last I have determined what to do', he informed her, '– I am going to run to Florence for a week, and then come quietly home and write my lectures at home when everybody is out of town ... it is essential for me to see the Angelicos and Ghirlandaios at Florence before I give my autumn lectures' (ALS, Bem.B.VI, 321). Ruskin had probably been influenced in this decision by an earlier invitation from Norton, then living in Siena. He had initially replied that he would come to Siena alone, after Switzerland. He now wrote again saying that he was to come straightaway, bringing with him the Hilliards and Joan. He warned his host, however, that he could not stay more than three days: 'I *must* be three days in Florence for my own work – I shall take those at once, at the Grande Bretagne before coming to you' (CRN, 195). The next morning Ruskin and his party were already in Florence.

The three days Ruskin had reserved for his own work in the city were spent re-visiting the galleries and churches, often in the company of his friends, and in discussions with

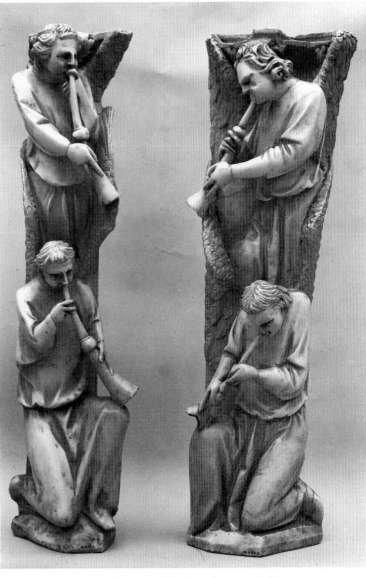

Marble pilaster with the symbols of the evangelists Matthew, Mark and Luke, probably from the parapet of the pulpit carved by Giovanni Pisano and assistants for the Duomo of Pisa *(see cats 96-8)*

Two marble pilasters with angels of the Apocalypse, probably from the parapet of the pulpit carved by Giovanni Pisano and assistants for the Duomo of Pisa *(see cats 96-8)*

Norton, who joined them on 22 June. In the evenings they would all drive out on to the hills, to Fiesole or the Certosa. On his first day in the city Ruskin felt he had already seen enough to make him sure of what he had to say concerning the Florentine school in his lectures. However, the galleries reserved a surprise in the shape of a painter whom he had previously held in little regard, Filippo Lippi. In 1845, he had noted with approval that Rio rejoiced in the perishing of the school of the two Lippi, father and son, and Botticelli,

also remarking on the excessive sadness of expression and haggard features which all these painters habitually gave their figures. Now Lippi was hailed as 'a new master of the religious schools in Florence ... being', as he later explained to another friend, Mrs Cowper-Temple, 'a complete monk, yet an entirely noble painter. Luini is lovely, but not monkish. Lippi is an Angelico with Luini's strength, or perhaps more, only of earlier date, and with less knowledge' (xx, lii). The discovery was announced immediately to his

mother, to whom he wrote on 25 June, 'Yesterday on St John's day I saw a picture of the religious schools by a man whom I never before had much looked at, which is as much beyond all other religious painting as Tintoret is above all secular painting – curiously enough, St John Baptist is also the principal figure in it, and I am really beginning, for the first time in my life, to be glad my name is John' (xx, lii). The previous day the party had visited the Accademia, so the picture may have been Lippi's *Coronation of the Virgin (see cats 233, 234)*, in which the Baptist, if not exactly the principal figure, is prominent. But also at the Accademia were four panels from a polyptych by Lippi representing St John the Baptist, St Anthony Abbot, the Virgin Mary and the archangel Gabriel. Ruskin would copy the head of Gabriel *(cat.95)* after returning from Siena, and Norton, associating himself no doubt with Ruskin's discovery, meantime regaled the other members of the party with photographs of the angel.

They travelled to Siena on the evening of 24 June, arriving after dark amid a flashing of sheet-lightning and shining of fire-flies recalled twenty-five years later in *Praeterita*. The three days of 'cloudless and pure' weather spent with the Nortons were passed in walks through the town, which Ruskin had not seen since 1840, and in the surrounding countryside. In the Duomo Ruskin sketched the lioness and her cubs supporting a pillar of Nicola Pisano's pulpit (ill. here), suggesting that his thoughts were beginning to turn to sculpture, although it was only well after his return to England that he decided to devote his autumn lectures to this art, rather than painting. Nor was this the only direction in which his interests were expanding. Back in Florence, while copying Lippi's archangel and making notes towards his lectures (now to include a talk on Lippi himself), Ruskin was also thinking ahead, and planning a lecture on the Baptistery for the following year (ALS, Bem.B.VI, 328). Further evidence of a fresh concern with Florentine architecture is the fact that among the photographs which, after his return to England, Ruskin asked Norton to obtain for him, was one of the south-east door of the Duomo, the original crockets from whose restored gable he even expressed an interest in buying (*CRN*, 207). This visit to Florence may also have led Ruskin to commission Bunney to draw a portion of the exterior of the Duomo *(cat.121)*.

On 30 June the party started for Pisa, stopping at Lucca to see 'Coz's favourite tomb of Ilaria de Carretto with the little dog resting on the drapery'. San Michele, and 'many other churches', 'especially Santa Maria della Rosa' (Morgan MA 3451, 109-10). In Pisa they were again joined by Norton and in addition to the usual sights visited the

John Ruskin, Lioness and cubs from the base of Nicola Pisano's pulpit in the Duomo of Siena, 1870, pencil, pen and wash

11th-century church of San Piero a Grado five kilometres outside of the city towards the sea. Ruskin wrote to his mother, 'I have had two good days at Lucca and here – many things left still as they used to be, especially at Lucca. and all are so lovely that are left. – I am glad I have come. Sta Maria della Spina is still uninjured – a little older – only, as I am – But the Campo Santo and Angelico are not to me what they were' (ALS, Bem.B.VI, 331).

After Pisa, the party left for Pistoia, from where Norton and Ruskin visited Prato to see the frescoes in the Duomo by Filippo Lippi. They were now on their way home, and looking back on the last few weeks Ruskin wrote to his mother, 'It is fortunate that I made this excursion south … I have learned infinite things. – of which the best is, that my notion of Tintoret was too low instead of too high – the Florentine school being more inferior than I believed' (ALS, Bem.B.VI, 333).

As he travelled north, Ruskin felt more and more that he was leaving Italy before he should. He promised himself and Norton, however, to return to Siena later in the summer, to finish his drawings of the lioness and cubs, with which he was dissatisfied. But the plan was put aside when in early September Ruskin finally decided to lecture that autumn on 'the elements of sculpture' as illustrated by Greek coins. He excused himself with Norton saying, 'Had I come back to Italy – I might never have taken up my broken Greek work again – whereas this has thrown me back on it, making not only my past labour of service, but laying a more formal foundation for all' (*CRN*, 208). In the event, the 'Greek work' of *Aratra Pentelici* was also to provide the foundation for a re-examination of Tuscan art.

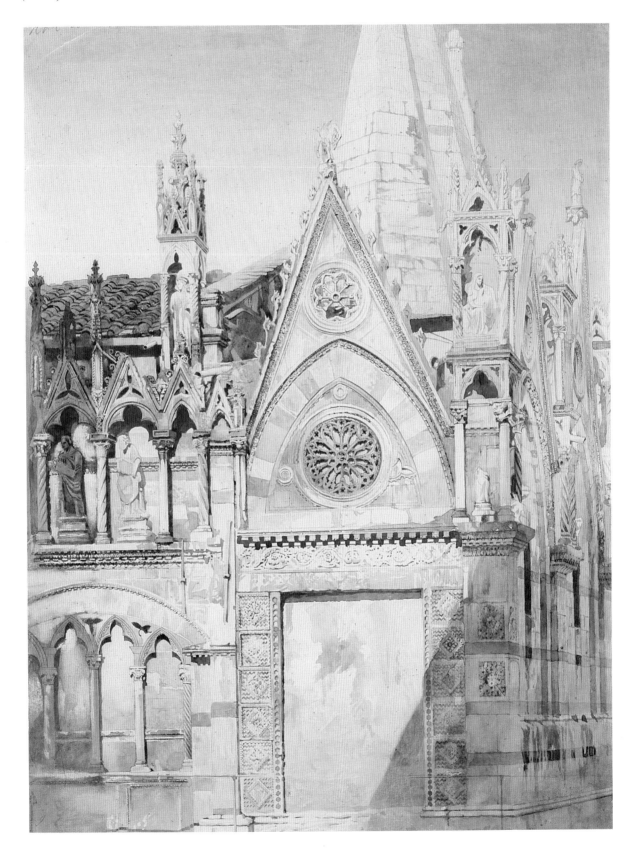

PLATE II
John Ruskin, after Fra Bartolomeo
St Mary Magdalene, notebook used in Italy in 1845 *(cat.20)*

E. Burne-Jones

Two studies from an album of drawings made in Italy in
1859 and 1862 *(cat.80)*

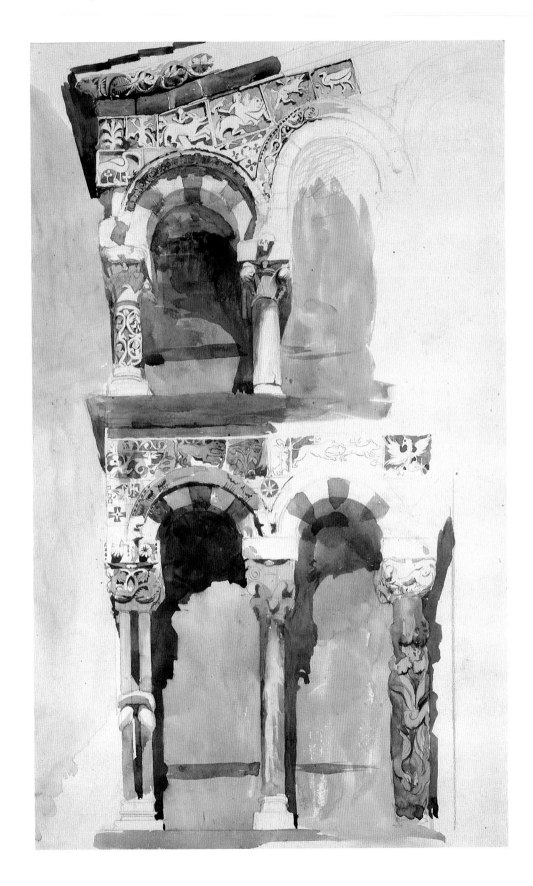

PLATE V
J. W. Bunney
View of Florence from south-east 1863-4 *(cat.83)*

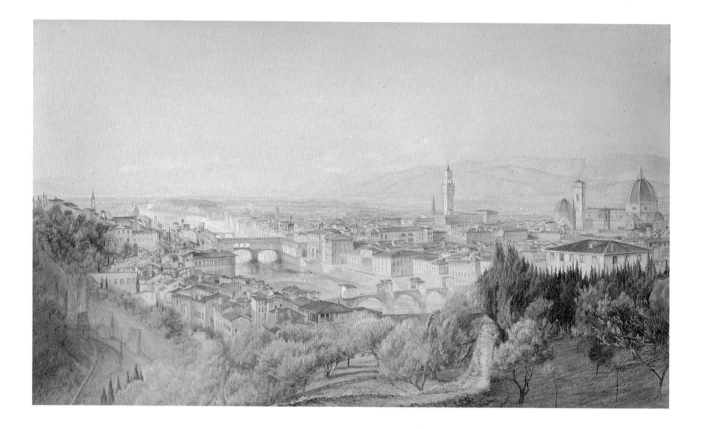

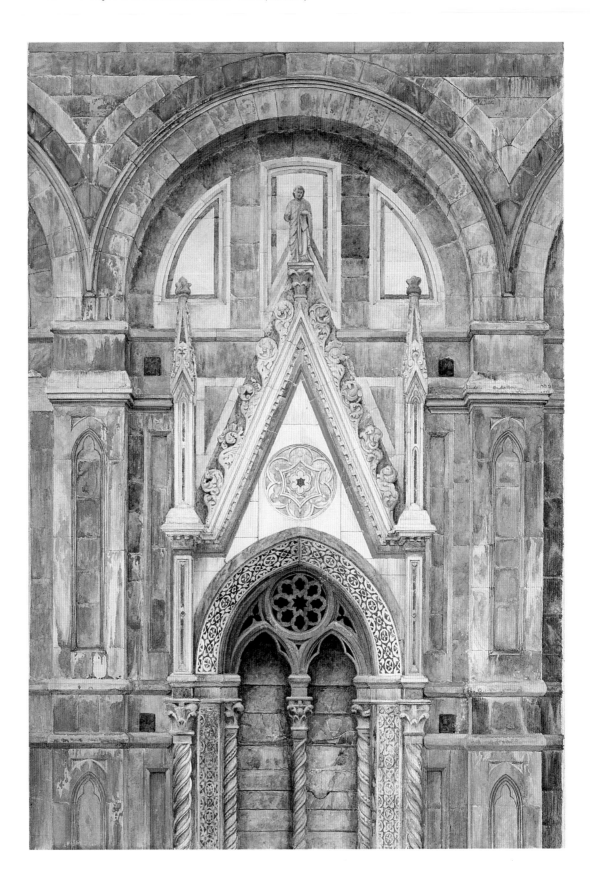

VII

VIII

PLATE X
John Ruskin
View of Pisa from outside the walls 1874
(cat.180)

PLATE XI
John Ruskin
'A vineyard walk : lower stone-work of
tower, 12th cent.' 1874 *(cat.181)*

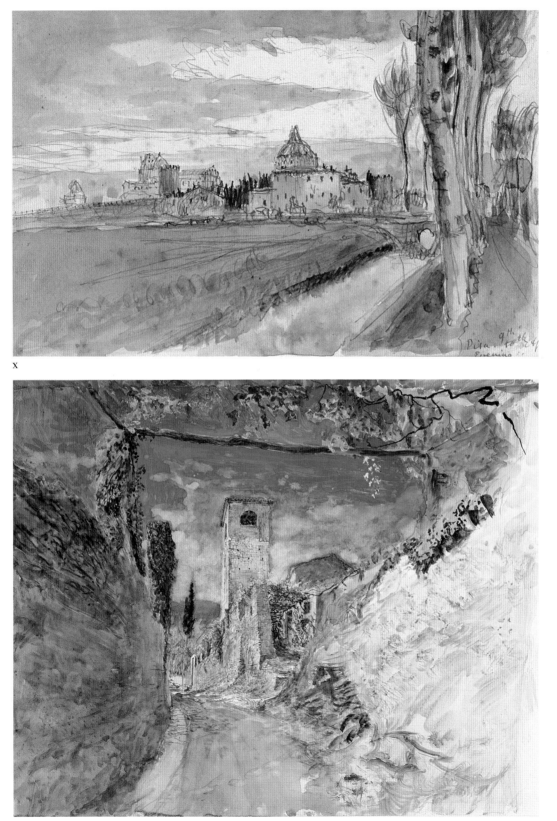

X

XI

87

Lectures on Art
Oxford: Clarendon Press, 1870
Sheffield R0786
PROV: Albert Fleming

88

Aratra Pentelici (Works series Vol.III)
London: Smith, Elder & Co, 1872
full blue calf
Bem.3.4

89

The Eagle's Nest (Works series Vol.IV)
London: Smith, Elder & Co, 1872
full blue calf
Bem.3.4

90

MS of 1st page of Lect.V, The Eagle's
Nest
Bem. MS 56A

91

Modern Painters Vol.V
London: Smith, Elder & Co, 1860
pale green cloth boards
open to show frontispiece, 'Ancilla
Domini'
Sheffield R3623
PROV: F.G.S. de Wesselow

92, 93

*Two sketches of a Greek terra-cotta of a
girl dancing*
1870
a. inscribed, in pencil, top right,
'[illegible]/Couch shell. Trumpet.'
pencil, bodycolour
258 × 176 (sheet)
b. pencil, bodycolour and wash
258 × 176 (sheet)
*The Visitors of the Ashmolean Museum,
Oxford (Rud. 52a, b)*
LIT: XXXVIII, 255 (808, 809)
(facsimile photographs)

In *cat.91* we find Ruskin typically re-
using earlier material, engraving his
Angelico drawing of fifteen years before
(cat.37). But by 1860 his earlier
enthusiasm for Angelico had already
waned. In looking back now on the tour of
1845, and the volume which came out of
it, *Modern Painters* II, Ruskin felt that his
reaction from the northern art of Rubens
and Rembrandt in favour of early Italian

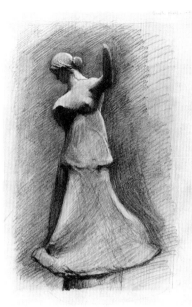

92

93

'Christian' art had been too strong. In
Modern Painters V that art was placed in
a new perspective. It erred, he now
thought, 'by pride in its denial of the
animal nature of man; – and in
connection with all monkish and fanatical
forms of religion, by looking always to
another world instead of this. It wasted its
strength in visions, and was therefore
swept away, notwithstanding all its good

and glory, by the strong truth of the
naturalist art of the sixteenth century'.
However, naturalist art had itself erred 'on
the other side; denied at last the spiritual
nature of man, and perished in
corruption'. Ruskin now considered the
art of Fra Angelico 'weak', but in
comparison with the 17th-century Dutch
painter Jan Wouverman, Angelico figures
as 'the entirely spiritual mind, wholly
versed in the heavenly world, and
incapable of conceiving any wickedness or
vileness whatsoever', as against the
'entirely carnal mind, – wholly versed in
the material world, and incapable of
conceiving any goodness or greatness
whatsoever'. So far, equals, then. But,
adds Ruskin, if we must err, let it be on
the side of Angelico, whose beatific
seclusion from the world in no way
implicated him in 'selfish and mindless
activity' (VII, 371-3).

Ten years later the same dichotomy was
again illustrated by means of the visionary
art of Fra Angelico, opposed this time to
naturalistic Greek sculpture. In a lecture
intended to be given at Oxford in 1870 or
1871 on the relation between Greek and
Christian art, Ruskin was to exhibit two
sketches of a terra-cotta of a girl dancing
(cats 92, 93) to illustrate Greek
indifference to the face. 'The artist's entire
purpose in the drapery is to show either
the beauty of the body itself, or its action.
He has no thought of the girl's mind at all;
she is merely a buoyant human creature,
entirely innocent, but entirely vacant. The
face is so slightly indicated in the terra-
cotta itself that in my drawing, coming in
the shadow, I left it out altogether. If I
could get the shoulders and drapery right
you wouldn't miss it; in the real statue you
never look for it.' Christian artists, on the
other hand, lavished attention on the face.
Angelico's Madonna at Perugia, for
example, 'is nothing but a charming piece
of drapery on a stick, with a thoughtful
face upon the top of it. A thoughtful face,
not a pretty one. It is just because it
ventures to be not so pretty as the Greek
one at first, that it is better, and capable
of higher beauty at last' (XX, 408).

In the *Lectures on Landscape* given in
the spring of 1871, the Greek dancing-girl
was set beside a Madonna and Child of
Filippo Lippi's to illustrate the difference

94

95

Accademia at Florence from a panel now in the Uffizi, was given his students at Oxford as a 'standard type' of Christian humility. But in a note on the drawing in the catalogue to the Educational Series this same character of humility, 'which the Gothic designers always give to the Messengers of Heaven' (XX, 357), is traced in part to the treatment of the hair, itself derived from an 'archaic Greek type of head-dress'. The hair on the top of the head, Ruskin pointed out, 'is always smoothed into braids, of which every line is definite, by early Greek workmen, by Lippi, and Angelico; on the contrary, the sensational and dramatic schools throw the hair wildly loose; as you may see in the photographs from Michael Angelo in the larger room' (XXI, 126). The 'Siren Ligeia' is an instance of the early Greek hair-style.

between what Ruskin called the Schools of Clay and Crystal: 'Greek motion against Gothic absolute quietness; Greek indifference – dancing careless – against Gothic passion, the mother's – what word can I use except phrenzy of love; Greek fleshliness against hungry wasting of the self-forgetful body; Greek softness of diffused shadow and ductile curve, against Gothic sharpness of crystalline colour and acuteness of angle, and Greek simplicity and human veracity against Gothic redundance of irrational vision' (XXII, 50-1).

The original statuette, from Cyrenaica, is in the British Museum (GR 1856, 10-1.44, C 808), which acquired it in 1856, so Ruskin evidently copied it there. It is 20 cm in height and dates from about 200 BC.

94
Electrotype of coin from Terina, c.450BC, showing 'Siren Ligeia' (Nikè)
Sheffield

95
after Filippo Lippi
Head of Archangel Gabriel
1870
grey-blue wash and white bodycolour over pencil on grey-blue paper
213 × 155
The Visitors of the Ashmolean Museum, Oxford (Ed.100)
LIT: XXXVIII, 263 (1023)

The relation between Greek and Gothic art was not simple. While the newly-discovered Lippi might be chosen, as we saw in the previous entry, to represent Gothic passion against Greek quiet and distinterest in personal character (further

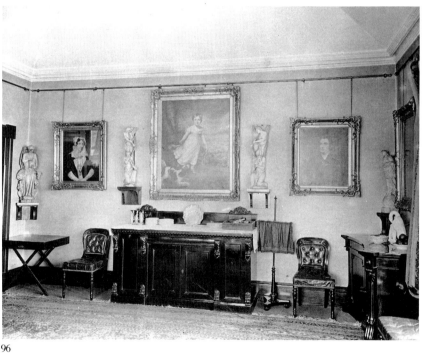

96

exemplified in the head on the coin from Terina *[cat.94]* which Ruskin called the 'Siren Ligeia', shown during the lecture on the 'School of Athens'), the same painter might also illustrate the direct descent of 'the great religious masters' from Greek art. This head of the archangel Gabriel *(cat.95)*, drawn by Ruskin in the

96
WALMSLEY BROS, AMBLESIDE
Photograph of the dining-room, Brantwood
c.1900
Bem.

97

ANON

*Photograph of Northcote's portrait of
Ruskin with Pisan sculpture in the
dining-room, Brantwood*
c.1900
Bem.

98

*Autograph letter to E.Burne-Jones 25/26
February 1873*
*The Syndics of the Fitzwilliam Museum,
Cambridge (Burne-Jones Papers, X.24)*

Cat.96 documents one of Ruskin's most
important purchases as a collector of
Tuscan art. The three sculptures to the left
of the photograph were among a number
of works bought for him in the early 1870s
in Tuscany by Charles Eliot Norton. All of
Carrara marble, they include two pilasters
carved to represent angels blowing
trumpets, and a group composed of the
symbols of three evangelists: angel (St
Matthew), lion (St Mark) and ox (St Luke)
(see ills p.63). Norton first told Ruskin the
pieces were available towards the close of
1870. Ruskin replied that he had nowhere
to put them, but Norton urged him to
reconsider, giving a detailed description of
the three sculptures, with measurements.
Norton apparently believed them to be by
Nicola Pisano: 'They show perfectly', he
wrote, 'not only the technical style of the
school, but the characteristic effort of
Niccolo towards truth to nature in his
rendering. They are full of touches of
genuine realism.' Their then owner, not
mentioned by name, had bought them a
few years earlier at an auction 'in one of
the old palazzi' in Florence, for 4500
francs, and Norton believed he would now
part with them for '4000 francs, perhaps
for £50' (*CRN*, 216). Ruskin later told
Burne-Jones *(cat.98)* that the carvings
were said to come from the font once at the
centre of the Florence Baptistery, but
dismantled in 1577. Its memory was
romantically associated with Dante, who
in the *Inferno* (xix. 17) tells how he saved
a child from drowning in it and in the
process accidentally broke off a piece of its
carving.

Ruskin promised to think the matter
over, but there is no further mention of the
sculptures in the extant correspondence
until December 1872, when he relented

98

and decided 'I'd better have all those
marbles' (*CRN*, 267). One reason for his
change of mind may have been the recent
purchase of Brantwood, of which, as he
wrote to Norton he wished 'to make more
a perfect home' (*CRN*, 276). They were
first placed in Ruskin's study at
Brantwood (a sketch in a letter written to

Norton soon after they arrived shows them
supporting its cross-beam), and only later
in the dining-room (*CRN*, 283).

The marbles were still at Brantwood in
1904, but were probably sold soon
afterwards, as in 1911 the two angel
pilasters were bought by the Metropolitan
Museum of Art, New York from another

collector, R. Langton Douglas. The third piece may well have been acquired by Douglas together with the others, as it was again from him that the Metropolitan purchased it in 1921. All three sculptures are still at the Metropolitan. It is now generally accepted that they were once part of the pulpit carved by Giovanni Pisano and assistants for the Duomo of Pisa between 1302 and 1311. This pulpit was dismantled around 1600 and was not 're-assembled' until 1926, by which time, however, not all the original components could be recovered. The evangelist group would have formed part of the traditional tetramorph, surmounted by the eagle-lectern, symbol of St John. The angels with trumpets, on the other hand, are the angels of the Apocalypse, and were probably positioned either side of the panels representing the Last Judgement. Of the pieces that had remained in Pisa, Ruskin had drawn one in 1870 in the Camposanto: the head of one of the eagles from the pulpit's base.

Cat.96 features two other statues, both of relevance here. The first, in the right-hand corner of the room, was given to Ruskin by Norton in 1871. It is Greek and represents Fortune standing on a globe. Found during the excavation of a Temple of Neptune on Corfu earlier in the century, it was sold to Norton in Florence by the daughter of an ex-Lord High Commissioner of the Ionian Islands, Sir Frederick Adam. Ruskin was delighted with this Fortune ('She is enough to change mine for life – the Greek darling' [*CRN*, 229]) and especially by the discovery that the globe was composed of interlocking incised hexagons, 'not chaotic under Fortune's feet; Greek this, and by a trained workman' (xx, 327).

On the sideboard to the right is a statue of a pelican feeding its young, symbol of Christ as Redeemer. It was given to Ruskin by Francesca Alexander and her mother when he first met them in Florence in 1882 (see p.120). He reported the gift in a letter to Joan Severn, using the baby-talk he often resorted to in letters to his cousin: 'And what does oo tink – di ma. – the kind peepies gave me ... the marble pelican that used to be over the altar at Orvieto – its a little pelly-welly about a foot high – and little under in the wings – and three

101

little-little-little pelly wellies being fed, oo know – di ma – and there's the ruffled place in the plumes, – and its all so booty – Giovanni Pisanos I suppose – anyhow a master's work' (ALS, dated '11th Oct. 1882', Bem. L 39). The pelican was also bought by Douglas at the Sotheby's sale 8 May 1931.

99

ANON
Photograph of pulpit, Duomo, Siena
*c.*1870
172 × 194
The Visitors of the Ashmolean Museum, Oxford (Ed.151)
(facsimile photograph)

100

ANON
Photograph of base of pulpit, Duomo, Siena
*c.*1870
191 × 257
The Visitors of the Ashmolean Museum, Oxford (Ed.152)
(facsimile photograph)

101

ANON
Photograph of lion eating horse from base of pulpit, Duomo, Siena
*c.*1870
545 × 460 (sheet)
*c.*470 × 370 (image)

The Visitors of the Ashmolean Museum, Oxford (Ref.72)
(facsimile photograph)

102

Lion eating horse from base of pulpit, Duomo, Siena
1870
watercolour, white, pencil
630 × 445
Bem. Add. L 34

In the second of his Oxford lectures on sculpture, *Aratra Pentelici*, given in November and December of 1870, Ruskin explained his choice of Nicola Pisano's pulpit in the Duomo of Siena (1266-8) 'as a type of original Italian sculpture' for insertion in the Educational Series of examples he was compiling for his students' use. The Pisa pulpit by Nicola's son Giovanni would have been preferable, but had been dismantled, and the casts of fragments currently on show at the South Kensington (later the Victoria and Albert) Museum were unsatisfactory (xx, 234). Ruskin illustrated Nicola's pulpit by two of the photographs shown here (*cats 99, 100*) and three of his own sketches of the lioness and cubs forming the base of one of its pillars (ill. p.64).

Though dissatisfied with his own drawings, when the photographs were forwarded to him by Norton later that summer, Ruskin wrote back, 'Weren't you pleased – when the photograph of the Pisano lions came – to see how pitiful it was, compared even to that rude sketch of mine? – and that we poor draughtsmen are still worth our salt?' (*CRN*, 207). He made the same point in his last lecture on sculpture, 'The School of Florence' (not published in *Aratra*), in which he showed his drawings of the lioness, explaining that he had sketched it 'from the real marble myself, though I photographed it also, and you will see, which will be a lesson to you in other respects, that there is an advantage in drawing over photography in that a draughtsman can seize the delicatest shadow on which expression of form depends, while a photograph is sure to miss these and retain any violent ones which are accidental and inharmonious' (xx, 362).

The lioness herself was to be compared with another of the pulpit's carved

supports, a lion eating a horse. Ruskin had this lion enlarged from his photograph, and made a drawing from this enlargement, perhaps to show at the lecture (cat.102). Lion and lioness beside one another illustrated the meeting at Pisa of Greek and Gothic schools, from which sprang 'the great Tuscan art'. The 'vital, naturalistic and sincere element' native to Greek art came to discipline and domesticate the inhumanities of the northern imagination: 'Nicolo Pisano is taught with the veracity and humanity of Paganism, and the phantom of the Lombard is in his hands to become true, and his cruelty gentle'. If the lion eating a horse was still cruel ('no Greek could have borne to carve the jaws crashing into the horse's skull, exactly through the eye, as the Italian does'), it was balanced by the maternal lioness and with respect to the column-bearing griffins beloved of earlier Lombard Romanesque architects, showed a clear advance in naturalism (xx, 362).

103

Lions flanking the central door, Duomo, Assisi
?1874
inscribed by Ruskin bottom, 'A. This at top'
watercolour and bodycolour over pencil
276 × 370 (sheet)
250 × 283 (image)
The Visitors of the Ashmolean Museum, Oxford (Ref.86a [upper])
EXH: RA 1919, 383.
LIT: XXXVIII, 263 (1028, as lion from Duomo, Lucca)

Ruskin found his characterisation of Lombard sculpture as 'cruel' confirmed when he visited the Duomo of Assisi in 1872. His diary for that year contains notes which relate the sculpture on its façade to the Pisano lion at Siena *(cats 101, 102)*, and re-explore the idea of the birth of 'original Italian sculpture' out of the meeting of North and South, advanced in the lecture on the 'School of Florence' cited above. Against the effeminacy of the debased southern tradition, Ruskin writes, 'comes Northern life quite pure in Duomo of Assisi. The she-wolf on its right-side as savage as can be; – but as living and true as can be'. He

goes on to note the 'immense cruelty in this northern rude life. Griffin eating knight – beginning at the head in Assisi Nicolo Pisano's lion eating horse – beginning at the head' (TS, Bod. MS Eng.Misc.c.226, 81-2). This 'griffin', actually a lion (it has no wings), is on the left of the main door of the Duomo, and is the further of the two lions in the drawing (wrongly catalogued at Oxford as a lion from the façade of the Duomo of Lucca).

In 1874 Ruskin returned to Assisi for a longer visit, principally to supervise the copying of Giotto's frescoes for the Arundel Society, but he was also able to study the Duomo. A list of drawings made at Assisi which he sent his cousin Joan includes '(8) my old pet griffin, better done, and (9) the other griffin on the other side of him' (XXIII, xliv). If the 'pet griffin' is the one eating the knight, then the present drawing is probably no.9 on Ruskin's list.

The drawing may have been shown in the first of the lectures on the *Aesthetic and Mathematic Schools of Art in Florence*, held in the autumn of 1874 after Ruskin's return from Italy. In reference to his previous characterisation of Lombard art as essentially cruel, Ruskin here made a distinction between Norman and Lombard savagery: 'I do not say, observe, that cruelty is the special sign of the Lombard race; still less that this sculpture I show you can be traced to Lombard chisels. It is twelfth-century architecture, and all I can tell you of it is, that it was built by the first Bishop of Assisi in that century. But it is, no less definitely than this other, characteristic of an entirely different race of sculptors, one which in default of better evidence and the name you may call Lombard ... It is distinguished, on the one side, from all Norman sculpture by absolute incapacity to draw a beautiful or dignified human form, and by a perfectly insane delight in facts of cruelty and pain; while, on the other side, it is distinguished from all Greek and Arabian sculpture by a fire, spirit, splendour of sharp chiselling, and ingenuity of architectural construction unrivalled before or since in Northern work' (XXIII, 188).

104

Lion waterspout from the Fonte Branda, Siena
1870
inscribed, 'You know where this is! Keep it for yourself JR 1879'
watercolour, pencil, pen and bodycolour
282 × 360
Bem.1359
PROV: Norton 1879; Whitehouse.
EXH: RA 1919, 331.
LIT: Whitehouse, 82; Harris, 4-5

The drawing was recently identified by Anthony Harris as the waterspout on the extreme right of the Fonte Branda, one of the oldest of the fountains of Siena. Mentioned in documents as early as 1081, it acquired its present form in the mid-13th century. In the famous fire-fly passage with which *Praeterita* comes to an end, Ruskin recalls seeing the Fonte Branda for the last time with Norton, so this drawing was probably made in 1870, when they were last in Siena together. Since Norton was in fact the addressee of the inscription (Whitehouse, 82), the drawing was probably sent with others Ruskin selected for an exhibition of his work which his friend organised in Boston and New York in 1879.

105

Head of living lion
1870
pencil
162 × 198
The Visitors of the Ashmolean Museum, Oxford (Rud.47)
EXH: AC 1983, 182.
LIT: XXXVIII, 263 (1019)

106

ARTHUR BURGESS, after Ruskin
Head of living lion
?1870
black chalk, squared up in pencil
750 × 510
The Visitors of the Ashmolean Museum, Oxford (Ref.75)

107

Lion's profile, from life
1870
inscribed, lower left, 'F. Lower of two'
watercolour and bodycolour over pencil
165 × 161

107

108

109

110

*The Visitors of the Ashmolean Museum,
Oxford (Ed.155)*
EXH: AC 1983, 183.
LIT: XXXVIII, 263 (1016)

Ruskin drew these lions from life at the
Oxford Zoological Gardens in 1870.
Cat.107, originally mounted with an
engraving by J. F. Lewis of a lion and
lioness, was placed in the Elementary
Zoology cabinet of the Educational Series,
while *cat.105* was included among
examples illustrating 'Heraldry' in the
Rudimentary Series. In a catalogue note of
1878 Ruskin wrote of this last drawing, 'A
really good sketch of my own which may
serve to show that I could have done
something if I had not had books to write.
It is to be copied by all advanced students
as an exercise in fast pencil drawing' (XXI,
179). The enlargement of the pencil sketch
by Burgess *(cat.106)* may have been made
to be shown at one of the *Eagle's Nest*
lectures.

108
*Electrotype of Greek coin from Elis
Sheffield*
EXH: AC 1983, 180.
LIT: XXX, 268

109
ANON
*Enlarged photograph of eagle on Greek
coin from Elis*
495 × 345 (cut off at corners)
*The Visitors of the Ashmolean Museum,
Oxford (Rud.50)*
(facsimile photograph)

110
*Eagle from base of Ghiberti's Arte di
Calimala niche, Orsanmichele, Florence*
1870
inscribed (in Joan Severn's hand)
'J. Ruskin'
watercolour, pencil, white on grey-blue
paper
213 × 138
Bem.1238
PROV: A. E. Cropper; Whitehouse.
EXH: AC 1960, 38.
LIT: XXXVIII, 248 (622)

111, 112
Eagle's head (common Golden), from life
(2 drawings)
1870
a. pencil, watercolour wash and
bodycolour
89 × 150
b. watercolour and bodycolour
162 × 195
*The Visitors of the Ashmolean Museum,
Oxford (Ed.165a, b)*
EXH: AC 1954, 37; AC 1983, 179a, b.
LIT: XXXVIII, 248 (618, 619); Penny, 52

Ruskin's chief argument in *The Eagle's
Nest* was that, whether dealing with
organic or inorganic form, 'Art has
nothing to do with structures, causes, or
absolute facts; but only with
appearances', and that 'in representing
these appearances, she is more hindered
than helped by the knowledge of things
that do not externally appear'. As to the
study of organic form, Ruskin insisted
that art concern itself with all living
things, not only man, to 'know them, so as
to be able to name, that is to say, in the
truest distinctive way, to describe them'.
Truth of description lay in thinking of the
creatures 'with their skins on them, and

111

with their souls in them'. Man was to study their peculiar physiognomy, from every possible point of view 'except one, – the Butcher's' (XXII, 322-3). To illustrate the evil of the anatomist's 'flesh and bones' approach to art, Ruskin showed a drawing of the skull of a Golden Eagle, pointing out how little it helped in drawing the living head. Indeed it would prevent the artist from noticing essential features such as the projecting brow: 'All the main work of the eagle's eye ... is in looking down. To keep the sunshine above from teasing it, the eye is put under a triangular penthouse'. No ornithological drawing had ever given the eagle's hooded eye. The same was true of another special trait, the 'entirely fleshy and ringent mouth, bluish pink, with a perpetual grin upon it' (XXII, 229-30). Nor did bird-illustrators convey the specific nature of the eagle's hooked beak as an instrument for *tearing*, as opposed to pecking or biting. For the eagle's true aspect one had to look to Greek and medieval literature and art. Among the examples shown were the enlarged photograph of a Greek coin of Elis *(cat.109)*, and Ruskin's drawing of Giovanni Pisano's eagle from the pulpit of the Duomo of Pisa and of a falcon from a 14th-century missal in the Bodleian Library. Both drawings were placed in the Educational Series alongside Ruskin's own studies of a Golden Eagle from life,

made in the Zoological Gardens *(cats 111, 112)*.

In 1870 Ruskin had planned, but not completed, a lecture entitled *The Eagle of Elis*, in which coins of Elis, all bearing the eagle of Zeus, were to have been compared with the Pisano eagle, and also with an eagle by Ghiberti from the base of the niche carved for the Arte di Calimala or cloth-merchants' guild on the exterior of Orsanmichele, Florence *(cat.110)*. An eagle gripping a bale of cloth was in fact the emblem of the guild. The point here was a historical one: Ruskin was to have shown the different conditions under which Greek and Italian art both satisfied 'the desire to give more life and veracity, even imitative veracity', namely 'the hope or not of immortality'. Whereas this hope exalted 'the development of emotion and imagination' in the Italians 'to its highest reach', its absence left the Greeks in a state of 'eminently prosaic rectitude'. In 'Eagle of Elis', Ruskin's MS notes read, 'show how prosy the Greeks are after all' (XX, 400).

Placed in the Rudimentary Series, the enlarged photograph of the Greek coin *(cat.109)* found a further, practical use. Here it illustrated 'the gradation of surface in fine Greek sculpture', and the student was invited to copy it in charcoal or sepia as a master exercise in chiaroscuro (XXI, 179).

1872: The Labyrinth

The two years between Ruskin's return to Tuscany in 1870 and his next visit were ones marked by sorrow and strain. A chance meeting with Rose La Touche in 1870 (the first in four years), had led to a period of reconciliation and revived Ruskin's hopes of marriage. However, his renewed proposal, supported by legal proof of his freedom to marry, met with embattled opposition from Rose's parents and was in the end harshly rejected by Rose herself. This crisis was undoubtedly an indirect cause of a serious illness – a near-fatal inflammation of the intestine – in the summer of 1871. Another may have been a sense of desertion at the marriage of his cousin Joan: he was on his way to join her and her newly wedded husband, the painter Arthur Severn, in Derbyshire when he fell ill at Matlock. Later that year Ruskin's mother's health began to fail, and in December she died. Her death brought not only added loneliness but domestic upheaval, with the selling of Denmark Hill, the family's home for twenty-five years. Ruskin finally left this the following Easter, distributing its contents between his two new homes, Corpus Christi College, Oxford and Brantwood, the house at Coniston which he had bought the previous autumn.

Meanwhile, work at Oxford had continued: the course on sculpture had been concluded by a lecture on Michelangelo and Tintoretto, fruit in part of the work done in Venice the previous summer. This had provoked considerable scandal by its zealous debasement of Michelangelo, whom Ruskin branded as the 'chief captain in evil' of the 'catastrophe' of early 16th-century Italian art (XXII, 82-3). There followed lectures on landscape, given in the spring of 1871, and, notwithstanding his mother's death, a series on the relation of natural science to art in Lent Term, 1872, to be issued under the title *The Eagle's Nest*. This volume, like *Aratra Pentelici*, appeared in a new series of Ruskin's works, for which in 1871 he also revised *Sesame and Lilies* and *Munera Pulveris*. Another new venture was the publication, from January 1871, of monthly letters addressed 'to the workmen and labourers of Great Britain', to which Ruskin gave the name *Fors Clavigera*. They were printed for him by Smith, Elder & Co, but were to be sold exclusively by his one-time pupil at the Working Men's College, George Allen, soon to become his sole publisher. If one adds to this list of commitments the setting-up of a drawing school at Oxford under a mastership personally endowed by Ruskin, as well as the arrangement of not one but four series of examples for use in the school, it is understandable that by the end of Lent Term, 1872, Ruskin should have written to a correspondent, 'I have been at my wits end with overwork' (TS, Bod. MS Eng.Lett.c.38 268).

Tired and depressed ('The sense of ended life is so complete since that child left me', he had written to Mrs Cowper-Temple a few weeks before [Bod. MS Eng.Lett.c.38 261]), Ruskin left for the Continent in the middle of April. With him again went Mrs Hilliard and her daughter, and Joan, this time with her husband. Another new companion, also a painter, was Albert Goodwin, who had been one of Ruskin's many nurses at Matlock. He and Arthur Severn drew throughout the journey, often under Ruskin's supervision. A sketchbook now in the Pierpont Morgan Library contains drawings by all three, and even some preliminary efforts by Joan, the outlines of two crosses at Lucca and Pisa, elementary exercises of the kind Ruskin was currently describing in a set of instructions for his drawing classes at Oxford.

The party's principal destination was Rome, where Joan was to be presented to her father-in-law, the painter and British consul Joseph Severn. After passing through France and Switzerland, they entered Italy via the usual route: Turin, Genoa and the Ligurian coast. At Sestri, as Arthur Severn recalls in his memoir of Ruskin, the lack of amusements and the dirt of the inn and beach led to 'open mutiny', and Ruskin, full of the beauty of the promontory and the walks it offered, was forced to leave (Dearden, 53-4). This was probably not the last time such clashes of interest occurred. After stopping at La Spezia, where Ruskin had two days of walking, they travelled to Pisa. Here 'the Professor' suffered his first bitter disappointment of the journey, finding Santa Maria della Spina in the process of being demolished prior to being rebuilt and restored *(cat.136)*. At Lucca, a few days later, another favourite Gothic chapel, Santa Maria della Rosa *(cat.84)*, had had its arches plastered up, and the two events are ominously coupled in a diary entry for 1 May: 'Chapel of Rose destroyed – as of Thorn at Pisa' (*Diaries*, 724).

Meanwhile he was drawing Romanesque masonry, ornamental carving and inlaid decoration for Oxford. Also, in addition to work on the instructions for the drawing classes, eagerly awaited by the master and itself interrupted by the urgent necessity to record things, like the Spina, in the process of being destroyed, Ruskin continued to write his monthly *Fors*, deriving material from episodes and encounters *en route*. *Letter XVIII* combined three incidents occurring at Pisa and Lucca into a lesson on 'benediction', lavished by the Pope, so Ruskin learned from the newspapers, on the 'Marquis of B.' on the occasion of his marriage, but denied the common people of Italy, whose potentiality for good was destined to go to waste, unless, like the 'peasant race of the Val di Niévole' (as Ruskin

inaccurately called the country immediately around Lucca), it was naturally blessed by 'honesty, kindness, food sufficient for them, and peace of heart'. These qualities were demonstrated by the story of how, in a walk on the hills above Lucca, Connie Hilliard had lost 'a pretty little cross of Florentine work', and how this was later found and duly returned to her by one of the children living in a nearby cottage, with whom she had previously made friends. 'Not unblest, such a people', Ruskin concluded, 'though with some common human care and kindness you might bless them a little more. If only you would not curse them; but the curse of your modern life is fatally near, and only for a few years more, perhaps, they will be seen – driving their tawny kine, or with their sheep following them, to pass, like pictures in enchanted motion, among their glades of vine' (XXVII, 308-9).

Though 'miserable among the horrible changes' at Pisa and Lucca, Ruskin was reluctant to leave for Rome. Here, as Joan wrote to Norton, he was 'much out of humour, with everything, or, rather, triumphant at having his bad opinion of things in Rome confirmed' (ALS, Houghton, bMS Am 1088/6361). This was evidently the frame of mind in which he first went to the Sistine, where he was pleased to find his attack on Michelangelo at Oxford the previous year fully justified: 'the Sistine roof', he wrote to Acland, 'is one of the sorrowfullest pieces of affectation and abused power that have ever misled the world' (XXII, xxvii). By contrast, the walls, with their frescoes by Perugino and Botticelli, were a revelation *(see cats 220-3)*: 'Nothing I have ever seen in mythic and religious art has interested or delighted me so much as Sandro and Perugino in the Sistine Chapel', Ruskin later wrote to Norton (*CRN*, 262).

Meanwhile the carved and inlaid decoration of the city's Romanesque churches, particularly the cloister of St John Lateran, suggested comparison with the Romanesque of Tuscany, as it would later on the journey with that of Assisi and Perugia. The notes in Ruskin's diary already referred to in connection with *cat.103* combine observations made in all these places in a rough sketch of the historical phases and cultural components – Southern and Northern, Greek and Lombard – of the development of Italian art in the 12th and 13th centuries, to be elaborated in three series of Oxford lectures, *Ariadne Florentina*, *Val d'Arno* and *The Aesthetic and Mathematic Schools of Art in Florence*.

After Perugia, the party visited Siena, and Orvieto before returning to Florence, where they remained for two weeks. For Ruskin these were mainly devoted to the study of the Baptistery, of whose exterior he drew a compartment *(cat.123)* and of which he also took the measurements. A small sketchbook *(cat.122)* largely filled with plans and sections of the building, and memoranda of its inlaid ornamentation, support his statement in a letter to Norton ten years later, 'I *did* the Florentine Baptistery in 1872, and found there wasn't a single space in all the octagon and all the panelling, that matched another' (*CRN*, 451).

From Florence they proceeded towards Venice, where at the end of June, Ruskin learned that Rose La Touche was now anxious to see him. Unwilling at first to interrupt his work, and to subject himself once more to the pain of rejection, Ruskin eventually cut the tour short and hastened home to meet Rose.

113

ADRIANO CECIONI (1836-86)
Caricature of John Ruskin ('Men of the Day, No. 40: 'The realization of the Ideal')
published in *Vanity Fair*, 17 February, 1872
350 × 210
Brant.
LIT: XXXVIII, 209 (no.26 in cat. of portraits, where attributed to F. Waddy)

Ruskin referred to this caricature in *Fors Clavigera, Letter LXVI* (published June 1876), in a satirical passage on Positivism addressed specifically to Frederick Harrison. Did the 'collective evolution', whose 'transcendent power' according to the Positivists held Ruskin and all men 'in the hollow of its hand' mean that he, Ruskin, was handsomer than the Elgin Theseus? He had indeed banished a cast of the statue from his Oxford Schools, but still he deemed it 'a very satisfactory type of the human form; arrived at, as you know, two thousand and two hundred years ago'. 'May I flatter myself,' Ruskin teased, 'it is really your candid opinion? Will you just look at the "Realization of the (your?) Ideal", in the number of Vanity Fair for February 17th, 1872, and confirm me on this point?' (XXVIII, 620).

Cecioni's original drawing is now at the Uffizi.

114

ANON
Photograph of the Ruskin party in Venice, June or July, 1872
(copy of original print in collection of M. J. H. Bunney)

The photograph shows, left to right, Ruskin, Mrs J. C. Hilliard, Joan Severn, Arthur Severn, Constance Hilliard and Albert Goodwin.

115

Register of the Hotel Victoria, Pisa
1868-79
Hotel Victoria, Pisa
(at Lucca only)

The Victoria, on the north side of the Arno, was the hotel Ruskin stayed at in Pisa in the 1870s and 1880s. First opened in 1839, it still exists and is run by a descendant of the landlord whom Arthur

VANITY FAIR. Feb. 17. 1872.

No. 172. MEN OF THE DAY, No. 40.
"The realization of the Ideal"

113

Severn, in his memoir of Ruskin, recalls being berated by the Professor for having allowed such a thing as the demolition of the Spina chapel to take place opposite his hotel (Dearden, 58). The register contains brief comments by Ruskin on his 1872 and 1874 visits.

116

Photograph of Albert Goodwin and daughter
?mid-1880s
(copy of original print)
Maidstone Museums and Art Gallery

Goodwin appears to be in his early forties here. If so the little girl would probably be either Olive or Edytha, second and third of the artist's five daughters, born in 1880 and 1882 respectively.

117

ALBERT GOODWIN
Loading the cart
1872
signed with monogram and dated 'May 2'
watercolour and pencil
63 × 89
Chris Beetles Ltd

118

A. GOODWIN
Via Crucis, Florence
1872/80
signed, inscribed, 'Via Crucis, Florence /72' and dated '80'
watercolour, bodycolour, pen and ink
280 × 433
Chris Beetles Ltd
LIT: *Albert Goodwin RWS (1845-1932).* Limited edn London: Chris Beetles Ltd, 1985, pl.12

119

A. GOODWIN
San Michele, Lucca
1893
inscribed with title, signed and dated '93' on mount
watercolour enclosed by watercolour, bodycolour and gold border
292 × 235
Chris Beetles Ltd
EXH: Maas 1991, 83

Cat.119 is an example of how Goodwin continued to produce pictures of the Tuscan cities visited on this tour, although he does not appear to have returned to Tuscany.

120

Ariadne Florentina. Six Lectures on Wood and Metal Engraving. II. 'The Relation of Engraving to other Arts in Florence'.
Orpington, Kent: George Allen, 1874
(original part with original printed paper covers)
open to show Fig.2, chronology of the 'artists of Christendom'
Bem.14.2

114

Joiner's Work

121 (Colour plate VI)
JOHN WHARLTON BUNNEY
*Window in the apse of the Duomo,
Florence*
?1870
watercolour
398 × 284
Brant.706

Bunney's diary for 1870 shows that he
delivered a number of Florentine
drawings, including studies of sculptural
details from the north door of the Duomo,
to Ruskin in Venice in June of that year.
The present drawing is not included in the
list. While this leaves open the possibility
of its having been made at an earlier date,
it is more likely to have been
commissioned later in the summer, after
Ruskin's visit to Florence had re-
awakened his interest in the inlaid marble

surfaces of Florentine architecture (see
p.64). On returning to England, Ruskin
wrote to Bunney asking him to move with
his family to Venice, adding 'there are
many things I want done at Florence
before you finally leave it' (TS of letter
dated 'D. Hill 30th July', private
collection).

122
Sketchbook 'Florence 1872 2. 1874'
110 × 177; hard cover; 36 leaves
*The Trustees of the Ruskin Museum,
Coniston, Cumbria (*CONRM *1990. 382)*
EXH: Coniston 1900, 334; AC 1964, 154

123 (Colour plate IX)
*Compartment of external wall, Baptistery,
Florence*
1872
watercolour over pencil
520 × 346

*The Visitors of the Ashmolean Museum,
Oxford (Ref.120)*
EXH: AC 1983, 206.
LIT: XXXVIII, 251 (685, incorrectly dated
1874); Penny, 72

Speaking, in the first of his Oxford
lectures on sculpture, against the notion
that architectural ornamentation should
be dependent on structure, Ruskin cited
the Baptistery of Florence, its flat external
wall overlaid with marble, in patterns
'which have no more to do with the real
make of the building than the diaper of a
Harlequin's jacket has to do with his
bones' (XX, 216). This building, Ruskin
told his students, would be their 'first
standard' and starting-point in the study
of architecture. In the event, Ruskin
began his teaching of architecture in
Michaelmas Term 1872 through the study
of engraving, which as the art of incised
linear design, 'is, indeed, a prior art to

that of either building or sculpture, and is an inseparable part of both, when they are rightly practised'. Exemplary was the Florence Baptistery, 'one piece of large *engraving*. White substance, cut into, and filled with black, and dark green ... the noblest type of intaglio ornamentation, which developed itself into all minor application of black and white to engraving' (XXII, 343). To illustrate this point, Ruskin very likely showed his drawing of a compartment of the Baptistery's external wall *(cat.123)*, made on the spot in the summer of 1872, 'with the best care I could – never took more pains with a drawing' (XXIII, 241).

124

ANON

Photograph of lecture diagram by Arthur Severn of the east door, Baptistery, Pisa
Bem. photo 903

The original diagram, enlarged by Severn from a photograph, was shown in the sixth lecture on Tuscan Art, 'Marble Couchant' (6 and 7 November 1873) of the series later published as *Val d'Arno*. The point it illustrated was again that of the independence of decoration from structure. To understand this it was necessary to consider 'all architecture as a kind of book, which must be properly bound indeed, and in which the illumination of the pages has distinct reference in all its forms to the breadth of the margins and length of the sentences; but is itself free to follow its own quite separate and higher objects of design'. There followed a detailed analysis of the distribution of ornament around the main door of the Baptistery in Pisa, showing that if the ornament did indeed follow the essential construction ('a square-headed opening in a solid wall, faced by an arch carried on shafts'), it did so arbitrarily. All parts of the doorway, horizontal and vertical, were of equal structural impor- tance, but some had been carved, others not, for no rhyme or reason (XXIII, 87-8).

In *Val d'Arno* Ruskin reproduced the original photograph of the doorway, explaining that 'the enlarged drawing showed the arrangement of parts more clearly, but necessarily omitted detail which it is better here to retain' (XXIII, 87).

125

125

Head from panel of font, Baptistery, Pisa
1872
watercolour and bodycolour over pencil
150 × 215 (image)
The Visitors of the Ashmolean Museum,
Oxford (Ref.99)
LIT: XXXVIII, 274 (1307)

126

ANON

Photograph of font and pulpit, Baptistery,
Pisa
401 × 547
The Visitors of the Ashmolean Museum,
Oxford (Ref.162)
LIT: XXI, 42
(facsimile photograph)

127 (Colour plate VII)
Part of the apse, Duomo, Pisa
1872
watercolour, bodycolour over pencil
460 × 318
The Visitors of the Ashmolean Museum,
Oxford (Ref.76)
EXH: RWS 1874, 105; FAS 1878, 60; AC
1983, 207.
LIT: XXXVIII, 274 (1315)

Ruskin showed his drawing of the apse of the Duomo *(cat.127)* in a lecture on

Nicola Pisano, the first of the *Val d'Arno* series (November 1873), together with a drawing of a portion of the Baptistery font *(cat.125)*, to rebutt Vasari's remarks on the 'old, ungainly' manner of the Greek builders of the Duomo and Baptistery, under whom Nicola was supposed to have learned his craft. It was the merit of Nicola and his son Giovanni, Vasari claimed, to have 'got rid of' that manner. Ruskin's own opinion was 'that no architecture on this grand scale, so delicately skilled in execution or so daintily disposed in proportion, exists elsewhere in the world'. Vasari was 'fatally wrong' in that he did not see that there were 'Greeks and Greeks'. The builders of the Duomo and Baptistery, the teachers of Nicola, were of the true Greek stock, unlike, say, the architects of the Lateran cloister in Rome, 'abortive, and monstrous beyond the power of any words to describe'. The tiny head Ruskin had drawn from the Pisan font was 'as pure as the sculpture of early Greece, a hundred years before Phidias', and supremely 'delicate' (XXIII, 16). In a note written in 1878 for an intended re-arrangement of the Educational Series, Ruskin instanced the Pisan head as representing the consummation of the Greek tradition. It

126

evinced the three main qualities of Greek art, naturalism, order and repose, but fully combined for the first time. 'It will be felt at once how the quiet humility of this head differs from everything Norman or German of the same period, how the exquisite order of its hair, of the folds of the beard, and of the leafage by which it is encompassed, separates itself from the confused intricacy of Arabic or other barbarous ornamentation, and, lastly, how the more or less languid grace of its undulating curves expresses a temper, capable of action indeed, but triumphing in repose, while the elasticity and spring of Gothic foliage as distinctly indicates a temper incapable of rest, unless fatigued. The introduction of the red and black mosaic on the flat ground and black beads

in the eyes complete this piece of work as a general symbol of all that the Greeks meant to praise by their term 'ποικιλία' (XXI, 148).

128
Façade of Palazzo Gambacorti, Pisa
1872
watercolour, pencil
176 × 211
The Visitors of the Ashmolean Museum, Oxford (Ed.86)
EXH: FAS 1907, 76.
LIT: XXXVIII, 275 (1323/4)
(illustrated only)

Ruskin's Pisan diary for 1872 records his getting up early on two mornings 'to draw palace opposite' (*Diaries*, 724). Across the Arno from the Hotel Victoria,

the Palazzo Gambacorti was built in the 14th century, probably by Pietro Gambacorti, Lord of Pisa until his murder in 1393. It is now the town hall. A MS note in 1878 shows that Ruskin intended to place this and a companion drawing of one of the palace's windows in the re-arranged Educational Series: 'I place next the most beautiful instance I ever saw of the use of these horizontal lines by the Pisans, and of the use of inlaid marbles in association with the Gothic forms which they had derived from the North. This palace … is … especially delightful to me in the proportions of its shafts and arches, and in the treatment of its decoration; with full trust in the spectator's careful watchfulness of the slightest variations, venturing all claim upon his admiration

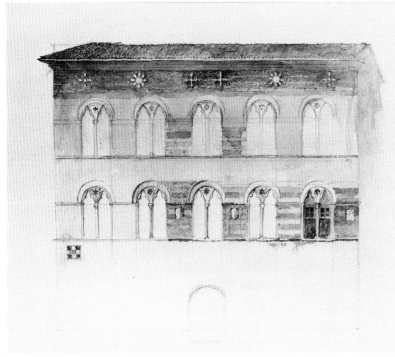

128

on the disposition of four flower-like stars, four coats of arms, and two crosses at the top' (XXI, 149).

129

Window, Palazzo Tolomei, Siena
1870 or 1872
watercolour and bodycolour over pencil
180 × 171
The Visitors of the Ashmolean Museum, Oxford (Ed.88)
LIT: XXXVIII, 283 (1557, where dated 1870); Harris, 5

Cat.129 has been recently identified by Anthony Harris as a window from the upper storey of the 13th-century Palazzo Tolomei, the oldest of the private palaces in Siena. It is given the date 1870 by Cook and Wedderburn. However, a companion drawing, now at Brantwood, was tentatively dated 1872 by Ruskin in 1878. A diary entry for 28 May 1872 reads 'Tuesday, sketch about Siena' (*Diaries*, 726).

130

Inlaid marble work at Lucca: shield from the façade of Palazzo Guinigi
?1872

inscribed by Ruskin bottom left, 'Lucca'
watercolour
175 × 155 (irregular)
Brant.939
EXH: FAS 1878, 20; Coniston 1900, 208; RWS 1901, 153; Coniston 1919, 210; RA 1919, 9.
LIT: XXXVIII, 264 (1050)

At the Fine Art Society in 1878, Ruskin exhibited three drawings under the title *Studies of inlaid marble work at Lucca*. The first was a sketch of the juncture of two arches from 'an early thirteenth-century palace'. Reference in the catalogue-note to the arches' Saracenic curve and inlaid brick rose-mouldings (requiring 'as much care in delineation as the petals of a living flower') marks the palace out as that of the Guinigi *(see cat.85)*. The second study, a shield, was clearly the present drawing, not only because this matches the description in the catalogue – 'porphyry and black marble, inlaid in white' – but because it too comes from the Palazzo Guinigi, where it is set into the façade: the arms are those of the Guinigi. The shield's border, Ruskin commented, 'was too fine to be drawn at all, in the time I had'. The third drawing

was not from Lucca, but Pisa, being a female head in bas-relief from the south-west door of Santa Maria della Spina – 'the curves of the hair and veil-border ... as subtle as is an Etruscan statue'. All three drawings showed 'qualities of a building' which could 'only be known by drawing it ...' (XIII, 501-2).

The shield and arches (Bem. 1365) probably both date from 1872, as Ruskin's diary records him drawing at the Guinigi Palace on 4 May (*Diaries*, 724).

131

Part of façade of Duomo, Lucca
1872
inscribed by Ruskin, bottom right, 'J Ruskin / Lucca. 1872'
watercolour, pencil, bodycolour
102 × 118
Abbot Hall Art Gallery and Museum, Kendal
PROV: Geoge Allen; ?Robert Cunliffe; Abbot Hall, given 1974

132

Part of the façade of San Michele in Borgo, Pisa
1870 or 1872
watercolour and bodycolour over pencil and black chalk, on blue paper
228 × 173
The Visitors of the Ashmolean Museum, Oxford (Ed.89c)
LIT: XXXVIII, 275 (1325, as 'Study of Pisan Gothic')

133, 134

Brickwork spandrel at Siena (2 drawings)
1870 or 1872
watercolour and bodycolour on blue paper
170 × 142
The Visitors of the Ashmolean Museum, Oxford (Ed.89a, b)
LIT: XXXVIII, 283 (1558, 1559); Harris, 14

135

Two carved heads, Santa Maria della Spina, Pisa
?1872
inscribed by Ruskin bottom left, 'masonry of sculpture, Pisa'
pencil
197 × 116
Bem.1441
PROV: Goodspeed

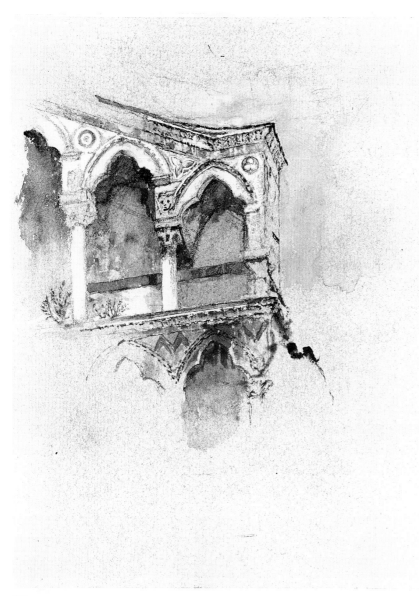

132

Spina *(cat.135)*, to illustrate 13th-century 'Cyclopean' architecture. This was essentially 'stone carpentry, in which the carpenter despises glue', buildings fitted rather than cemented together, and its first characteristic was that the joint-lines between the stones significantly added to the beauty of the building, as also in 'the separating lines of the bricks at Siena' (XXIII, 102). In his Oxford catalogue, Ruskin similarly drew attention to 'the care taken in finished Italian brickwork to obtain grace of arrangement' (XX, 83). The second characteristic of Cyclopean architecture was the habit of disregarding the joints and carving continuously over the whole surface, as in the two panels from the Spina chapel. One 'would naturally suppose that the enclosing panels would be made of jointed pieces, and the heads carved separately and inserted. But the Pisans would have considered that unsafe masonry, – liable to the accident of the heads being dropped out, or taken away. John of Pisa did indeed use such masonry, of necessity, in his fountain; and the bas-reliefs have been taken away. But here one great block of marble forms part of two panels, and the mouldings and head are both carved in the solid, the joint running just behind the neck' (XXIII, 102). The two panels decorate the right side of the south-west door of the chapel. They are balanced by two similar panels, with a male and a female head, to the left of the door. Ruskin drew these also. A coloured sketch of the female head *(see cat.130)* is at Bembridge, and a rough memorandum of the male head is on the verso of *cat.131*.

136

Fors Clavigera. Letters to the Workmen and Labourers of Great Britain. Letter XX (August 1872)
printed by Smith, Elder & Co and sold only by G. Allen
(original part with original printed paper covers)
open to show frontispiece
Bem.10.6

The frontispiece to this *Fors* was a photogravure of Ruskin's own drawing of the Spina chapel of ?1846-7 *(cat.68)*. Ruskin had been horrified to find on his arrival in Pisa in April of that year that

Cat.132 was catalogued by Ruskin at Oxford as *Study of Pisan Gothic* and mounted with his two drawings of Sienese brickwork *(cats 133, 134)*. These are unlikely to have been made later than 1872, as Ruskin apparently refers to them in a lecture held in November of the following year (see below). It was Norton who drew Ruskin's attention to the brickwork of Siena. In a letter inviting the latter to Siena in the summer of 1870, he makes specific mention of the brickwork architecture there as one of the things he wishes Ruskin to see (*CRN*, 193).

San Michele in Borgo, Pisa, dates from the early 11th century, but was subsequently much enlarged and altered. The Gothic arcades of its façade are of the first decade of the 14th century. This was not the first time Ruskin had drawn them. His architectural notebook for 1846 *(cat.42)* contains sketches of an arch and an inlaid spandrel.

The two brickwork spandrels were probably shown in the lecture afterwards to be published as 'Marble Rampant' in *Val d'Arno*, along with the sketch of the two sculpted heads from Santa Maria della

the chapel was 'under restoration'. That is how Arthur Severn puts it in his memoir: 'Dust and noise and hammering, beautiful bits of Gothic carving lying about'. Severn tells how the enraged Ruskin harangued the baffled workmen, accusing them of perpetrating greater damage to Italy than the Austrians ever had (Dearden, 57).

The restoration was a radical one: Ruskin was not exaggerating when he captioned his frontispiece 'Part of the Chapel of St Mary the Thorn, Pisa as it was 27 years ago. Now in Ruins.' It had been decided to dismantle, re-build and restore the building, partly because its decrepit state seemed to require such a drastic solution, and partly with a view to the raising of the quays, which a series of floods (the most recent, in 1869, had led to the collapse of the Pont a mare) had made urgent. The chapel was eventually re-assembled a little south-west of the position it had originally occupied, and raised by about a metre. The plan for restoring the Spina had been approved by the town council, after some controversy, in June 1871. Work is usually said to have begun on the chapel in the same year: a much-reproduced photograph of a group of workmen standing by a small heap of rubble where the chapel used to stand, is usually dated 1871. However, this stage could not have been reached before late 1872, if, in April of that year, as Severn's memoir suggests, the chapel was still in the process of being taken apart. That this is what was happening seems to be confirmed by *Fors Clavigera, Letter XVIII*, in which Ruskin told how 'the cross of marble in the arch-spandrel next the east end ... was dashed to pieces before my eyes, as I was drawing it for my class in heraldry at Oxford' (XXVII, 315). Moreover, Ruskin's sketchbook of 1872 *(cat.122)* shows that he was also able to make drawings of the arch, with its unrestored broken trefoil and patchwork masonry, immediately below that cross. The carved heads were probably also drawn at this time, in a hurried attempt to record as much as possible. In a letter to Henry Acland written from Siena on 27 May, Ruskin apologises for delay over completing the promised instructions for use of the Oxford Drawing School, explaining 'my brains were failing me and

I had to look at some things in Pisa, literally for the last time as they were breaking them down before my eyes' (TS, Bod. MS Eng.Lett.c.38, 278).

In *Fors XX* Ruskin tells the history of the Spina chapel after his own fashion. There is no mention of flooding, and it is even denied that the church was in need of repair: 'In the year 1840 I first drew it, then as perfect as when it was built'. (The chapel had in fact been subject to almost continual restoration from the 14th century on, owing mainly to the instability of the ground on which it was built.) Ruskin sardonically attributes the Spina's recent misfortunes to the work of British Protestant, German philosophical and French republican 'missionaries', who had progressively undermined the faith of the Italians, thus leaving the field open to their own 'Engineering missionaries', who having rendered human arms redundant 'set them to break up the Spina chapel' (XXVII, 349).

137
'Pisa. South Ripa d'Arno (B)'
?1872
inscribed by Ruskin top right, 'main archivolt'; middle right, 'little trefoil'; centre, 'vertical'; bottom right, 'Pisa. South Ripa d'Arno. See companion A. (B)'
178 × 254
Bem.1443
PROV: Goodspeed.
EXH: Coniston 1919, 141 ('Pisa, south Ripa d'Arno, 1872 and 1884'); RA 1919, 58 ('Masonry at Pisa, south Ripa d'Arno, 1872')

The drawing is not, as the inscription might suggest, from the church of San Paolo a Ripa d'Arno, the south side of which is plain-built in stone. None of the arches on the façade or north side of the church, moreover, corresponds to that in the drawing. The arch in question might therefore be from any of the buildings on the south bank of the Arno, possibly the Spina chapel itself, which does have similar, though not identical, arches on its façade. If of the Spina, the drawing is, however, unlikely to have been made in 1872 (the date apparently given it in the two Ruskin centenary exhibitions of 1919), when Ruskin would hardly have had time to produce anything so precise. Nor would

Ruskin have drawn the Spina after 'restoration'. The inscription is in Ruskin's mature hand, which, unless it was added long after the drawing was made, excludes a date earlier than 1870.

Love and line

138

Fors Clavigera, Letter XXIII (November 1st, 1872)
printed by Smith, Elder & Co and sold only by G. Allen (original part with original printed paper cover)
open to show frontispiece, 'Theseus. With the symbol of his Life-problem. Thus drawn by a Master of the Mint in Crete'
Bem.10.6

139

Fors Clavigera. Vol.II
printed by Smith, Elder & Co, and sold only by G. Allen 1872
open to show woodcut of labyrinth, Duomo, Lucca (*Letter XXIII*)
Sheffield

140

Fors Clavigera, Letter XXVIII (April 1st., 1873)
printed by Smith, Elder & Co, and sold only by G. Allen
(original part with original printed paper cover)
open to show frontispiece, 'The Tale of Ariadne. As it was told at Florence'
Bem.10.6

141, 142, 143

Electrotypes of three Greek coins from Cnossos
i. (Theseus and fret) 5th century BC
ii. (square labyrinth) *c.*350-300 BC
iii. (round labyrinth) late Hellenistic period
Sheffield

As had been promised in the previous issue, *Fors Clavigera, Letter XXIII* is dedicated to the figure of Theseus, in the role of the first great 'squire' of history. The term had three meanings for Ruskin, reflecting three forms of moral and political heroism: *rider*, or 'master and governor of beasts', hence teacher of chivalry; *shield-bearer*, or 'the declarer, by legend, of good deserving and good intentions, either others' or his own'; and *carver*, or 'Lord of the Land, and therefore giver of Food'. Founder of Athens, Theseus was also the 'first true Ruler of beasts: for his mystic contest with the Minotaur is the fable through which the

141

142

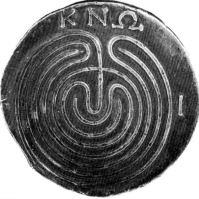

143

Greeks taught what they knew of the more terrible and mysterious relations between the lower creatures and man'. Though 'wise and liberal historians' might assert the non-existence of Theseus, Ruskin insisted on the lasting educative force of the mythic *idea* of him. Indeed, he assured his readers, 'you never pass a day without being brought, somehow, under the power

of Theseus'. It was sufficient to let one's eyes fall on a plate or building decorated with the Greek fret. Ruskin had once hated this motif 'as the chief means by which bad architects tried to make their buildings look classical'. He had since come to understand its significance as a graphic memorial to that contest of Theseus and the Minotaur, hence to Theseus as 'the exterminator of every bestial and savage element, and the type of human, or humane power' (XXVII, 408).

Ruskin reproduced three coins of Cnossos *(cats 141, 142, 143)*, one with the hero's fret-enclosed head and the other two with the labyrinth where he had defeated the monster, to show the relationship between pattern and symbolic structure. Also illustrated was the labyrinth carved on one of the columns of the atrium of the Duomo of Lucca *(cat.139)*, which Ruskin told his readers he had come on a few months earlier. The 1872 Coniston sketchbook *(cat.122)* contains a drawing of this labyrinth with its inscription, from which Arthur Burgess made the wood-cut reproduced in *Fors* (where the image is laid on its side). Ruskin translates the inscription, 'This is the labyrinth which the Cretan Dedalus built, Out of which nobody could get who was inside, Except Theseus; nor could he have done it unless he had been helped with a thread by Ariadne, all for love' (XXVII, 401). The similarity of its opening 'grave announcement' to that of the nursery rhyme 'This is the house that Jack built' gave Ruskin an opportunity for one of his frequent exercises in rendering the 'sublime' familiar. Dædalus is equated with Jack, builder of the house, 'Jack of all trades', for his is 'the power of finest human, as opposed to Divine, workmanship or craftsmanship'; and no mortal, according to the Greeks, could be properly speaking 'Master' of any skill. Dædalus' history exemplifies 'whatever good there is, and whatever evil, in the labour of the hands, separated from that of the soul'.

The Cretan labyrinth was Dædalus' 'finest piece of involution, or cunning workmanship', and therefore also his most ambiguous achievement (XXVII, 402-4). In *Aratra*, Ruskin had warned of the ingenuity of the craftsman lapsing into

144

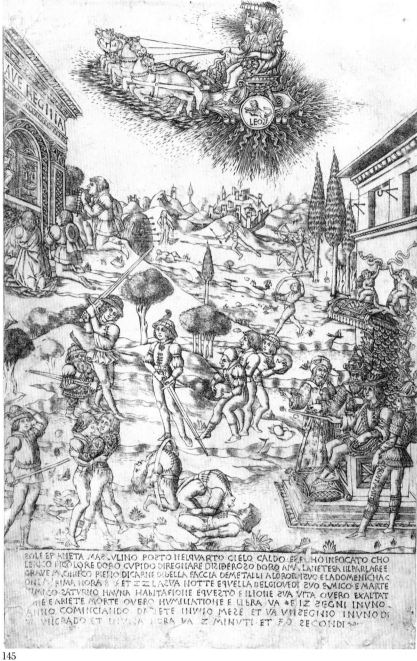

145

brutality, a mere building of 'labyrinths for monsters', literally accommodating the bestial element which it was the mission of the 'great Athenian squire' to subdue. The ambiguity of the labyrinth was perfectly illustrated in an early Florentine engraving (1460-70) of the legend of Theseus and Ariadne (Hind A. II 16,1, II) which Ruskin reproduced as the frontispiece to *Letter XXVIII (cat.140)*: 'Could anything more precisely represent the general look of your architecture now? When I come through Wigan, it seems to me that I have seen that thing itself, only built a little higher, and smoking, or else set on its side, and spinning round, a thousand times over in the course of the day. Then the very writing of the name of it is so like your modern education! You miss the first letter of your lives; and begin with A for apple-pie, instead of L for love;

and the rest of the writing is – some little – some big – some turned the wrong way; and the sum of it all to you, Perplexity. "Abberinto"' (XXVII, 510).

144

Ariadne Florentina. Six Lectures on Wood and Metal Engraving. III. 'The Technics of Wood Engraving'

Orpington, Kent: George Allen, 1874 (original part with original printed paper covers)
open to show Pl.I 'Things Celestial and Terrestrial as apparent to the English Mind' (3 details from woodcuts by Thomas Bewick)
Bem.14.2

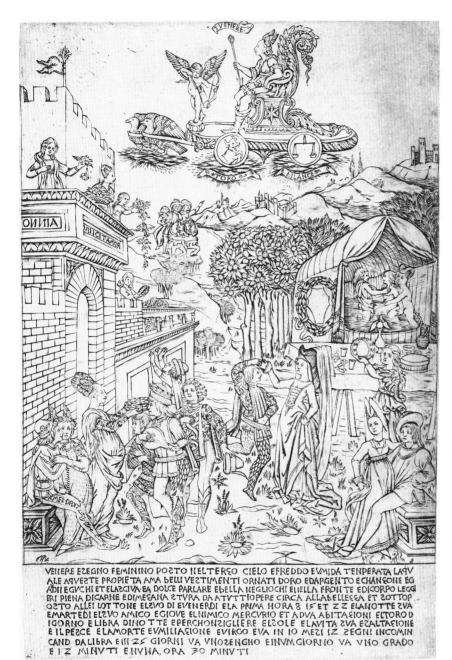

VENERE ESEGNO FEMININO POSTO NELTERÇO CIELO EFREDDO EVMIDA TENPERATA LAQV
ALE AQVESTE PROPIETA AMA BELLI VESTIMENTI ORNATI DORO EDARGENTO E CHANSONE EG
ADII EGVCHI ET ELASCIVA EA DOLCE PARLARE EBELLA NEGLIOCHI ELIELLA FRONTE EDICORPO LEGGI
ERI PIENA DICARNE EDIMEÇANA STVRA DA ATVTTIOPERE CIRCA ALLABELLEÇÇA ET ÇOTTOP
OSTO ALLEI LOTTONE ELEVO DI EVENERDI ELA PRIMA HORA 8 15 ET 22 ELANOTTE SVA
EMARTEDI ELSVO AMICO EGIOVE ELNIMICO MERCVRIO ET ADVA ABITAÇIONI ELTORO D
IGORNO E LIBRA DINOTTE EPERCHONSIGLIERE ELSOLE ELAVITA SVA ESALTAÇIONE
E ILPESCE ELAMORTE EVMILIAÇIONE EVIRGO EVA IN IO MESI 12 SEGNI INCOMIN
CAND DALIBRA E IN 25 GIORNI VA VNOSENGNO EINVMGIORNO VA VNO GRADO
E I2 MINVTI E NVNA, ORA 30 MINVTI

146

145, 146
Two early Florentine engravings from the 'Planets' series
*c.*1460
i. *Sun*
323 × 216 (plate)
ii. *Venus*
327 × 218 (plate)
The Trustees of the British Museum
(shown at London and Sheffield only)

147, 148, 149, 150
Four early Florentine engravings from the 'Prophets' and 'Sibyls' series
i. *Joshua*
1470s
178 × 107 (plate)
ii. *Libyan Sibyl*
1470s
176 × 106 (plate)

iii. *Cumaean Sibyl*
*c.*1465
178 × 107 (plate)
iv. *Hellespontine Sibyl*
*c.*1465
178 × 108 (plate)
The Trustees of the British Museum
(shown at London and Sheffield only)

The *Planets*, *Prophets* and *Sibyls* series are among a group of 15th-century engravings in what is known as the Fine Manner (it also includes that of Theseus and Ariadne reproduced *cat.140*), which have traditionally been ascribed to Baccio Baldini (*d.*1487). Though the tradition may simply be based on Vasari's mention of Baldini as a follower of Maso Finiguerra, regarded by him as the inventor of the art of engraving plates for printing, the whole group of engravings are generally regarded as by the same hand, and the engraver identified with the draughtsman who produced the *Florentine Picture Chronicle* (*see* pp.89-92). For convenience's sake he is still referred to by some scholars as Baldini. Vasari also said of Baldini that, having little gift for original design, he depended on the invention of Botticelli, who provided designs for all his engraved work. This statement gave rise to a tradition among the early print cataloguers whereby Baldini and Botticelli worked in collaboration, a tradition repeated by Ruskin in *Ariadne Florentina*, where he reproduced the engravings shown: '[Botticelli] and his assistant, Baccio, worked together; and in such harmony, that Bandini [*sic*] probably often does what Sandro wants, better than Sandro could have done it himself; and, on the other hand, there is no design of Bandini's over which Sandro does not seem to have had influence' (XXII, 381). This tradition permitted Ruskin to regard all the engravings shown, though not necessarily all the series from which they come, as the work of Botticelli.

The *Planets* series comprises seven plates in which personifications of the planets ride in chariots above scenes illustrating their respective modes of influence on earthly life. These scenes were omitted by Ruskin in his reproductions. The planets' motions and attributes are summarised in inscriptions that show the

same idiosyncrasies of spelling and
grammar Ruskin had noted in the Theseus
and Ariadne engraving and also in the
Florentine Picture Chronicle. Copies of
the plates also exist, reversed and slightly
smaller than the originals. The
impressions reproduced by Ruskin are
from the original series: the *Sun* (Hind
A.iii.4, a) is in a reworked state, while
Venus (A.iii.5, a) is from the unreworked
plate.

The *Prophets* and *Sibyls* series were also
copied, or rather freely adapted, probably
by Francesco Rosselli, in a different style
of engraving, known as the Broad Manner.
The difference between the two styles
consists above all in the shading, which in
the Fine Manner is made up of short, fine
lines, often closely cross-hatched and
rather blurred in effect, while in the Broad
longer, sharper lines and parallel hatching
are used. It is difficult to say whether it is
this distinction between the two versions,
or simply a distinction between states or
impressions within the same version to
which Ruskin refers when, in an Appendix
to *Ariadne*, he writes that he has been
'made more doubtful on several points
which were embarassing enough before,
by seeing some better (so-called,)
impressions of my favourite plates,
containing light and shade which did not
improve them'. The engraving of Joshua
was reproduced as an example 'of the
inferior execution and more elaborate
shade which puzzle me' (xxii, 477).
However, Ruskin also reproduced the
Broad Manner copy of the *Libyan Sibyl*,
and this rather blurs his position.

The impressions reproduced by Ruskin
are:
Joshua: Broad, State ?I (C.i.23B)
Libyan Sibyl: Broad, State I (C.ii.2B)
Cumaean Sibyl: Fine (C.ii.7A)
Hellespontine Sibyl: Fine (C.ii.8A)
Ruskin did not own copies of either the
Planets, *Prophets* or *Sibyls* series. These
are probably the 'Botticelli' engravings to
which he refers in a letter of 29 September
1872 to his then secretary R. St John
Tyrwhitt, telling him how he had found
them in the British Museum the previous
month, 'in the very nick of time for the
lectures' on engraving (Birch, 149-50).

Of the two planet engravings, the *Venus*
is used twice in *Ariadne*, and both times

147

148

149

150

contrasted with a Venus *(cat.144)* cut by
Thomas Bewick for an edition of Aesop's
Fables, where it is the head-piece to 'The
Young Man and his Cat'. The first point

the comparison illustrates is the principle
that the engraver's main concern is 'the
decorative arrangement of *lines*'. This is
natural to the Florentine, but Bewick 'is

overpowered by his vigorous veracity'. However, 'to engrave well is to ornament a surface well, not to create a realistic impression' (XXII, 379-80). The comparison is repeated in the lecture on 'Design in the German Schools of Engraving', in the context of a broad distinction between the revived classicism of the Northern Reformation and that of the Florentine Renaissance. In the North, the revival of learning produced only 'civilized boors', while the Florentines were by birth 'reanimate Greeks'. Bewick's paltry Venus, though the epitome of classical nudity, could not match with the comparatively overdressed Florentine Venus. *Her* divinity was apparent, despite her buskins, because every line of her had been drawn by a gentleman. The still more extravagantly ornate figure of the Sun *(cat.145)* showed that the artist was also a scholar. For, as Ruskin proceeded to show, the many details of the representation – the prominent epaulettes, the cornucopia, the at first sight laughable horses – actually stood for a series of facts concerning the solar power, and were proof of the 'veracity' of the Florentine's conception of that power. In this he was more Greek than the sculptor of the Apollo Belvedere, for whom 'Apollinism is merely an elegant idea on which to exhibit his skill' (XXII, 402-3).

Ruskin was especially inclined to consider some of the *Prophets* and *Sibyls* Botticelli's, because this fitted with his view both of the latter as Italy's 'wisest reformer', and of Michelangelo as the corrupting father of modern art. For he liked to think of the engravings as related to Botticelli's preparatory drawings for frescoes for the Sistine Chapel ceiling, intended to complement those he, together with Perugino and Ghirlandaio, had painted on the walls to illustrate the 'ratification and completion' of the Mosaic law by Christ. The 'great choir of prophets and sibyls' planned by Botticelli showed his understanding of classical mythology not as anti-Christian, but as pre-Christian, 'the foundation of Christianity'. Michelangelo, to whom 'all Christian and heathen mythology had alike become ... only a vehicle for the display of his own powers of drawing limbs and trunks', had borrowed the scheme without

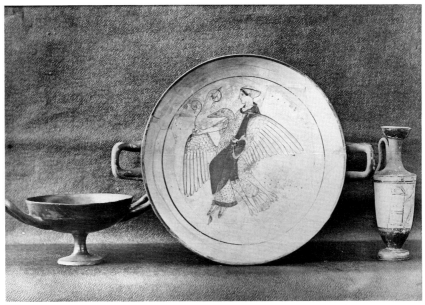

151

understanding its significance (XXII, 440-1).

Modern scholars would not see Botticelli as special in seeing the Sibyls as 'pre-Christian' witnesses to the Revelation, for their association with the prophets was a commonplace of typological thinking throughout the late classical and medieval periods.

151
ANON
Photograph of Greek patera with Aphrodite riding on a swan
196 × 277
The Visitors of the Ashmolean Museum, Oxford (Rud.51)
LIT: XXI, 180
(facsimile photograph)

152, 153, 154, 155
Four engravings from the series known as the 'Tarocchi of Mantegna' (E-Series)
i. *Apollo*
ii. *Poesia*
iii. *Astrologia*
iv. *Venus*
not later than 1467
178-80 × 99-101 (plate)
The Trustees of the British Museum
(shown at London and Sheffield only)
The series of fifty engravings has gone by the name of the 'Tarocchi (Tarot cards)

of Mantegna' since at least the end of the 17th century, but has long since been recognised as neither the work of Mantegna nor indeed a pack of Tarot cards. It is now attributed to the school of Ferrara and thought to have had a didactic function, possibly in the form of a game, illustrative of the divine disposition of the universe. The series consists of five groups of ten cards, each marked by letters in reverse order with respect to the card numbers, to symbolise the ascent from earthly to celestial spheres:
E (cards 1-10) – Conditions of Man
D (cards 11-20) – Apollo and the Muses
C (cards 21-30) – Liberal Arts
B (cards 31-40) – Cosmic Principles and Virtues
A (cards 41-50) – Planets and Spheres
The *Tarocchi* exist in two versions, known as the E-Series and the S-Series, as in the latter the first group is marked by the letter S. The S-Series also shows less technical precision than the E-Series, of which it is generally thought to be a copy.

Ruskin attributed the series to 'Bandini' (Baldini) after early designs by Botticelli. Some he believed to have been engraved by Botticelli himself.

Ruskin possessed a complete set of the E-Series *Tarocchi*: thirty-two prints were given to Oxford and the remaining

eighteen were bought by the Ashmolean at one of the Sotheby's sales of the Ruskin estate in the 1930s. Ruskin bought the set partly on the recommendation of Burne-Jones (see letter of 25/26 February 1873, *cat.98*), and probably before 1868, when he used *Astrologia* in a lecture delivered in Dublin on 'The Mystery of Life and its Arts'.

An enlarged copy of the laurel 'sceptre' held by Apollo *(cat.152)* was placed in the Educational Series (No.8) as an example of conventional outline. Students who measured and copied it with the brush would learn that precision was more important than fineness of execution in drawing. The lines might look coarse, but the student would find that they could not 'be altered in the curvature even by a small fraction of an inch without losing grace, and that it is very difficult to follow their curvatures without altering them, owing to their continual subtlety of change'. In its very conventionalism Baldini's laurel was the simplest but most faithful possible abstract of 'growth in noble vegetation'. Indeed, 'the especial beauty of this group of foliage as terminating the rod of Apollo is the strength with which it is springing' (XXI, 109-10).

Poesia and *Astrologia* are presented by Ruskin in *Ariadne Florentina* as examples of the oldest and purest school of engraving, distinguished by its avoidance of the elaborate chiaroscuro of inferior later schools in favour of the linear clarity and grace proper to the art: 'no lustre attempted, – no texture, – no mystery'. A telling instance were the stars in Astrology's crown, '*black* instead of shining!' Again, in the *Poesia*, the water was without reflection. But Ruskin pointed out how 'the observer's attention is supposed to be so close to every dark touch of the graver that he will see the minute dark spots which indicate the sprinkled shower falling from the vase into the pool'. This 'habit of strict and calm attention' in artist and observer made for an art of intellect, in which every detail 'has a meaning, if you care to understand it'. One of many details instanced by Ruskin to illustrate this was the single tree surmounting the hill behind the figure of Poetry. On the face of it absurd, and like

153

nothing so much as a mushroom, to the instructed eye it 'connects our Poesia with the Iliad' : for the hill is the mountain of Parnassus, sacred to Apollo and the Muses, and the tree the Immortal Plane Tree planted there by Agamemnon, of which Homer tells (XXII, 385-6).

Our fourth engraving from the *Tarocchi* series, *Venus*, had already been used in the lectures on sculpture in 1870, where it had been placed alongside a representation of Aphrodite riding on a swan from a white Athenian patera in the British Museum *(cat.151)*, to show in 'rude and diagram-like outline' the main differences between the Greek and Florentine schools. Ruskin points out three essential differences. First, the Aphrodite is pretty, where the Venus is plain. 'That is because a Greek thought no one could possibly love any but pretty people; but an Italian thought that love could give dignity to the meanest form that it inhabited ...' Second, the Greek goddess' full breasts and flowering plant indicate 'that her essential function is child-bearing', while the Italian's breasts are small, her body is strong and angular,

155

and she holds a decorative garland. 'These signs mean that the Italian thought of love as the strength of an enternal spirit, for ever helpful; and for ever crowned with flowers, that neither know seed-time nor harvest, and bloom where there is neither death nor birth.' The third essential difference lies in the goddesses' expressions. The Aphrodite is calm, the Venus 'all quivering and burning with passion and wasting anxiety'. Again the Aphrodite is 'self-possessed, and self-satisfied : the Italian incapable of rest; she has had no thought nor care for herself; her hair has been bound by a fillet like the Greek's; but it is now all fallen loose, and clotted by the sea, or clinging to her body; only the front tress of it is caught by the breeze from her raised forehead, and lifted, in the place where the tongues of fire rest on the brows, in the early Christian pictures of Pentecost, and the waving fires abide upon the heads of Angelico's seraphim' (XX, 336-7).

In *Ariadne*, the comparison is repeated, but the balance this time is decidedly in favour of the Italian Venus. However, Ruskin's aim here is less to distinguish

between them than to align both with another Venus, from the *Planets* series *(cat.146)*, against Bewick's *(cat.144)*. The context is again the contrast between North and South. 'Why is the English one vulgar?' Ruskin asks the reader. 'What is it, in the three others, which makes them, if not beautiful, at least refined? – every one of them "designed" and drawn, indisputable, by a gentleman?' (XXII, 406).

156
Les simulachres et historieés faces de la mort, autant elegammẽt pourtraictes, que artificiellement imagineés.
Lyon, 1538
original edition, with 42 wood-block illustrations by Hans Holbein; bound in morocco with a skull in gilt on the boards
Sheffield R 0918
LIT: XXX, 250 and n.

157, 158, 159, 160
Four enlarged photographs of woodcuts from Holbein's 'Dance of Death'
1. 'He that hath ears to hear, let him hear' (XX. 'The Senator')
2. 'The Two Preachers' (XXI. 'The Preacher')
3. 'The Last Furrow' (XXXVIII. 'The Ploughman')
4. 'The Child's Bedtime' (XXXIX. 'The Child')
Sheffield

161
Fors Clavigera, Letter XXII (October 4, 1872)
printed by Smith, Elder & Co, sold only by G. Allen
(original part with original printed paper covers)
open to show frontispiece, 'The Mount of Compassion, and Coronation of its Builder. Drawn thus by Sandro Botticelli'
Bem.10.6

162, 163
The History of British Birds. The figures engraved on wood by T. Bewick. 2 vols.
Newcastle, 1797 and 1804
Vol.I open at p.87 to show 'Military Glory'; Vol.II at p.v to show 'The Two Old Soldiers'
Sheffield R0882/3
LIT: XXX, 244

159

160

The rare first edition of Holbein's *Simulachres et historieés faces de la mort*, traditionally known as the *Dance of Death*, was among the first exhibits placed by Ruskin in the museum he founded in 1875 at Walkley, near Sheffield, for the Guild of St George.

Ruskin showed facsimiles by Arthur Burgess of four of Holbein's woodcuts in the course of his lectures on engraving, reproducing them in the published version, *Ariadne Florentina*. Two of the woodcuts, entitled by Ruskin 'The Last

Furrow' *(cat.159)* and 'The Two Preachers' *(cat.158)*, illustrated the assertion that the best engraving 'disdained chiaroscuro' (XXII, 352). In the first, of a ploughman tilling at sunset, Holbein is so far careless of the light and shade that he even forgets where the light is coming from, letting the figure cast a shadow sideways, though the sun is in front of him. Not that Holbein is incapable of doing better; but it is his 'object, here, to express the diffused and intense light of a golden summer sunset, so far as it is consistent with grander purposes' (XXII, 353). And though minimal, Holbein's chiaroscuro is effective. Ruskin demonstrated this by placing the image of the ploughman beside that of the false preacher, with its dimly-lit interior: 'you will feel', Ruskin prompts his audience, 'that the diffused warmth of the one subject, and diffused twilight in the other, are complete; and they will finally be to you more impressive than if they had been wrought out with every superficial means of effect, on each block' (XXII, 353).

Holbein's 'grander purposes' are those of 'the Rationalist spirit of Reform', which ensures that what might have been nothing more than a 'scenic effect' becomes a 'symbol'. In the woodcut of the preacher, Ruskin reads the dim interior ('the sun is totally shut out of it') as an index of the vain rhetoric of this *sincere preacher of untruth* (XXII, 355). In the 'Last Furrow', on the other hand, the light in the west, beyond the village church, signifies the final reward of a life passed in hard labour.

As painter-reformer, Holbein is paired by Ruskin with Botticelli. But whereas the Italian represents 'the *Faithful* and *Catholic* spirit of reform', the German 'reads Nature in her desolate and narrow truth, and she teaches him the Triumph of Death' (XXII, 353, 415). Where it was once the task of the artist 'to exhibit the virtues of this life, and the hopes of the life to come', Holbein aims 'to show the vices of this life, and to obscure the hopes of the future' (XXII, 415). Nothing shows this better, Ruskin thinks, than the two woodcuts he entitles 'The Child's Bedtime' *(cat.160)* and 'He that hath ears to hear, let him hear' *(cat.157)*, usually known as 'The Child' and 'The Senator',

162

163

respectively. Ruskin interprets the second as representing the death of a miser, and contrasts it with the sensationalism of traditional treatments of the theme: no deathbed vision of hell here, but only mean indifference to the prospect of death as 'the rich man counts with his fingers the gain of the years to come'. The very devil at his ear is only 'a paltry, abortive fiend, with no breath even to blow hot with. He supplies the hell-blast *with a machine*' (XXII, 417). The death of a child, especially a country child, was another theme apt to exercise the morbid imagination of the old 'commonplace preacher'. But Holbein admits no flights of angels or flowery consolations into his stark picture of rural poverty: he 'sees the facts' and blanks out the vision (XXII,

416). Botticelli also attacks the 'guilt of wealth', but 'uses neither satire nor reproach' (XXII, 439). 'He engraves the design which, of all his work, must have cost him hardest toil in its execution, – the Virgin praying to her Son in heaven for pity upon the poor: "For these are also my children." Underneath, are the seven works of Mercy; and in the midst of them, the building of the Mount of Pity: in the distance lies Italy, mapped in cape and bay, with the cities which had founded mounts of pity, – Venice in the distance, chief. Little seen, but engraved with the masters loveliest care, in the background there is a group of two small figures – the Franciscan brother' – Fra Marco of Monte Santa Maria in Gallo, the inventor of the 'mount of pity' – 'kneeling, and an angel

of Victory crowning him' (XXII, 439-40). Ruskin is describing a late 15th-century Florentine engraving in the Broad Manner representing *The Preaching of Fra Marco and the Works of Mercy* (Hind B.III.8, I). An impression of an early state of the plate was acquired by the British Museum in 1854, and was probably among the engravings by 'Botticelli' which Ruskin saw there in late September 1872 (see p.84). He reproduced the central 'mount of pity' together with the figure of Fra Marco being crowned by an angel, as the frontispiece to the following month's *Fors* *(cat.161)*. Ruskin describes the angel crowning Fra Marco as an 'angel of Victory', because it is taken, he claims, from a Greek coin showing a winged Victory. The engraving had been attributed to Botticelli by William Young Ottley (1816).

As opposed to the 'immodesty of narrow imagination, trained in self-trust', typical of the northern Reformers, Botticelli's art exhibits 'the modesty of great imagination trained in reverence'. The point is illustrated by comparing the Joshua from the *Prophets* series *(cat.147)*, with two woodcuts by Thomas Bewick *(cats 162, 163)*. All three treat of war, 'and the reforms necessary in the carrying on of war' (XXII, 436). The two woodcuts were made to illustrate a *History of British Birds* published in two volumes in 1797 and 1804. The copy here exhibited was Ruskin's own, and was thoroughly annotated by him, probably while preparing the lectures on engraving. The titles here given Bewick's woodcuts, which were not reproduced in *Ariadne Florentina*, are taken from Ruskin's inscriptions (published in XXX, 281-8).

Bewick's vision of war, in Ruskin's opinion, was informed merely by what was visible of its results from his remote rural vantage-point: 'So, for the pathetic side of the business, he draws you two old soldiers meeting as bricklayers' labourers; and for the absurd side of it, he draws a stone, sloping sideways with age, in a bare field, on which you can just read, out of a long inscription, the words "glorious victory"; but no one is there to read them, – only a jackass, who uses the stone to scratch himself against' (XXII, 437). Botticelli had seen war often, and 'would fain see his

Florence at peace; and yet he knows that the wisest of her citizens are her bravest soldiers. So he seeks for the ideal of a soldier, and for the greatest glory of war, that in the presence of these he may speak reverently, what he must speak'. He chooses 'the soldier who put the children of Israel in possession of their promised land, and to whom the sign of the contest of heaven was given by its pausing light in the valley of Ajalon. Must then setting sun and risen moon stay, he thinks, only to look upon slaughter? May no soldier of Christ bid them stay otherwise than so? He draws Joshua, but quitting his hold of the sword: its hilt rests on his bent knee; and he kneels before the sun, not commands it' (XXII, 437-8).

164

Enlarged copy of Aphrodite riding on a swan from white Athenian patera
?1870
ink, white
515 × 472
Bem.Add.A.75

165

Enlarged copy of part of 15th-century Florentine engraving of Cumaean Sibyl (reversed)
?1872
watercolour, white, pencil
698 × 495
Bem.Add.B.73

The Aphrodite was probably made to be shown during the lectures on sculpture given in 1870, the Cumaean Sibyl for the *Ariadne* series in 1872. The sibyl is reversed, but is clearly taken from the Fine Manner version of the engraving reproduced in *Ariadne*, and not from the Broad, which is also reversed. Only the head and shoulders are given, probably because one of the main focuses of Ruskin's attention in discussing the sibyls was the treatment of hair and head-dress. The symbolism of these elements was first explored in *Aratra*, for example in the comparison between the Aphrodite enlarged here and the Venus from the *Tarocchi (cat.155)*. 'The binding of the hair by the single fillet', commented Ruskin, 'marks the straight course of one great system of art method' from Greece to 15th-century Florence (XX, 338). In

Ariadne, the point was reiterated. The binding of the hair, by fillet or crown, in all the great schools signified obedience: 'Royalty, or kingliness, over life, restraining and glorifying'. It could be seen in the crown of the *Tarocchi Astrologia*, of exactly the same form, Ruskin pointed out, as that of Athena on an archaic coin he had shown his audience two years earlier. The diadem of the Cumaean Sibyl, who is seen as the symbol of enduring life, 'is withdrawn from the forehead – reduced to a narrow fillet – here, and the hair thrown free'. From her Ruskin passes to the Hellespontine Sibyl *(cat.150)*, noting the 'close fillet, and the cloth bound below the face', and finally to the 'loveliest of the southern pythonesses', the Libyan *(cat.148)*. As the voice of God 'springing in desolate places' she is crowned with flowers and grass, her hair knotted. Her conical cap is none other than the Petasus of Hermes, 'the mist of morning over the dew', as befits her role as prophet of the birth-day of Christ, 'the oracle of the temple of the Dew' (XXII, 450-4).

The Florentine Picture Chronicle
A Florentine Picture Chronicle was the title given by Sidney Colvin to his facsimile edition (1898) of an album of 15th-century Florentine drawings, once the property of Ruskin and now in the British Museum. It consists of fifty-five folios (originally fifty-nine), all but three with drawings on both sides in brown ink and wash. The subjects of the drawings, from Biblical history and classical mythology, form what Sidney Colvin described as a 'Universal History before the birth of Christ'. The Chronicle was attributed by Colvin to Maso Finiguerra, but this is now disputed. The artist is thought to be the same as the engraver responsible for the majority of Florentine Fine Manner prints, such as the Planets, Prophets and Sibyls series, traditionally identified as Baccio Baldini.

Ruskin bought the album in the spring of 1873. In mid-February it had been offered to the British Museum by the Parisian dealer Clément, for a thousand pounds. The Museum was unable to afford this, and G.W. Reid, then Keeper of Prints and Drawings, encouraged Burne-Jones, who saw the album while it was at the Museum for inspection, to inform Ruskin of its availability. This he did, describing the drawings at length and with relish: 'Everybody who should be in the book is in it – prophets many and sibyls many – all the Antediluvians in most pretty skin coats – a triumph of Joseph with corn trophies the like was never done for Joseph ... and a golden Calf on such a pillar, which by some means you must get photographed or copied for a future Fors ... O tell me what is to be done there are but 3 or 4 worthless drawings in all the book and the best of them are glorious and there is [?sure] not so much of that age to be saved now' (ALS, EBJ to JR n.d. n.p., Houghton Autograph File). Ruskin was not able to go and look at the book himself, but decided to buy it on Burne-Jones' recommendation: 'I will trust to your dealing in this matter. The Bandini's [sic] I got (on your judgment partly) are among the most precious things I have – and these Sibyls make my mouth water ...' (Memorials II, 21-2). From Burne-Jones' letter it appears that the album had

?Baccio Baldini, Theseus before the labyrinth, from the
Florentine Picture Chronicle, *c*.1460-70, brown ink and wash

been attributed to Benozzo Gozzoli, but
that either Burne-Jones or Reid thought it
'really Paduan or Lombard Work'. This
seems to have encouraged Ruskin to
regard it as by Mantegna, which is how
he evidently described it to Charles Eliot
Norton, to whom Ruskin lent the book
shortly afterwards. The attribution was
confirmed by Norton, who shared Burne-
Jones' enthusiasm for the drawings: 'I
have never seen anything out of Italy in
which there was so much of Italy. It is
simply Italianissimo' (CRN, 287). Ruskin
himself had been disappointed with them:
in a letter to Norton he complained of the
absence, not only of 'native perspective',
but 'of all beauty. Not one face I care for
all through' (CRN, 288). However, he
soon revised this opinion, and was able to
tell Norton on 9 May, 'I like my book now'
(CRN, 291). Norton traced the work of an
'inferior hand' as well as that of the
'master' in the album. Ruskin, on the
other hand, 'thought it all most likely
Mantegna's when he was a boy'. He
wondered, though, whether the fact that
Norton, on the contrary, considered it
'Mantegna at his best', might not mean
they were 'both wrong in calling it his'
(CRN, 288). The attribution was
evidently retained, however, as the two
folios from the album placed by him in his
Sheffield Museum were referred to in Laws
of Fésole (1879) and in the museum
catalogue as by Mantegna.

In 1888, a crisis in Ruskin's financial
affairs led to the Chronicle's being offered
for sale to the British Museum a second
time. Ruskin had by now spent the capital
left him by his father and was dependent
on his portion of the profits on the sale of
his books paid to him on a monthly basis
by his publisher George Allen. Despite
this, Ruskin continued to spend
considerable sums. So that when, in July
1888, Allen was unable to make the usual
payment, partly to cover costs for the new
edition of Modern Painters, and partly to
thwart the Severns, whom he regarded as
parasites, the situation became urgent.
Ruskin was abroad at the time, where
expensive hotel bills only aggravated the
problem. He instructed his cousin to look
out the '15 century book' and send it to
Colvin telling him he might have the
whole for the original price of £1000, or
else the unframed leaves (Ruskin had
unbound the drawings and had framed
fifteen) for £500. But the remnant of the
book could not be found at first, and it was

?Baccio Baldini, Joshua at Jericho, from the *Florentine Picture Chronicle*, c.1460-70, brown ink and wash

not until October that Joan Severn approached Colvin. Meantime Ruskin was obliged to ask the husband of an old pupil of his at Winnington Hall, Dora Livesey, now Dora Lees, for a loan of £500.

Colvin had seen the Picture Chronicle on a visit to Brantwood the previous year and had already expressed an interest in buying it for the Museum to Joan: 'You asked me if ever I saw a chance of my cousin's parting with that "Early Italian Book"', she wrote, 'to let you know' (*ALS*, Letters received 1886-9, Department of Prints and Drawings, BM). She was of course unable to convey Ruskin's real motives for selling, presenting his decision as a passing whim which Colvin would do well to take advantage of; but she made it clear that

Ruskin would require to be paid immediately. Colvin replied that the Museum did not have £1000 at its disposal at present, but that he hoped to interest an agent in advancing the money. The agent was found and the money reached Ruskin's bankers on 20 October. Six days later Ruskin wrote to Joan from Flüelen, 'I have yours of the 24th and enclose with pleasure the receipt for Colvin. I am sure he has done well in buying the book and I shall be very thankful to pay my debt to Mr Lees, – but will keep the full balance at the bankers for a little while' (Rylands 1252/12).

After the book entered the Museum's possession, it became apparent that six leaves were missing. Colvin made enquiries of Joan, who evidently was unable to find the drawings, for in

November 1889, she wrote to Norton asking if he knew of Ruskin's giving any to America or elsewhere. The two leaves at Sheffield had been forgotten; and it was only in 1890, prompted by a letter from the museum's curator on another matter, that Colvin thought to make enquiries after the missing drawings in that quarter. It was agreed by the Trustees of the Guild of St George that the two leaves belonged to the set disposed of by Ruskin, and they were promptly handed over to the British Museum. The remaining four leaves were presumably found at Brantwood after Ruskin's death, as in May 1900 they were given to the British Museum by the Severns.

Ruskin had at one stage meant to place a leaf from the Chronicle at Oxford, as his notes for an intended re-arrangement of

?Baccio Baldini, Medea, from the *Florentine Picture Chronicle*, *c*.1460-70, brown ink and wash

the Rudimentary Series shows. The first drawing in the revised series was to have been of the inscription over the main doorway of the Badia at Fiesole (see cat.215). It was therefore fitting also to close the series with an example of Florentine work and Ruskin chose a drawing whose subject 'as we are told in the inscription, closes the first and begins the second epoch, representing the era of the Patriarchs by the figures of Lamech, Enoch and Tubal-cain – Lamech holding his bow and saying, "I have slain a man to my wounding"; Tubal-cain with his hammer; Enoch supported on the wings of two angels, and raised from the earth in a floating cloud from which two other angels emerge. I do not know anything in studies of this rapid kind more beautiful than the rapt expression of his face, nor anything more convincing than the whole drawing is of the lovely and happy faith of these first Tuscan schools' (XXI, 298).

166, 167, 168, 169
FREDERICK HOLLYER
Four photographs of leaves from the
Florentine Picture Chronicle
i. *Caesar before Florence*
257 × 178
Bem. Phot.1093

ii. *Gideon*
Hollyer's stamp verso
204 × 160 (image)
*The Trustees of the Ruskin Museum, Coniston, Cumbria (*CONRM *1990.444.1)*
EXH: Coniston 1900, 228

iii. *Nebuchadnezar and the three Chaldeans*
Hollyer's stamp verso
223 × 160 (image)
*The Trustees of the Ruskin Museum, Coniston, Cumbria (*CONRM *1990.444.2)*
EXH: Coniston 1900, 229

iv. *Joshua at Jericho*
Hollyer's stamp verso
223 × 167 (image)
*The Trustees of the Ruskin Museum, Coniston, Cumbria (*CONRM *1990.444.3)*
EXH: Coniston 1900, 227

In September 1875, Ruskin wrote to Norton saying that he had 'been trying to get photos of the Italian book for you' (*CRN*, 364). The photographs shown here may have been taken at this time. Hollyer, who photographed Ruskin himself in 1894, specialised in the reproduction of paintings and drawings.

170
EDWARD BURNE-JONES
Sketchbook used in Italy, 1873
29 folios, sheet size 179 × 254; boards covered in white linen
The Syndics of the Fitzwilliam Museum, Cambridge (1070/5)
PROV: Sir Philip Burne-Jones and Mrs Mackail (artist's children); Fitzwilliam, given July 1922.
EXH: Fitzwilliam 1991, 36.

Gimignano. The present sketchbook was used during this portion of the journey. It is open to show a drawing of a *Massacre of the Innocents* (1481) by Matteo di Giovanni, one of the fifty-six large inlaid marble designs decorating the floor of the Duomo and dating from the mid-14th to the mid-16th centuries. Duncan Robinson has pointed out the relevance of such copies for Burne-Jones' own work of this period.

170

LIT: D. Robinson, 'Burne-Jones, Fairfax Murray and Siena', *Apollo*, CII (November 1975)

In the spring of 1873, Burne-Jones made his fourth visit to Italy, together with William Morris. After Venice, they visited the painter Spencer Stanhope in Florence, where it rained for a week. This only confirmed Morris in his poor opinion of Italy, which, together with his relative lack of interest in seeing pictures, made him a trying travelling companion. Burne-Jones therefore stayed on another two weeks after Morris' departure, in which time he visited Siena (where he found 'little Murray' working on his copy of Lorenzetti's Good Government fresco for Ruskin [*cat.187*]), Volterra and San

The *Val d'Arno* lectures, given at the end of 1873, were to have been followed by others on the 'Relations of Outline between Rock and Perpetual Snow in the Alps' in Lent Term. When the time came, however, a state of great emotional stress disabled Ruskin from delivering them, and they were postponed until October: 'I have no heart or strength for *speaking*', he explained to Joan, 'and could not have looked people in the face. The sorrow so sucks the life out of me' (XXIII, xxx). The sorrow was due to Rose. After their meeting in 1872, Ruskin had once more asked her to marry him, and she had again fiercely refused. Now, seriously ill, Rose had returned to England to consult doctors in London. She was staying at the Crystal Palace Hotel, within sight of Ruskin's old house at Herne Hill, from where he wrote to Norton on 11 February, 'But she won't write to me, nor let me see her. She can't live with her own people any more, just now – goes wandering about the world with her maid' (*CRN*, 306).

At the end of March Ruskin left England for Italy, where 'a furious six months work' (*CRN*, 343) would radically alter his conception of early Italian art and advance a return, already under way, to a more explicitly Christian view of morality and religion. This time Ruskin travelled alone, except for Crawley and a German courier named Klein, afterwards to act as his valet; George Allen and Sidney Colvin also joined him for short periods in Lucca and Florence. Connie Hilliard had offered to come, with her brother for chaperon, but Ruskin had refused, 'thinking my Giotto work had better be steady, however sad' (*CRN*, 306).

The 'Giotto work' was the supervision of the making of copies of frescoes at Assisi by the Austrian painter Edward Kaiser (1820-95) for the Arundel Society. After entering Italy by Mont Cenis, Ruskin therefore headed first for Assisi, via Genoa and the coast. In Pisa he allowed himself one day only for essential work; or possibly he did not care to stay longer. 'Fearful gloom in this destroyed place for me', he writes in his diary for 10 April, and in a letter to Norton of the previous day expresses regret at not having drawn the now reconstructed Spina chapel in 1870 when it was still unrestored – 'and the old River quays. Connie's fault – wanting to go to Venice' (*CRN*, 313). However, he enjoyed a walk *outside* the walls *(see cats 179, 180)* and consoled himself in noting 'The courtesy and dignity of the older peasants, and the essential sweetness of character of the people generally, – polluted and degraded as they are' (ALS dated 'Pisa. Thursday. 9th April', Bem. L 39).

Ruskin did not stay long initially at Assisi. After seeing Kaiser settled to work, he left for Rome, where Murray was already engaged in copying the Botticelli frescoes in the Sistine Chapel *(cats 222, 223)*. Ruskin obtained permission to work in the chapel for six months if he chose, but before starting on his drawing left for Sicily, where he was the guest of Sir Henry Yule and his wife, whose daughter Amy had been a pupil at Winnington Hall when Ruskin used to visit it in the late 1850s and early 1860s. After ten days in which Ruskin (at first rather reluctantly) abandoned himself to being shown the sights by the darkly beautiful, vivacious and uninhibited Amy ('my Sicilian witch' [Clegg, 115]), he returned to Rome and began his copy of the figure of Zipporah from Botticelli's fresco of *Moses Slaying the Egyptian (cat.220)*. In Sicily, to all intents and purposes, Ruskin felt he had been in Greece, and the experience told in his partly mythological conception of Botticelli's shepherd-princess, whom he would later describe as the 'Etruscan Athena'.

But Sicily coloured his view of Zipporah in another way too. Flirting had become 'Essential to me' (TS, Bod. MS Eng.Lett.d.1, f.82). In Zipporah he found another 'enchantress', but one, unlike Amy or others, who was unknowing and could raise no feelings of guilt towards Rose (Clegg, 126), indeed might on one level be ideally identified with her. Zipporah thus became the first in a series of art-surrogates with whom Ruskin on this tour engaged in a sort of flirtation via his letters to Joan. Though dominated, Ruskin noted, by 'a great big Rose tree' (ALS dated 'Rome. 16th April', Bem. L 39), he intended that 'pretty Zipporah' should 'make some people jealous' (ALS dated 'Rome. Saturday morning 19th April', Bem. L 39). In the letters to Joan descriptions of the picture and of the specific difficulties encountered in copying it all assume a teasing sexual character, couched in disarming baby-talk; 'Di wee ma, me's nearly driven myself quite wild today with drawing little Zipporah's chemisette – you never did see such a dearly w dear little wimply-dimply, crinkly edge as its got just across four inches under her th[?] chin – and it looks as if the least breeze would blow it loose – and di ma, me do so want to see whats inside it – me don't know *fot* to do' (ALS dated 'Rome, 6th May', Bem. L 39).

From Rome Ruskin returned to Assisi, where he made the first of the two great discoveries of the tour. He himself recounted it three years later in *Fors Clavigera*. While copying Giotto's *Marriage of Poverty and Francis*, 'I discovered the fallacy under which I had been tormented for sixteen years, – the fallacy that Religious artists were weaker than Irreligious. I found that all Giotto's "weaknesses", (so called,) were merely absences of material science ... that the things I had fancied easy in his work, because they were so unpretending and simple, were nevertheless entirely

inimitable; that the Religion in him, instead of weakening, has solemnized and developed every faculty of his heart and hand' (XXIX, 91). At the actual time, however, it was less the work of Giotto than of Cimabue that provoked the recantation; specifically, a Madonna in the lower church of San Francesco, a 'wholly unexpected' find, of which Ruskin immediately informed Norton: 'You will comprehend in a moment what a new subject of investigation this is to me – and the extraordinary range of unexpected interests and reversed ideas which it involves. Giotto is mere domestic gossip – compared to Cimabue. Fancy the intellect of Phidias – with the soul of St John, and the knowledge of a boy of ten years old! in perspective, light and shade &c.' (*CRN*, 318).

While at Assisi, Ruskin also made a careful study of the Duomo – 'all fire and effort at veracity', as he had noted on his last visit (TS, Bod. MS Eng.Misc.c.226, 83) – drawing several of the fierce Lombard animal carvings *(cat.103)*, and drafting part of what would become the first of his autumn lectures on Florentine art, dedicated to Arnolfo di Cambio.

In the middle of July, Ruskin moved to Perugia, where, while continuing to visit Assisi, he drew from Fra Angelico. This was the first time he had done so since 1845, Rome excepted, where he had copied part of the fresco of St Lawrence giving alms in the chapel of Nicholas V in the Vatican. Now at Perugia he was surprised to find his early enthusiasm for the painter still further revive: 'There *is* nothing like him in his own way', he wrote to Joan. 'Lippi gives me more satisfaction, but the passion and heavenliness of Angelico almost force one to believe what he chooses. I have learned a great deal in this last six weeks, but at heavy cost of worry and effort. I don't know if it could have been done with less. I am very glad to have put myself right about Angelico. I had been unjustly dwelling on his weaknesses, and had not seen his best work for too long a time' (XXIII, xlvi).

The worry and effort were only to increase in the next two and a half months, passed between Florence and Lucca, as the new insights came fast on one another and Ruskin struggled, as he told Carlyle, to 'keep up with the story of the magic lantern'. The second major discovery of the tour was made in this period, namely, as summarised again to Carlyle, 'that the old Etruscan race has never failed and that Florentine is all Etrurian Greek – down to the fifteenth century – when it expires in modern confusion' (TS, Bod. MS Eng.Lett.c.40, 28).

From Perugia Ruskin returned to Florence, where his luxuriously appointed hotel room gave him the 'general sense of being in one of the deepest holes of Dante's Inferno … after my cell at Assisi' (XXXVII, 125). Discomfort turned to rage as here and at Arezzo, which he visited from Florence, the 'improvements' confronted him on every side; and Ruskin fed his anger by reading Jeremiah. On 28 July he left for Lucca, a still blessed place by contrast with Florence, though here too Ruskin was to be saddened by change, especially in a walk round San Romano, 'the church where my joy in Italy first began', and now a barracks (TS, Bod. MS Eng.Misc.c.227, 20). He began drawing the Duomo and the effigy of Ilaria del Carretto *(cat.237)*, but soon felt beaten by Ilaria. On 31 July he returned to Florence for the day, probably to take another look at the Spanish Chapel, which he had visited before leaving for Lucca, and which he had immediately asserted to contain 'the greatest *political* fresco of old times' (XXXVII, 136), the *Church Militant* on its right wall. Equally important was the *Triumph of St Thomas Aquinas* opposite, with its assembly of liberal arts and theological sciences: indeed, between them the frescoes represented 'the entire system of Fors politics and morals, superbly painted' (ALS dated '24th August 74', Bem. L 39). The idea that by the following year, or even month, all this painted doctrine might have 'dropped from the wall with the vibration of the railway outside' (XXXVII, 136), made Ruskin decide to prolong his stay in Italy by a month, to commit as much as possible of it to paper.

Meantime he went back to Lucca and continued the struggle for Ilaria, whom the return to religious art, first revealed to him in its proper setting here in 1845, and association with the sick Rose invested with momentous poignancy, not to be translated into line and colour. Ruskin refreshed himself with walks among the vines and chestnuts on the hills to the south and north of the city, idyllically described in letters to Joan. One favourite walk was on the hill overlooking the convent of San Cerbone, sometimes referred to as 'Mamie's [Mrs Hilliard's] convent', near which Connie had lost her cross in 1872 *(cat.177)*. It was not just the scenery in which Ruskin exulted, but the 'perfect possibilities of human life' which it offered, actually realised by the peasants he met, 'the sweetest I have ever known – keeping the manners of their old Ghibelline training, and untainted by any modernism' (TS, Bod. MS Eng.Lett.c.40, 34).

Ruskin's theory of the direct Etruscan descent of the Tuscans was now gathering form, and was also invoked to explain the peasants' character. The 'mark of the race' was even traced in features thought to resemble those found in what Ruskin was coming to think of as a 'pure native Etruscan' school of Romanesque sculpture. Crucial was the

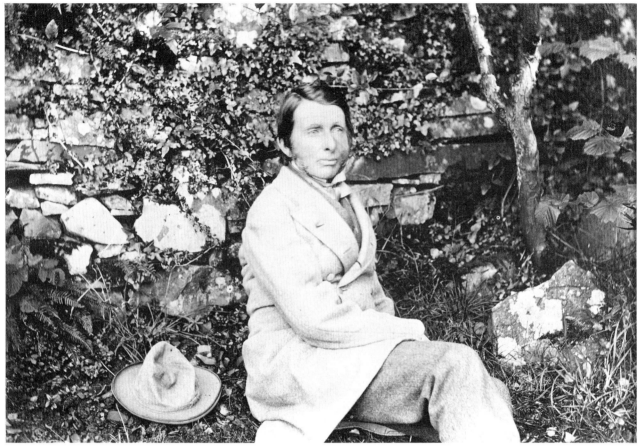

171

discovery of the figure of a reaper representing June, from the series of months carved in relief on either side of the central door of the Duomo. Its inlaid black eyes and straight, furrowed hair were immediately seen to be the same as those of the head on the Baptistery font in Pisa which Ruskin had drawn in 1872 *(cat.125)*. Now he had the clue to the difference between 'Greeks and Greeks' asserted in *Val d'Arno* with respect to that head and the dead Romanesque of the St John Lateran cloister: 'I've found it all out now', he wrote to Norton. 'The effete Greek of St John Lateran is real Byzantine – polluted at Rome to its death. The font of Pisa is native Etruscan. So is that of Pistoja. So are the masons of *Como* – who formed the Free masons. The race has held its own to this day; one of them drove me last night, with the same black eyes that are inlaid on the Font of Pisa – the same sharp ridged nose – a breast like a Hercules' (*CRN*, 326).

On the date of this letter to Norton, 18 August, Ruskin wrote in his diary, 'Woke again at 1/2 past four, head so full of thoughts which I don't like to lose, that I don't know what to do. Must go to Arezzo to draw Etruscan reaping, and as well as here' (TS, Bod. MS Eng.Misc.c.227, 26). In the event he left the next day for Florence, where he was soon busy drawing in the Spanish Chapel and '*finding out things* – of immense importance and value, perhaps one every five minutes or so' (ALS dated '24th Aug 74' Bem. L 39). His artistic explorations among the female personifications of the Liberal Arts were often as at Rome translated into piquant little mock-erotic descriptions for Joan, particularly in the case of Logic, with her closely-fitting white jacket *(cats 178, 191)*.

The letters were partly a diversion from the constant stress of work, and the 'horror of new and new and new sights in Florence' (TS, Bod. MS Eng.Misc.c.227, 36). The mental excitement, the indignation, combined with the unceasing noise of the city, even at night, kept Ruskin from sleeping, despite two changes of room at his hotel. But still the work multiplied as the projects formed themselves in his mind one after another. By the end of August he had begun a lecture on the Baptistery and had drafted part of

an account of the Spanish Chapel. This work led to a scheme for an 'attack on Mr Murray's guides' in the form of 'a *bit* of Ruskin guide-book (at the eleventh hour as usual) for Florence', on which he told Allen on 15 September he was working 'almost night and day' (TS, Bod. MS Eng. Misc.c.227, 29). At this stage Ruskin envisaged three 'mornings in Florence' but a few days later they had become four, and shortly afterwards again increased to five. They were to range from Santa Croce (where Ruskin had been studying the frescoes by Giotto in the Bardi chapel, uncovered in 1852), to Santa Maria Novella (taking in the Spanish Chapel and 'four entirely unknown small frescoes of sweet Giotto' [ALS dated 'Florence 17th Sept. 74', Bem. L 39] in the Chiostrino dei Morti, now usually attributed to Nardo di Cione or his circle), to the Uffizi and the Baptistery. This remained more or less the scope of the book, except for the dropping of the 'Morning' devoted to the Baptistery (but dwelling also on 'old Etruscan Bronzes' [ALS dated 'Sunday 20th Sept 74 / 9 morning', Bem. L 39]), and the addition of that given over to the Campanile, 'The Shepherd's Tower' *(see cats 195-209)*. Ruskin drafted much of *Mornings in Florence*, to be published in parts over the next three years, during this stay.

Nor was this all. Ruskin also found time to take a ladder to pictures by Angelico, Lippi and Botticelli at the Accademia – where Botticelli's *Coronation of the Virgin* and San Barnaba altarpiece in particular left him 'smashed, and mashed and powdered and crushed – and beaten thin' (ALS dated 'Florence 29th [August 1874]', Bem. L 39). He was also drawing from Botticelli's *Primavera* in the Uffizi, and at San Domenico below Fiesole *(cat.212)*, to which he would often resort in the evenings. His discovery of the inscription over the doorway of the Badia *(cat.215)* led to his giving a stonemason some Etruscan letters to cut: 'he can't do it, and I had to kneel down on his shop step in the open street and chisel one out myself' (TS, Bod. MS Eng.Lett.c.40, 22). Little wonder, all told, that both to Susan Beever and himself he should have expressed the fear of breaking down (XXXVII, 138; TS, Bod. MS Eng.Misc.c.227, 35).

Ruskin finally left Florence for Lucca on 20 September, stopping at Pistoia on the way to draw the 'Etruscan' sculpture on the font in the Baptistery *(cats 217, 218)*. The last week at Lucca was spent in work on his Florentine 'Mornings', planning the lectures to follow on the postponed course on mountain form, and to be called *The Aesthetic and Mathematic Schools of Art in Florence*, and walking and drawing in the countryside. But perhaps its chief event, what rendered it memorable, was the receipt of a succession of letters from Rose, who, once again repentant and eager to see Ruskin, had re-established contact, at first through the Severns and Mrs Hilliard, and now directly. So it was once again to meet Rose that at the end of September Ruskin set out for home. At Chambéry he wrote to Joan, 'I past the Cenis, the other way, exactly six months ago – 4th April. It seems hardly an hour since I felt with exultation the train move in the plashing rain – feeling – I was fairly off for Italy – and how much I would do &c &c. And here I am again! I should be thankful for entire safety of accident and illness, for a half year of considerable – (for some people) – risk, in climate, and for any people – hard work – and – for dangers of the way – have I not seen Scylla and Charybdis!' (ALS dated 'Chambery Oct 4th 74', Bem. L 39).

171
FRANK MEADOW SUTCLIFFE
Photograph of Ruskin seated on a bank near Brantwood
1873
135 × 202
Sheffield
(facsimile photograph)

172
Portrait miniature of Rose la Touche
1872
engraved on back of original frame, '1872'
watercolour
55 × 30 (oval)
Sheffield R0003
PROV: Juliet Tyler (Mrs Sidney Morse)

172

1900; Ruskin Museum 1934.
EXH: AC 1964, 284; AC 1983, 22; Whitworth 1989, 23.
LIT: Morley, 222-3

173
Undated note to Joan Severn, with 'Botticelli blot'
Bem.
EXH: AC 1983, 39

174
CHARLES FAIRFAX MURRAY
Self-portrait
1872
Signed 'CFM. PISA/1.72'
watercolour

100×140
Private collection
(shown at Lucca only)

Painted during Murray's first stay in Italy in the winter of 1871-2. It appears, from a consolatory letter sent him by Burne-Jones in December, that Murray's first experience of Italy was not a happy one: 'you will have to look upon Pisa', Burne-Jones suggested, 'as a kind of distant Hastings, where you have gone to winter with Campo Santo thrown in' (ALS, n.d., envelope postmarked 26 December 1871, Burne-Jones Papers XXVI, Fitzwilliam Museum Library, Cambridge).

175
C. F. MURRAY
Sketchbook containing drawings of early Tuscan sculpture and paintings
255×195; bound in vellum
open to show annotated drawing in pen of Archangel Michael weighing souls of dead from unidentified panel painting
Private collection
(shown at Lucca only)

176, 177, 178
Three autograph letters from Ruskin to Joan Severn, 1874
i. Rome, Whit Sunday
ii. Lucca, 8th August
iii. Florence, 29th August
Bem.L. 39
PROV: Severn; Whitehouse (bought at Sotheby's sale, 18 May 1931)

179, 180 (Colour plate X)
Two views of Pisa from outside the walls
1874
i. (upper) inscribed lower right, 'Pisa from walls 9[?th]'
watercolour
125×190
ii. (lower) inscribed lower right, 'Pisa 10th 9th April/Evening'
watercolour
125×190
The Trustees of the Ruskin Museum, Coniston, Cumbria (24)
EXH: RWS 1901, 69 (dated 1882).
LIT: XXXVIII, 275 (?1326, 1327; dated 1882)

Though previously dated 1882, the inscription on the lower drawing shows that this (and doubtless its companion)

174

175

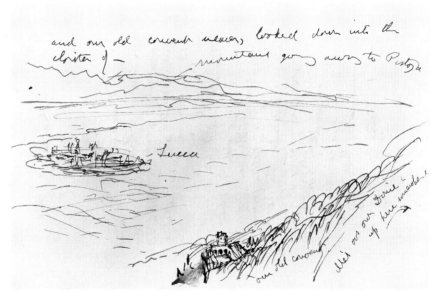

177

were made in 1874, the only year in which Ruskin was in Pisa on this date. An entry in his diary for 9 April 1874 in fact reads: 'To-day all round wall of Pisa, and examine Baptistery' (*Diaries*, 783). Ruskin also mentions the walk in his letter to Joan that day (ALS, Bem. L 39).

181 (Colour plate XI)
'A vineyard walk: lower stone-work of tower, 12th cent'
1874

watercolour, bodycolour, pencil
335×423
Bem.1369
EXH: RWS 1901, 160; FAS 1907, 161; RA 1919, 37; Coniston 1919, 160; AC 1964, 146; London 1969, 34; Kendal 1969, 56; Rye 1970, 27; Portsmouth 1973, 46; Oundle 1977, 28; AC 1983, 199; Maas 1991, 23.
LIT: XXXVIII, 264 (1055); Whitehouse, 82; Walton, 112

The subject of this well-known drawing

has now been identified as the campanile of a small Romanesque church in the hamlet of Pozzuolo, just above Lucca to the south-west.

The present is the full title given the drawing by Cook and Wedderburn in their catalogue, where it is included among drawings from Lucca, and dated 1874. It was exhibited under the same title, also placed in inverted commas, in 1901. The source for the title is not known: there are no inscriptions on the drawing itself, nor, being undated, is it listed in Collingwood's earlier catalogue of Ruskin drawings. However, now that the subject of the drawing is known, entries in Ruskin's diary written at Lucca in 1874 confirm the date usually given, and suggest Ruskin himself as a source for the title. On 18 August he writes, 'Then up to village with old masonry in tower ...' (*Diaries*, 805); and on 24 September, 'Up to country church and drew well ...' (*Diaries*, 812).

Perfect Government and Education

182
Holograph MS of end of Ch.X, Val d'Arno
Bem.MS 51/L

183
Val d'Arno, Lecture X, 'Fleur de Lys' (original part in original paper covers)
Bem.14.2

184
Mornings in Florence, Being Simple Studies in Christian Art for English Travellers
Sheffield

185
Fleur-de-Lys (Iris Florentina)
1871
watercolour, pencil
312 × 216
The Visitors of the Ashmolean Museum, Oxford (Ed.12)
EXH: AC 1983 (231).
LIT: XXXVIII, 259 (891)

On 18 May 1871 Ruskin wrote to Charles Eliot Norton of his plans to donate £5000 to appoint a sub-master of drawing at Oxford, adding that he was 'painting the white Florentine lily for him to teach with ...' (*CRN*, 230). *Lily*, by virtue of its association with the heraldic *giglio* of Florence. Indeed, Ruskin's purpose in drawing the *Iris Florentina* for his schools was not simply that the student should learn to draw it correctly (taking care, as instructed in the catalogue to the collection of examples, 'to get the perspective of the divisions of the left-hand sepal'). The drawing would also teach him something of the natural and national mythology of flowers. On the one hand, here was 'the most lovely expression among plants of the floral power hidden in the grass, and bursting into luxuriance in the spring', and for this reason (so Ruskin thought) associated by the Greeks with Cora and Triptolemus, whose 'triple sceptre' he identified with this flower. The 'authoritative' disposition of its petals rendered it a symbol not only of the upswelling but also of the subduing of vegetative force, and so of the domination of inchoate matter by cosmic law (XXI,

185

113). Hence, too, was it fitted, as the *fleur de lys*, to become the flower of chivalry, indeed the emblem of 'the utmost brightness and refinement of chivalry in the city which was the flower of cities' (XIX, 373).

Ruskin also placed a drawing of one of the *red* lilies from the base of Giotto's campanile later in the same series (once no.211, but afterwards removed). In *Val d'Arno* he reads much into the fact that the Florentines had reversed the colours of the city's flag after the 1250 revolution which had established 'republican' rule. Oxford students were exhorted to 'draw that red lily then, and fix it in your minds as the sign of the great change in the temper of Florence, and in her laws, in mid-thirteenth century' (XXIII, 67).

186
ANON
Photograph of the pulpit by Nicola Pisano, Baptistery, Pisa
533 × 403
The Visitors of the Ashmolean Museum, Oxford (Ref.163)
LIT: XXI, 42
(facsimile photograph)

In his lecture on Nicola Pisano (20 October 1873), first of the *Val d'Arno* series, Ruskin stressed the novelty of the trefoils introduced by the sculptor in the arches of this pulpit. They signified the

change, he asserted, for all Europe, from the architecture of the Parthenon to that of Amiens. For here was the 'first architecture of Gothic Christianity'. The statement prompted a reflection on the special character of Christian architecture: 'All other noble architecture is for the glory of living gods and men; but this is for the glory of death, in God and man. Cathedral, cloister, or tomb, – shrine for the body of Christ, or for the bodies of the saints. All alike signifying death to this world; life, other than of this world' (XXIII, 22).

In another lecture of the same series, Ruskin pointed out how the trefoils were not only 'without structural office', but also 'struck out by Niccola so roughly that there is not a true compass curve or section in any part of it. Roughly, I say. Do you suppose I ought to have said carelessly? So far from it, that if one sharper line or more geometric curve had been given, it would have caught the eye too strongly; and drawn away the attention from the sculpture' (XXIII, 96).

187 (Colour plate XV)
C. F. MURRAY, after Ambrogio Lorenzetti
Allegory of Good Government
1873
bodycolour
396 × 940
Bem.375
LIT: Harris, 1991

188
C. F. MURRAY
Sketchbook used 1873-5
bound in vellum, inscribed on cover, 'Book of Sketches from Italian Paintings. Bequeathed by J. R. Holliday, Aug.1927' open to show studies of quadrilobates from Lorenzetti's *Allegory of Good Government*, f.5
The Syndics of the Fitzwilliam Museum, Cambridge (1042)
PROV: J. R. Holliday.
LIT: D. Robinson, 'Burne-Jones, Fairfax Murray and Siena', *Apollo*, CII (November 1975); Harris, 1991

In 1873, Ruskin commissioned Murray to make copies from the Botticelli frescoes in the Sistine Chapel, intending to put them at the disposal of the Arundel Society. In the event, the present drawing

was the first commission actually executed by Murray for Ruskin. After arriving in Italy some time in March Murray had been taken ill and had been obliged to delay his journey to Rome. In early May he was in Siena, where Ruskin instructed him to 'make what you can of the Peace' and the 'pretty virtues' in Lorenzetti's *Allegory of Good Government*, one of a cycle of frescoes painted in a room of the Palazzo Pubblico between 1338 and 1341, illustrating the nature and effects of good and bad government. An enthroned figure symbolising wise civic government (often referred to as a 'king') is shown flanked by Magnanimity, Temperance and Justice (on his left hand), and Prudence, Fortitude and Peace (on his right). Above him are Faith, Hope and Charity. At the extreme left of the fresco is another representation of Justice, her eyes turned upwards to the figure of Wisdom. Below Justice sits Concord, gathering with one hand two ropes attached to the scales of Justice, which she then passes on, twined, to a line of citizens. On her knees Concord has a plane signifying equity.

In answer to a letter from Murray asking for more detailed directions, Ruskin wrote, 'I can only say – do any face that strikes you – In this composition I care more for completeness of record, than for accurate copying. There is nothing in it that I esteem exquisite as painting: but all is invaluable as design and emotion. Do it as thoroughly as you can, pleasantly to yourself. For me – the Justice and Concord are the importantest' (ALS, Morgan MA 2150/17).

Ruskin had written of the fresco in *The Political Economy of Art* (1857). He there stressed the particular interpretation given by the painter to the three theological virtues. Faith here meant not just religious faith, but 'the faith which enables work to be carried out steadily, in spite of adverse appearances and expediencies; the faith in great principles, by which a civic ruler looks past all the immediate checks and shadows that would daunt a common man, knowing that what is rightly done will have a right issue'. Hope was not just 'heaven-ward hope which ought to animate the hearts of all men', but signified that all good government 'is expectant as well as conservative; that if

it ceases to be hopeful of better things, it ceases to be a wise guardian of present things'. And the peculiar office of Lorenzetti's Charity was to crown the King, 'since in the first place, all the authority of a good governor should be desired by him only for the good of his people, so that it is only Love that makes him accept or guard his crown: in the second place, his chief greatness consists in the exercise of this love, and he is truly to be revered only so far as his acts and thoughts are those of kindness; so Love is the light of his crown, as well as the giver of it: lastly, because his strength depends on the affections of his people, and it is only their love which can securely crown him, and for ever. So that Love is the strength of his crown as well as the light of it' (XVI, 54).

The gold frame, inscribed with the title 'The Policy of Siena', is probably the original.

A sketchbook now at the Fitzwilliam (*cat.188*) contains drawings by Murray of some of the quadrilobates from the border of the *Good Government*, decorated with representations of the Liberal Arts.

189, 190, 191
Three studies of frescoes by 'Simon Memmi' (Andrea di Bonaiuto) in Spanish Chapel, Santa Maria Novella, Florence
1874
i. *The Church Militant* (sketch of whole fresco)
pencil, watercolour, bodycolour
131 × 152
Brant.916

ii. *Pope and Emperor* (detail from *The Church Militant*)
watercolour and bodycolour over pencil
495 × 329
The Visitors of the Ashmolean Museum, Oxford (Ref.123)
LIT: XXXVIII, 252 (717)

iii. *Logic and Rhetoric* (detail from *The Triumph of St Thomas Aquinas*)
watercolour and bodycolour over pencil
422 × 290
The Visitors of the Ashmolean Museum, Oxford (Ref.122)
EXH: AC 1954, 39.
LIT: XXXVIII, 252 (715)

190

191

The frescoes from which these studies
were made decorate opposite walls of the
Spanish Chapel, once the chapter house,
of Santa Maria Novella. The chapel has
been so called since 1540, when it was
assigned by the Grand Duchess Eleonora
of Toledo to the Spanish members of her
suite. The *Church Militant*, to the right of

the altar, celebrates the mission, works
and triumph of the Dominican order,
while the fresco opposite depicts St
Thomas Aquinas amid prophets and
apostles, with the theological and cardinal
virtues above, and, below, female
personifications of seven Theological
Sciences and the seven Liberal Arts, each
with a historical representative at her feet.
Prior to the 19th century the frescoes were
ascribed, following Vasari, to 'Simon
Memmi' (*alias* Simone Martini) and
Taddeo Gaddi. The tradition was first
called into question in 1827 by Rumohr,
and in the mid-1860s Crowe and
Cavalcaselle re-attributed the frescoes to
one Andrea da Firenze, by this date known
to be the painter of the part of the *San
Ranieri* cycle in Pisa, also given by Vasari
to 'Simon Memmi' *(see cat.34)*. This
Andrea was subsequently identified as
Andrea di Bonaiuto, from a document
dating the commission at 1365.

The question of the frescoes' authorship
puzzled Ruskin too: 'I can't make out
whose they are', he wrote to Norton: 'not
Gaddi – nor the man called Simon Memmi
at Assisi' (Ruskin is referring to frescoes in
the lower basilica at Assisi, traditionally
ascribed to Giotto, but earlier in the
century attributed to Martini) (*CRN*, 323).
After a month's drawing in the Spanish
Chapel, Ruskin decided, partly to spite the
modern masters of attribution and partly
for love of the story of Taddeo's brotherly
ceding of the commission to Simone, that
'poor old Vasari' had been right. Taddeo,
he concluded, had painted the ceiling and
the upper part of the *Triumph of St
Thomas*, Simone the rest. But if Vasari
was right, then the frescoes at Assisi could
not be Simone's, for these, as Ruskin
wrote to Murray, were by 'a vulgar brute
– whoever he is'. One thing was sure: for
Ruskin, as for Vasari and Crowe and
Cavalcaselle, the Spanish Chapel and the
San Ranieri frescoes in Pisa were by the
same man.

Ruskin's most extensive comments on
the frescoes are in *Mornings in Florence*,
where he dedicated a whole 'Morning'
(issued in 1876) to the interpretation of the
Triumph of St Thomas Aquinas. His title
for the fresco, 'The Strait Gate', from the
narrow archway through which Grammar
is shown encouraging her pupils to pass,

stressed its didactic character: 'Here ...
you have pictorially represented, the
system of manly education, supposed in
old Florence to be that necessarily
instituted in great earthly kingdoms or
republics, animated by the Spirit shed
down upon the world at pentecost'
(represented on the ceiling directly above
this fresco) (XXIII, 379). The key to the
whole was the writing on the book held
open by Aquinas, which Ruskin
translated, '"I willed, and Sense was given
to me./I prayed, and the Spirit of Wisdom
came upon me,/And I set her before
(preferred her to) kingdoms and thrones"'
(XXIII, 383). Ruskin interpreted this as
meaning that, whereas education in the
Earthly Sciences (the seven Liberal Arts)
was dependent on *volition*, the Heavenly
or Theological Sciences (Ruskin follows
Lord Lindsay in his identification of the
other seven allegorical figures) may only
be acquired by *petition*.

In considering the figure of Rhetoric,
Ruskin stressed her commanding but
'cool' stance. Rhetoric was the art of
speaking, 'primarily of making oneself
heard therefore: which is not to be done by
shouting'. Unlike the other sciences, or
indeed the modern Florentines, she had no
use for her hands, except to carry her
scroll, which however was not 'thrust
forward to you at all, but held quietly
down with her beautiful depressed right
hand'. The scroll reads 'Mulceo, dum
loquor, varios induta colores' (I caress as
I speak, dressed in many colours). 'Her
chief function, to melt; make soft, thaw
the hearts of men with kind fire; to
overpower with peace; and bring rest, with
rainbow colours. The chief mission of all
words that they should be of comfort'
(XXIII, 389-90). Ruskin found his
interpretation of Rhetoric confirmed in the
figure of Cicero below her, though the fact
of his having three hands seemed to
contradict it. Yet the only entirely genuine
hand in Ruskin's view (therefore the only
one drawn by him) was the hand
supporting the chin; and the gesture
implied that Cicero was 'not speaking at
all, but profoundly thinking *before* he
speaks'. Ruskin considered Cicero's face
the most beautiful among those of the
philosophers portrayed, even if retouched:
indeed, he uncharacteristically attributed

its peculiar beauty precisely to the caution and skill with which this had been done (XXIII, 390-1).

The placing of Logic, the science of reasoning, after Rhetoric, implied that 'though you must speak before you have been taught how to speak, you may yet properly speak before you have been taught how to think'. Of this figure, with her branch and scorpion, symbols of syllogism and dilemma, nearly all was safe, 'the outlines pure everywhere, and the face perfect: the prettiest as far as I know, which exists in Italian art of this early date. It is subtle to the extreme in gradations of colour: the eyebrows drawn, not with a sweep of the brush, but with separate cross-touches in the line of their growth – absolutely pure in arch; the nose straight and fine; the lips – playful, proud, unerringly cut; the hair in sequent waves, ordered as if in musical time; head perfectly upright on shoulders; the height of the brow completed by a crimson frontlet set with pearls, surmounted by a fleur-de-lys'. Ruskin's diary shows that he also drew a real-size copy of this face, which however has not survived (Diaries, 808). Below Logic is a figure which Ruskin interpreted as Aristotle, but which Vasari and others have identified as Zeno, 'intense keenness of search in his half-closed eyes' (XXIII, 391-2).

Ruskin intended to supply a similarly detailed interpretation of the Church Militant in Mornings in Florence. However, its account of the Spanish Chapel was interrupted after the description of the Triumph of Aquinas, 'until one of my good Oxford helpers, Mr Caird, has completed some investigations he has undertaken for me upon the history connected with' the opposite fresco. Caird was to write a supplement to Mornings in Florence on the subject. Entitled 'The Visible Church', it was set up in type but not published until included in the Library Edition. Meanwhile Ruskin supplied a 'brief map' of the Church Militant – 'the Pilgrim's Progress of Florence' – for his readers (cat.189):
'On the right, in lowest angle, St Dominic preaches to the group of Infidels; in the next group towards the left, he (or some one very like him) preaches to the Heretics: the Heretics proving obstinate,

he sets his dogs at them [black and white like the robes of the Dominicans, or Domini canes, hounds of the Lord], as at the fatallest of wolves, who being driven away, the rescued lambs are gathered at the feet of the Pope ... The Church being thus pacified, is seen in wordly honour under the powers of the Spiritual and Temporal Rulers. The Pope, with the Cardinal and Bishop descending in order on his right; the Emperor, with King and baron descending in order on his left; the ecclesiastical body of the whole Church on the right side, and the laity, – chiefly its poets and artists, – on the left.

Then, the redeemed Church nevertheless giving itself up to the vanities and temptations of the world, its forgetful saints are seen feasting with their children dancing before them (the Seven Mortal Sins, say some commentators). But the wise-hearted of them confess their sins to another ghost of St Dominic; and confessed, become as little children, enter hand in hand the gate of the Eternal Paradise, crowned with flowers by the waiting angels, and admitted by St Peter among the serenely joyful crowd of all the saints, above whom the white Madonna stands reverently before the throne. There is, so far as I know, throughout all the schools of Christian art, no other so perfect statement of the noble policy and religion of men' (XXIII, 411-12).

192

C. F. MURRAY, after Botticelli
'University Education of a noble Florentine youth'
1881
watercolour
550 × 810
Keble College, Oxford (on loan from Ashmolean Museum from 1983)
PROV: Ruskin commission 1879.
EXH: Manchester 1904, 215.
LIT: XXI, 299-300
(not in exhibition)

On 25 October 1879 Ruskin wrote to Murray, now living in Florence, requesting 'some notes of the Botticelli frescos in some villa on the way to Fesole – I've seen photos of them quite divine – but can't make out subjects – I believe said to be from Boccaccio ...' (Morgan MA 2150/69). The villa in question was just outside

Florence in the direction, not of Fiesole, but Sesto Fiorentino. Its owner, named Lemmi, had discovered the frescoes under a coat of whitewash in 1873. In 1882 two were bought by the Louvre, where they were let into the wall at the entrance of one of the upper galleries (Louvre R321/2). In the one a young man is introduced to the assembled seven Liberal Arts, presided over by a figure which has been identified as Phronesis or Philosophy. In the other, a young girl is presented to Venus by the Graces. It used to be thought that the frescoes celebrated the marriage of Lorenzo Tornabuoni and Giovanna degli Albizi, but this is now disputed.

Murray copied the fresco with Venus and the Graces first, completing the drawing by June 1880. Ruskin was full of praise ('It is the first finished drawing of yours with which I have been wholly satisfied') and urged Murray to 'do what else is in that room, at your fastest convenience for me ...' (ALS, Morgan MA 2150/79). The second copy reached Ruskin some time the following year, and was paid for in October – price, as for the first, £100.

For Ruskin, the 'myth' of these frescoes was 'the Divine Love and Wisdom in Human Education'. The theme was later expounded in the third of the Art of England lectures (May 1883), when Murray's two copies were shown as examples of 'quite central and classic Florentine painting'. 'Their subjects should be of special interest to us in Oxford and Cambridge, as bearing on institutions of colleges for maidens no less than bachelors. For these frescoes represent the Florentine ideal of education for maid and bachelor, – the one baptized by the Graces for her marriage, and the other brought to the tutelage of the Great Powers of Knowledge, under a great presiding Muse.' If uncertain who this Muse was (he elsewhere identifies her with 'Heavenly Wisdom'), Ruskin was sure of the crucial significance of a detail which, as he indignantly told his audience, had been cut away from the original during restoration at the Louvre: 'observe, that, as in the frescoes of the Spanish Chapel, before he can approach that presence he has passed through the "Strait Gate", of which the bar has fallen, and the valve is

thrown outwards' (XXXIII, 313-15). It is surprising, given that Ruskin made this precise iconographical connection between the present fresco and those of the Spanish Chapel, that he should also have had doubts about the identity of the figure leading the young man in, whom Herbert Horne, on the basis of other iconographical correspondences with the Spanish Chapel Liberal Arts, and without reference to the excised gate, identifies as Grammar (Horne, 145-7).

The present copy used to hang on the walls of the Drawing School at Oxford, where it bore the inscription 'The scheme of University Education for a noble Florentine youth'. Its companion, entitled by Ruskin 'The Education of a girl', was intended for Somerville College, but is not there now.

Etruscan Christianity

193

HENRY RODERICK NEWMAN
Piazza del Duomo and east face of Baptistery, Florence
1881
signed bottom right, 'H. R. Newman 1881'
watercolour
782 × 643
Sheffield R19
PROV: Ruskin 1881; Guild of St George (Bewdley 1887-90, Ruskin Museum 1890).
LIT: Morley, 122

194

H. R. NEWMAN
South door of the Duomo, Florence (Porta dei canonici)
1881
signed bottom left, 'Henry Roderick Newman/1881'
watercolour, bodycolour
793 × 650
Sheffield R21
PROV: Ruskin Commission 1881; Guild of St George (Whitelands College, Putney 1890, Ruskin Museum 1890).
EXH: 'Artistic & Natural Beauty', Sheffield 1959, 16.
LIT: Forman, 531; Morley, 123

Both drawings were bought by Ruskin for the Guild of St George in 1881. At Sheffield they were to have been placed alongside the Verrocchio *Madonna and Child* bought for Ruskin by Charles Fairfax Murray, 'to show how, for 500 years, Italy remained steadfast to what may be, in all its branches, called "art of precision", doing everything as accurately, finely and thoroughly as possible' (XXX, 208). The drawing of the Porta dei canonici *(cat.194)* (of the two doors on the south side of the Duomo, the one closer to the transept) was a copy of one Ruskin had seen in 1880. Despite his offer of 200 guineas, Newman had preferred to sell it in America. Ruskin replied, 'I should be well pleased that it stayed in America if your countrymen outbid me – and that you did another for me' (XXX, 208n). In his unfinished Sheffield catalogue, Ruskin wrote of the drawing, 'Exquisitely rendered in the colour of the marble, remaining still uninjured by restoration, except in the

clearly visible white patches of fresh stone and the upper crockets of the gable' (XXX, 208; and see above, p.64). H. Buxton Forman tells how further restoration to the doorway was suspended at Newman's request so that he might finish his drawing.

The drawing of the Baptistery *(cat.193)* was described by Ruskin as 'an exquisitely careful rendering of the effect of the marble walls of this building, seen in half light, reflected from the façade of the Duomo. The gate is the one of which the valves were executed by Ghiberti with a skill which has ever since been the admiration of Europe.' It was bought for £105 (XXX, 208).

Newman's drawing of the Piazza del Duomo illustrates a central piece of late Ruskinian topography. In his lecture on Ghiberti (November 1874) for the *Aesthetic and Mathematic Schools of Art in Florence* series, Ruskin told his students, 'All that is needful for you to learn essentially of the history of Italian architecture may be learned on the little area, scarcely larger than a peasant winnows his corn upon, of smooth pavement between the Baptistery of Florence and Giotto's Tower' (XXIII, 239). Indeed, as he had already stated in the second lecture on engraving, the 'whole history of *Christian* architecture and painting' began with 'this Baptistery, and its associated Cathedral'. Yet if the Baptistery was 'the centre of Christian knowledge and power' (XXII, 343) it was because its was also the consummation of the native Greek, or Etruscan, tradition. The Baptistery was 'the last building raised on the earth by the descendants of the workmen taught by Dædalus', just as Giotto's Campanile opposite was 'the loveliest of those raised on earth under the inspiration of the men who lifted up the tabernacle in the wilderness'. The centrality of this particular spot lay in the concourse of two cultural traditions. 'For there the traditions of faith and hope, of both the Gentile and Jewish races, met for their beautiful labour' (XXIII, 413).

But that was in the past. In modern Florence, as Newman's drawing also records, the area Ruskin had indicated was still a point of concourse, but of a different character. In the lecture on

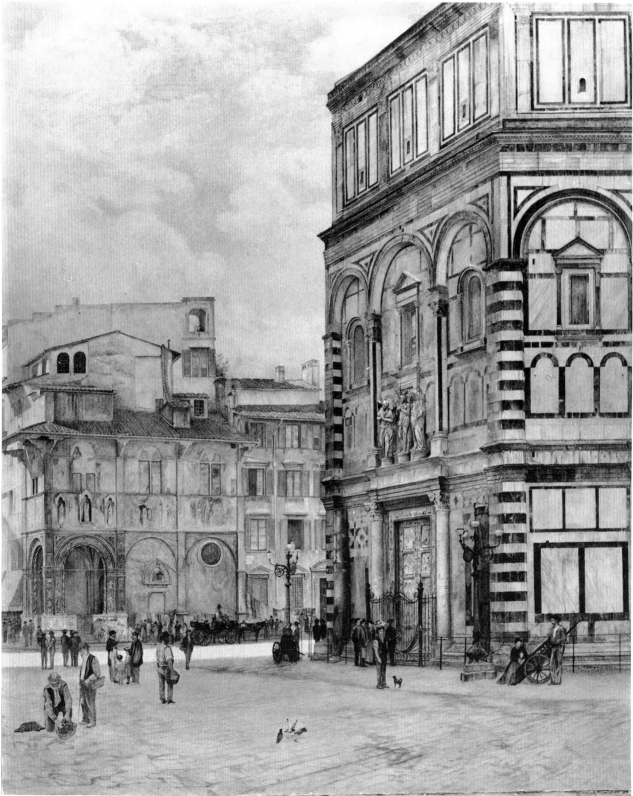

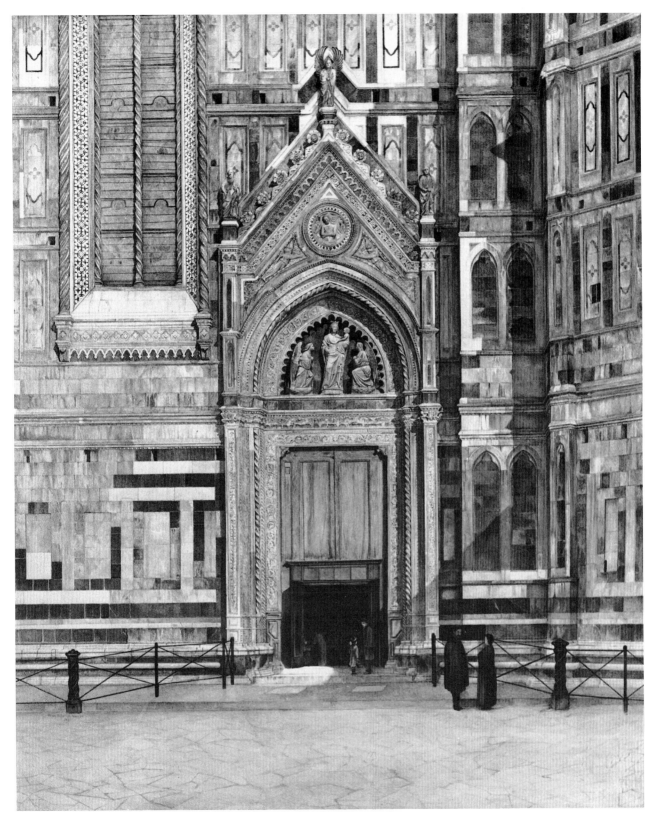

194

Ghiberti, Ruskin had to warn his students, 'You can't stand … where I want you to stand, between the Baptistery and the Cathedral, for that is now the main place for omnibus traffic' (xxiii, 240). An unpublished note in his Florence diary for 1874 shows he planned an assault in *Fors* on the subject: 'Fors on sacredness – Baptistery here, with hack[ney] carriages at its gates – The Arno, and Rhine at Lauffenbourg, recipients of sacred gifts from the people's – back chambers …' (TS, Bod. ms Eng.Misc.c.227, 28). Ruskin held fire until Part VI (1877) of *Mornings in Florence*, where the hackney coaches, 'with their more or less farmyard-like litter of occasional hay, and smell of variously mixed horse-manure', occasion a vision of scatological defilement: 'Deluge of profanity, drowning dome and tower in Stygian pool of vilest thought – nothing now left sacred, in the places where once – nothing was profane' (xxiii, 414).

195-209

ANON

Photographs of fifteen carved marble panels from base of Giotto's Campanile, Florence

numbered on the back by Ruskin

i. [2.] 'Creation of Woman' (245 × 203)
ii. [3.] 'Original Labour' (252 × 193)
iii. [4.] 'Jabal' (247 × 205)
iv. [10.] 'Pottery' (248 × 201)
v. [11.] 'Riding' (247 × 202)
vi. [12.] 'Weaving' (246 × 205)
vii. [14.] 'Dædalus' (247 × 207)
viii. [17.] 'Ploughing' (247 × 205)
ix. [19.] 'The Lamb with the Symbol of Resurrection' (247 × 205)
x. [20.] 'Geometry' (247 × 200)
xi. [21.] 'Sculpture' (247 × 203)
xii. [22.] 'Painting' (247 × 205)
xiii. [24.] 'Arithmetic' (246 × 203)
xiv. [25.] 'Music' (247 × 201)
xv. [27.] 'The Invention of Harmony' (247 × 205)

Bem.Phot.2133-5, 2141-3, 2145, 2148, 2150-3, 2155-6, 2158

210

ANON

Photograph of 'Creation of Adam and Eve and the Fall' by Ghiberti from Porta del Paradiso, Baptistery, Florence
Bem.Phot.2122

195

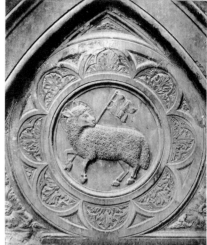

203

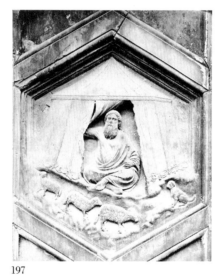

197

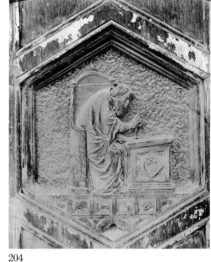

204

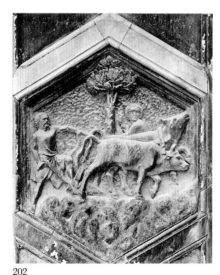

202

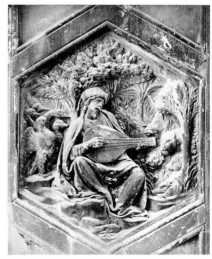

208

211

*The Laws of Fésole. A Familiar Treatise
on the Elementary Principles and Practice
of Drawing and Painting. As Determined
by the Tuscan Masters. Vol. I.*
Orpington, Kent: George Allen, 1879
open to show fig.1, p.12
Sheffield R0907

The sacredness of 'beautiful labour',
was precisely the teaching, as Ruskin read
it, of the carved panels decorating the base
of Giotto's Campanile. He had sketched
that of Jabal *(cat.197)* long ago in 1845
(Bem. MS 5A, f.8v.), and in 1872 had also
drawn 'Painting' and 'Music' (Brant. 910;
see cats 206, 208). Two years later 'his last
piece of work in Florence', as he told
Norton, was to have the whole series
photographed (*CRN*, 343). It was
probably the close study of these
photographs, more than of the panels
themselves, that informed the account
given in the sixth of the *Mornings in
Florence*, 'The Shepherd's Tower' (1877).
For in Florence that year Ruskin's time
was largely taken up with drawing and
writing on the frescoes in the Spanish
Chapel and Santa Croce, and none of the
various plans for the book drawn up
during this stay include a section on the
Campanile. In 1876 Ruskin had the
Florentine firm of Brogi take a new set of
photographs of the reliefs, after
discovering that the original series had
'got bought up by the Florentine dealers,
and … could only be got in what I held to
be damaged states, trimmed at the
margin, and the like' (XXIII, 464). When
the negatives were finally obtained from
Brogi (Murray was instructed to go and
claim them in June 1879), they were
placed in the hands of Ruskin's assistant,
William Ward and, in 1881, satisfactory
impressions were issued as a supplement
to 'The Shepherd's Tower'. The
photographs shown here, from a set
belonging to Ruskin, are not those
published in 1881, and may therefore be
assumed to be those taken in 1874.

The Campanile was begun to Giotto's
design in 1334, and was continued after
his death three years later under the
supervision of Andrea Pisano. Tradition
ascribes the design and actual carving of
some of the reliefs set into the first zone to
Giotto himself. But this remains a matter
of controversy, as does Andrea Pisano's

part in their conception and execution.
Certainly, neither was responsible for the
execution of five of the panels on the north
face, for which Luca della Robbia received
a commission a hundred years later.
However, the subjects of these five
hexagons have also been much debated,
and it is uncertain whether they have even
any precise iconographical relation to the
other twenty-one of the first zone. The
original series begins with the Creation of
Adam and Eve and their first labours, and
continues with the Biblical inventors of
various crafts and activities, and then
what are now generally recognised as
representations of the seven *Mechanical
Arts*, punctuated by the figures of two
mythological patrons of human art and
civilization. Some have sought to identify
the seven figures carved on Luca's five
panels as the Liberal Arts, but there are
problems in this, not least the fact that
when Luca received the commission,
reliefs of the Liberal Arts had already been
placed in the second zone. Though aware
that five were by Luca, Ruskin included all
twenty-six hexagons of the first zone in a
progressive 'plan of civilization' ('Giotto's
Darwinian theory of development', he
called it), which took into account their
order and architectural disposition.
Crucial was the interruption of the series
by the doorway, with the Lamb, symbol of
Christ the Redeemer, carved over it, for
this marked 'the great division of
Christian and pre-Christian arts'. The four
sides of the tower corresponded to 'four
successive historical periods'. The first
showed that of 'nomad life, learning how
to assert its supremacy over other
wandering creatures, herbs and beasts,
Then the second side is the fixed home life,
developing race and country; then the
third side, the human intercourse between
stranger races; then the fourth side, the
harmonious arts of all who are gathered
into the fold of Christ' (XXIII, 420).
Adherence to this scheme involved, among
other things, the interpretation of *cat.198*
as 'Pottery' ('The first civilized furniture;
the means of heating liquid, and serving
drink and meat with decency and
economy'), ignoring its possible
identification as Medicine, which Ruskin
would have found discussed by Lord
Lindsay, and which is now the preferred

reading, owing to Medicine's being one of
the *Artes Mechanicae*.

In the lecture on Ghiberti and again in
Mornings in Florence, Ruskin contrasts
'Giotto's' understanding of early Biblical
history, as seen in the reliefs of the
Campanile, with Ghiberti's, as seen in the
Porta del Paradiso of the Baptistery
opposite. In the lecture, Ruskin's principal
concern is the distinction between the
'Aesthetic' and 'Mathematic' schools of
art in Florence. By the former, he meant
the school of Giotto, the 'perfect school of
Christian art' formed in Florence around
1300, from the mingling of northern and
southern strains of 'savage art', and which
'had, by reason of use, its senses exercised
to the discernment of good from evil'. The
Mathematic school on the other hand
(Brunelleschi, Jacopo della Quercia and
Ghiberti), was the school of 'scientific
form' which prevailed a century later,
'dextrous in the representation of all
natural objects – chiefly the body of man'
(XXIII, 185-6). But the Mathematic school,
Ruskin explained, would never have
displaced the Aesthetic without the
'accomplished grace and infinitely
decorative invention of Ghiberti' (XXIII,
242). An example of such grace was to be
had in the panel from the Porta del
Paradiso representing the Creation of
Adam and Eve and their expulsion from
Eden *(cat.210)*. 'It is constructed like a
heraldic shield', comments Ruskin, in
which protagonists become mere
'supporters' to the central 'apparition of a
pretty woman … This is not the beginning
of Creation, but of operatic scenes from it.'
Ghiberti's relief is a 'coldly mellifluous'
composition, in which Biblical tradition is
either ignored (Eve is raised from Adam's
shoulder, not his side), or else
hypocritically relegated to a corner (like
the embarassing serpent and apple).
Giotto, on the other hand, excludes
altogether what he knows nothing of. So
that in the succession of episodes from
Genesis chosen by him for the Campanile
reliefs, there is 'Actually no Fall of Man …
All the sacrificing, murdering, cursing,
missed out. "I know nothing of all that. I
know sheep must be fed, and shepherds
live in tents". And hence, on the exact
centre of his tower, he carves his own early
life' (XXIII, 247).

Ruskin is referring to the fourth relief in
the series *(cat.197)*, which shows Jabal,
described in Genesis as 'the father of all
such as dwell in tents, and of such as have
cattle'. He also alludes to the story, told by
Vasari, of the artist's having been found,
a shepherd boy, by Cimabue, drawing one
of his sheep on a stone. But the central
position accorded this relief was of more
than autobiographical significance, just as
the legend of Giotto's boyhood was not the
only reason why Ruskin called his
Campanile 'The Shepherd's Tower'. In a
lecture delivered at Eton after his return
from Italy in 1874 Ruskin used this relief,
in particular the detail of the puppy, to
illustrate his thesis of the Christian
flowering in Giotto's Florence of an
ancient and unbroken native Etruscan
tradition. The Etruscans, though warriors,
were essentially a pastoral race: 'Living on
their own land as shepherds and
husbandmen; holding first the Greek
religion and then the Christian in sincerity
and intensity never elsewhere paralleled'.
Small wonder, then, that Giotto should
have chosen the Biblical father of nomadic
pastoral life for the subject of his central
panel; nor that Jabal's dog, a mere puppy
indeed, was actually Greek sculpture of
the grandest and epitomised all the great
principles of art. First, it was life-like.
Second, it showed 'life in perfect power,
but in repose'. Third, its masses were
broad and unbroken: 'Think how easy it
would have been', Ruskin told the boys at
Eton, 'for a common sculptor to have cut
his dog all over crisp hair, and made him
project from the stone, so that everybody
would have gone to look at the wonderful
dog. No, says Giotto; Love me, love my
dog, and look for him. And he shall be
carved more in the spirit than in the body.
Puppy heart more than puppy body,
puppy body more than puppy skin, and
puppy skin, more than puppy hair' (XXIII,
471-5).

It was chiefly in honour of 'the shepherd
boy of Fésole' (Ruskin adopted Milton's
spelling in *Paradise Lost*) that Ruskin's
second drawing manual, published in
parts between 1877 and 1879, received its
title. As he explained in his Preface, 'this
book is called The Laws of Fésole because
the entire system of possible Christian Art
is founded on the principles established by

212

213

Giotto in Florence, he receiving them from
the Attic Greeks through Cimabue, the
last of their disciples, and engrafting them
on the existing art of the Etruscans, the
race from which both his master and he
were descended'. The purpose of the book
was specifically to oppose the teaching
method officially promoted by the South
Kensington Museum, geared to the
training of professional designers, and
instead 'to teach our English students of

art the elements of these Christian laws, as
distinguished from the Infidel laws of the
spuriously classic school, under which, of
late, our students have been exclusively
trained' (XV, 345).

It was entirely appropriate, therefore,
that the first exercise required of these
students should have consisted in tracing
'the two elementary forms which the
shepherd of Fésole gives us, (Fig.1.)
supporting the desk of the master of

Geometry' *(cat.211, see cat.204)*. (The panel is now generally considered to represent Architecture, a subdivision, along with Sculpture and Painting, of the Mechanical Art of *Armatura*, the art of construction. In Ruskin's scheme Christian Geometry – the 'due Measuring of the Earth' – was distinguished from pre-Christian Architecture.) Ruskin invited his readers to check the accuracy of the outline against the relevant photograph in the 'Shepherd's Tower' series, an outline 'which otherwise you might suppose careless, in that the suggested square is not a true one, having two acute and two obtuse angles; nor is it set upright, but with the angle on your right hand higher than the opposite one, so as partly to comply with the slope of the desk. But this is one of the first signs that the sculpture is by a master's hand. And the first thing a modern restorer would do, would be to "correct the mistake", and give you instead, the, to him, more satisfactory arrangement. (Fig.2.)' (xv, 358-9).

212
San Domenico, Fiesole
1874
inscribed by Ruskin bottom right, 'San Domenico Fiesole/25th Aug. 74'
pencil
Brant.908
EXH: FAS 1907, 138; RA 1919, 192.
LIT: XXXVIII, 251 (?678)

213
'Eve Book' (sketchbook used in Florence, 1874)
169 × 254; bound half morocco with marbled boards
open at f.14 to show sketch of San Salvatore al Vescovo
Bem.1521

214 (Colour plate VIII)
Column bases, doorway of Badia Fiesolana
1874
inscribed, verso (not by Ruskin), 'Details from the Badia of Fiesole 1874'; 'Frame no 163 (on glass)'
watercolour, pencil
166 × 246
Bem.1252
EXH: RWS 1901, 247; Manchester 1904,

216

395; Coniston 1919, 163; AC 1983, 208.
LIT: XXXVIII, 251 (676)

215
Inscription over doorway, Badia Fiesolana
1874
pencil
90 × 230
The Visitors of the Ashmolean Museum, Oxford (Rud.13)
LIT: XXXVIII, 251 (677)
(not in exhibition)

216
THOMAS MATTHEWS ROOKE
Façade of Badia Fiesolana
1887
inscribed lower left, 'Badia di Fiesole/1887'
watercolour, bodycolour
514 × 363
Sheffield R35X
PROV: Ruskin; Guild of St George (Bewdley 1887; Ruskin Museum 1890).
LIT: Morley, 207

217

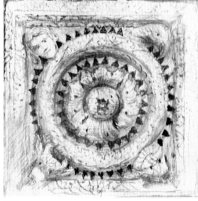

218

217, 218
Two studies of panels from font,
Baptistery, Pistoia
1874
watercolour
i. (upper) 123 × 127
ii. (lower) 120 × 124
The Trustees of the Ruskin Museum,
Coniston, Cumbria (23)
EXH: RWS 1901, 5.
LIT: XXXVIII, 275 (1331, ? also 1333-4)

219 (Colour plate XIX)
Carved pillar with Adam and Eve and
Tree of Jesse from façade of Duomo,
Lucca
?1874
inscribed in pencil, lower right,
'A. bottom.'
watercolour and bodycolour over pencil
356 × 287 (sheet)
326 × 250 (image)
The Visitors of the Ashmolean Museum,
Oxford (Ref.86b [lower])

EXH: RA 1919, 383.
LIT: XXXVIII, 263 (1029)

Christianity, Ruskin thought, had
turned the 'Etruscans' of the Arno valley
from outstanding workmen into the
greatest of artists (XXIII, 472). The
Baptistery was 'as purely a native
Etruscan building as the Parthenon is a
native Athenian one'. Associated with it,
as 'the final architecture of the native
Etruscan' were the church of San Miniato,
the Badia Fiesolana, and 'a small, most
precious, and I doubt not soon to perish
remnant near the old market' (XXIII,
240-1). Ruskin's is not, as Cook and
Wedderburn state, 'a prediction since
fulfilled'. For the Romanesque façade of
San Salvatore al Vescovo, incorporated
into a later construction itself part of the
archbishop's palace, and inlaid with
tawny yellow and green marble in
geometric patterns, may still be seen in
Piazza dell'Olio, behind the Baptistery.
However, many of the surrounding
buildings did perish in the 1880s when the
neighbouring market and part of the
Ghetto were demolished. So that Ruskin's
sketch of the church, looking down the
side of the Archbishop's palace and
towards Giotto's Campanile in the
background *(cat.213)* records a view no
longer existing: the building blocking the
entrance into the Piazza was pulled down,
the palace moved back, and the area on
the right entirely razed and re-built,
leaving the street much widened.

Of the other two churches associated
with the Baptistery, the Badia Fiesolana
was of special importance, not only be-
cause Ruskin believed it to be the 'earliest
remnant of Etruscan-Christian building
near Florence', but because the original
Etruscan settlement had been on the hill
overlooking it, at Fiesole (Ruskin pictured
the race as 'coming down in Christian
peace from their rock' to found Florence
[XXIII, 241]). There was also the vicinity
of Fra Angelico's first convent of San
Domenico *(cat.212)*. In the summer of
1874 Ruskin made two drawings of details
from the doorway of the Badia. *Cat.214*
combines the 'sweet marble bases' of its
two lateral columns, as may be seen if
compared with *cat.216*, which shows the
whole façade, and was painted for Ruskin
by Rooke in 1887. The second drawing

(cat.215) was of the inscription over the
doorway, which Ruskin (XXIII, 268)
translates

'ALL THINGS THAT YOU SEEK IN PRAYER,
BELIEVE THAT YOU SHALL RECEIVE THEM,
AND THEY SHALL BE FULFILLED TO YOU'.

'WHEN YOU STAND PRAYING, FORGIVE IF
YE HAVE AUGHT AGAINST ANY'.

Ruskin attached great significance to this
inscription. It is cited in two lectures given
the autumn after his return from Italy –
on Botticelli and on 'Giotto's Pet Puppy'
(see p.108) –, in both of which the boy
Giotto is imagined to have been found by
Cimabue, not so much drawing, as
scratching on a stone, 'imitating the lines
which he had seen engraved by these
exquisite Etruscan sculptors, most
probably imitating those of this very
stone'. For the whole of Florentine art was
simply the exposition of the 'principles of
faith and law' incised on the lintel – 'in
lovely, variable letters, contracted or
expanded, shortened or raised, as fitted
the elevation of the stone' (XXIII, 267-8,
474). For this reason, in his intended re-
arrangement of the Rudimentary Series at
Oxford, Ruskin placed his drawing of the
Badia inscription first, as the most 'fitting
introduction to our work under the "laws
of Fésole"' (XXI, 265).

Associated with the Etruscan-Greek
architecture of the Badia and the other
Romanesque churches was 'an Etruscan
archaic sculpture, equally perfect. It is
distinguished by perfectly straight
furrowed hair drawn delicately by the
furrows of the chisel, every furrow counted
as in a ploughed field, the eyes inlaid with
black' (XXIII, 239). A prime example was
the head from the font of the Baptistery in
Pisa, which Ruskin had drawn in 1872
(cat.125). Returning to Lucca from
Florence later in the summer, Ruskin
stopped at Pistoia expressly to draw the
font in the Baptistery *(cats 217, 218)*.

The drawing of the pillar with Adam
and Eve and the Tree of Jesse *(cat.219)*
from the north-west pier of the façade of
the Duomo of Lucca was probably also
made during this tour, as it is mentioned
(inaccurately described as the 'pillar with
tree of patriarchs') in the MS of a lecture
on the Florence Baptistery begun while
Ruskin was in Tuscany. Here the pillar is

in fact described as 'Greek', and together with drawings of sculpture from the Duomo of Assisi (Madonna, dragon and she-wolf), it was to have illustrated a passage on the Iconoclast reform which developed a contrast between the sculptural pre-dispositions of Lombard and Greek. The talent of the former 'never lay in the carving of Gods. That gift is essentially Greek, and remained at this very time of Iconoclast quarrel in the hands of the Greeks. But the Lombard could carve pigs, boars, and wolves, and dogs ... and a church which would not let him so much as scratch the outline of his hare – his hound – his falcon, or his fat pig, was not to be tolerated on any grounds, ecclesiastical or civil.' The façade of the Duomo of Lucca is then instanced as unique 'evidence of the coexistent work of two races, one careless of religous symbolism and busy in active life: the other profoundly versed in religious symbolism, and entirely contemplative' (Princeton, MS in holograph vol. *Mornings in Florence* n.d., CO199, General Manuscripts [Bound] Oversize).

This reading of the pillar clearly explains why Ruskin should have mounted it together with the lions from the Duomo of Assisi *(cat.103)*, at Oxford.

220 (Colour plate XIII), **221**
Two copies of portions of the 'Trials of Moses' by Botticelli, Sistine Chapel
i. *Zipporah*
1874
watercolour
1430 × 540
Brant.880
EXH: Brighton 1876; RWS 1901, 112,; RA 1919, 228; Coniston 1919, 165.
LIT: XXXVIII, 234 (253)

ii. *A sheep*
1874
watercolour, pencil
302 × 454
Bem.1167
PROV: Goodspeed

222, 223 (Colour plate XVI)
C.F. MURRAY, after Botticelli
Two copies of portions of the 'Trials of Moses', Sistine Chapel

i. *Moses and his family leaving Midian*
1874
pencil, watercolour
251 × 258
Sheffield R312
PROV: Ruskin commission 1874; Guild of St George (Ruskin Museum, 1890).
EXH: Manchester 1904, 210.
LIT: XXX, 192; Morley, 106

ii. *Gershom and his dog*
1874
watercolour
1120 × 730
Private collection
(shown at Lucca only)

Ruskin had visited the Sistine Chapel again after thirty-two years in 1872, when his diary briefly records the discovery of a 'glorious Moses by Perugino, and little dog of Sandro Botticelli' (*Diaries*, 725). The dog occurs in the *Trials of Moses*, which depicts episodes in the prophet's early life: his slaying of the Egyptian, and consequent flight into Midian; his deliverance of the priest of Midian's daughter, Zipporah and her sisters, leading to his marriage with Zipporah; the vision of the burning bush; and the return of Moses, with his wife and sons, to Egypt (Exodus 2-4). Later in the tour, at Perugia, Ruskin wrote, 'I am wofully forgetting the lovely Sandro of the Vatican. Moses at the Burning Bush twice over ... Below he is leading his family away from Jethro's house, his staff in his hand; the infinitely wonderful little dog is carried, with the bundle, by the eldest boy; its sharp nose and living paws marvellously foreshortened' (XXIII, xxviii). When, two years later, Murray was sent to Rome to copy the Sistine Botticellis, this particular detail of Gershom and his dog would be the first he drew *(cat.223)*. His diary (now in the Fondation Custodia, Paris) shows that he began a drawing of the subject on 18 February, and this was evidently finished when Ruskin joined him in Rome two months later, for on his arrival the latter wrote to Joan Severn, 'We've got little Gershom's dog, all right' (ALS dated 'Rome 16th April [1874]', Bem. L 39). Ruskin shortly afterwards left for Sicily, returning to Rome at the beginning of May. While he was away, Murray also

made a sketch of the whole group of Moses and his family leaving Midian *(cat.222)*.

Ruskin himself copied the dog towards the end of his stay in Rome, but the whereabouts of this drawing are not known. He also made two studies of sheep from the same fresco (Brant. 879, *cat.221*). Dog and sheep are both cited in an appendix to *Ariadne Florentina*, probably written in Italy in 1874, to show how the southern painter could if he wished rival the northern in 'literal veracity'. But it was Gershom's dog which claimed all Ruskin's attention: 'It is a little sharp-nosed white fox-terrier, full of fire and life; but not strong enough for a long walk. So little Gershom ... carries his white terrier under his arm lying on the top of a large bundle to make it comfortable. The doggie puts its sharp nose and bright eyes out, above his hand, with a little roguish gleam sideways in them, which means, – if I can read rightly a dog's expression, – that he has been barking at Moses all the morning and has nearly put him out of temper: – and without any doubt, I can assert to you that there is not any other such piece of animal painting in the world, – so brief, so intense, vivid, and absolutely balanced in truth: as tenderly drawn as if it had been a saint, yet as humorously as Landseer's Lord Chancellor Poodle' (XXII, 486-7).

If it had been the 'veracity' of the animal drawing which had initially attracted Ruskin to the fresco, it was now above all its religious meaning, in which Gershom's dog too had its part, though it was only as the 'lowest note' sounded in 'the most sacred picture of humanity, and the law by which it lives, ever produced by the Christian art of Europe' (XXIII, 270). In this picture Botticelli had written 'the life of Moses the Shepherd; hero and deliverer, in his human loving-kindness and meekness. This is the hero of the Christian Greek. To Botticelli, Moses is the Christain Knight, as much as the Christian lawgiver' (XXIII, 275). But here was not yet the highest note in the picture, and when Ruskin returned to Rome in May it was not to copy Moses but the figure of Zipporah from the centre of the fresco, full-size *(cat.220)*. The drawing was begun on 6 May and though repeatedly announced, in letters to Joan, as 'all but done', was actually finished at

the end of the month. Zipporah was harder than the Luini figure of St Catherine he had copied full-size twelve years earlier: 'the Botticelli lines are so terribly certain – and won't bear slurring in the least. – they're as fine as Holbein' (ALS dated 'Second Series 5. Rome 19th May morning', Bem. L 39). Despite the numerous difficulties, especially in the long 'finishing' stage, Ruskin was pleased with his efforts and told Joan (five days before he actually finished), 'when I can paint a life size figure to my own tolerable satisfaction in 14 days, I am quite sure I ought to go on doing them' (ALS dated 'Rome Whit Sunday', Bem. L 39).

Zipporah's high place in the religious 'harmony' of the picture was due to certain mythological, and specifically iconographical resonances detected by Ruskin. For Botticelli's Zipporah was 'simply the Etruscan Athena, becoming queen of a household in Christain humility' (XXIII, 275). In a note on the picture written for an exhibition held in 1876, Ruskin enumerated the correspondences between Zipporah and the classical Greek iconography of Athena, to show how Botticelli's representation of the wife of Moses had retained the 'essential character of the Etrurian Pallas ... yet changing the attributes of the goddess into such as become a shepherd maiden'. To illustrate these correspondences Ruskin also sent to the exhibition a copy of a woodcut of the figure of Athena from a red-figure amphora in the British Museum, published in *Aratra Pentelici*.

'There is first the sleeved chiton or linen robe, falling to the feet, looped up a little by the shepherdess; then the peplus or covering mantle, very nearly our shawl, but fitting closer; Athena's, crocus coloured, embroidered by herself with the battle against giants; Zipporah's, also crocus coloured, almost dark golden, embroidered with blue and purple, with mystic golden letters on the blue ground; the fringes of the aegis are, however, transposed to the peplus; and these being of warm crimson complete the sacred chord of colour (blue, purple, and scarlet), Zipporah being a priest's daughter.

'The aegis of Pallas becomes for Zipporah a goatskin satchel, in which she carries apples and oak (for pleasure and strength); her lance becomes a reed, in [sic] which she carries her wool and spindle; the tresses of her hair are merely softened from the long black falling tresses of Athena; a leaf of myrtle replaces the olive. The scarcely traceable thin muslin veil over her breast represents the part of the aegis which, in the Pallas, is drawn with dots, meaning soft dew instead of storm' (XXIII, 478-9).

224
Arundel Society chromolithograph of Botticelli's 'Primavera', from a drawing by Costantini
1884
530 × 823
Sheffield R148
LIT: XXX, 192

225
Fors Clavigera. Vol. I
Orpington, Kent: George Allen, 1871
open at title-page to show rose vignette after Botticelli
Sheffield

226
ANGELO ALESSANDRI, after Botticelli
Study of the three Graces in the 'Primavera'
1881
pencil, heightened with white on grey-green paper
230 × 268
Sheffield R577
PROV: Ruskin; Guild of St George (Bewdley 1887; Ruskin Museum 1890).
EXH: FAS 1886, 110; AC 1964, 377.
LIT: Morley, 12-13

227
A. ALESSANDRI, after Perugino
St John and St Benedict
1881
inscribed verso in pencil, in modern hand, 'Fresco at Florence. Cloister of Convent of la Maddalena. Perugino. St John and St (Joseph of Arimathea?) at the Crucifixion Signor Alessandri'
watercolour, bodycolour
379 × 252
Sheffield R38
PROV: Ruskin; Guild of St George (Bewdley 1887; Ruskin Museum 1890).

LIT: Morley, 116-17 (as Murray)
'I am more and more crushed every day under the stupendous power of Botticelli', Ruskin wrote to Norton from Florence. Of the various works by the painter in the Accademia and the Uffizi which he somehow found time to study, the only one he actually drew was the *Primavera*. Yet of this Ruskin attempted only Spring's left foot (on a leaf in the 'Eve Book', cat.213), and a fresh drawing of the roses on her dress – 'from the clearest bit of the pattern ... where it is drawn tight over her thigh' – which he had had engraved in 1871 and since used on all his title-pages (see cat.225). In *Fors Clavigera, Letter XXII* (published October 1872), he had explained its meaning: 'whatever I now write is meant to help in founding the society called of "Monte Rosa"' (XXVII, 371). This was intended as a company within the St George's Company or Guild, 'entirely devoted, according to their power, first to the manual labour of cultivating pure land, and of guiding pure streams and rain to the places where they are needed: and secondly, together with this manual labour, and much by its means, they are to carry on the thoughtful labour of true education, in themselves, and of others'. The name had been chosen 'because Monte Rosa is the central mountain of the range between north and south Europe, which keeps the gift of rain of heaven' (XXVII, 296), but was of course principally a tribute to Rose La Touche.

In 1874 Rose was a still more potent presence in the *Primavera*. The Graces in particular came to be included, together with Zipporah and the Spanish Chapel Arts and Sciences, among the icons of thwarted sexual longing. After a week in Florence Ruskin wrote to Joan Severn, 'I'm so at my wits end between Botticelli's Graces and Simon Memmi's virtues ... How I'm going to get away from these Botticelli girls, I don't know.' And a year later he told Norton 'the one thing I physically want is one of those Graces out of Botticelli's picture of the Spring. I can't make out how that confounded fellow was able to see such pretty things, or how he lived among them' (CRN, 353).

In January 1881, Alessandri, a young Venetian artist Ruskin had met in 1877, wrote to him of his plan to visit Rome and

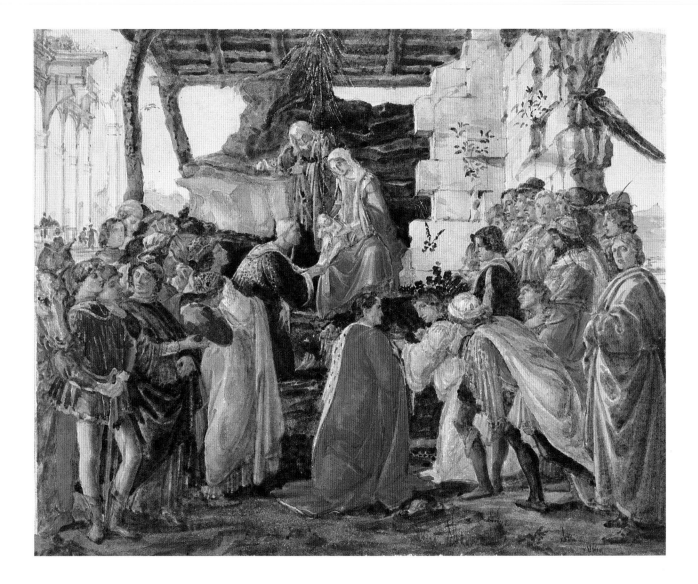

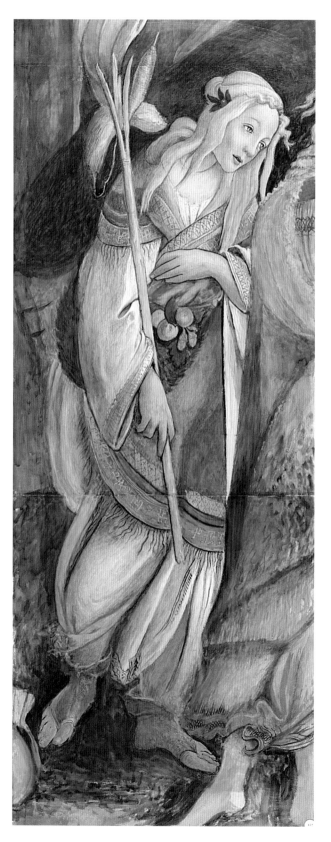

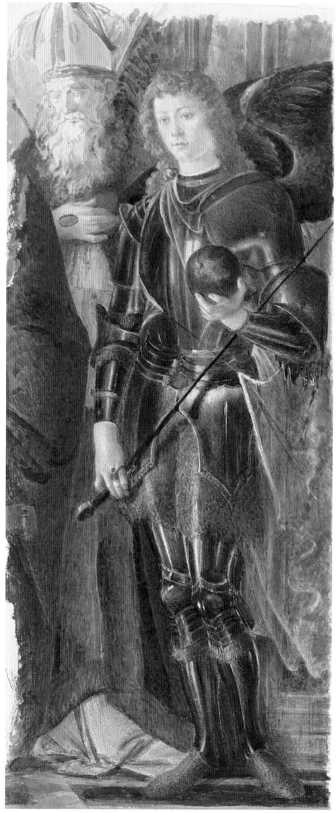

PLATE XV
C. F. Murray, after Ambrogio Lorenzetti
Allegory of Good Government 1873
(cat.187)

PLATE XVI
C. F. Murray, after Botticelli
Gershom and his dog, from the
'Trials of Moses' 1874 *(cat.223)*

PLATE XVII
T. M. Rooke
Study of stained glass:
Aaron, from sanctuary, Santa Croce,
Florence 1886-7 *(cat.269)*

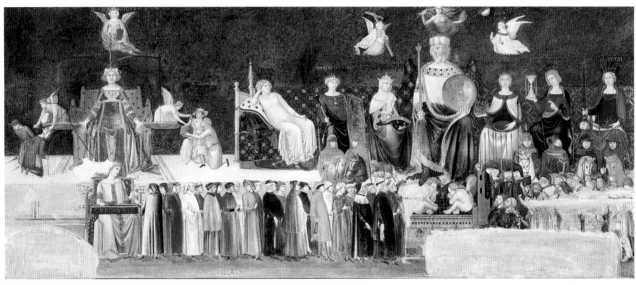

XV

XVI

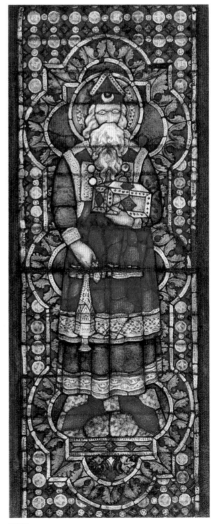

XVII

PLATE XVIII
John Ruskin
Part of pier in atrium of Duomo, Lucca 1882 *(cat.257)*

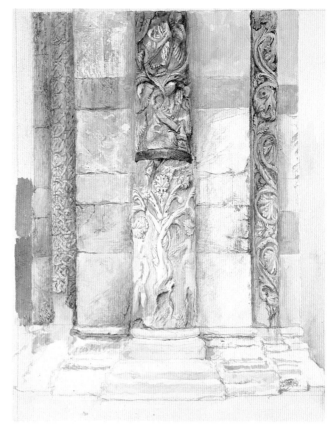

XIX

XVIII

PLATE XIX
John Ruskin
Carved pillar with Adam and Eve and Tree of Jesse from façade
of Duomo, Lucca ?1874 *(cat.219)*

PLATE XX
W. G. Collingwood
Sculptured pilaster, actual size, porch of Duomo, Lucca 1882
(cat.258)

XX

PLATE XXI
H. R. Newman
Façade of Duomo, Lucca 1885 *(cat.261)*

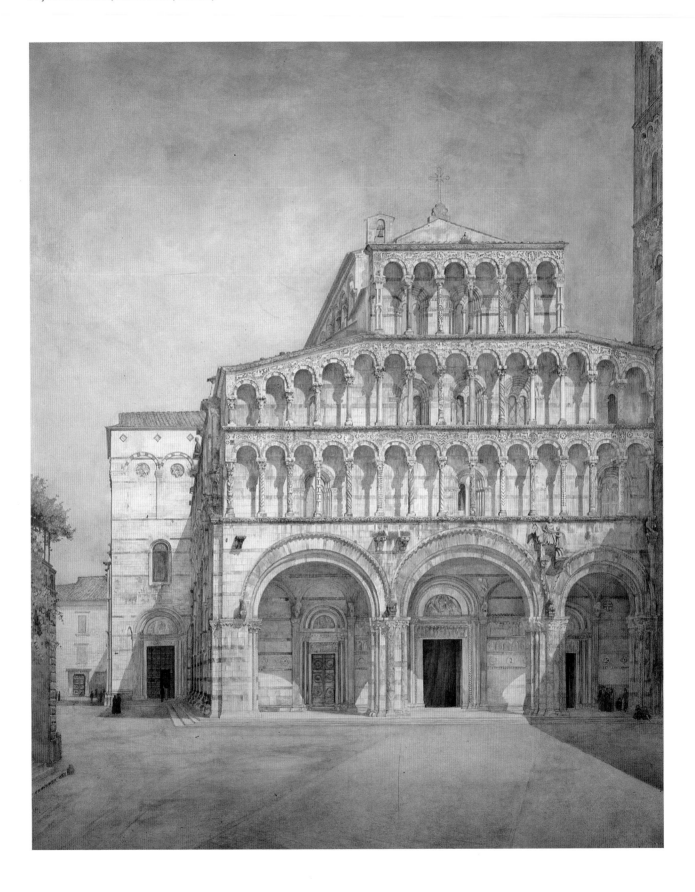

PLATE XXII
John Ruskin
Part of panel from font, Baptistery, Pisa ?1882 *(cat.273)*

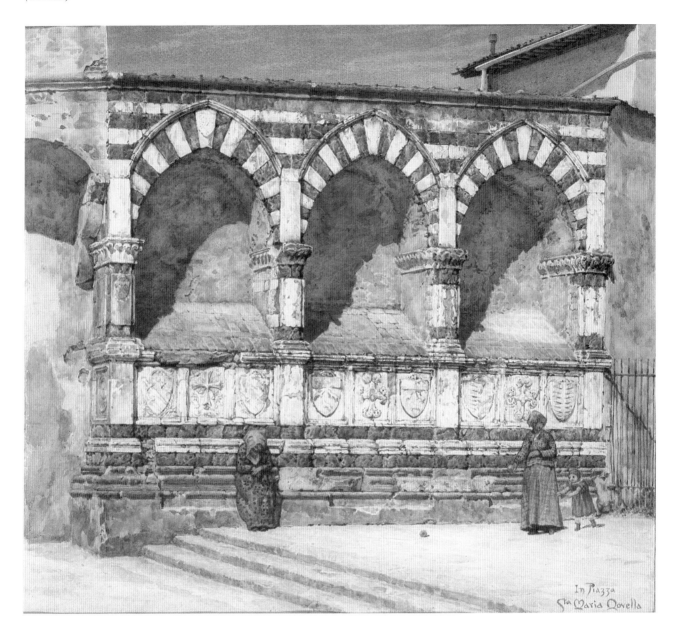

PLATE XXIV
A. Alessandri
San Niccola, Pisa. Part of façade and campanile 1882 *(cat.276)*

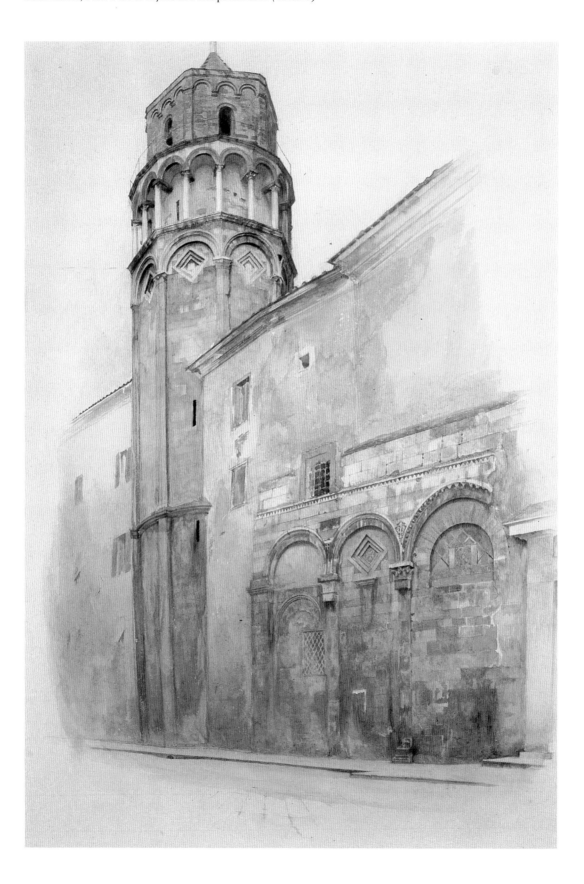

226

Florence, adding 'I should be very happy if I could do any commission for you there'. Ruskin responded with a gift of £10 for travel expenses and instructions to study the Peruginos and Botticellis in the Sistine Chapel. In April, while Alessandri was in Rome, Ruskin wrote again to suggest subjects of study in Florence 'Filippo Lippi Sandro, and Perugino (especially in his fresco – the Nunnery one – and his divine picture in the Annunciata), are to be pretty nearly your only studies. *Draw* the heads in Sandro's Spring as far as you can!!!! ~~with~~ in grey or brown only' (AA). Ruskin cancelled this last instruction in his next letter, thinking it better for his pupil to continue copying in colour for the present. But Alessandri seems to have ignored this advice, and in his reply confessed to having begun the drawing from the Spring.

The 'nunnery' to which Alessandri was directed for the fresco by Perugino was that of Santa Maria Maddalena dei Pazzi, and the fresco was the Crucifixion in the cloister which Ruskin had himself studied in 1845. *Cat.227* and a companion drawing at Sheffield, showing the

Madonna and St Bernard from the same fresco, are listed by Cook and Wedderburn and Catherine Morley as by Murray. However, Ruskin himself had exhibited the Madonna and St Bernard as the work of Alessandri, and William White in his book on the Guild collection (1895) lists both drawings as his. While there is no evidence that Murray copied the Perugino fresco for Ruskin, it is specifically proposed as a subject for Alessandri – who inscribed the letter acknowledging receipt of his 'quite beautiful' drawings from 'Perugino and Botticelli', 'riguarda le copie del Perugino (monastero) e del Botticelli (Primavera)' – *ie*, 'regarding the copies after Perugino (monastery) and Botticelli (Primavera)' (AA). *Cat.227* has therefore been restored to Alessandri.

228 (Colour plate XII)
C. F. MURRAY, after Botticelli
Adoration of the Magi
1875-82
watercolour
218 × 270
Sheffield R583

PROV: Guild of St George (Walkley 1888; Ruskin Museum 1890).
LIT: Morley, 106

The original picture is in the Uffizi and is known as the 'Medici Adoration', from its including portraits of members of that family. The figure on the extreme right in the yellow cloak has traditionally been identified as a self-portrait by Botticelli.

There is no specific mention of this copy in Ruskin's correspondence with Murray.

229 (Colour plate XIV)
C. F. MURRAY, after Botticelli
St Michael, from the San Barnaba altarpiece
1876-9
watercolour
336 × 142
Sheffield R47

PROV: Ruskin commission 1876; Guild of St George (Walkley 1888; Ruskin Museum 1890).
LIT: Morley, 105

The San Barnaba altarpiece was one of the two pictures by Botticelli in the Accademia which so overwhelmed Ruskin in 1874, the other being the *Coronation of the Virgin*. Both are now in the Uffizi. A year later Ruskin asked Murray to obtain photographs of them, but seems to have kept only details from the second (ALS, Morgan MA 2150/36, 38). In March 1876, Ruskin wrote, 'I shall be grateful for any memoranda you can make [of] any parts that interest you either in the Crowning of Madonna or St Catherine & Michael [?&] Madonna of Botticelli's – the clouds & angels of the first especially' (ALS, Morgan MA 2150/39). Murray did not carry out the commission immediately, and drawings of the two saints from the *Coronation* were not completed until the spring of 1879. On 20 March, Ruskin wrote, 'Today your two most valuable sketches came and I am most glad of them. I can't criticize – and I fear you would not care if I did – but I wish you had done the ball in St Michael's hand more carefully instead of his leg armour' (ALS, Morgan MA 2150/63). The ball would have been one of the first things Ruskin looked for in Murray's copy. In his 1874 lecture on Botticelli he had drawn attention to it as the saint's only trophy, 'the globe of the world, and on its surface

the dark seas take the cloudy shape of the dragon'. This St Michael bore no other sign of victory because he was a patron of peace, the soldier's peace which in Ruskin's reading of her history Florence had vehemently pursued since the Year of Victories, 1254 *(see cat.15)*. In that year, 'for the first time in the history of nations, in the midst of a world of war, Florence had raised her lily standard in the name of the peace of God; not the narrow Irene of Athens, peace only within her own walls, and prosperity in her own palaces, but peace published with eager foot upon the distant hills, and shout of the good tidings in the streets of strangers' (XXIII, 272).

230

C. F. MURRAY, after Botticelli (or workshop)
Nativity
1875-82
watercolour
275 × 228
Sheffield R43
PROV: Guild of St George (Bewdley 1887; Ruskin Museum 1890).
EXH: Manchester 1904, 210.
LIT: Morley, 106

The original is a fresco possibly once decorating a tabernacle which by 1895 had been transferred to canvas and was in the collection of Sir William Abdy. After this it was periodically sighted in the sale-rooms of Europe (Paris in 1913 and Berlin in 1937) before travelling to the States, where it is now on show at the Museum of Art, Columbia, South Carolina. It is now thought by some to be by Botticelli himself, and not, as has usually been assumed, a production of his workshop.

The copy is not specifically mentioned in Ruskin's letters to Murray.

231

C. F. MURRAY, after Botticelli
Madonna and Child with St John (Madonna del roseto)
1880
watercolour
335 × 230
Sheffield R45
PROV: Guild of St George (Walkley 1888; Ruskin Museum 1890).
EXH: Morley, 118

231

This may be the 'new Botticelli' drawing of which Murray wrote to Ruskin late in 1879, and for which he apparently asked more than the £20 Ruskin sent him on Christmas Day: 'it is *sure* to be worth twenty pounds to us, – at Sheffield; but if I think it likely to justify me in the public estimate, in giving full price for it, you shall have it. – so that the cheque I send now is sure – and more I hope to come' (ALS, Morgan MA 2150/71). It was certainly the present drawing which reached Ruskin in February 1880, when, after informing Murray through his secretary that he enjoyed the 'drawing from Botticelli daily more & more', Ruskin himself wrote, 'Your Madonna and roses and little St John are glorious. – but

tell me exactly where the picture is, and what size? How could I have missed it!' (ALS, Morgan MA 2150/75).

The original is in the Galleria Palatina, Pitti Palace, Florence. Its authenticity has been questioned by some scholars.

232

WALMSLEY BROS, AMBLESIDE
Photograph of Ruskin's study, Brantwood, showing Adoration of the Virgin by 'Luca della Robbia' (Andrea della Robbia)
*c.*1900
inscribed on mount: 'Ruskin's study Brantwood Walmsley Bros, Ambleside'; verso: 'Charlotte Mason College'
159 × 204
Bem.

About the same time as the copy of Botticelli's *Madonna del roseto (cat.231)*, Ruskin received a glazed terra-cotta relief of the Adoration of the Virgin, supposed to be by Luca della Robbia, which Murray had bought for him in Florence. This was the second della Robbia relief Murray had suggested Ruskin should buy. In November 1877 he had sent a photograph of another, along with a sketch of a Madonna by Botticelli being sold by the dealer Tricca, for Ruskin's consideration. Ruskin bought the Botticelli for £300 but did not take the della Robbia, a decision he later much regretted. Murray must have written to him of the availability of a second relief in November or December of 1879, as on 10 December Ruskin wrote, 'And now, chiefly – what can I have that Luca Madonna for? ~~please telegraph~~ – No – I won't be hurried – send me word what others are available as well – and what you mean by saying "not repeated" are there duplicates of the one I saw the photo of?' (ALS, Morgan MA 2150/70). Murray's description of the relief as 'not repeated' suggests that it was not the one eventually bought by Ruskin, of which there are a number of replicas, with slight variations (see below). Murray must immediately have supplied Ruskin with the information he requested, including a photograph of the relief bought, as on Christmas Day, Ruskin wrote to him, 'My second business is to beg you to secure the Luca of which you sent me a photo – (there can't be any mistake, I think – the

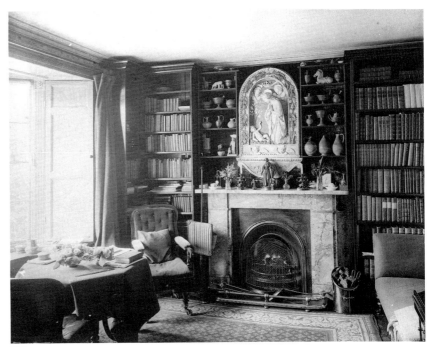

232

Madonna kneeling to child who raises his hand to her – two cherubs above – crown and two hands between – wreath of fruit round – and arms below – lion rampant and cross mitre – this I understand you can get for about 180 pounds? (5000 francs used to be 200 pounds in my day, but I suppose its paper money?) – however – you will do the best you can, and I will remit cheque forthwith' (ALS, Morgan MA 2150/71). The purchase was concluded shortly afterwards, presumably for the price stated, and Ruskin offered Murray 500 francs as a commission. By the end of February the Madonna was in Ruskin's study 'a perpetual pride and care – quite one of the most precious things I have – but yet – how the photograph flattered it! in some ways. – It must surely have been touched to conceal the defect in the face of the infant? and the forehead of one cherub – Also the darkening green of the foliage made it look so much richer' (ALS, Morgan MA 2150/75).

The relief remained at Brantwood until the death of Arthur Severn. It was bought by a Spanish art gallery at the Sotheby's sale on 8 May 1931 for £780. It is now in the National Gallery of Art, Washington, which acquired it in 1945. In 1922 Allan

Marquand included it in his catalogue of Andrea della Robbia, attributing it to his workshop, though at Washington it is now attributed to Andrea himself. The relief can be assigned a date of 1477, when a marriage took place between the Donati and Girolami families whose twinned arms appear on the console. It is probably the earliest specimen of an iconographical type for which Marquand lists twelve variants and which, like all Andrea's *Adorations*, seems to derive from an earlier model by Luca.

In the scheme of Tuscan Christian art set out in the lectures on the *Aesthetic and Mathematic Schools of Art in Florence*, Luca figures as mid-way between the two traditions. His art is the culmination of the Pisan 'mathematic' tradition of naturalism, fathered by Nicola Pisano, but touched with 'the Florentine religious fervour' typical of the 'legendary and imaginative' 'aestheticism' of Florence founded by Cimabue (XXIII, 198).

233, 234

C. F. MURRAY
Two studies from Filippo Lippi's Coronation of the Virgin in the Uffizi
i. *'Children and their guardian angels'*

(Sts Eustace and Theophista and their children, and other saints)
?1878
pencil, watercolour
344 × 260
Sheffield R563
PROV: Guild of St George (Bewdley 1887; Ruskin Museum 1890).
LIT: Morley, 115

ii. *Lippi's 'self-portrait'*
1878
inscribed on label on back, 'Fra Filippo Lippi, by himself / C.F.M.'
watercolour
191 × 157
Sheffield R506
PROV: Guild of St George (Bewdley 1887; Ruskin Museum 1890).
EXH: FAS 1886, 125; Manchester 1904, 210.
LIT: Morley, 115

Murray's diary (Fondation Custodia, Paris) shows that he began the sketch of 'Lippi's *portrait*', on 14 June 1878, and that he received 100 francs for it from Ruskin. The sketch of saints from the foreground of the painting was probably also done at this time. The tradition which identified the half-length figure on the right of the *Coronation* seen emerging from a stairway as Lippi's self-portrait had been memorably recounted by Browning in his dramatic monologue 'Fra Lippo Lippi' (1855). The monk is currently working on the picture and describes how it is to show 'God in the midst, Madonna and her babe, / Ringed by a bowery, flowery angel-brood', with 'in the front, of course a saint or two':

Well, all these
Secured at their devotions, up shall come
Out of a corner when you least expect,
As one by a dark stair into a great light
Music and talking, who but Lippo! I! —
Mazed and motionless and moon-struck —
　I'm the man!
Back I shrink — what is this I see and
　hear?
I, caught up with my monk's things by
　mistake,
My old serge gown and rope that goes all
　round,
I, in this presence, this pure company!
Where's a hole, where's a corner for
　escape?

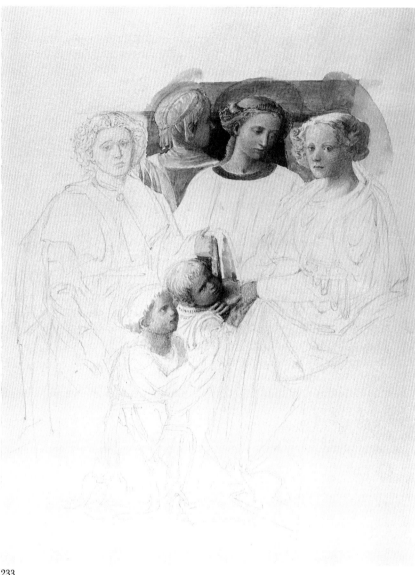

233

Then steps a sweet angelic slip of a thing
Forward, puts out a soft palm — 'Not so
　fast!'
— Addresses the celestial presence, 'nay —
He made you and devised you, after all,
Though he's none of you! Could Saint
　John there, draw —
His camel-hair make up a painting-brush?
We come to brother Lippo for all that,
Iste perfecit opus!

In the picture, the Latin phrase is inscribed on a scroll held by the angel indicating the figure in question. It has long since been shown that this is not the portrait of Lippi but of Domenico Maringhi, the chaplain of Sant'Ambrogio, who after the death of his uncle Francesco, responsible for giving Lippi the commission, saw the work through to its completion. This is the sense of the inscription, which does indeed mean 'This one carried the work through (XXIX, 536), but the 'carrying through' is that of the patron, not of the painter.

Ruskin, whose Lippi was not Browning's irrepressible hedonist but Botticelli's mentor and ally in reform, improbably read inscription and portrait as a lesson in the pride and humility of

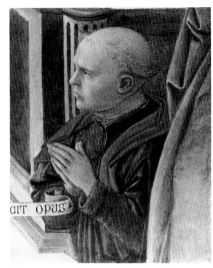

CIT OPUS

234

workmanship. In *Ariadne Florentina* one of the main things Lippi is imagined to have taught Botticelli is 'to finish his work perfectly, and in such temper that the angels might say of it – not he himself – "Iste perfecit opus"'. In the lecture Ruskin apparently showed the 'portrait' (probably the photograph of the whole *Coronation* at Oxford, Ref.101), together with his own copy of the head of Lippi's archangel Gabriel *(cat.95)*, as evidence that the painter was not, as was traditionally believed, 'a shameful person'. The allusion was to the story, first told by Vasari, and made much of by Browning, of Lippi's elopement with a novice. Though not understood as such at the time, nor indeed by Browning, Ruskin maintained that this was 'a step in Church reformation correspondent to Luther's marriage' (XXII, 424).

235

C. F. MURRAY, after Filippo Lippi
Madonna and Child
?1875-80
watercolour, body colour
336 × 232
Sheffield R40
PROV: Guild of St George (Walkley 1880; Ruskin Museum 1890).
LIT: Morley, 115

236

'Lesson Photo' No.2: Filippo Lippi,
Madonna and Child (Uffizi, Florence)
1875

mounted on card inscribed, 'John Ruskin / I pass this, – being more like the picture than darker proofs – but don't get fainter' *Bem. MS 85, No.546*

Murray's copy of the Lippi Madonna *(cat.235)* is not mentioned specifically in the surviving correspondence, but Henry Swan recalled that it was among the first pictures sent to Sheffield. Ruskin was critical of the copy, but attributed its inadequacies to the 'exquisite fineness of draughtsmanship' in the original. This, as he explained in a note, later published by Swan, comparing the drawing with Murray's copy of Carpaccio's *Reception of the Ambassadors* from the *St Ursula* cycle, made it comparatively difficult to copy. Whereas Carpaccio's 'simplicity of expression', actually the expression of his greater genius, meant that Murray's copy of the Venetian painting was not only more successful, but might even afford as much pleasure as the original.

In the same note Ruskin also compared Murray's drawing of the Lippi Madonna with a photographic reproduction of the painting, pointing out where each scored over the other: 'The drawing often misses the perfectness of Lippi's line; the spiral of the chair, for instance does not taper rightly; the Madonna's dress does not sit so easily; the angel's sleeve does not fold so truly at the shoulder. On the other hand, all that is red or orange-tinted in the painting, is darkened in its masses like a Bolognese picture, and blotted by the inky wing, which looks like a bit of ebony screwed on' (XXIV, 451).

The photograph was no doubt that issued to readers of *Fors Clavigera* in 1875 as the second of a set of four 'Lesson Photographs' of works of art *(cat.236)*, also comprising an 'Etruscan' relief from the Villa Albani in Rome (then thought to represent Leucothea with the infant Bacchus), Titian's 'Madonna of the Cherries' from Vienna, and Velasquez' portrait of the Infanta Margarita Teresa, also from Vienna. Ruskin's intention was to provide his readers with the nucleus of their own domestic art-treasury. Placed in historical sequence, the four images also illustrated the changing relations of religion and 'realization' in the art of successive epochs. The first, the 'Leucothea', was 'entirely noble religious

art, of the fifth or sixth century B.C., full of various meaning and mystery, of knowledges that are lost, feelings that have ceased, myths and symbols of the laws of life, only to be traced by those who know much of both life and death. Technically, it is still in Egyptian bondage, but in course of swiftly progressive redemption'. The Lippi was a 'nobly religious work of the fifteenth century of Christ, – an example of the most perfect unison or religious myth with faithful realism of human nature yet produced in this world'. Ruskin repeatedly pointed out how the Estruscan traditions were preserved in it, 'even to the tassels of the throne cushion', the pattern of which he traced to an Etruscan tomb in the British Museum, whose double cushion was used 'with absolute obedience to his tradition' by another 'true-born Etruscan', Jacopo della Quercia, in the tomb of Ilaria del Carretto. The Titian represented the last phase of religious art, in which realisation was consummate but the 'supernatural aspect' refused. And lastly, the Velasquez was from an era which had attained the 'highest reach of technical perfection', but in which belief in the supernatural had 'entirely passed away from the artist's mind' (XXVIII, 626).

237

Tomb of Ilaria del Carretto by Jacopo della Quercia, Duomo, Lucca
1874
watercolour, bodycolour
216 × 486
The Visitors of the Ashmolean Museum, Oxford (Ref.79)
LIT: XXXVIII, 258 (865)

238

Head of effigy of Ilaria del Carretto from same
1874
watercolour
320 × 454
The Trustees of the Ruskin Museum, Coniston, Cumbria (21)
PROV: W. G. Collingwood; Coniston.
LIT: XXXVIII, 258 (863)

238

239
Head of effigy of Ilaria del Carretto
1874
watercolour, pencil, white
324 × 430
Bem.1367
EXH: Portsmouth 1973, 47; AC 1983, 204.
LIT: XXXVIII, 258 (862); Whitehouse, 49

Despite his early love for the tomb, Ruskin had never yet attempted to draw it. Impelled now perhaps by a new sense of its place in his own development, he did so almost continuously in the three weeks spent at Lucca on the present tour, but with a protracted sense of defeat, repeatedly confessed in his diary and letters to Joan Severn. The problem was partly technical – Ilaria was decidedly difficult – but had as much to do, as Ruskin himself recognised, with the inevitable evocation of Rose. 'It's partly the paper, and the colours, and the light and the hurry, and the worry', he wrote to Joan after two weeks' struggle – and the being like some peepies that ain't dead but are of stone' (ALS dated 'Lucca 11th August', Bem. L 39). By this stage, Ruskin had begun and apparently abandoned a first drawing of the head *(cat.239?)*, begun and 'brought through' with a drawing of 'the statue' *(cat.237)*, and also begun a second drawing of the head 'full size this time' *(cat.238?)*. The attempt to capture Ilaria assumed all the character of

a pitched battle. 'I am more than usually beaten with my drawings, which is always bad for me', he wrote to Joan a few days later. It is very difficult for me to determine how far it is right to fight through an extreme difficulty at the cost of much time & energy, or whether there is not real wisdom in giving up an attack in time. I feel a little with Ilaria like Frederick the Great at the battle of Kunersdorf – and am afraid I may come to similar grief' (ALS dated 'Lucca 13th August', Bem. L 39). The battle lasted until Ruskin left for Florence on 19 August, and its only real prize had been a drawing of 'Ilaria's Tiff' – the dog at her feet (Brant. 1003), destined to join Jabal's puppy and Gershom's white terrier in Ruskin's catalogue of the prize-dogs of Christian art.

Dog and statue were extensively glossed in the lectures given at Oxford in the autumn. Jacopo della Quercia was there classified 'among the highest representatives of the mathematic schools of sculpture of 1400', whose beginnings were also to be seen in a work housed in the Duomo of Lucca – Nicola Pisano's Deposition in the porch. Ruskin exhibited one of his drawings *(cat.237?)*, but only 'to show you this place and the look of the tomb; it is impossible to draw it'. He described it in the position it occupied before the return of the fourth side of the

sarcophagus from Florence and its removal to the centre of the transept where it is today, standing 'simply by the transept wall of Lucca Cathedral as a table at the side of your room, and just at the height of your hand, if you wished to raise the head on its pillow which will never move more. Fortunately again, the wall behind is of dark brown marble, relieving the white form; and a cross and circle, cut deep into its stone, before the tomb was placed there, sign her resting-place with sweet fortuitous sacredness'. The gist of Ruskin's reading of the tomb (remarkably reminiscent of the youthful account of it given in a letter to his father of thirty years earlier) is already expressed in this piece of scene-setting. The tomb is said to represent 'perfect equipoise' between the early, rigid type of recumbent effigy and later, naturalistic tomb sculpture, insolently forgetful of the power of death. This equipoise results in 'a sacred portrait of an infinite peace – laid as it were between the living and the dead – Christ's word spoken in perpetual marble: "She is not dead – but sleepeth."' To attain this, Jacopo has had to subdue imagination, skill and pride, refusing all dispensable decoration, all terror and all curiosity (no denting of the pillow or crumpling of the dress). The pose is natural, but the drapery impossibly, hieratically taut, except at the breast where it is moulded by 'the soft outline of the form beneath'. Lastly, Jacopo admits the 'lower creature' to the presence of death and places her faithful dog (a bull terrier, rightly chosen as the most faithful of dogs) at her feet, in place of the 'old heraldic hound, its head turned to her face: "Will she not wake, then?"' (XXIII, 222-32).

1882: Handing On

The years between the feverishly active tour of 1874 and Ruskin's last visit to Tuscany in 1882 were marked by the the death of Rose La Touche ('*seal* of a great fountain of sorrow that can never now ebb away' [XXXVII, 168]), and broken by three attacks of madness, the first of which had as one of its consequences Ruskin's resignation from Oxford. The third attack came in March 1882 and while he jokingly claimed to have recovered more quickly this time owing to the attentions of a 'pretty nurse' (*CRN*, 447), Ruskin also confessed to being left 'more heavy and incapable' than on the first two occasions: 'this attack has both alarmed and stupified me, so that I'm afraid to work in the morning, and can't in the afternoon; but what I do seems to me perhaps of more useful quality, from its very caution' (Hunt, 385). The remark reflects the mixed despondency and resilient will-to-work which was to characterise his mood throughout the tour which on his doctor's recommendation he undertook that autumn.

Ruskin left London on 10 August, in the company this time of a former Oxford pupil, William Gershom Collingwood, now his assistant, and Baxter, who had replaced Crawley and Klein as his valet. Though intended primarily to consolidate Ruskin's recovery, the present tour too had its specific objectives connected with work. One of these had to do with plans for a new St George's Museum at Bewdley, for which the architect Edward Robert Robson (1835-1917), best known for his work for the London School Board, had been requested to draw up plans. Ruskin had very precise and rather extravagant ideas about the style of the building, which was to be modelled on the Romanesque of Pisa and Lucca: at a meeting held in 1884 he specified a 'porch like the Baptistery of Pisa ... a semicircular apse at the east end – the Pisan porch at the west ... brick covered with marble' (Scott, 33-4). Robson had meanwhile been ordered to Lucca, where he was to study the architecture of the Duomo, and try not to be 'too much aghast at the comic inlays – I am not going to imitate them, but study the relief sculpture of the central gate ... till I come' (*Journal of RIBA* [February 1917], 95).

Lucca was therefore Ruskin's principal destination, but it would be well over a month before he reached it. After visiting Laon, Rheims, Troyes and Sens, he lingered two weeks in Avallon, where he had not been before, and where he botanised, geologised and drew 'the most wonderful 12th century porch I ever saw – Pisa not excepted' (*CRN*, 447), while Collingwood made 'heaps of sketches' (ALS from W.G.C. to fiancée dated 'Avallon Aug 27-1882', Abbot Hall, Kendal). From Dijon it was necessary to visit Citeaux and the birth-place of St Bernard of Clairvaux at La Fontaine,

in connection with a planned section of *Our Fathers Have Told Us*, 'relating to England' and 'the nature and extent of Benedictine and Cistercian power' (ALS dated 'Pisa 7th Nov. 82', Bem. L 39). There was another long halt at Sallenches, where Ruskin entered in his diary, 'I never have been happier in seeing the Alps once more – nor felt more desire to do better work on them than ever yet. And I never was so persecuted by the storms and clouds' (TS, Bod. MS Eng.Misc.c.232, 18). The last remark introduces the obsessional undernote of this tour. For some years now Ruskin had been observing and recording what he believed to be a fateful change in European weather under the malignant influence of what he usually referred to as a 'plague-wind'. The phenomenon was to be analysed in two lectures held in 1884, and published as *The Storm-Cloud of the Nineteenth Century*, in which records made on this tour were among those cited. The most ominous sign of this evil at work was the melting of the glaciers of Mont Blanc: 'All the snows are wasted', he wrote to Norton, '– the Eternity of Being – are all gone from it ... And as the Glaciers – so the sun that we knew is gone! The days of this year have passed in one drift of soot-cloud – mixed with blighting air' (*CRN*, 448).

After another short stay in Annecy, so that Collingwood could make geological sections and Ruskin could draw 'old houses', they arrived at Chambéry, where Ruskin wrote to Joan, 'I must take three days now of fast trains – and get to Lucca at last' (ALS dated 'Hotel de France/Chambery Wednesday evening [Sept 82]', Bem. L 39). A few days later he was in Pisa, surprisingly undistressed by the 'perpetual roar and intermittent flash' of the new coast tunnel from Sestri to La Spezia (ALS, Houghton bMS Am 1088/6372). 'Here once more', he wrote in his diary, 'where I began all my true work in 1845. Thirty seven – full years of it – how much in vain! How much strength left I know not – but yet trust the end may be better than the beginning' (TS, Bod. MS Eng.Misc.c.232, 28). On his first morning Ruskin walked to the Camposanto and Baptistery and was thankful to find 'everything I care for, left as yet, in peace *there*' (ALS, Houghton bMS Am 1088/6372). But in the following days, the glowering weather, preventing him and Collingwood from drawing in the Baptistery *(cats 273, 274, 275)*, and the dismal changes elsewhere in the city – among them the sight of the cloister of San Francesco *(cat.36)* 'dilapidate and desolate, to a degree inconceivable' (TS, Bod.MS Eng. Misc.c.232, 29) – brought on depression, and a hankering after the Alps.

After an 'utterly black day' (ALS dated 'Michaelmas Day [1882]', Bem. L 39) Ruskin and Collingwood left Pisa for

Lucca, which he found comparatively uninjured, though still the plague wind blew. 'Collie greatly impressed', Ruskin wrote to Joan on the first fine day, 'with beauty of things – Ilaria and all. – but we both agree that Italian mountains as compared with the Alps, have a look of – demi-monde – as if they spent their lives mainly in pleasure' (ALS dated 'Lucca 1st Oct [1882]', Bem. L 39). Almost directly they arrived the news came of the death of Bunney: 'A heavy warning to me', Ruskin wrote in his diary, '– were warning needed – but I fear death too constantly – and feel it too fatally – as it is' (TS, Bod. MS Eng.Misc.c.232, 31). Robson had telegraphed to say that he was unwell and unable to come to Lucca, so Ruskin settled to a routine of drawing – in the now 'sunny streets – under walls a thousand years old', and before the Duomo *(see cats 257, 259, 260)* – interspersed with walks on the 'marble hills'. Collingwood too was put to work, and by 16 October had 'shaded already fourteen churches with 12th century (or earlier) fronts' (*CRN*, 453).

On 5 October work was interrupted, and Ruskin and Collingwood left for a short visit to Florence, chiefly for the younger man's sake: Ruskin did not intend to draw, 'but merely look round at things', returning 'in a week at the latest' (ALS dated 'Lucca – 4th Oct 82', Bem. L 39). The changes in the city disgusted him more than ever: 'Everywhere paviours, masons, ruin – degradation – folly and noise – and the wretched Germans, English and Yankees busy upon it like dung-flies'. The memory of the past hung heavy on him, and after a few days left him 'on the whole in a state of collapse as never before' (TS, Bod. MS Eng. Misc.c.232, 33).

Distraction came in the form of drives to Bellosguardo and Fiesole, and in meetings with Henry Roderick Newman, of whom he wrote to Joan, 'I'm very happy in all I've seen of Mr Newman and he and Collie Wollie go about like brothers' (ALS dated 'Florence – 9th Oct [1882]', Bem. L 39). Another source of pleasure was the introduction, through Newman, to the painter Francesca Alexander and her mother. At their first meeting Ruskin was shown Francesca's book of illustrations of Tuscan songs, which he resolved to buy for the Guild of St George's Museum at Sheffield – as 'showing all I want to say about Italian peasantry' (TS, Bod. MS Eng.Misc.c.232, 35). On another visit – 'such kind people – gave me Ices, and American Raspberries – and Aleatico – besides the tea' – he came away with 'the marble pelican that used to be over the altar at Orvieto' *(cat.96)*. On the same day he returned to Fiesole to draw a part of the Etruscan walls, built directly on the rock, which had been exposed during a recent excavation. He had dis-

Francesca Alexander on a terrace of the Hotel Bonciani, Florence, overlooking Via Panzani

covered, as he wrote excitedly to Norton, that the 'superb fitting of the varied joints of the wall' simply imitated the cleavage of its rock foundation (*CRN*, 455-6).

Perhaps a little relieved to escape the kindness of the Alexanders, Ruskin returned to Lucca, where he continued with his drawings while awaiting the arrival of Robson and his wife. On his walks he noted the flora and gathered stones, listing them in his diary under the heading 'Stones of Tuscan series', much as he had done forty-two years earlier. Newman joined him and Collingwood for a few days towards the end of the month, and after him came the Robsons, to whom Ruskin devoted two full days.

A letter to Joan of 27 October gives a good idea of how Ruskin's days were spent during this stay:

Yesterday, I corrected a sheet and a half of new edition M.P. – saw the picture gallery here – wrote letter to Director begging for picture down for Colly Wolly to copy – (permission got this morning) – worked hard & well on my drawing from 1/2 past 10

to one, – lunched on pears and Gorgonzola: drove to foot of Monte Pisano – climbed it, (2000 ft –) got blazing sunset at the top of the Promontory of Sestri – Spezzia bay – Carrara Mountains – Apennines as far as Florence – and all the Val di Serchio – lay down on the rocks for a quarter of an hour while Collie secured the foundations of a 'Bogus' – broke out, with Baxter's help, the best specimen of twisted marble I ever found, from the very summit – ran – (at least walked full pace) a long mile along the ridge – till we could see Pisa on the right – Lucca on the left, and all that was going on in all the streets of them (if we had eyes enough – I mean we were so high above both – that also if we had had arms enough we could have pitched a 'marble' on to any body's head in all Pisa – or – Lucca –

Blazing Mediterranean under brave breeze – far away to Capraia & Gorgona – lovely mounds of hill and swathes of meadow just beneath – we kept on – after another ten minutes, into the winding head of the valley. – did a little bit of Alpine walking on steep slopes – then a run down of a couple more good miles to the plain, the last of it through chestnut groves by moonlight – (Her Majesty's Theatre never did a better Moon –) and so home to a flask of Chianti and roast fowl and chestnuts – and I'm as fresh as any daisy this morning and evy oos own poo wee dood for somefing yet Di Pa (ALS dated 'Lucca 27th [Oct. 1882]', Bem. L 39).

The next day Ruskin returned to Florence for a quick visit of two days, where he had an appointment with Murray *(see cats 279, 280)*, and again saw the 'loving and generous Alexanders'. The over-excitement left him dispirited: 'I ought to have new life in me, which (under the depression) I have, in knowing there are such good people in the world, nor exceptionally, but in multitudes, if one looks for them, as Coutet used to say of the chamois, "ou ils sont"' (TS, Bod. MS Eng.Misc.c.232, 44).

After two further days in Lucca, Ruskin and Collingwood went back to Pisa, where Ruskin had the week before summoned from Venice Angelo Alessandri and his friend the young Giacomo Boni, currently draughtsman to the director of the restoration of the Ducal Palace in Venice, and later famous as excavator of the Forum in Rome. Ruskin had corresponded with Boni (by whom the exchange had been initiated the previous year), and had architectural drawings of his which he valued, but they had not yet met. Ruskin had written to Alessandri asking him to bring Boni with him, 'and help me by drawing some Pisan architectural decorations' (AA). This was indeed the task set Alessandri during his week in Pisa, in which he produced his three drawings of San Niccola *(cats 276, 277, 278)*. But the principal reason for Boni's being asked to join him was to help Ruskin fulfil a promise to Norton, by taking careful measurements of the Duomo. For Norton had asked Ruskin to ascertain whether the west end had not been intended

to incline from the first. 'You might as well try to measure the sea-waves', had been Ruskin's first reaction (*CRN*, 450), but Boni, a trained architect, had 'Govt. authority to examine any public building he wishes', with freedom to 'put ladders and scaffolding where he likes', and was now 'getting the Cathedral levels and measures to a centimetre' (*CRN*, 454). Boni apparently drew up a report of his investigations, but this never reached Norton, being mislaid by Ruskin (*CRN*, 488). The only trace now left of it are two faint memoranda in pencil of the side(s) of the Duomo, covered in minutely written measurements, among Boni's papers at the Istituto Lombardo of Milan. But its final pronouncement is probably anticipated in Ruskin's assertion to Norton at the time that Boni, Collingwood and himself were all agreed that 'there is no endeavour to obtain deceptive perspectives anywhere, but only to get continual variety of line – and an almost exalting delight in conquering difficulties or introducing anomalies' – particularly the subsidence of the five western arches of the nave, 'added after the rest with less careful foundation' (*CRN*, 454).

The stay ended memorably for Collingwood, in an ascent of the Baptistery with Boni at sunrise. A sketch in a letter to his fiancée *(cat.243)* shows him holding on to the statue of St John on the top and waving his hat, and 'Boni getting round the cornice – de corneechy as he calls it – & 3 workmen. That's exactly like what it must have looked to anyone in a balloon' (ALS dated 'Annecy – Nov 13 1882', Abbot Hall, Kendal). Two days later at Aix-les-Bains Ruskin, who had throughout the time in Italy so longed to be back out of it, wrote in his diary, 'Friday in glowing sunshine – Pisa to Turin Saturday in frightful damp and cold, Turin to Aix – but quite easy days both, and it is delightful to think how pleasant both will be to do back again, running from Dijon straight here would make just four days from Paris to Pisa' (TS, Bod. MS Eng.Misc.c.232, 51).

240

HERBERT R. BARRAUD
Photograph of John Ruskin seated at a desk
1882
signed: 'faithfully yours J. Ruskin'
Sheffield

One of a series of photographs taken by Barraud in 1882. Afterwards Ruskin wrote to the photographer, 'We are all more than pleased with these results of your extreme skill and care; they are the first photographs ever done of me that expressed what good or character there is in me for my own work; and as pure photography they seem to me to go as far as the art can at this day (and I do not believe it can ever do much better)' (XXXIV, 562).

241

ANON
Photograph of the interior of the wooden extension to St George's Museum, Walkley, opened in 1885
203 × 150
Sheffield

242

WILLIAM GERSHOM COLLINGWOOD
Self-portrait
1886
inscribed on reverse, 'attempt at a "self portrait"' 1886 in pencil
watercolour
355 × 241
Private collection
PROV: W. G. Collingwood 1932; Barbara Collingwood 1932; Janet Gnosspelius 1961.
EXH: National Museum of Iceland 1962; Kendal 1968, 78; Kendal 1971, 6.
LIT: repr. Harraldur Hannesson, *Á.Söguslóðum*, Reykjavik 1969; Harraldur Hannesson, *Fegurd Islands*, Reykjavik 1988

243

W. G. COLLINGWOOD
Autograph letter to his fiancée, 'Annecy, Nov. 13 1882'
Abbot Hall Art Gallery and Museum, Kendal

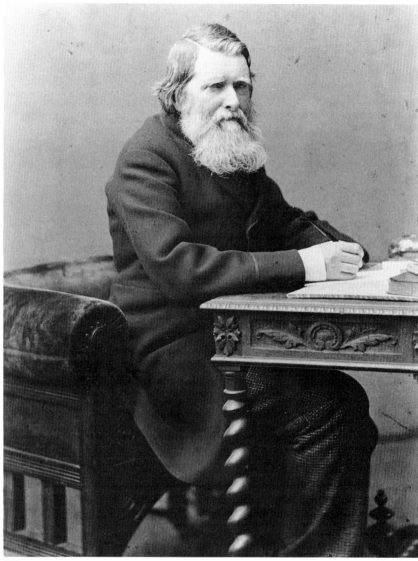

240

244, 245

HENRY RODERICK NEWMAN
Two studies of Florentine anemones
i. *Wild anemones (6 heads)*
undated
inscribed lower edge, 'unfinished 23-0, [illegible]' and on label on back 'No 3 Anemones/H. N.'
watercolour, bodycolour
180 × 142
Sheffield R596

ii. *3 anemones on a hillside*
1888
signed bottom right, 'Henry Roderick Newman 1888'
watercolour, bodycolour
260 × 170
Sheffield R817

were presented with a loaf a piece,
which amused everybody — and
this morning at four were there
with tea with a most fearful tootle-looing
and dressed in new and misfitting breeches
& drilled — dreadfully & mercilessly.

I meant to have written you a description
of my ascent of the Baptistery at Pisa with
Boné, at sunrise — but haven't time —
so will make you a sketch of it instead —
Mediterranean in distance — Carrara
mountains — to right — St John in bronze
on the top — me holding on to him & waving my
hat — Boné getting round the cornice — de cornice
one calls it — & 3 workmen. Meant exactly like —

Nov 13 1882

My darlingest Dorrie

I've put off answering
day by day — first because I was
rather a rush to finish up at
Pisa & then because we have
been travelling here as fast as
we could — from Pisa to Turin
in the sunshine — & from Turin
to Aix-les-Bains, in the snow.
& then here — among all the
prettiest autumn colours that
ever were made into remnants
of old rainbows patched up
into a gala dress for the world
but the weather this year
never holds out — for two days
morning — when we use beginning
to draw — because unless you

finish in a couple of hours the
light changes — and next
day it is bound to be foggy.

It is very cold after being
in that warm climate for so
long. I have put on several
more jerseys & a flannel shirt.
and are going on the steamboat
to look for rooms at Talloires,
where the prettiest part of the
lake is. We hope to go from
there to Sixt and from there
to Geneva — Hôtel des Bergues,
as before — where you may write
once more within 4 or 5 days,
after receiving this. Any other
letters should go to Herne Hill.
where we are due on the 1st or 2nd
December. I don't want to

stop at Herne Hill — and I
daresay they won't want me.
Besides, I have six or seven
teeth to be filled — and one
is dull what dentist to go to —
so I shall stay in town and
try to find out a very good tooth
stopper, & have them done.

So do be in London at the
beginning of December, & don't
make any special old maid,
to take your walks abroad with,
if you can help it — in the
interests of dentistry; I'll come &
see you — and show you such a
heap of sketches — three books
& portfolios full —

They are levying the yearly
conscription here — yesterday afternoon
all the new conscripts in blouses

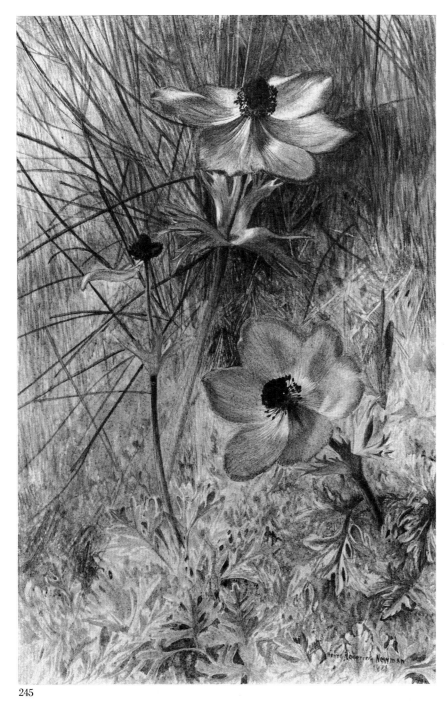

245

248

chestnuts on one side of it – and the other, all myrtle, full of blue berries, like our blaeberries – and Ilex – and Arbutus with blossom and red and yellow berries as big as plums, all at once – cyclamen and pinks in the crannies, and lovely monastery on the ridge of the hill above. With the plain of Lucca seen down the glen at its opening' (ALS, Bem. L 39).

246
Lucca, hills across the Serchio
1882
inscribed bottom right, pen, 'Lucca 3rd Oct 82. Evening JR'
pencil
122 × 201
Bem.1364

247
Lucca, clouds
1882
inscribed lower right, pen, 'Lucca 3rd Oct. 1882. JR'
pencil
116 × 195
Bem. Add. L 32
PROV: Adams bequest
Ruskin's diary for 3 October describes a walk 'to foot of hills across Serchio – where we rested among olive woods with low cypress avenues mingled – grass terraces under the olive trees quite rich in grass – and the cyclamen in masses on the shady pink banks with full bright crimson pink everywhere, and peppermint in vivid

Flowers, especially the wild anemonies of the Tuscan hills, were among Newman's favourite subjects. There are a number of his Florentine flower studies at Sheffield, some of which are said by William White in his catalogue of the collection (1891) to have been made in 1881. If the date is correct, then Ruskin may well have bought them from Newman in Tuscany in 1882. They may even have come out of walks with Ruskin and Collingwood at Lucca, such as the one described in a letter from Ruskin to Joan Severn of 24 October: 'Such a walk as I had, yesterday with Collywolly & Mr Newman – up a marble glen, with pitty girlies gathering

249

blue, I looked for forget-me-nots. View of Lucca of course too lovely to draw' (TS, Bod. MS Eng.Misc.c.232, 32).

248

T. M. ROOKE
Self-portrait miniature
1870
signed and dated on back, 'T M Rooke / 8th Decr / 1870'
watercolour
30 × 24 (oval)
Private collection

249

T. M. ROOKE
Sketchbook used in France and Italy
1886-7

Private collection
PROV: Phillida Rooke; anon sale (Colin G. Steer) Sotheby's, 13 July 1989 bt in; E. H. Yardley 1990 (when re-bound)

250, 251, 252, 253

ESTHER FRANCES ('FRANCESCA') ALEXANDER
Four drawings for The Roadside Songs of Tuscany

i. 'La Madonna ed il riccone' (title-page to 'The Madonna and the Rich Man')
382 × 275
EXH: Keswick 1909, 39.

ii. 'Non ho nè pan nè vino, cosa ti posso dar?' (from 'The Madonna and the Rich Man')

381 × 277
EXH: Keswick 1909, 38.

iii. 'The Jessamine window'
389 × 284
EXH: Keswick 1909, 29.

iv. 'Parlami, parlami, bocchin d'amore' ('The Colonel's Leave')
382 × 276
EXH: Keswick 1909, 30
pen and ink (sepia and black)
Sheffield R545-8
PROV: Guild of St George (Walkley 1883; Ruskin Museum 1890).
LIT: Morley, 24-5

Non ho nè pan nè vino cosa ti posso dar?

There on the plain a little
house I see,
And in that house my lady lives herself;
Beside the door a green pomegranite tree.
A jessamine blooming on the window
shelf;
Come love and set thy jessamine in the
air:
Sing, I can hear thee at thy window there.
Come love and set thy jessamine in the sun
Sing, I will answer when the song is done.

Là casa del mio amor sta in un
bel piano,
Rimpetto alla mia par un giardino.
Appiè dell'uscio c'è un bel melagrano
Alla finestra ci ha un gelsumino
Piglia quel gelsumin, mettilo al fresco;
Canta pur su, che ti rispondo a questo.
Piglia quel gelsumin, mettilo al sole;
Canta pur su, che ti rispondo amore.

Parlami parlami bocchin d'amore

254

'FRANCESCA' [ALEXANDER]

The Story of Ida: Epitaph on an Etrurian Tomb

Orpington, Kent: George Allen, 1883
open to show frontispiece, 'In the last ray of Sunset. / And the last day of the Year / 1872'

Bem.13.6

255

F. ALEXANDER

The Roadside Songs of Tuscany. Ed. J. Ruskin

Orpington, Kent: George Allen, 1885
open to show frontispiece, 'Beatrice / Of the Field of the Alder-Trees'

Sheffield R O680

256

F. ALEXANDER

Christ's Folk in the Apennine. Ed. J. Ruskin

Orpington, Kent: Geoge Allen, 1887
Sheffield R O233

PROV: Mary E. Eady-Borlase

The day after Newman had taken him to meet the Alexanders and to see Francesca's drawings Ruskin wrote to her mother, 'I wish I could learn an entirely new writing from some pretty hem of an angel's robe, to tell you with what happy and reverent admiration I saw your daughter's drawings yesterday.' What had most moved him was 'the entirely sweet and loving spirit which animated and sanctified the work, and the serenity which it expressed in the surest faiths and best purposes of life'. He went on to say that he had decided to buy the whole album of Tuscan songs 'for the service of our English peasantry'. He had apparently already mentioned the possibility to Francesca the day before, as he now stated his intention to offer the six hundred guineas she had already named as her price, and 'place it in the St George's Museum'. But he had also formed the plan of publishing the book 'to insure its perfect usefulness', and invited Francesca to write 'by way of an introduction to it – such brief sketches as she may find of easy arrangement of the real people whose portraits are given', for 'one of my chief objects in obtaining the book will be the conveying to the mind of our English

peasantry (not to say our princes) some sympathetic conception of the reality of the sweet soul of Catholic Italy'.

In his letter Ruskin also asked permission to come and see Francesca work. She later recalled how on that occasion Ruskin spoke a good deal about a story she had written about a young Florentine seamstress, Ida, who according to the summary Collingwood gave his fiancée 'died of a broken heart & weak lungs – a bit of both' (ALS dated 'Lucca Oct 15 1882', Abbot Hall, Kendal). Ruskin now astonished her by proposing to publish this too: 'He said it would be a very useful religious book ... especially from the absence of all sectarian feeling in it, and he seemed much pleased at the strong friendship and religious sympathy between Ida and myself, belonging as we did to two different and usually opposing churches' (Swett, 376). This reported statement is closely echoed in Ruskin's preface to *The Story of Ida*, which was the first of Francesca's works to be edited by him, coming out the following year. The book was also presented there as a model of 'domestic history': 'The lives we need to have written for us are of the people whom the world has not thought of, – far less heard of, – who are yet doing the most of its work, and of whom we may learn how it can best be done' (XXXII, 6).

Meanwhile the drawing of the dying Ida 'as she lay asleep in the evening of the last day 1872', from which the frontispiece to *The Story of Ida* was engraved (by W. Roffe [*cat.254*]) had been the first of Francesca's to be shown at Oxford, where Ruskin had recently resumed his professorship. Towards the close of his first lecture on 'Realistic Schools of Painting' Ruskin paid tribute to the purity and simplicity of the unnamed American 'girl' (Francesca was forty-five!) and her work, and also that of her peasant subjects, 'God's own poor, who have not yet received their consolation'. 'She has drawn in faithfullest portraiture of these peasant Florentines, the loveliness of the young and the majesty of the aged: she has listened to their legends, written down their sacred songs; and illustrated, with the sanctities of mortal life, their traditions of immortality' (XXXIII, 283).

Ruskin proceeded with his plan for the

publication of the album of Tuscan songs, promising Francesca, 'These songs will not be forgotten nor will these Italians pass away. They will not all be taken to Heaven – yet. Their song shall still be heard in the springtime of their native land' (Swett, 28). The problem, as Ruskin later explained in his Preface, was to decide in what form the album was to be published. All of its 109 leaves had drawings on them, but to photograph the entire collection would make the book prohibitively expensive. Nor did it make sense to publish the text of the songs without the illustrations: this 'would have deprived them of what to my mind is their necessary interpretation; they could not be in what is best of them understood, – even a little understood, – without the pictures of the people who love them'. Twenty illustrations, including three of the four drawings exhibited here *(cats 250, 251, 252, 253)*, were therefore selected to be photographed by Frederick Hollyer. The results (obtained by the platinum process, invented in 1873 and used for fine quality prints) greatly pleased Ruskin: 'one or two only of the more highly finished ones necessarily become a little dark, and in places lose their clearness of line, but, as a whole, they are quite wonderful in fidelity and clearness of representation' (XXXII, 52).

As to the drawings themselves, Ruskin in his Preface asked the reader 'to observe that Miss Alexander's attention is always fixed primarily on expression, and on the accessary circumstances which enforce it; that in order to let the parts of the design on which its sentiment depends be naturally seen and felt, she does not allow any artifices of composition, or charms of light and shade, which would disturb the simplicity of her appeal to the feelings'. If adhesion to this method had steadily weakened her sense of light and shade, this and other faults were not to be counted against her, none being due to 'affectation, indolence, or egoism' (XXXII, 52-3).

The drawings were not, as Ruskin had originally intended, all placed in the museum at Sheffield, but distributed between St George's Museum (the four here shown), Oxford, Girton College, Cambridge and Whitelands College, Chelsea.

The third of the books Ruskin published for Francesca, *Christ's Folk in the Apennine (cat.256)*, first issued like *Roadside Songs* in parts, consisted in a selection of the letters in which she told him of her peasant friends. Ruskin selected from these 'what might, with the writer's permission, and without pain to any of her loved friends, be laid before those of the English public who have either seen enough of the Italian peasantry to recognize the truth of the ritratti, or have respect enough for the faith of the incorrupt Catholic Church to admit the sincerity, and rejoice in the virtue, of a people still living as in the presence of Christ, and under the instant teaching of His saints and apostles'. The first story, 'The Peace of Polissena,' was especially written for Ruskin by Francesca, after he complained that the sadness of the *Story of Ida* 'conceded too much to the modern feeling of the British public that people who are quite good have nothing to do but die' (XXXII, 255-6).

257 (Colour plate XVIII)
Part of pier in atrium of Duomo, Lucca
1882
inscribed, lower left, 'John Ruskin / 1882' and lower right, 'Part of / Atrium Pier. / LUCCA'
label attached to back: 'Thomas Thornton of London and St Petersburg 1854-1908'
watercolour on grey-blue paper
528 × 365
Sheffield R59
PROV: Given by Ruskin to Thomas Thornton 1886; Ruskin Museum 1908.
EXH: Artistic & Natural Beauty, Sheffield 1959, 1.
LIT: XXXVIII, 264 (1036); Morley, 229

258 (Colour plate XX)
W. G. COLLINGWOOD
Sculptured pilaster, actual size, porch of Duomo, Lucca
1882
signed and dated, lower right, 'G. Collingwood. / Lucca, 1882.'
inscribed verso, 'Pillar in the porch of S. Martino, Lucca / natural size / G. Collingwood 1882'
watercolour
360 × 260
Sheffield R492

PROV: Guild of St George (Bewdley 1887; Ruskin Museum 1890).
LIT: Morley, 60

On 14 October, Ruskin wrote to Joan, 'Rain & thunder here all day long! but I've three drawings in hand – all going on in spite of them'. The three drawings were all of the Duomo façade, and included the study exhibited here *(cat.257)* of the 'delicate pillar' on the face of the right-hand pier supporting the central arch of the atrium, begun that same day (*Diaries*, 1033). The other two were larger drawings of a part of the porch and the first ranges of arches above it, reproduced by Cook and Wedderburn in vols XII (Pl.xv) and XXXVII (Pl.x) of the Library Edition. A few days later, Ruskin wrote again, 'I've got into what Collingwood calls a "grind" with my drawings – they're just at the point where I usually give them up. but I'm going to do all I know on them' (ALS dated 'Lucca 18th Oct [1882]', Bem. L 39). Resolved not to admit defeat, Ruskin pushed through with the two larger drawings, which he was pleased to report at the end of his stay were 'farther on the way to finish than usual' (ALS dated 'Lucca 1st Nov. 82', Bem. L 39). A newspaper report of the first lecture in the *Art of England* series held that winter, shows that Ruskin exhibited these two drawings by way of conclusion, 'to show that though he was growing older his hand had not lost its steadiness' (XXXIII, 286n). The effort meant the abandonment of the 'delicate pillar', however, but as Ruskin remarked to Joan, 'I never finished a drawing in my life except the crab, at Oxford' (ALS dated 'Lucca 1st Nov. 82', Bem. L 39).

About the time he began his study of the 'delicate pillar', Ruskin got Collingwood to draw another carved column in the porch of the Duomo, on the right side of the main door *(cat.258)*. In a letter to his fiancée, Collingwood described himself at work: 'Yesterday it rained horridly, and I was in the cathedral porch up a sort of stand, against a pillar doing carved leaves – and the wind blew the rain in. The dean & chapter came to see and all the [illegible] I mean [cancelled] choir boys – and 5 gendarmes, and several worshippers, and two French Tourist ladies – and an Italian gentleman made a

260

speech on my abilities and presented me with a carved matchbox as a token of [cancelled] Lucchese esteem – to which I replied that I couldnt speak Italian & couldnt repay him, & couldnt think of accepting – at which he was desolated' (ALS dated 'Lucca Oct 15 1882', Abbot Hall, Kendal).

259
Sketch of Duomo, Lucca
1882
inscribed lower right, 'J. R. Lucca. 30th Sept. 82.'
inscribed on mount, lower left, 'Drawn for the plan of composition of picture/ to be done by Henry Newman, who lost / himself and me, alike, in his unhappy egotism / of ultramarine – Rose Madder & yellow ochre! – see unlucky drawing / sent to Bewdley. /JR. 17th May 89' and lower right, 'Lucca fast scrawl touched with colour'
pencil, watercolour
125 × 200
Brant.938
EXH: AC 1964, 148.
LIT: XXXVIII, 263 (1030); Walton, 115

260
Lucca street (Guinigi Palace)
1882
inscribed lower right, 'Lucca. JR / 1882'
pencil
201 × 122

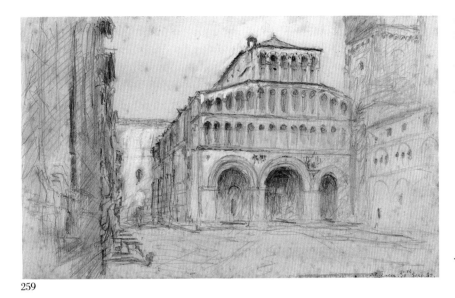

259

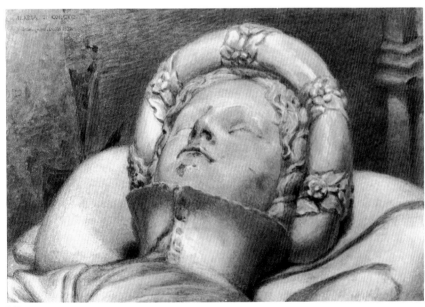

262

Brant.941
EXH: Coniston 1900, 207; RWS 1901, 104;
Manchester 1904, 394; AC 1983, 200.
LIT: XXXVIII, 264 (1051).

261 (Colour plate XXI)
HENRY RODERICK NEWMAN
Façade of Duomo, Lucca
1885
signed and dated lower left,
'H.R.Newman 1885'
watercolour, bodycolour
775 × 635
Sheffield R23

PROV: Ruskin commission 1882; Guild of
St George (Bewdley 1887; Ruskin Museum
1890).
EXH: Manchester 1904, 303; Artistic &
Natural Beauty, Sheffield 1959, 15.
LIT: Morley, 126
 Ruskin's 'scrawl' of the Duomo
(*cat.259*) was done on his first full day in
Lucca. A comparison with the 'unlucky'
view by Newman (*cat.261*) for which the
sketch was supposed to provide the
composition, shows Ruskin's preference
for the dynamic perspective typical of

many of his later drawings. It is also found
in the rapid pencil sketch of the Guinigi
Palace made at the same time (*cat.260*),
and in the earlier 'Vineyard walk'
(*cat.181*). In the drawing of the Duomo,
the result is what Paul Walton calls 'a
stream of spatial recession rushing out of
the square at the left, past the old church
leaning heavily against its bell-tower'.
 Newman did two views of this subject,
nearly identical. The second is in the
Birmingham Art Gallery.

262
W.G.COLLINGWOOD
*Head of the effigy of Ilaria del Carretto
from her tomb, Duomo, Lucca*
1882
inscribed upper left, 'ILARIA DI CORETTO /
G.Collingwood. Lucca 1882'
watercolour, bodycolour
170 × 250
Sheffield R498
PROV: Guild of St George (Bewdley 1887;
Ruskin Museum 1890).
EXH: Coniston 1900, 231; Manchester
1904, 304; AC 1964, 147.
LIT: Morley, 60
 On 24 October Collingwood wrote to his
fiancée, 'The weather is worse again – but
drawing goes on as usual You'll soon have
reason to be awfully jealous of Ilaria, with
whom I am over head and ears in love –
and have drawn her portrait twice with
great care. She has such pretty hair, a bit
like yours – and such a nice little fat
double chin' (ALS dated 'Lucca. Oct 24
1882', Abbot Hall, Kendal). Ruskin may
have suggested the angle adopted by
Collingwood in this drawing, as it seems to
be the difficult favourite view of Ilaria
which he had mentioned in a letter to Joan
of 1874: 'Ilaria beat me yesterday. – the
loveliest [?look] of her is a little in front
– giving complex difficulties and my paper
again proved abominable and I had to
give in' (ALS dated 'Lucca 30th July
[1874]', Bem. L 39).
 The second 'portrait' mentioned by
Collingwood, in pencil, is now at Abbot
Hall, Kendal.

263
W.G.COLLINGWOOD
Lucca street (Via Fillungo)
1882

signed lower left, 'W.G.C'
watercolour
252 × 173
Bem.165

Via Fillungo is one of the main streets
in the city, connecting San Michele with
San Frediano. On the right can be seen the
church of San Cristoforo, rebuilt in the
13th century, and beyond it the Torre
dell'Ore, which dates from the same time
and whose mechanical clock has tolled the
hours since 1471. Ruskin had described it
to Joan in 1874: 'The clock has just struck
Four – at evening – which means Tea,
English time. It's a grand old turret clock
near St Michaels and tolls the quarters,
with the hour after them that they're past
... only it can't strike – (or [illegible]) –
more than six – and so begins again. – So
one is one and seven, and two is two and
eight – and three is three and nine – and
four is four & ten – does at puzzy wuzzy
oo tebby webby pussy mussy?' (ALS dated
'Lucca Sunday 9th Aug 74', Bem. L 39).

264
Ponte Vecchio, Florence
1882
inscribed lower left and right, 'John
Ruskin'
pencil
Brant.911
PROV: Lord Henry Bentinck.
EXH: ?RWS 1901, 192.
LIT: XXXVIII, 251 (?703); Whitehouse, 61

265
Ponte Vecchio, central arches
?1882
pencil
78 × 102
Bem.1254

266
Buildings at south end of Ponte Vecchio
?1882
pencil, watercolour, white
168 × 118
Bem.1257

These drawings were probably made in
1882, when Ruskin made a number of
sketches of the bridge, mostly in pencil. A
letter to Joan written in Florence in
October makes it clear that in one instance
at least he did so with the projected *Our*

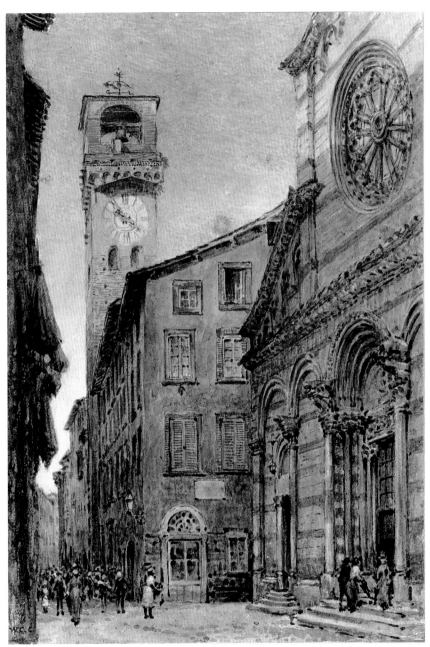

263

Fathers Have Told Us series in mind, of
which the fifth volume, never written, was
to have been called *Ponte Vecchio*: '...
I've done a pretty chiaroscuro of Ponte
Vecchio this morning, which will make a
charming plate for "Our Fathers have told
us". Usually, the sun shines in at the
windows so that one can't draw in the
morning. but it has been most usefully
grey till now – 1/2 past ten' (ALS dated

'Florence. Saturday 28th Oct 82', Bem. L
39). The windows were those of the Hotel
de la Grande Bretagne which overlooked
the Arno just to the east of the bridge. On
first taking up residence there three weeks
earlier, Ruskin had noted in his diary that,
should the weather prove bad, he might
draw the 'yellow houses beyond Arno'
(*Diaries*, 1030).

266

267

H. R. NEWMAN

Three tombs beside Santa Maria Novella, Florence

1877

signed lower right: 'H. R. Newman / 1877'

watercolour

415 × 523

Brant.757

PROV: Sharp; Bembridge 1960.

EXH: Maas 1991, 99

268 (Colour plate XXIII)

T. M. ROOKE

Three tombs beside Santa Maria Novella, Florence

1887

inscribed lower right: 'In Piazza / Sta Maria Novella / 1887'

watercolour

278 × 304

Sheffield R34x

PROV: Ruskin commission 1886; Guild of

St George (Bewdley 1887; Ruskin Museum 1890).

EXH: Walthamstow 1959.

LIT: Morley, 207

In the fifth part of *Mornings in Florence*, 'The Strait Gate', issued in 1876, Ruskin had the reader stop before entering Santa Maria Novella to observe the lower 'refined, fourteenth-century' portion of the façade, and especially a line of detached tombs immediately to the left of the entrance. This, he tells the reader, 'untouched in its sweet colour and living weed ornament', he would wish to have painted, 'stone by stone: but one can never draw in front of a church in these republican days; for all the blackguard children of the neighbourhood come to howl, and throw stones, on the steps, and the ball or stone play against these sculptured tombs, as a dead wall adapted for that purpose only, is incessant in the fine days when I could have worked' (XXIII, 382).

The following year Ruskin was shown a drawing of the Piazza and façade of Santa Maria Novella by Henry Roderick Newman, to whom he wrote a letter of enthusiastic praise. He concluded this by advising the constant practice of drawing from the early Florentine masters to maintain the artist's 'keen perception of natural fact', suggesting two possible subjects: 'a bit of Angelico's St Lawrence (face or dress)' from the San Marco altarpiece, 'or a bit of the wreath of cloud and angel in Botticelli's Coronation of the Virgin'. 'I wish', he added, 'you could do those three old arches, seen right in front on the left of the steps going up to Sta M. Novella. If they are still uninjured and wear their weeds, there's nothing lovelier in Florence' (XXX, lxxiii). Newman carried out the drawing of the arches, and this was bought by Ruskin for the St George's Museum. Newman also drew the other two subjects Ruskin suggested: his copy of the Angelico *St Lawrence* and a copy by H. B. Warren of his drawing of angels from the Botticelli *Coronation* are in private collections in America.

Newman's drawing, however, seems never to have gone to Sheffield, and in 1886 Ruskin commissioned another from T. M. Rooke, who was in France and Italy from May 1886 until the summer of the

following year as a salaried copyist for the Guild of St George. Ruskin wrote to him in Florence, 'I want you to work chiefly on things perishing'. This principally meant the Badia Fiesolana *(cat.216)*. But as an alternative, 'on days when you don't care to go so far as Fèsole', Ruskin suggested the same three arches at Santa Maria Novella, provided they were 'yet unrestored' (ALS, Brantwood headed paper, n.d., HRHRC, Texas).

269 (Colour plate XVII), **270, 271**
T.M.ROOKE
Three studies of stained glass, Florence
1886-7
i. *Aaron, from sanctuary, Santa Croce*
watercolour
252 × 102
Sheffield R587

ii. *St Barbara, from sanctuary, Santa Croce*
watercolour
253 × 88
Sheffield R588

iii. *Two figures from window in north transept of Duomo*
inscribed in pencil lower right, '23'; and in pencil verso, 'J Ruskin/Brantwood/ Coniston/Lancashire/Inghilterra'
watercolour
324 × 180
Sheffield R1674
PROV: Ruskin commission 1886; Guild of St George (Bewdley 1887; Ruskin Museum 1890).
LIT: Morley, 204-5

Aside from the threatened Badia Fiesolana and the Santa Maria Novella tombs, Ruskin also required Rooke while in Florence to draw 'some of the painted glass of Cathedral and Sᵗᵃ Croce – not that *this* is perishing, but that it hasn't been done, and only you can do it' (ALS, Brantwood headed paper, n.d. [1886], HRHRC, Texas). Ruskin was hard on the first of the drawings to reach him, from the window in the Duomo. This, and a drawing from the Orcagna Orsanmichele tabernacle, he thought 'wasted time; the Orcagna is too dark – and wasn't worth doing. and the window is ugly' (ALS, Brantwood headed paper, dated '24th Feb [1887]', HRHRC, Texas).

He was more pleased with the other two

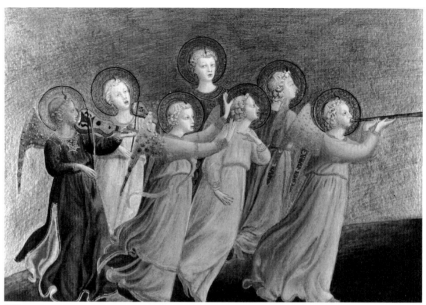

272

drawings, which he declared 'among the very delightfullest and usefullest you have done for me' (ALS, Brantwood headed paper, dated '22nd March 87', HRHRC, Texas).

272
LOUISE VIRENDA BLANDY, after Fra Angelico
Seven angels from 'Risen Christ in Glory', National Gallery
?1883-4
watercolour, bodycolour, gold
170 × 257
Sheffield R635
PROV: Guild of St George (Walkley 1885; Ruskin Museum 1890).
EXH: AC 1964, 373.
LIT: Morley, 32

Catherine Morley has suggested a date of between 1883 and 1884 for this drawing, as it is mentioned in letters between Ruskin and Louise Blandy of this period, and was certainly at Sheffield by 1885.

273 (Colour plate XXII)
Part of panel from font, Baptistery, Pisa
?1882
watercolour and bodycolour over pencil
512 × 360
The Visitors of the Ashmolean Museum, Oxford (Ref.100)
LIT: XXXVIII, 274 (1306)

274
Detail of carved pillar from east door, Baptistery, Pisa
?1882
watercolour, bodycolour over pencil
155 × 98
Birmingham Museums and Art Gallery (15'16)
PROV: Birmingham (presented by Councillor C. Combidge) 1916

275
W.G.COLLINGWOOD
Figure at base of left-hand pillar, east door, Baptistery, Pisa
1882
inscribed top right in pencil, 'W.G. Collingwood/Pisa 1882' and verso, 'Part of a pillar in the porch/of the Baptistery at Pisa,/natural size./ W.G. Collingwood. 1882'
watercolour
360 × 260
Private collection
PROV: Barbara Collingwood 1932; Janet Gnosspelius 1961.
EXH: Kendal 1971, 4

On 28 October, Collingwood wrote to his fiancée from Pisa, 'I am drawing sculptures in the Baptistery – and writing this in a hurried interval' (ALS, Abbot Hall, Kendal). Ruskin's diary shows that both during the four days spent at Pisa at

280

The church of San Niccola dates from the 10th century, the lower part of its façade from the 12th. The octagonal campanile was built about 1250 and is traditionally ascribed to Nicola Pisano.

It has been suggested by Catherine Morley that the commission had some connection with the projected fourth volume of *Our Fathers Have Told Us*, to be dedicated to Pisa and to be named after its seaward bridge, *Ponte-a-Mare*, or with the plans for the new Guild museum at Bewdley, for which Ruskin envisaged an architecture partly modelled on the Pisan Romanesque style.

Among the papers of Giacomo Boni at the Istituto Lombardo of Milan is a sheet with a sketch and measurements of the detail of inlaid ornamentation in *cat.278*.

279, 280

C. F. MURRAY, after Benozzo Gozzoli
Two studies after frescoes in the Campo-santo, Pisa
1881
i. *Abraham leaving Babylon with Sarah and Lot*
watercolour
228 × 280
Sheffield R508

ii. *The birth of Jacob and Esau*
watercolour
229 × 283
Sheffield R509
PROV: Guild of St George (Bewdley 1887; Ruskin Museum 1890).
LIT: Morley, 116

The drawings (of which the first has until now been mistakenly described as 'Jacob leaving Laban') do not appear to have been expressly commissioned by Ruskin. They were sent him by Murray in the autumn of 1881: on 20 October Ruskin wrote to Murray, 'The "two sketches by Benozzo Gozzoli" are not yet arrived, so far as I know: but they may have been put aside by my servant. What are their subjects?' (ALS, Morgan MA 2150/91). A letter dated 28 October, probably of the same year though placed out of sequence in the correspondence, reads, 'Your summary of the sketches, received yesterday, puts me right about them all ... I had entirely forgotten the Benozzo's – in the press of almost insupportably various

the end of September, and also in the longer stay at the beginning of November, he too was drawing in the Baptistery. One drawing was brought 'even to a point of satisfactory – or at least endurable, end' on 5 November (*Diaries*, 1038). This may be a study of a panel from the Baptistery font at Oxford (*cat.273*), not mentioned, like that of a head from another panel (*cat.125*) in *Val d'Arno*, nor in the note on the head written in 1878 for the intended re-arrangement of the Reference Series, suggesting *cat.273* was not yet at Oxford. Its comparative softness (typical of the late drawings) and finish (at Lucca Ruskin's determination to show that his powers of drawing were despite age and illness not irremediably undermined had led to two more than usually finished drawings [see entry for *cats 257, 258*]) are further reasons for thinking so.

Alternatively, the drawing finished may have been *cat.274*, until now catalogued as a 'Sculptured Pillar: Porch of S. Martino, Lucca', but actually a detail from one of the pillars to the immediate left of the main door of the Pisan Baptistery. Again the style points to a late date. Moreover, the details drawn are surprisingly high off the ground, suggesting that Ruskin may have taken advantage of the ladders and scaffolding brought with him by Boni for the measuring of the cathedral.

276 (Colour plate XXIV), **277, 278**
ANGELO ALESSANDRI
Three studies of San Niccola, Pisa
1882
i. *Part of façade and campanile*
watercolour, bodycolour
291 × 203
Sheffield R485
PROV: Ruskin Commission 1882; Guild of St George (Bewdley 1887; Ruskin Museum 1890).
EXH: AC 1964, 379; Lancaster 1992.
LIT: Morley, 13-14

ii. *Three arches from façade*
watercolour
143 × 291
Sheffield R486
PROV: Ruskin Commission 1882; Guild of St George (Bewdley 1887; Ruskin Museum 1890).
EXH: Lancaster 1992.
LIT: Morley, 13-14

iii. *Detail of inlaid ornamentation of façade*
watercolour
178 × 234
Sheffield R532
PROV: Ruskin Commission 1882; Guild of St George (Bewdley 1887; Ruskin Museum 1890).
EXH: Lancaster 1992.
LIT: Morley, 13-14

business' (ALS, Morgan MA 2150/98).
However, a year later (in the course of
which Ruskin suffered his second attack of
madness), Murray had evidently still not
received payment for the drawings or
perhaps even been informed whether they
were to be kept or not. For on 27 August,
presumably in answer to further
prompting from Murray, Ruskin wrote,
'The Benozzo drawing [*sic*] will, I have no
fear, be an extremely valuable addition to
the Museum, and I believe it is safe at
Herne Hill – I enclose cheque for another
£50 but please send me receipted
statement of price of the Benozzo' (ALS,
Morgan MA 2150/95). The affair was
presumably settled in Florence later that
autumn. The copies were probably the last
by Murray to have been purchased by
Ruskin, as shortly afterwards a
disagreement over the price of another
drawing, aggravating Murray's evidently
increasing annoyance at delayed and
disorderly payments, led to a complete
break in their relationship.

Modes of Opposition:
Tuscany in the Oxford Lectures[1]

Jeanne Clegg

1. School of Crystal, School of Clay

When Ruskin took up his professorship at Oxford in 1870 he had not been to Tuscany for twenty-four years. Painting and architecture had taken him to Venice, Turin and Milan, history and landscape to Switzerland; economic, social and political questions kept his attention on England and the present. To all of these the painters of thirteenth- and fourteenth-century cloisters of Pisa and Florence seemed irrelevant or worse. In the second of his Inaugural Lectures as Slade Professor of Art at Oxford Ruskin made a violent attack on religious art as harmful both to art and to religion.[2] More moderately, he stated that the English could never 'be successful in the highest fields of ideal or theological art', for humorous delight in evil was too much a part of our culture. And since his immediate purposes at Oxford were to teach the gentlemen of England to draw correctly, and to train them as intelligent patrons of unrecognised young artists, Ruskin intended to concentrate on the naturalistic art which used best the national gifts for portraiture, domestic drama, observation of animals and landscape. As for the quality he had come to prize in fifteenth-century Italian engraving: 'We shall never excel in decorative design', a discipline of hand and fancy which could only be developed over generations, and in a less anxious society than that of Victorian England (xx, 28-9).

Ruskin's attack on religious art was, however, partly a form of revenge over Rose La Touche, 'the woman, Who bade me trust in God, and her,/ And taught me/The cruelty of Religion/And the Vanity of Trust'.[3] Over the next four years Rose was to sicken, the wish to hurt her was to fade and religion become a source of hope, so changing the whole bent of Ruskin's views on Christian art. But in any case, right from the beginning of his professorship, Ruskin set himself an aesthetic task which would make him look again at Tuscan art, and enable him to do so with eyes relatively unencumbered by the religious issue. The last three of the Inaugural Lectures go back to visual first principles – line, colour, mass; and offer a model of the relationships between the schools of art which takes the shape of a hexagon (xx, 128):

1 LINE Early schools

2 LINE & LIGHT Greek clay 3 LINE & COLOUR Gothic glass
4 MASS & LIGHT Leonardo & school 5 MASS & COLOUR Giorgione & school
6 MASS, LIGHT & COLOUR Titian & school

Here all art begins in line and ends in full representation, but individual artists develop from one to the other via one of two paths. The School of Light, also called the School of Clay, avoids colour and uses chiaroscuro in its search for solid form, for having no hope of resurrection its members look to earthly substance, tolerating imperfection and 'lik[ing] their patterns to come in the Greek way, dashed dark on light

1. Catherine Morley long ago suggested a unique connection between Ruskin's Oxford and Tuscan experiences, and here as in so many areas her work on Ruskin – first her doctoral thesis and then her book, *Ruskin's Late Work*. New York: Garland, 1983 – has been vital

2. On this and on Ruskin's views on Greek art and religion in the Oxford context see Dinah Birch's *Ruskin's Myths*. Oxford: Clarendon Press, 1988, chapter VI

3. Part of the inscription Ruskin intended for Rose's copy of the Inaugural Lectures: letter of 20 March 1870, *The Letters of John Ruskin to Lord and Lady Mount-Temple*. J. L. Bradley (ed.). Ohio State University Press, 1964, p.273

...'. The School of Colour or Crystal avoids shadow and uses pure, flat tints; secure in the comfort of their religion its members seek visionary shapes and delight in 'intricate patterns, in order to mingle hues beautifully with each other ...' (xx, 171).

The Oxford lectures are in many ways a re-visiting of *Modern Painters*, one of them being that both start as attempts to construct a whole system of art.[4] But whereas the *Modern Painters* system uses abstract and natural universals (Ideas of Truth, Beauty, Intellect, Power), the Oxford one is built of visual, material and cultural qualities; and whereas the earlier system is a series of linked but autonomous components, this later one has an organic and dialectical structure. In the hexagon straight lines link points on a circle, offering a maximum of positions which are at once opponent and directly related to each other. Each element in this symmetrical system becomes meaningful in relation only to its partner in the series of minimal pairs. The simplicity of the first school makes sense when opposed to the sophistication of the last, the earthiness of Clay cannot not be understood without the clarity of Crystal, the effect of mass combined with light stands out by contrast with mass and colour.

So the theory. In practice, Ruskin told his students they would have to choose: 'coloured windows ... Angelican paradises' could not be united with 'the gloomy triumphs of the earth' (xx, 174). He himself belonged 'wholly' to the chiaroscurist school, and since all naturalistic art is assigned to that school, it should follow logically that so did England as a whole (172-5). But almost as soon as the Inaugural series were over, signs of uncertainty begin to show. Ruskin had planned to lecture next on Tintoretto, and in April 1870 set off for Venice. He then became afraid of concentrating too much on an exceptional painter and travelled on 'to look at the Florentine school'. In Florence Filippo Lippi, a painter he had not considered much before, taught Ruskin that a 'complete monk' could also be a strong and 'entirely noble painter'. He had come to Tuscany 'anxious about many of these things', he told Mrs Cowper-Temple, but had now 'learned much ... and hope to tell things in the autumn at Oxford that will be of great use'.[5] Ruskin seems to have begun early to discover that he did not belong so 'wholly' to the School of Clay after all.

Nevertheless, it was first through Clay, Nature and Greek chiaroscuro that the public Ruskin was to make his way back into Tuscan art. During a visit to Charles Eliot Norton near Siena in late May he drew the lion cubs at the base of Niccola Pisano's pulpit in the cathedral. Ruskin probably also discussed Greek sculpture with Norton, for while revising the lectures for publication he received from the American thirty or so vases and a statuette from Corfu which incorporated a happy combination of personification and symbolic shape. 'The Fortune has come', Ruskin

4. See John Hayman, 'Towards the Labyrinth: Ruskin's Lectures as Slade Professor of Art', in *New Approaches to Ruskin: Thirteen Essays*. Robert Hewison (ed.) London: Routledge & Kegan Paul, 1981, pp.111-24. Hayman's is one of the few studies of the Oxford lectures, and I am much indebted to it

5. Letter of 1 July 1870, *Letters to Mount-Temples*, p.278

wrote on receiving it, 'She is enough to change mine, for life – the Greek darling – and a globe made of Hexagons' (XXXVII, 31; see XXXVII, 42).

Like the diagram of schools, the conceptual structure of the 1870 lectures on 'the Elementary Principles of Sculpture' – published the following year under the more provocative title *Aratra Pentelici* – is built of pairs, similar or contrasting or both. In many of those pairs, one component is Greek, the other Tuscan. For

the conditions necessary for the production of a perfect school of sculpture have been only twice met in the history of the world, ... for a short time ... [and] in narrow districts, – namely, in the valleys and islands of Ionian Greece, and in the strip of land deposited by the Arno, between the Apennine crests and the sea (XX, 331).

Geologically coupled through the availability of a fine white marble (Carrara being the equivalent of the Mount Pentelicus alluded to in the published title of these lectures), Greece and Tuscany together illustrate the basic principle of sculpture's duty to be superficial: to produce a pleasing surface, irrespective of the thing imitated or the structure underneath. 'Pleasant bossiness of surface' is illustrated by a Greek coin shown from such a distance that the head represented is unrecognisable. The 'hexagonal box' of the Baptistery of Florence – in fact it is octagonal, but Ruskin evidently had hexagons on his mind – shows how

eye and intellect are to be interested by the relations of dimension and curve of encrusting marble of different colours, which have no more to do with the real make of the building than the diaper of a harlequin's jacket has to do with his bones.[6]

But Ruskin still thought the English mind too untrained in the 'sense of abstract proportions' to understand the 'musical' aspect of sculpture. *Aratra* therefore concentrates on the 'zoo-plastic – life-shaping' aspect (XX, 217-8, 220-1). Greek and Tuscan are again paired as greatest in the highest of mimetic tasks: the representation of the human being (XX, 33). Within that pairing, they are complementary. What the Greeks had done for the body, the Italians for the face, is illustrated by comparing a Greek Aphrodite Urania of the fifth century *(cat.151)* and a Florentine Venus of the fifteenth *(cat.155)*. The first is pretty, neat and domestic, full-breasted, calm; she epitomises a 'mode of mind' which conceives of love as 'happy terrestrial domestic life'. The second 'will not condescend to be pretty', and 'looks up, her face all quivering and burning with passion and wasting anxiety ... incapable of rest'; she epitomises

the agonizing hope of an infinite good, and the ever mingled joy and terror of a love divine in jealousy, crying '... love is as strong as death, jealousy as cruel as the grave.[7]

Both comparative and contrastive uses of Tuscan and Greek are possible

6. XX, 217. On his next visit to Florence Ruskin was to draw for Oxford one compartment of the Baptistery so as to fill the picture plate and make it impossible to relate to the building as a whole *(cat.123)*

7. XX, 366-8. A terra-cotta 'dancing girl' *(cats 92-3)* exemplified even more clearly the attention to the 'beauty of the body itself, or its action ... [the artist] has no thought of the girl's mind at all' (XX, 408; Oxford Rud.52). At the opposite extreme Dante and Beatrice exemplify the exclusively Christian 'imaginative purity of the Passion of Love'

because the Tuscany of the Oxford lectures is a meeting place of opposites: here of Crystal and Clay, Greek and Gothic. In *Aratra* the 'great Tuscan art' develops out of the coincidence of 'the veracity and humanity of Paganism, and the phantom of the Lombard'. Nicola Pisano's Siena pulpit *(cats 99-102)* preserves in the lion biting through the eye of the horse the 'grotesque and ghastly brutality' of the Northern, Christian tribes; in the lionness suckling her cubs Greek practical domesticity dominates (xx, 262).

Opponent principles are illustrated in two juxtaposed images here – we can compare by looking from one to the other. Elsewhere opposing qualities are superimposed in a single image. The Florentine Venus used in *Aratra* to contrast with the Greek was to be used in *Ariadne Florentina* to show continuity with the Greek. Ruskin tried to reassure his students about this sort of complication in the *Lectures on Landscape* delivered in the Spring Term of 1871. 'Momentary contradictions' were inevitable, for

… the modes of opposition in the greatest men are inlaid and complex; difficult to explain, though in themselves clear (xxii, 49).

Inlaid but not blended, complex not graduated. Ruskin could not

too often urge you to keep clearly separate in your thoughts the school which I have called 'of Crystal', because its distinctive virtue is seen unaided in the sharp separations and prismatic harmonies of painted glass, and the other, the 'School of Clay', because its distinctive virtue is seen in the qualities of any fine work in uncoloured terra-cotta, and in every drawing which represents them (xxii, 49).

The chiaroscurist devotes himself to the representation of degrees of a single quality – unseparated light; the colourist deals in distinctions, must see each colour, like each note in music, as having a 'different office' and lay them side by side as in 'inlaying or joiner's work … the fitting of edge to edge with a manual skill precisely correspondent to the close application of notes … in fine harp or piano playing' (xxii, 51-2). Again the facing on the Baptistery of Florence is a key example.

One could read these passages as comments on his own work at Oxford. Rejecting the gradualist, approximating method of the chiaroscurist, Ruskin was himself attempting a 'joiner's work' of inlaying, fitting distinct formal and cultural concepts into an increasingly complex geometry. There are moments when he seems to lose control of the configuration, as categories subdivide and re-combine, or qualities slip out of their couplings or mirror each other across the divides. It is as if the very concept of 'joiner's work' itself proves slippery. To see this we need to backtrack. In *Aratra* all pattern, as well as all mimesis, is traced back to the Greeks. First in 'simple veracity' they are also 'first leaders of ornamental design', delighting in

spottiness and chequeredness ... crossed or starred or spotted things ...
glistenings ... piercings ... stainings ... burnishings ... quartering ... and
arabesque ... all enlargement, and all diminutions of adorning thought ...

The examples run quick as mercury through the universe of European
art: from the pillars of Agrigentum to the finials of Santa Maria della
Spina, from the hexagonal decoration of Furness Abbey to the 'hex-
agonal' box of the Baptistery of Florence, the

glittering and irridescent dominion of Daedalus prevails; and his ingenuity in
division, interposition, and labyrinthine sequence.

Within the mimetic-decorative duality of 'Greek' art lies a moral duality,
itself double. The brightness carries a 'lurid shadow' or danger, which
in its turn is 'twofold':

first, in leading us to delight in glitterings or semblances of things, more than
their form, or truth; – admire the harlequin's jacket more than the hero's
strength; and love the gilding of the missal more than its words; but farther,
and worse, the ingenuity of Daedalus may even become bestial, an instinct for
mechanical labour only, strangely involved with feverish and ghastly cruelty
... building labyrinths for monsters, – not combs for bees (xx, 353-4).

Here Ruskin warns against but seems also fascinated by the difficulty
of distinguishing semblance from form, honeycomb from monster-house.
Builder of hexagonal systems and pursuer of the 'triumphs of the earth',
he was himself a Daedalian constructor who might lead others into battles
with monsters. In the first two series of lectures Ruskin accepts that risk
and wishes his audience to recognise it. But then he seems to turn away.
Ambivalence seems to be removed from the world of art, or rather the
objects Ruskin loved best are purged of it. In *Aratra* the 'harlequin's
jacket' of the Florence Baptistery falls within the dominion of Daedalus,
but in *Lectures on Landscape* it typifies the 'prismatic harmonies' of the
School of Crystal. In the great 1872 series of lectures Ruskin was to con-
centrate not on the construction of the labyrinth and the battle with the
beast but on how to find the way through the maze and reach the loved
one. It is not the builder but the guide who is important, not Daedalus
but Ariadne and the line – itself labyrinthine – by which she enables
Theseus to negotiate the ingenious trap.[8]

2. North and South

The journey of 1872 reduplicated features of that of 1870 (*see*
Chronology) but was much more extensive. The party included once
again the Hilliards and Joan, and added Joan's recently acquired
husband, the painter Arthur Severn, and Albert Goodwin, a young land-
scapist. This time Ruskin led his party – as far as he was able – there
was a good deal of bickering on the trip – down the early 1840s route
down the Tirreno coast to Lucca, Pisa and Florence, returning home via

8. John Hayman (op.cit.) has discussed in detail
Ruskin's invocation of 'complexity with the
intent of triumphing over it', his use of
Daedalus as guide and of the labyrinth as
'triumphant image of the unity of man's
endeavours'. I do not see, as he does, a
'movement from the curve to the labyrinth as
a central point of reference', for the spiral
persists as a cardinal image and is in any case
one of the forms of the labyrinth – as Ruskin
explained in *Fors Clavigera* XXIII

Venice. Unusually though – between Tuscany and the Veneto – they went to Rome, never Ruskin's favourite city, but included now in order to introduce Joan to her aging father-in-law, Joseph Severn – and in Rome Ruskin discovered the Botticelli and Perugino frescoes in the Sistine Chapel. Though his next lecture course, delivered as 'Sandro Botticelli and the Florentine Schools of Engraving', mainly concerns engraving, the centrality of Botticelli was probably due to this discovery. He was to return in 1874, have scaffolding put up and make one of his most ambitious copies *(cat.220)*. The later parts of the 'Engraving' lectures, revised for publication under the title *Ariadne Florentina* over the next three years, are therefore the products also of the 1874 journey and, as we shall see, both of the changing relationship with Rose La Touche, and modifying religious views.

Even the first two lectures, issued in November and December 1873, show signs of a tendency to Christianise. Florence is 'the source of chief power in all the normal skill of Christendom' (XXII, 322). In the peculiar pasteboard diagrams Ruskin waved about in lectures to fix in his students' minds the chronology of the twenty-five artists they were to know and understand, over half are Tuscan, five of them of the fourteenth century, five of the fifteenth (XXII, 334-5; *cat.120*). He now wished to direct his students' attention not to the wordly portrayers of nature and humanity – the School of Clay in other words – but to 'seers or prophets', 'earlier, many of them weaker, men, who yet, for the very reason of their greater simplicity of power, are better guides for you' (XXII, 330-1). And if these men are mostly Tuscan, Tuscany is now the place where true Christianity comes into being. It is only in the mid-thirteenth century that

true human life begins, and the cradle of this life is the Val d'Arno. There the northern and southern nations meet; there they lay down their enmities; there they are first baptized into John's baptism for the remission of sins ... (XXII, 443).

From a 'hexagonal box' which illustrates the dangerous attractions of the harlequin's jacket the Baptistery of Florence has become the place of 'John's baptism', the starting point of Ruskin's 'whole history of *Christian* architecture and painting', the 'centre of Christian knowledge and power' (XXII, 344).

At points like these, religion threatens to swamp any sense of material, manual art. At others, piety is pushed into the background. The Baptistery may be the centre of European Christianity, but – like the green and white façade of San Michele at Lucca *(cats 23, 72)* – it is also 'one large piece' of engraving – white substance, cut into, and filled with black'. Engraving itself is the 'art of scratch', or covering with pleasant lines a hard surface. Its first virtue is the '*decorative* arrange-

ment of *lines*', irrespective of meaning, a quality illustrated by the dis-
armingly domestic example of a damask tablecloth, in which the pattern
emerges from threads running first one way, then the other in a 'texture
of meshed lines'. A comparison between a 'primarily realistic' Venus by
Thomas Bewick *(cat.144)* and a 'primarily ornamental' one – the Floren-
tine Venus used in *Aratra* – proves that 'to engrave well is to ornament
a surface well' (XXII, 379-80).

Underlying this formal opposition is a cultural one between north and
south. The nineteenth-century Englishman cannot draw beautifully
firstly because we have lost the technique of constructing the line 'of
successive minute touches ... a chain of delicate links' (XXII, 382); but
secondly because the North of Europe lacks that discipline of mind and
fancy to which Ruskin had referred in his Inaugural Lectures, and which
he here identifies with ancient Greece. Without classical learning we can
produce Bewick's pigs and frogs – and Bewick's Venus; but never the
'design or painting of forms' in a Greek coin, in the 'Baldini' Venus
(cat.146), in 'Botticelli's' erudite Libyan and Cumaean sibyls *(cats 148,
149)* (XXII, 395-7). In *Ariadne* the survival or loss of learning determines
all intellectual, religious, social experience. To Botticelli as a 'reanimate
Greek' the revived natural philosophy of the fifteenth century is a
recovered memory allowing him to be 'more and more himself again';[9]
to Holbein it is alien and he wears it awkwardly. Similarly with the north-
ern and southern forms of Protestantism and social protest. Unlike Botti-
celli, Holbein has no ancient religion to fall back on when the Church
proves corrupt; he therefore 'reads Nature in her desolate and narrow
truth, and she teaches him the triumph of Death' (XXII, 415). The mere
'facts' do not permit beautiful drawing and visions of angels. Beside the
plates of the miser and the death of the poor child from the *Dance of
Death (cats 157, 160)*, Ruskin set Botticelli's less pessimistic *Mount of
Compassion* (XXII, 438-40; *cat.161*). Against Bewick's plate of two
mutilated soldiers and the scornful drawing of an ass rubbing its behind
against a military monument, he set Botticelli's reverent 'reproof of war',
an engraving of Joshua at prayer (XXII, 435) *(cat.147)*.

Antitheses are as plentiful here as in the earlier lecture series, and
as 'inlaid and complex'. But unlike the earlier series, these also try for
synthesis. Tuscany, Florence especially, is the peaceful centre of the
north-south axis, the point where the enemies 'lay down their arms'.
Greece is for the Florentine not anti-Christian but pre-Christian, even
the 'foundation of Christianity'. Botticelli had 'seized the harmonies' of
both Mosaic and classic theology; had it been completed his Sistine
Chapel would have been a 'great choir of prophets and sibyls'. The
engravings of these sibyls are all manifestations of the Florentine
Ariadne; and she too is of course a synthesis, the 'chain of delicate links'

9. XXII, 400; for Ruskin's illustration of this see
his reading of the natural philosophy
symbolically figured in the 'Sun in Leo' Plate,
xxii, 403-6 *(cat.145)*

leading from classical Greece to early Renaissance Tuscany and binding together the 'entire body of ornamental design'.

But *Ariadne* ends with a statement of failure. Ruskin himself had hoped to justify his title 'by careful analysis of the methods of labyrinthine ornament' which had 'entangled in their returns the eyes of men' from Theseian traditions to Assyrian, to Greek vase, Medieval manuscript, Venetian and Roman arabesque:

But the labyrinth of life itself, and its more and more interwoven occupation, became too manifold, and too difficult for me ... (XXII, 451-2).

The metaphor is of losing the thread, or of its breaking. The old 'instinctive labyrinthine intricacies' have become merely symbols of a foolish sect, and

The very labyrinth of grass and flowers of our field, though dissected to its last leaf, is bitten bare, or trampled to slime, by the Minotaur of our lust ... (XXII, 453).

Ruskin writes of art teaching as one of the 'blind alleys' of the labyrinth, of the uselessness of speaking of Cimabue and Giotto in a 'land of furnaces', and in a reading of Botticelli's *Libyan Sibyl* of the failure of her promise of rain, daybreak and new birth:

the daybreak came not then, nor yet has come, but only a deeper darkness; and why here there is neither queen nor king of nations, but every man doing that which is right in his own eyes, I would fain go on, partly to tell, and partly to meditate with you ... (XXII, 454-5).

Implied here is a break in continuity between past and present, between ancient Greece and modern England, a break occurring after Botticelli and determining the subsequent history of Europe – its arts, its political systems, its morality, its use and abuse of nature. Ruskin's next series of Oxford lectures, concerned with Tuscany in relation to modernity rather than antiquity, was to raise the question as to whether that break had not originated in Val d'Arno itself.

3. Apron and Shield

By the time the last *Ariadne* lecture appeared in print in July 1875, Ruskin had in fact already said something to his Oxford audiences about the disappearance of queens and kings and the growth of confidence in individual judgement. His course for Michaelmas Term 1873 was *Val d'Arno: Ten Lectures on the Tuscan Art directly antecedent to the Florentine Year of Victories*.[10] The main title gives a clue to the genesis of the lectures. In a letter to the Cowper-Temples of the summer of 1871 Ruskin had asked what they would

say to a walk

10. These lectures were set in type before delivery, but the publication date was 1874

'At evening on the top of Fesole,
Or in Val d'Arno – to descry new lands'
not in *her* spotty globe, but in our own England – through Florentine art and laws?[11]

Through *Fors Clavigera*, the monthly 'Letters to the Workmen and Labourers of Great Britain' founded at the beginning of 1871, Ruskin was in fact committed to 'descrying new lands', finding models for an alternative England. The August 1871 issue of *Fors* announced plans for utopian agricultural communities – later named for St George – in whose schools was to be taught 'the history of five cities: Athens, Rome, Venice, Florence and London' (xxvii, 143). Initially parallel but separate, Ruskin's University work and St George's were by 1873 becoming increasingly entangled.[12] *Val d'Arno* is a series of lectures on Tuscan architecture, but it is also an attempt to make out a new England through the medium of 'a dead nation, in character greatly resembling her own …' (xxiii, 14).

Val d'Arno begins with the story of a revolution. In 1250 the merchants and tradesmen of Florence depose their Podestà, setting up in his place a Lucchese as 'Captain of the People' and a council of twelve ancients chosen from among themselves. This Ruskin sees as the beginning of the 'passing away of the feudal system', the coming of 'our modern liberties, … of action or of trade' (xxiii, 11). The main dialectic in these lectures is the fight between knights, whose arms are blazoned on the shield, and trades, whose bearing is the apron: the first an aristocracy of the blood, the second of skill. Other oppositions crop up in *Val d'Arno*, complicating this one. Most important is the 'war between the solid, rational and earthly authority of the King, and State, with the more or less spectral, hooded, imaginative, and nubiform authority of the Pope, and Church' (xxiii, 12). But imperial and papal forces are for Ruskin only two forms of chivalry, one 'infidel', the other religious, and Guelphs and Ghibellines kill each other on the city streets in a deadly but historically insignificant form of sport. The main dynamic of his Carlylean historiography is economic, social, and cultural: the process by which both King and priest lose power to the third estate, an economy based on manufacture and exchange rather than on rapine, and a religion relying on individual conscience rather than ceremony.

These changes affect the whole of Europe, but Tuscany, now called Etruria, lies

… in the exact midst of all such transition … receiving, resisting, and reigning over all … (xxiii, 40).

Helped by Nicola Pisano, Florence destroys or lowers the towers of the nobles, signalling the end of German tyranny. She then proclaims – and

11. *Letters … to Mount-Temple*, 27 July 1871, p.311. His mother's illness had made it impossible for Ruskin to go abroad that summer. The quotation is from *Paradise Lost* I, 287-91, where the shield of Satan is compared to '… the Moon, whose Orb/Through Optic Glass the *Tuscan* Artist views/at Ev'ning from the Top of *Fesole*,/Or in *Valdarno*, to descry new Lands,/Rivers or Mountains in her spotty Globe'. Also anticipated here is the *Laws of Fesole*, Ruskin's drawing manual based on principles 'Determined by the Tuscan Masters' (1877-8)

12. *Val d'Arno* is not the only Tuscan volume to serve both. The *Laws of Fesole* was intended for use in St George's Schools as well as in the Drawing School at Oxford

enforces on all the cities of Etruria – 'free – because honest – commerce', and expanding commerce makes peace and justice economic necessities. Civil society protects and provides for itself by great public works: fountains and markets, canals, acqueducts, docks and defensive walls are built on an unprecedented scale (xxiii, 45-51). And as economic conditions call for peace and justice, the establishment of a peaceful and ordered society enables men for the first time to 'comprehend the full import of Christianity' (xx, 151). In 1293 Florence establishes

So perfect a type of national government [as] has only once been reached in the history of the human race …

Then follow the 'seventy years of glory' in which the city gives Europe 'the entire cycle of Christian art' (xxiii, 158). Not only Christian, but 'quasi-Protestant', in 1375 Florence rebels against the Church and leads the 'great cities of Etruria' in an undertaking to free 'all the people who groaned under the tyranny of the church' (xxiii, 111-2). From Pisa meanwhile come the techniques of building – and destroying – for peaceful purposes, and Christian doctrine enters architecture with the Gothic of the baptistery pulpit *(cat.186)* and the Camposanto cloister. And in Lucca merchants raise churches with 'all kinds of junctions, insertions, refitting, and elevations …' (xxiii, 84). No Daedalian ambiguity troubles this 'intricate harlequinade' of bands of serpentine and marble, or the cementless, dove-tailed 'stone carpentry' of the cross which the east gate of Lucca

bears … above it, as the doors of a Christian city should. Such a city is, or ought to be, a place of peace … (xxiii, 100).

'Is, or ought to be'. In the lecture ironically entitled 'Pax vobiscum', Ruskin tells how Florence, seeing around her 'much protectionist ignorance', devastates the cities who oppose her will to make 'pacific mercantile states also of those benighted towns' and extend 'the privileges of their own new artisan government' (xxiii, 70, 74). He believed the Florentines to be fighting 'in absolutely good faith' in this, but in the end Ruskin attributes the fall of Etruria also to 'fratricidal struggle' between her cities. He was also to accuse Florence of greed – allowing usury, a 'Protestant form of Madonna worship' of which England too was guilty. If Florence – and the other cities of Tuscany – are 'nation[s] very much resembling our own' the analogies are both positive and negative. Both Etruria and England are modern, commercial societies, dedicated to free trade, 'Protestant' in religion, and 'democratic' in government, and both run the risks of modern societies.

Allusions to these risks are indirect but frequent in *Val d'Arno*. The spectre of class warfare for instance repeatedly surfaces and is buried. Ruskin denies any resemblance between 'franchise' and 'freedom', the liberty as understood in thirteenth- and fourteenth-century Florence and

the 'policy which is now preached in France, Italy, and England' (XXIII, 113). The 1250 revolution is described as a revolution against the violence of feudalism; but in 1257 'the people' go further, torturing and beheading Ghibelline suspects summarily. And when the imperial party is ousted with French and English help in 1267, we are told to

Remember ... this revolution ... expresses the lower revolutionary spirit of the trades, with English and French assistance ...[13]

Here the story is interrupted. We are told to 'leave Florence ... [to] watch, for a while, darling little Pisa, all on fire for the young Conradin', Conradin being the last of the heirs of Frederick II. *Val d'Arno* frequently betrays Ghibelline sympathies, and I suspect a current of uneasiness at the defeat of 'infidel', heroic chivalry by the allied forces of religion, trade and democracy. Ruskin speaks admiringly of Pisa as 'mad little sea-falcon' standing out alone against Genoa; of the 'splendour of spirit and brightness of youth' of Conradin, killed at Tagliacozzo in 1266; Frederick's natural son Manfred, 'one of the purest representatives of northern chivalry', goes to his death at Benevento

not claiming God as his friend, not asking anything of Him, as if His purpose could be changed; but accepting simply His sign that the appointed day of death was come (XXIII, 143).

Charles of Anjou, the Guelph leader, then slaughters Manfred's barons, 'all the faithful Ghibelline knights of Pisa', cuts off the feet of the resisters at Augusta, and destroys the power of Calabria and all of southern Italy. In so doing he enables Florence to 'prosper in her religious-democratic constitution', makes 'Italy secure in the Catholic creed' and can die 'in an odour of sanctity' (XXIII, 144).

Ruskin's old horror at the cruelty perpetrated in the name of Christianity re-surfaces in this sarcasm. In comparisons with modern Europe Etruria still comes off best. The English gentleman will not cut the throats of children, 'but he will kill any quantity of children by disease in order to increase his rents'. Charles's massacres cost the lives of no more than 20,000; the Franco-Prussian war then being waged in the name of what 'Christian nations now call "patriotism"' had so far massacred at least 500,000:

Their passions, tumultuous and merciless as the Tyrrhene Sea, raged indeed with the danger, but also with the uses, of naturally appointed storm; while ours, pacific in corruption, languish in vague maremma of misguided pools; and are pestilential most surely as they retire (XXIII, 144-5).

Etruria here can teach but is no perfect model, and earlier ages are neither 'authoritative in doctrine, [nor] ... in example'. In this passage this is because they are 'too savage'. But in looking for a new England through the medium of Val d'Arno, Ruskin had also discovered the origins of the misguided, modern England he was trying to reform.

13. XXIII, 153. Ruskin continues: 'Its immediate result was the appointment of five hundred and sixty lawyers, woolcombers, butchers, to deliberate upon all State questions ...'. This sounds simply snobbish but also recalls Burke's *Reflections on the Revolution in France*, where the large number of lawyers in the French Estates General is seen as contributing to the Revolution

4. Aesthetic and Mathematic

Perhaps nothing confirms suspicions of uneasiness about the libertarian version of Etruria more than the fact that the lectures delivered in Michaelmas Term 1874, *The Aesthetic and Mathematic Schools of Art in Florence*[14] make no reference to quasi-Protestantism, revolutionary spirits, war or free trade. Instead Etruria is celebrated mainly as the centre of an archaic Etruscan Christianity. It preserves the 'political state of chivalry' even after becoming civic and peaceable (XXIII, 253), and in religion is visionary where the proto-Protestantism of *Val d'Arno* is practical and down-to-earth.

There are biographical reasons for the shift. In between the two series of lectures came the journey of 1874, a journey made without the usual accompaniments of Hilliards and Severns and its consequent visiting of sights and 'somewhat luxurious hotel life'.[15] This time Ruskin travelled to Sicily, where he drew the tomb of the Emperor Frederick II in Palermo; then worked in the Sistine Chapel copying Botticelli's Zipporah, like Ariadne, like Ilaria del Carretto and like the Proserpina who haunts his Sicilian visit, an incarnation of Rose La Touche. This was followed by a month in Assisi studying Giotto and Cimabue, and discussing the Bible with the sacristan, who gave Ruskin the use of his cell and allowed him to 'rummage' among the relics 'a great heap of them on the table at once, like a dinner service!'[16] In the *Aesthetic and Mathematic Schools* the school Ruskin claims to belong 'wholly' to is a 'perfect Christian school of art', able to 'discern right from wrong and beautiful from base with a precision never before or since reached by the conscience or intellect of man' (XXIII, 224, 212). As he knew from his own experience the aesthetic 'habit' of perception can reach

an insane degree of intensity; that is to say, to the point of actually seeing and hearing sights and sounds which had apparently no external cause.[17]

Again Etruria is the centre of Europe: meeting point of centripetal forces, then point of departure for centrifugal ones. At Florence two pairs of opponents come together: 'Northern savage' with its two strains (Lombard and Norman) and 'Southern savage' (Greek and Arabian). This time synthesis does seem to be achieved, made possible by the concept of an original archaic stock which Ruskin sees as fusing Greek and Christian (XXIII, 190-1). In this 1874 version of Val d'Arno history the Etruscans live quietly at Florence until the thirteenth century, when the restless warrior Lombards intermarry with them. There follows 'one continual clatter of street-fighting' until the 'great revolution to peace' of 1250. This time the revolution is not economic and political, merchants and trades against feudal nobles, but racial and cultural – Etruscans overcoming Lombards, and strengthened by their fight, beginning 'their

14. This is not Ruskin's title for he did not publish them at the time – they were popular but he recognised that they were not his best. They were printed for the first time in the Library Edition from the incomplete manuscript, and with the aid of notes taken during the lectures by A. Wedderburn

15. XXXV, 561-2. The last paragraph of *Praeterita* conflates the 1870 and the 1872 journeys, compressing last sights of the fountains of Trevi in Rome (1872) and Branda in Siena (1870). A critical footnote here refers to Joan's objections to 'my early catholic opinions' and names her, Norton, Lady Trevelyan, Connie Hilliard and John P. Robinson of Lowell's *Biglow Papers* as the '*five* opponent powers' who 'may be practically held responsible for my never having followed up the historic study begun in Val d'Arno, for it chanced that, alike in Florence, Siena, and Rome, all these friends, tutors, or enchantresses were at different times amusing themselves when I was at my hardest work ...'; the suggestion that he was distracted from studying Catholicism is hardly fair – but interesting in the light of the anti-Protestant undercurrents in *Val d'Arno*

16. Letter to Susan Beever quoted in W. G. Collingwood, *The Life and Work of John Ruskin*. London: Methuen, 1893, II, 144-5

17. XXIII, 212. Here Ruskin refers to prophetic dreams he had had when ill at Matlock in 1871, dreams of which he had written also in *Ariadne Florentina* (XXII, 445-7). At Assisi he had dreamed that he had been made a member of the Franciscan order, and been tempted to regard that dream as an instruction. Visions were to become increasingly important in his life from now on; see Van Akin Burd's *The Christmas Story*. London: Oxford University Press, 1991

own Florentine life' — and that of Europe. The man who is 'first of the Florentines' is also 'first of the European men' (XXIII, 197).

Here Ruskin returns to the painters he had put aside at the end of the last *Ariadne* lecture. Cimabue is 'the Florentine spirit itself — the Etrurian lover of religion and mystery returning to its strength'. Ruskin was now convinced that he and Giotto

are both absolutely of the Graeco-Etruscan race as opposed to the Norman, that they represent the new budding of the underground stem which has its root partly in Greece proper, partly in Egypt … They are at once Greek of the Greeks, and Christian of the Christians … (XXIII, 200).

In the cathedral of Florence Arnolfo, and in the Campanile Giotto, 'Etruscan lad of the Fesole', unite the Etruscan way of encrusting with marble with the Gothic form which replaced the old tomb-shaped churches with the 'luminous temples' proper to a religion of love on earth (XXIII, 192-242).

It is a sign of the distance Ruskin had moved in the four years 1870-4 that what had been Daedalian is now not only crystalline but Christian, and that the School of Clay to which he had once 'wholly' belonged is virtually denied.[18] Whereas the colourists put their art at the service of religion, the sculptors merely use religion as subject-matter. Nicola Pisano is in these lectures first of the dangerously atomistic Mathematic artists. This school relies on 'learning and demonstration' rather than visionary sight, and is so proud of its anatomical knowledge what it makes what should remain hidden the main incident and hides what should be shown (XXIII, 224). In the Deposition in the porch of Lucca cathedral the healing herbs in Nicodemus's basket cannot be seen from the ground, while right in the middle of the sculpture is 'a man pulling the nails out [of the feet of Christ] with a big pair of pincers' (XXIII, 226). For Ilaria del Carretto's *(cats 237-9)* sake Jacopo della Quercia is saved from mathematical damnation by being made an 'old central Etruscan' who manages to retain deep religious sentiment while respecting the new naturalism. But no mercy is allowed Ghiberti, whose 'grace and inventive decorativeness' enables the Mathematic School to overcome the 'rapture of the Goth and the dream of the Etruscan', opening the way to the deadly art of Raphael and Michelangelo. The 'religious ballet' of 'operatic scenes' on the bronze doors *(cat.210)* of the Florence Baptistery is contrasted with Giotto's scenes of peace and honest work in the lozenges of the Campanile (XXIII, 242) *(cats 195-209)*.

At the end of the fourteenth century, however, Ruskin revives the Aesthetic School once more to make room for two special painters. Giotto had been unique in his ability to understand both sides of 'chivalric Christianity' — monastic and domestic. His legacy is then divided between

18. Ruskin now removes Turner, as well as himself, into the Aesthetic School

the two unmatched masters in painting of romantic Christianity, Angelico and Botticelli [, who] taught to Florence, one the happiness of Heaven, and the other the Holiness of Earth (XXIII, 253).

About Angelico's 'old Etruscan faculty – Fesole faculty – of jewellery, with Christian passion in it', Ruskin has no reservations now. And Botticelli here is not so much engraver of sibyls as painter of the Moses cycle, 'the most sacred picture of humanity, and of the law by which it lives, ever produced by the Christian art of Europe' (XXIII, 271). Via the inlaid marbles, an inscription from the Gospel of St Mark,[19] and leaf carving in the cornice, Ruskin pairs the Badia – the 'earliest remnant of Etruscan Christian building near Florence' – and Angelico's convent at Fiesole with the Baptistery in Piazza Duomo:

as Angelico in the repose of Fesole, so [Botticelli] among the concourse of men in the square of Florence, ... and for the first time in the history of nations, in the midst of a world of war, Florence then raised her lily standard in the name of the peace of God; not the narrow Irene of Athens, peace only within her walls, and prosperity in her own palaces, but peace published with eager foot upon the distant hills, and with shout of good tidings in the streets of strangers (XXIII, 272).

Here Etruria does achieve the status of utopia. But the celebratory prose is over-strained, and except for odd moments, this series lacks the closeness to objects and the intellectual excitement of *Aratra Pentelici* and *Ariadne Florentina*. Twice Ruskin regrets his choice of distinguishing labels (XXIII, 199, 249), and I suspect he had outgrown the 'joiner's work' of inlaying 'modes of opposition'. Aesthetic and Mathematic are not balanced interrelated concepts as are the Schools of Crystal and Clay; in 1874 Ruskin really did commit himself 'wholly' to one of the two terms, and his hymn to Florence as centre of the art of Christendom signals his having come full circle from the furious denunciations of religious art in the Inaugural series. He still had his Florentine guide-book to finish and a drawing manual based on principles 'Determined by the Tuscan Masters'. He was to continue to use Tuscany in *Fors Clavigera*, drawing on Florentine social structure and trade laws as models, on Lorenzetti's great painting in Siena for an ideal of government. He planned histories of Florence and Pisa for the standard libraries of St George's Schools, and hoped to ornament the Guild museum with inlaid coloured marbles. But Ruskin did not lecture on Tuscan art again at Oxford, where he was in any case to lecture much less frequently from now on. He had exhausted a second cycle of systematic explanation of the first principles of art, and contemporaneously exhausted his second and perhaps most productive phase of Tuscan experience.

19 'ALL THINGS THAT YOU SEEK IN PRAYER, BELIEVE THAT YOU SHALL RECEIVE THEM, AND THEY SHALL BE FULFILLED TO YOU. WHEN YE STAND PRAYING, FORGIVE IF YE HAVE AUGHT AGAINST ANY.' Mark xi, 24-5 *(cat.215)*

Biographies

Alessandri, Angelo (1854-1931)

Possibly of Armenian descent, Alessandri was born in Venice on 23 April of educated though not wealthy parents. He entered the Accademia di Belle Arti in 1866, where he studied figure-drawing, ornamental design, statuary, anatomy and history of art, winning prizes in figure-drawing, theory of anatomy and picture composition. Alessandri met Ruskin in 1877, possibly at the Accademia, with which he seems to have retained some informal connection after finishing his studies there in 1871. Ruskin undertook to instruct Alessandri in landscape drawing, taking him in May of that year to Stresa and Domodossola specifically for this purpose. However, Alessandri was subsequently to work for Ruskin almost exclusively as a copyist, in connection with the St George's Guild collection. He received regular commissions on behalf of the Guild from 1879 on, principally for copies after paintings by Carpaccio and Tintoretto in Venice. In 1881, however, Allessandri drew for Ruskin in Florence and Rome, while in 1882 he was summoned, together with Giacomo Boni, to Pisa, to make drawings of architectural decorations; and again in 1884 a trip to Verona was directed by Ruskin from England. In 1884-5 Alessandri was given a lectureship in figure-drawing at the Accademia, where he apparently taught for the rest of his life. He married in 1887 and had two daughters. Alessandri's last meeting with Ruskin was in Venice in 1888, when the latter was already seriously ill, but he continued to sell pictures to the Guild of St George even after Ruskin's final collapse a year later. Alessandri also worked as a copyist for the court of the Tsar and for Frederick III of Prussia. He may also have done some work for the Arundel Society. Alessandri exhibited at the 13th International Exhibition of Art at Venice and at the Mostra delle Tre Venezie at Milan. He also sent pictures to the Ruskin exhibition at Manchester in 1904.

REFS: *Dizionario biografico degli italiani*, II, Roma, 1960; Jeanne Clegg, 'John Ruskin's Correspondence with Angelo Alessandri', in *Bulletin of the John Rylands University Library of Manchester*, 60, No.2 (Spring 1978), 404-33; Morley, 1-2

Alexander, Esther Frances ('Francesca') (1837-1917)

Esther Frances Alexander (later given the name Francesca by Ruskin) was born in Boston on 27 February 1837, the only child of the portrait-painter Francis Alexander and Lucia Gray Swett, whose grandfather had been the greatest individual ship-owner in the United States. Francesca began to draw at an early age, illustrating stories and poems she composed for herself. Though encouraged by her father she never had any formal artistic training. At thirteen she pro-duced her first oil-painting but was never happy in this medium, and worked mainly in pen and ink. Francesca first visited Florence at about fifteen, when she was taken to Europe to develop her musical and artistic talents. The Alexanders settled in the city a year or so later on account of their daughter's ill-health, initially at Bellosguardo, where the pious Francesca devoted herself to her drawing and to assisting and instructing the poor. These became her preferred models and from them she learned many of the traditional stories and songs she would afterwards collect and illustrate. But the chief source for the songs comprised in her main work, the hundred and more illustrated leaves of which Ruskin published a small selection under the title *The Roadside Songs of Tuscany*, was the celebrated improviser of verses, Beatrice di Pian degli Ontani, a shepherdess from the mountains above Pistoia, whom Francesca met in 1862 during the first of many summer visits to the Abetone. In 1869 the Alexanders moved down to Florence, taking an apartment in a wing of the Hotel Bonciani, looking onto Piazza Santa Maria Novella. It was here that Ruskin met her in 1882, a visit that led to the purchase and publication of the *Roadside Songs*, and made of Francesca's roof-top studio an object of pilgrimage among cultured English residents and tourists in Florence. Ruskin formed a close friendship with both Francesca and her mother (her father had recently died), corresponding with them until his collapse in 1889. They did not meet again, however, until 1888, when Ruskin stayed with them in Bassano during his last visit to Italy. Towards the end of her life Francesca's eyesight failed. She died a year after her mother, on 17 January 1917, and is buried with her parents in the Evangelical Cemetery at Allori, outside Florence.

REFS: Constance Grosvenor Alexander, *Francesca Alexander: A 'Hidden Servant' ... Memories Garnered by One Who Loved Her Dearly*. Cambridge, Mass, 1927; Swett; Regina Soria, *Dictionary of Nineteenth-Century American Artists in Italy 1760-1914*. London and Toronto: Associated University Press, 1982, 52; Morley, 22-4; Linda S. Ferber and William H. Gerdts, *The New Path: Ruskin and the American Pre-Raphaelites*. New York: Brooklyn Museum/Schocken Books Inc, 1985, 228-31; Paolo Bellucci, *Poetessa pastora: la storia e i canti di Beatrice di Pian degli Ontani scoperta da Tommaseo e amata da Ruskin*. Florence: Edizioni Medicea, 1986

Blandy, Louise Virenda (1860-90)

Louise Blandy was one of the many girls to whom Ruskin taught drawing, usually by correspondence. He first began teaching her in 1873. The following year she was referred to Ruskin's assistant William Ward for elementary lessons

in watercolour technique. Ruskin took Louise to the National Gallery for the first time on 29 January 1874, setting her to copy a shield. The lessons seem to have been discontinued around 1876, after which Louise apparently had some formal training. The association with Ruskin continued, however, and in the early 1880s she did some copying and minor secretarial work for him. Between 1879 and 1881, Louise exhibited at the Grafton Galleries.

REF: Morley, 30-2

Bunney, John Wharlton (1828-82)

Bunney was born in London on 20 June 1828. Son of a sea-captain, the boy accompanied his father on voyages and is said to have sailed round the world three times by the age of eleven. He early developed the desire to be an artist, but was actively discouraged by his father, who apprenticed him to a stationer-uncle in the city. After his father's death, Bunney obtained a post at the publishers Smith, Elder & Co, but was also freer to develop his painting: in 1854 he began attending Ruskin's drawing classes at the Working Men's College in Red Lion Square and soon afterwards showed his first exhibited work at the Royal Academy. In 1857 he gave up his job and supported himself and his family by teaching drawing and other art-work. Ruskin was sufficiently impressed by Bunney's gifts to send him to Switzerland in 1859, and the following year to Venice. Back in London, Bunney deputised for Ruskin both at the Working Men's College and privately, teaching among others Octavia Hill and Rose La Touche. In 1863 he married and left England for Italy, where, perhaps at Ruskin's suggestion, he settled in Florence, at Bellosguardo. In 1866-7 he made architectural drawings for Ruskin in Lucca, and in 1869 was called to Verona, where Ruskin was engaged in work for the Arundel Society. In 1870, Ruskin asked Bunney to move to Venice, where he lived for the rest of his life, a point of reference for the growing number of English and Italian copyists employed by Ruskin in Italy in connection with the Oxford and St George's Guild collections. Bunney's major commission from Ruskin was a large oil-painting of the west front of St Mark's, which occupied him for 600 sessions from 1877 to 1882, shortly before his death on 23 September. A large number of works by Bunney were included in an exhibition of paintings and drawings of Venice at the Fine Art Society in November of that year, and Marcus Huish, secretary of the Society, Arthur Severn and Ruskin organised a public subscription to assist the artist's widow and children.

REFS: Unpublished letters from John Ruskin to J. W. Bunney 1866-70, private collection; A. Wedderburn, 'Memoir of John Wharlton Bunney', in catalogue of exhibition, FAS 1882; Morley, 32-7.

Burgess, Arthur (d.1887)

Arthur Burgess was a poor wood-engraver who in 1860 approached Ruskin for help, apparently at the suggestion of Octavia Hill. Ruskin employed him to make engravings from old botanical plates and from real flowers for *Proserpina*. Burgess did not work for Ruskin again until 1869, when he was taken to Verona to help in work undertaken there for the Arundel Society. Here it was as much his 'mechanical ingenuity and mathematical intelligence' as his outstanding qualities as a 'draughtsman in black and white' which were of service: he drew the mouldings of the Scala tombs, collated and corrected Ruskin's measurements and also made a model in clay of the Castelbarco tomb, 'showing that without any cement the whole fabric stood on its four pillars with entire security' (XIV, 351). In the early 1870s, when Ruskin was teaching at Oxford, Burgess was his salaried assistant, responsible for the preparation of lecture diagrams, drawings for the collections of examples and illustrations of Ruskin's books. This arrangement lapsed after Ruskin's resignation in 1874, but the two met again in 1878, when Burgess made several visits to Brantwood. They did not see each other again, though in 1880 Burgess was sent by Ruskin to Rouen, to supervise the photographing on his behalf of the west front of the Cathedral. Generally poor in health, Burgess suffered from bouts of nervous illness. Ruskin has left a vivid portrait of him in an article written after Burgess' death in 1887: 'grave face, honest but reserved, distressed but unconquerable, vivid yet hopeless, with the high-full-forward but strainedly narrow forehead' (XIV, 349).

REFS: John Ruskin, 'Arthur Burgess' (1887), XIV, 349-56; Morley, 44-6

Collingwood, William Gershom (1854-1932)

Collingwood began attending Ruskin's drawing classes at Oxford in 1872 while an undergraduate. He had already exhibited landscapes in watercolour. He collaborated with a fellow-student, Alexander Wedderburn, later to be one of the editors of the Library Edition of Ruskin's works, on the translation of Xenophon's *Economist* for the *Bibliotheca Pastorum* series of standard texts which Ruskin planned for the St George's Guild. Collingwood visited Brantwood in 1873 and again in 1875, together with Wedderburn, to

finish the translation of Xenophon: in intervals they helped to dig the harbour. By 1881, when he went to live in the Lake District, Collingwood was acting as Ruskin's assistant. The following year he accompanied Ruskin to France and Italy, where he was encouraged to develop not only his painting and knowledge of art but also his geology, drawing sections of the French Alps for future scale models, a study which would lead to the publication of his *Limestone Alps of Savoy* (1884). After Ruskin's withdrawal from active life in 1889-90, Collingwood produced a two-volume edition of his poems (1891) and a biography (1893, revised in 1900). He also wrote a study of Ruskin's thought entitled *The Art Teaching of John Ruskin* (1891). In this period Collingwood also developed an interest in local archaeology, becoming the President of the Cumberland and Westmoreland Antiquarian and Archaeological Society. He was later appointed Director of the Department of Fine Art at University College, Reading. He married Edith Mary Isaac, daughter of a Notting Hill corn-merchant, a professional miniaturist and talented pianist. Their son, the philosopher Robin George Collingwood, was born in 1889.

REFS: Morley, 56-8; *Dictionary of National Biography* (Robin George Collingwood)

Goodwin, Albert (1845-1932)

Goodwin was born on 17 January 1845 in Maidstone, son of a builder. After attending Mr Weekstead's school in Bedford Place, Maidstone, he was apprenticed to a local draper. In 1860 Goodwin exhibited his first picture, at the Royal Academy. Shortly after this he became a pupil of Ford Madox Brown's, having previously met William Holman Hunt and Arthur Hughes. In 1867, when he was living in Arundel, he married his first wife, Mary Ann Lucas, who died two years later. From 1870 to 1877 Goodwin lived in Fulham. In the spring of 1871 he was invited by Ruskin (whom he may have met through Arthur Hughes) to join him on a sketching holiday in Abingdon, partly to 'get used' to him before a proposed tour to Verona together. Later that summer Goodwin helped nurse Ruskin through a serious illness at Matlock. In the same year Goodwin was elected an Associate of the Royal Society of Painters in Water-Colours. In 1872 he travelled to Italy with Ruskin and Joan and Arthur Severn, Mrs John Hilliard and her daughter Constance. In the following years Goodwin visited Switzerland and Egypt. Meanwhile he had married his second wife Alice Desborough, with whom he had three daughters and a son. In 1881 he was elected a full member of the Royal Society of Painters in Water-Colours. Before his death at the age of eighty-seven, when he was still paint-

ing, he travelled widely, visiting the Netherlands, Norway, Switzerland, Italy, Egypt, the West Indies, America, New Zealand and Australia.

REF: Catalogue of exhibition, *Albert Goodwin R.W.S. 1845-1932*, RWS 1986

Murray, Charles Fairfax (1849-1919)

Murray was born in Bow, London on 30 September, son of a draper, James Dalton Murray and Elizabeth Scott. Murray's father may also have been an amateur artist. By the 1860s he was an inmate of the almshouse attached to the Charterhouse, where he died in 1876. Murray does not seem to have had any formal artistic training, but a self-portrait dated 1867 (repr. Beresford, 197) shows precocious technical ability. As a clerk in an engineer's office in Westminster he is said to have drawn attention to himself for his drawing ability, and was subsequently introduced by Murray Marks the art-dealer into Pre-Raphaelite circles. In 1866-7 Murray became assistant first to Burne-Jones and then also to Rossetti. Later he worked for the firm of Morris & Co, transferring designs to stained glass and painting panels on furniture and woodwork. He did similar work for the firm of Collinson and Lock, antique furnishers and decorators. Meanwhile Murray was developing as an artist in his own right: he exhibited at the Royal Academy in 1867 and 1871, and through Burne-Jones began to receive portrait commissions, a genre for which he showed special talent. It was probably also at this early stage that Murray began, on a small scale, his activities as a collector and dealer, since he first approached Ruskin in 1869 offering to sell him some engravings by Lefèbre. It was not until 1872, however, that Murray and Ruskin actually met, after Burne-Jones had shown Ruskin copies of frescoes in the Camposanto of Pisa which Murray had made during his first visit to Italy the previous year. Partly on behalf of the Arundel Society, Ruskin sent Murray to Italy in 1873 to make copies of frescoes in Siena and Rome. From this time Murray was more or less permanently resident in Italy (though he later had homes in London and Paris too), marrying the seventeen-year old Angelica Collivichi in Pisa in 1875, and eventually settling in Florence. Angelica had six children, of whom three died in infancy or early youth. Murray continued to work as a copyist for Ruskin, in Tuscany and also in Venice, throughout the 1870s. Meanwhile he began to establish a reputation for himself as a connoisseur and collector, although he also continued to paint and exhibit, at the Grosvenor and New Galleries. He made a number of purchases for Ruskin, the most important being the *Madonna and Child* by Verrocchio from the

Palazzo Manfrini in Venice and now in the National Gallery, Edinburgh. Relations between the two men were sometimes tense, and in 1883 were broken off altogether, over the question of inadequate and erratic payments on Ruskin's part. However, the break was probably also the inevitable result of a personality clash: Murray, described by W.S.Spanton as 'friendly, sympathetic, but no flatterer' and by Colin Agnew as a hater of 'all forms of authority and society' certainly lacked the docility of Alessandri or Bunney. Moreover, the two men had opposed views of art, and though Ruskin from the beginning valued Murray's scholarship as much as his drawing, he noted that this often took the form of 'antagonism' (XXIII, 409), by which he meant historical and technical criticism of the kind practised by the new historians of art such as Crowe and Cavalcaselle (whom Murray knew and supplied with information). In 1893 Murray was recommended by Burne-Jones as Director of the National Gallery. By this time he was working as an expert at Agnew's and Colnaghi's. Murray published catalogues of the Duke of Portland's collection (1894) and of portions of his own, for example that of the large collection of Old Master drawings bought *en bloc* by J.Pierpont Morgan (1912), now part of the Pierpont Morgan Library of New York. Murray was a generous benefactor of a number of British museums and galleries, including the National Gallery, the Fitzwilliam Museum, Cambridge, the Birmingham City Art Gallery and the Dulwich Picture Gallery. After Murray's death in Chiswick on 25 January 1919, it emerged that he had formed a family in England in addition to that in Italy, and had named an English son, Arthur Richmond, as his heir. It is not known for certain whether Arthur Richmond was Murray's real or adopted son, nor how many other children, real or adopted, may have formed part of Murray's English family (it is thought there may have been as many as six). There was an unsuccessful attempt on the part of the Italian widow and children to invalidate the will, while the English heir tried to prevent the sale of all Murray's possessions in Italy. The result seems to have been that all those possessions which were in England at the time of Murray's death remained there, while those in Italy were kept by the Italian family.

REFS: Unpublished autograph letters from Ruskin to Murray and TS of interviews with Fritz Lugt and Colin Agnew, Morgan MA 2150; documents in the possession of Murray's great-granddaughter, Daniela Dinozzi, Livorno; W.S.Spanton, *An Art Student and his Teachers in the Sixties*. London 1927; Morley, 103-5; Sandra Beresford, 'Preraffaellismo ed estetismo a Firenze negli ultimi decenni del XIX secolo', in *L'idea di Firenze: Temi e interpretazioni nell'arte straniera dell'Ottocento*. Atti del

convegno Firenze, 17, 18, 19 dicembre 1986. A cura di Maurizio Bossi e Lucia Tonini, Firenze: Centro Di, 1989, 191-210; J.Christian (ed.), *The Last Romantics: The Romantic Tradition in British Art – Burne-Jones to Stanley Spencer*. London: Barbican Gallery/Lund Humphries, 1989, 91

Newman, Henry Roderick (1843-1917)

Newman was born in March 1843 in Easton, New York, son of a physician. His family moved to New York City in 1845. In accordance with his father's wishes he began to train as a doctor, but abandoned his studies in 1861, on the death of his father. He was given one year to prove himself as an artist by his mother, at the end of which several of his nature studies were exhibited at the National Academy of Design. Between 1861 and 1870 he exhibited almost every year at the Academy and at the Brooklyn Art Association. In 1864 Newman became a member of the Ruskin-inspired Association for the Advancement of Truth in Art. Between 1865 and 1866 he taught at the Free School of Art for Women at the Cooper Union. In 1867 he was elected a member of the newly formed American Water-colour Society. For reasons of health, Newman moved to Florida after the death of his mother in 1868, but moved back to New York State the following year. In 1870 he left for Europe, going first to Paris, where he enrolled at the Ecole des Beaux-Arts. But within a few weeks the outbreak of the Franco-Prussian war forced him to leave France for Italy. Here he lived first in Florence and then in Venice, where he met John Wharlton Bunney. In 1877 the American artist Charles Moore introduced Ruskin to Newman's work: Ruskin was enthusiastic and gave Newman the first of many commissions for the St George's Guild collection. Newman met Ruskin in England in 1879, and subsequently in Florence and Lucca during Ruskin's 1882 tour, when Newman in turn introduced Ruskin to the work of Francesca Alexander. By this time he had settled permanently in Florence, where his home in Piazza dei Rossi became a centre for Anglo-American residents and visitors. In 1883 he married an Englishwoman, Mary Watson Willis. From around the mid-1880s they took to wintering in Egypt, where Newman painted many pictures of the architecture. In the late 1890s he also visited Japan. Newman died in Florence in December 1917 and is buried in the cemetery at Allori.

REFS: H.Buxton Forman, 'An American Studio in Florence', in *The Manhattan* III, No.6 (June 1884), 525-39; Kent Ahrens, 'Pioneer Abroad, Henry R. Newman (1843-1917): Watercolorist and Friend of Ruskin', in *The American Art Journal* (November 1976), 85-98; Regina Soria, *Dictionary of Nineteenth-Century American Artists in Italy 1760-1914*. London and Toronto:

Associated University Press, 1982, 209-10; Morley, 119-21; Linda
S. Ferber and William H. Gerdts, *The New Path: Ruskin and the
American Pre-Raphaelites*. New York: Brooklyn Museum/
Schocken Books Inc, 1985

Rooke, Thomas Matthews (1842-1942)

Rooke was born in Marylebone, London, the son of a Jermyn
Street tailor who was also an amateur artist. While working
in an army agent's office the young Rooke attended evening
art-classes at the South Kensington school, enrolling as a
full-time student at the Royal Academy by 1868. Shortly
afterwards he applied for a post with Morris and Co, and
was assigned to Edward Burne-Jones, whom he helped on
projects for the Firm, but also assisted in transferring
designs to the large canvas format Burne-Jones was now
using. Strongly influenced by his 'Master', Rooke exhibited
imaginative paintings of his own at the Royal Academy and
the Grosvenor and New Galleries. He was also active in the
Arts and Crafts movement, helping to found the Art
Workers' Guild (1884) and exhibiting with the Arts and
Crafts Exhibition Society. From the late 1870s his work was
principally in watercolour and consisted in records of
mosaic, stained glass and architecture. His two main spon-
sors in this field were Ruskin and later the Society for the
Preservation of Pictorial Records of Ancient Works of Art.
Rooke first worked for Ruskin in Venice in 1879-80, where
he copied the mosaics in St Mark's, as part of Ruskin's
scheme for a series of 'Memorial Studies' of the church
under threat from restoration. Rooke returned to Venice
for Ruskin in 1884, when he also made studies of mosaics
in Ravenna, the first of three trips as a salaried copyist for
the St George's Guild. The following year Rooke was sent
to Chartres, and in 1886-7 he drew in Auxerre, Laon, Aval-
lon and then in Florence. In 1891 Rooke became an associ-
ate member of the Royal Watercolour Society, receiving full
membership in 1903. He continued to exhibit with the
Society until 1939. Rooke married Leonora Jones, a
schoolmistress from the Channel Islands, in 1872, and they
had two children: Margaret (1880-1955) would become Pro-
fessor of Italian Medieval Classics at Smith College, and
Noel (1881-1953), painter, wood-engraver, book illustrator
and poster designer who taught at the Central School of
Arts and Crafts, London. Rooke was also a musician, play-
ing violin, viola and cello.

REFS: M. Lago (ed.), *Burne-Jones Talking: His Conversations
1895-1898 Preserved by his Studio Assistant Thomas Rooke*.
London: Murray, 1981. Morley, 174-8; J. Christian (ed.), *The Last
Romantics: The Romantic Tradition in British Art – Burne-
Jones to Stanley Spencer*. London: Barbican Gallery/Lund
Humphries, 1989, 85

'He observed and collected'

He observed and collected
And he understood everything.
He knew well that every form brings us
Health or destruction.
He didn't believe in innocence
Of vapour or of rocks.
He saw in an apple or in the beak of an eagle
The eternal struggle between good and evil.
Before his eyes mountains and glaciers
Preached of edification
Or of damnation.
The others lacked this simple courage,
This madness of intelligence.
They did not dare take literally
The universe and its trifles,
Its natural infernos
And its sheer valleys:
The world of a leaf and rampaging branch
Were much more than a clue or a sign
They were a dwelling place of life,
A nest, a temple.
Precision was the only way of loving.
Lies were merely a bad relationship
Between form and matter,
A stupid tolerance of senselessness,
A denial of word, message and truth
To whatever makes its home in space and time
Organising whatever the circumstances offer
Into a destiny, a beauty
Pure and simple,
Like the mouth of a lion or a dragon
Without useless extras.
Because reality
Does not need dressing up
But to be looked at long, loved, described
And left to itself.

ALFONSO BERARDINELLI

'Osservava e collezionava'

Osservava e collezionava,
capiva tutto, lui,
sapeva bene che ogni forma ci porta
salute o distruzione,
non credeva all'innocenza
del vapore e delle rocce,
vedeva in una mela o in un becco d'aquila
la lotta eterna fra il bene e il male,
montagne e ghiacciai
tenevano davanti ai suoi occhi
il loro discorso di edificazione
o di dannazione.
Agli altri mancava questo semplice coraggio,
questa follia dell'intelligenza,
non osavano prendere in parola
l'universo e le sue inezie,
i suoi inferni naturali
e le sue valli scoscese:
il mondo di una foglia
e un tumultuoso ramo rampante
erano molto di più
di un indizio o di un segnale,
erano una sede stabile della vita,
un nido, un tempio,
la precisione era il solo modo di amare,
le menzogne non erano che una cattiva qualità
del rapporto fra forma e materia,
una stupida indulgenza nei confronti dell'insensato,
un negare parola, messaggio e verità
a ciò che prende dimora nello spazio e nel tempo,
organizzando quello che le circostanze offrono
fino a farne un destino, una bellezza
pura e semplice,
come la bocca di un leone o quello di un drago,
senza inutili aggiunte,
perché la realtà
non ha bisogno di essere vezzeggiata
ma guardata molto a lungo, amata, descritta
e lasciata a se stessa.

ALFONSO BERARDINELLI

Acknowledgements for permission to publish

The authors and publishers thank the literary trustees of John Ruskin for permission to publish manuscripts by him. It has not always been possible to trace the present copyright holders of other unpublished material. The author and publishers apologise if copyright has been unintentionally infringed. They are further indebted to the current owners of the unpublished MSS listed below for permission to quote from them in the catalogue.

W. G. Collingwood, letters to Edith Isaac 1882, by permission of Abbot Hall Museum and Art Gallery, Kendal.

J. Ruskin, Diaries and letters to his mother and Joan Severn; letter from his father to Ruskin, by permission of The Education Trust Ltd, Ruskin Galleries, Bembridge School, Bembridge, Isle of Wight.

J. Ruskin, numerous passages from the transcripts of his diaries and correspondence, by permission of the Bodleian Library, Oxford.

J. Severn, letter to S. Colvin, by permission of the Keeper, Department of Prints and Drawings, British Museum.

J. Ruskin, letter to E. Burne-Jones; E. Burne-Jones, letter to C. F. Murray [26 December 1871], by permission of the Syndics of the Fitzwilliam Museum, Cambridge.

C. F. Murray, Diaries 1874, 1878, by permission of the Fondation Custodia, Paris.

J. Ruskin, letters to T. Rooke (1886/7), by permission of the Harry Ransom Humanities Research Center.

E. Burne-Jones, letter to J. Ruskin; J. Severn, letter to C. E. Norton; by permission of the Houghton Library, Harvard University, Cambridge, Mass.

J. Hobbs, Travel Diary [1846-1849]; J. Ruskin, letters to R. Durheim; J. Ruskin, letters to C. F. Murray; J. Severn, Diary 26 April – 28 July 1870, by permission of the Pierpont Morgan Library, New York.

J. Ruskin, lecture on 'The Baptistery of Florence', by permission of the Princeton University Library.

J. Ruskin, letter to Joan Severn, by courtesy of the Director and University Librarian, the John Rylands University Library of Manchester.

Acknowledgements for reference photographs

The Trustees of the British Museum, London: *Medea*, *Theseus before the labyrinth* and *Joshua at Jericho*, from the *Florentine Picture Chronicle*, pp.90-2.

The Metropolitan Museum of Art, New York: three marble pilasters from the pulpit carved by Giovanni Pisano and assistants for the Duomo of Pisa (Rogers Fund, 1921 [21.101]; Hewitt Fund, 1910 [10.203. 1-2]), p.63.

New York Public Library Francesca Alexander, p.120.

Peter Tucker The Carlton Club, St James's Street, London, 1992, p.45.

Photographic acknowledgements

Ashmolean Museum, Oxford cats 7, 32, 33, 84, 86, 92, 93, 95, 101, 107, 109, 111, 123, 125, 126, 127, 128, 132, 151, 185, 190, 191, 219, 273

Birmingham City Museum and Art Gallery cat.38

David Briggs cats 3, 42, 217, 218, 238

The Trustees of The British Museum, London cats 145, 146, 147, 148, 149, 150, 153, 155

J. N. Bunney cat.81

Courtauld Institute Galleries, London cat.12

Renzo D'Angiolo cats 174, 175, 223

Fitzwilliam Museum, Cambridge cats 35, 98, 170

Kunstmuseum, Bern cat.14

Lake District Art Gallery and Museum Trust cat. 243

Duncan MacNeill cat.83

Manchester City Art Galleries cat.22

Andrew Morris cats 1, 2, 49, 58, 61, 113, 121, 212, 220, 259, 260

Ruskin Gallery, Sheffield cats 4, 5, 19, 28, 31, 39, 50, 68, 74, 94, 108, 141, 142, 143, 159, 160, 162, 163, 171, 172, 193, 194, 216, 222, 226, 228, 229, 231, 233, 234, 240, 241, 245, 248, 249, 250, 251, 252, 253, 262, 268, 269, 272, 280

Frank Taylor cats 10, 11, 20, 21, 24, 25, 34, 36, 37, 46, 48, 51, 52, 57, 67, 69, 97, 110, 114, 144, 177, 187, 195, 197, 202, 203, 204, 208, 213, 232, 263, 266